In loving memory of

Flora Whitney Miller

and

Gertrude Vanderbilt Whitney

A museum should be never finished,
but boundless and ever in motion.

Goethe

Preface

Through art alone are we able to emerge from ourselves, to know what another person sees of a universe which is not the same as our own and of which, without art, the landscapes would remain as unknown to us as those that may exist in the moon. Thanks to art, instead of seeing one world only, our own, we see that world multiply itself and we have at our disposal as many worlds as there are original artists, worlds more different one from the other than those which revolve in infinite space, worlds which, centuries after the extinction of the fire from which their light first emanated, whether it is called Rembrandt or Vermeer, send us still each one its special radiance.

— Marcel Proust, *Time Regained*

I want to start this book with a recognition of what's most important: art and artists.

I'm infinitely grateful for the joy I've received, through the Whitney Museum of American Art, from art and artists. Art remains, in the ancient biblical words, "when evening falls, and the busy world is hushed, and our work is done." I can look at a Johns painting or a sculpture by Andrew Lord, I can read a poem by Mary Oliver, or listen to "Drumming" by Steve Reich, or watch Trisha Brown dancing, or Laurie Anderson performing — or just remember them. A thousand other artists of our time connect me to as many worlds of vision and emotion, unsettle my preconceptions, and enrich my life immeasurably. As George Steiner says, "The encounter with the aesthetic is, together with certain modes of religious and metaphysical experience, the most 'ingressive,' transformative summons available to human experiencing" (*Real Presences*, University of Chicago Press, 1989).

All contemporary art isn't equal. For me, though, an open mind is essential. Who knows what wondrous, strange object might fly in? I often can't see the new right away, and so don't like making quick

judgments. As one entices a wily trout with the right fly, so one teases out the meaning of a work of art — like the trout, it's not always on the surface, one must explore the depths. In order to reap the reward, I must bring all I can of my mind and feelings to the search. Sometimes it's easy, more often it takes a lot of time and effort, and sometimes it doesn't happen at all. I've taken what I need, too, not necessarily what the artist intended.

A Greek temple silhouetted against an azure sky has revealed an ideal world. Michaelangelo's Vatican ceiling has deepened my sense of humanity. Rubens has delighted me with his understanding of the love of men and women. In Picasso I've seen that we are fragmented, complex, but ultimately whole. Agnes Martin and Richard Tuttle, in different ways, have helped me to believe in happiness and innocence.

In my desire to embrace it all, I lack the discrimination necessary for a curator, art historian, or critic — but I'm none of these. As a lover, I won't apologize for my enthusiasm, or for ignoring art I don't like.

The imposing granite Marcel Breuer building standing proudly at the corner of Madison Avenue and Seventy-fifth Street in New York City houses the Museum founded in 1930 by my remarkable grandmother, Gertrude Vanderbilt Whitney.

One woman's perception that American artists needed an institution of their own, her vision, her personal collection of work by contemporary American artists, and her indefatigable dedication created the Whitney Museum of American Art, one of New York City's — and the world's — major art institutions. Today, it is renowned both for its architecture and for what the Museum represents artistically.

Gertrude headed her Museum with Juliana Force, the director she chose, until she died in 1942. After her death, her daughter, Flora Whitney Miller, took the helm.

Then it passed to me. And today, my daughter Fiona, a fourth-generation Whitney woman, is an active board member of the Museum.

This is the story of that eminent institution, of my grandmother, of our family — all integral parts of my own memoir. And yet, this memoir does what all memoirs do; it tells only part of the story.

Don't memoirs allow writers to keep from revealing all they know?

The Whitney Women

and

The Museum They Made

One

*E*ver since I can remember, the Museum hovered at the edges of my consciousness.

At first, like New York, the Museum was another faraway place to which my parents would disappear for weeks at a time to see "Mama," my mother's mother, Gertrude Vanderbilt Whitney. "Mummy needs to see *her* Mummy, too, just like *you* do," my nurses would say. "She'll be back soon." Small comfort. She was surely too old to need a mummy.

The image of the Museum grew as I did. Much later, in the '50s, it came to symbolize a completely different way of life from mine.

I had chosen marriage and family over college and career. My mother, wanting me home, arranging for me to "come out" in society, had persuaded me to give up my dream of going to Bryn Mawr College to attend, instead, New York City's Barnard. Barnard is an excellent college, but living at home was a return, in part, to my protected childhood. Loving my mother, still wanting her approval, I had agreed. And then, that same year, at eighteen, I fell in love with Michael Henry Irving, a Harvard graduate who had served in the Navy as an officer in the Pacific theater during World War II. Astonishingly, this charming, intelligent friend of my older brother's loved me too — and I was bowled over. Besides wanting to be with Mike, I felt stifled by what I perceived as my parents' indolent lifestyle and saw marriage as a chance to have an independent, adult life with a mature, responsible man. We were married in June of 1947.

Over the next ten years, we had four children. I aimed to be the perfect wife and mother, in contrast, of course, to my own mother, and to *her* mother, my grandmother, Gertrude. Not for me the round of

parties, beaux, trips, or a career spiriting me away from the home where I belonged. Mike's and my relationship would be a loving, happy one forever. Our roles, while intersecting and blending, would be clear: he would be the primary worker outside the home, on the way to becoming the successful architect he deserved to be, while I would keep house, care for the children, and limit my outside activities to the school and church within which our children would flourish. And in fact this is the way we lived for many years. Mike was a kind, loving, and thoughtful husband and father, and a very hardworking architect who designed distinguished houses and commercial buildings in Connecticut, where we lived after our first few years in New Jersey and Long Island. We took vacations with the children every summer in the Adirondacks, fishing, swimming, and camping in the very same places where my great-grandparents, grandparents, parents, and I had fished, swum, and camped. Later, we also cruised up and down the coast of New England — because Mike was a skilled sailor, and the children grew to love sailing as much as he did.

I felt, at that time, morally superior to my grandmother, whom I criticized for having neglected her young children. While my mother had survived marvelously well, her brother and sister had, I thought, been harmed by their parents' lives of traveling, parties, and work away from them, and had passed on their wounded psyches to their own children. Without really knowing, I made unjustified assumptions, blaming my grandmother for the woes of my daring and dazzling but often troubled cousins. Today, I see that I was overlooking part of my own nature. The whole idea of being such a perfect wife and mother was impossible; I was hiding my subconscious aspirations. When I came to recognize them, in the '70s, that ideal family life no longer seemed possible. I didn't manage to live in several worlds, as my grandmother had, but chose instead to leave our home and the husband I had loved for so many years.

All the while, I know now, my grandmother secretly attracted me. Her ways, her style, her behavior, were compelling. Not only had she transcended mediocrity, she had eluded the traditionally confining role of women. Moreover, after her death, she had left to the world the rich legacy of her talents: her large monuments, smaller bronzes, and stone carvings, as well as a whole museum bearing her name. An institution — I was looking through my much younger eyes — where art was all over the walls and floors for us to see. Where creativity reigned.

Where people laughed and drank and discussed ideas. Where one could penetrate the mysteries of art. And seek the truth.

In 1942 my mother, Gertrude's oldest and closest child, had inherited her mantle.

In 1967 my mother, Flora Whitney Miller, passed it on to me.

As I spin out the thread of my life, stretching from a small southern town to a northern New Mexico village, and now back again to New York City, it weaves and knots with people and places. A mother and a father, two husbands, four children and their husbands or wives, all greatly loved. Eight grandchildren, a great-grandchild. A sister, two brothers, uncles, aunts, cousins, friends. That memorable grandmother. Houses, which did or did not become homes, on red clay roads, sandy roads, paved roads; near forests, rivers, mountains, oceans, or lakes.

Much more past than future, now.

Joye Cottage, the house I grew up in and still dream of, at the corner of Whiskey Road and Easey Street, in Aiken, South Carolina; the house Mike designed for us in the Connecticut woods, with big windows and warm colors and materials, that gave our family a sense of both openness and intimacy; and the adobe house where I lived in the '90s in Taos, New Mexico, are like shells, protecting, sheltering, and expanding as we grow. The sense of peace emanating from those New Mexican walls, from the landscape, from the air itself, was familiar, linked emotionally to that house in Aiken with expansive radiating wings that, as a child, I wore like a skin.

So different, those two villages, those homes, from New York's noisy, exciting energy, where temptations to look, to listen, and to play abound. In Aiken, as a child, I learned to read, to be alone. In Taos, I found the same kind of serenity in which to write. In New York, where I lived in the late '70s and '80s, I could not have written this book.

One August night in Taos, wakeful, as mountains loomed black in the brilliance of a full moon and coyotes howled, I drifted in memory to the Aiken of my childhood. I saw again the long-ago firelight flicker on my bedroom ceiling as I fell asleep, hearing the clip-clop of horses' hooves, while a mockingbird sang outside my bedroom, perched in the magnolia tree whose luminous, waxy flowers' sweet scent weighted the air.

I heard again the stair creak under the worn red carpet as my brother Leverett and I, at about, respectively, the ages of six and nine, tiptoed

past our sleeping parents' doors. We passed quietly through the big, square red and white living room, past the fox heads mounted on the wall over the bar, through the billiard room where the smell of chalk lingered on the tips of cues lined up against the wall, to the dining room where we sniffed the odor of pancakes and syrup from the kitchen beyond. That house rambles forever, as, in memory, I walk through its rooms: the wide porches with their "Aiken sofas" covered in pale corduroy, the yellow "dove room" where my father eats his poached eggs on a tray borne by fat and dignified Herbert, the British butler, who props the *Herald Tribune* on a silver holder for my father to read. My older, braver siblings call him "Dirty Herb," and demand Horses' Necks and other exotic drinks for themselves and their gang, undeterred by the sometimes hysterical scolding of Sis, their French governess, whom they adore but seldom obey. Afternoons, Sis and I take long walks on the soft roads, across log bridges, past bushes of sweet star jasmine, by big houses set in green lawns where gardeners clip and rake, and further, to cabins with swept dirt yards where we wave at children with tight braids. Singing, singing, singing — she's teaching me French, and French history as well. Sis describes the dreadful revolution as we bellow out *"Aux armes, citoyens! Formez vos bataillons!"* and then we launch into my favorite, the song of the *"petit navire qui n'avait ja-ja-jamais navigué"* who ends up in a stewpot for his starving shipmates. I took for granted, somehow, the bloodthirsty nature of French nursery songs, although that brave little sailor tugged at my heart for years.

Across the hall, in the pink bedroom, my mother sleeps away most of the morning. At each corner of her French bed, four twisted, inlaid brass posts stand like guardian angels, holding a tulle canopy high over her head. Her dark curls froth over monogrammed linen sheets. By the time her tiny, frazzled French maid Josephine — "Peenabo" to my older sister and brother, who played infuriating tricks on her — allows me in, around eleven, my mother is awake, wearing a quilted satin bedjacket, leaning against her lacy pillows, eating tiny triangles of toast, sipping coffee from a delicate Sevres cup, and talking on the telephone. Captivating smells waft around her: honey, Turkish cigarettes, Chanel perfume, her own particular fragrance.

Oh, to be grown-up!

My images of adult life come from my mother and father, my idols. They bring me visions of future happiness. Of pleasure, once freed

from the discipline and regularity imposed on my brother and me. Of the never-ending joys of reading, shooting, riding, and fishing. Of late evenings with friends, drinking and playing games after delicious dinners.

I'm always longing for more attention from my parents than I get. A reward, I've decided, that will come from accomplishment, manners, and "being good." I'm well on the way to becoming a perfectionist, a burden that haunts me still.

These moments of longing recur when I hear, for instance, all these decades later, the sounds of clinking ice at someone else's cocktail time.

My father has taught me to carefully measure gin and vermouth in the silver shaker. The quiet of tea time, now over, swells as people arrive, talk, tell stories, laugh. Sometimes my parents argue. Oblivious, fixed in the center, I shake and pour and measure again. Nine years old, and I can make the consummate martini. I am showered with praise, until for the moment I have enough.

Summon all your energy, I tell myself then. Will the darkness away. It is merely a phantom.

Good cheer is real. The world is in order. God's in his heaven. Be perfect, I tell myself. Win love.

May to November, from 1992 to 1998, my second husband Sydney and I lived in Taos, where I wrote most of this book. We looked over a green well-watered valley where horses and sheep grazed, where orchards flourished. Storms and brilliant sun, sunrise and sunset, turned the Sangre de Cristo Mountains in the distance from green to blue to red to purple, as clouds, lightning, or rainbows made vivid patterns on their rocky flanks. Infinite space lay before us, although we shared adobe walls with neighbors on two sides.

As Sydney and I moved into our old house, I watched Antonio Martinez, the carpenter, punch a doorway in a wall about two hundred years old. The powdery surface fell away, revealing thirty-pound adobe bricks, their binding straw still gold in the shadows.

Antonio removed bricks reverently. Then he mixed a paste of mud and water, and patched and sealed the doorway. Our neighbor, Jim Heese, applied the final coat along the edges: a thin solution of *terra vaillita*, a pink-beige mud painted on with sheepskin in big sloppy zigzags that would look smooth and creamy when dry. Jim taught me

the ancient technique. I delighted in the mud's smell and silkiness, and in the rhythm of sweeping the walls with the wet, furry scrap of wool. Our house was connected to Jim's, in the Spanish village way, and for six years Jim was the best neighbor anyone could ever have. We worked side by side in the garden, we ate together, we hiked way up to a mountain lake, we talked about everything. Jim expanded my experience with clay by taking me to his pottery class, where I learned with great satisfaction to make bowls from an Apache master. That sharing walls could lead to such friendship seemed a miracle, beyond even the magic of the house itself and the surrounding landscape.

This process, this mud, these walls, the friends we made, contributed to the peace we felt. Life was quieter. We were more likely to reflect and accept.

These two places, Aiken and Taos, seemed to bracket my life, until last year when, wanting to be closer to family, we moved back to New York City.

One other place was never far from my consciousness, for many years. This was the Whitney Museum of American Art.

Few days have passed without my awareness of the Whitney Museum. Mail, faxes, phone calls, memory, or dream, the Museum is always with me. It has provided me worthwhile and deeply satisfying work. Sometimes I embrace its current values, sometimes I abhor them. Sometimes, too, in rejecting my goals and hopes for it, it has seemed to reject me. In some ways, the Museum embodies that part of my family heritage I most respect, a heritage, too, that's far from perfect.

Once, giving a talk at the Whitney, my mother, who was then its chairman, said, "My mother left me the Museum — she said I could keep it, or sell it. I decided to keep it."

So it was that my mother Flora's care kept it going from 1942, when Gertrude died, until 1966, for the twenty-five years of her presidency. For my mother, the Museum embodied not simply her love for her mother but her admiration, as well, for Gertrude's achievement as founder of the Museum. In the same way, the part of the Museum's story I myself can tell is also a love story.

I'm writing it because I want to discover more than I now know. What really happened? I hope, with the distance I now have, with the

comparative serenity of my life today, with the few but treasured advantages of age, that the years of turmoil will seem clearer, that some truths will become apparent.

Always, the Whitney represented one kind of home. Always, the Museum has been a dream for me, as it was for my grandmother and my mother. I was formed by these extraordinary women. With time, however, I became increasingly influenced by others, by the Museum's directors, its curators, and by new, nonfamily trustees. The Museum changed continually over my forty years of involvement as a trustee, as vice president, as president, as chairman, and as honorary chairman.

Since I can remember, art was magic.

That has never changed.

Artists, I knew, saw the world through different eyes. If I applied myself and looked enough, I told myself when I was young, I, too, could see what they saw. Work and exposure would bring clarity and understanding along with happiness. What could be better for the world?

But can one ever cross that bridge? Can one really pierce to the heart of creation? Only by a lifetime of making or studying works of art. I will continue to be rewarded by all forms of creation, including nature itself — but a barrier will always remain between me and the world I crave, because I haven't given myself to it fully and always. Very few have.

Early on, though, the Museum, for me, was the force that could bring about wonder and understanding for all who came.

My grandmother, right from the start, had wanted the American public to become aware of its rich heritage. When the Whitney Museum opened to the press and special friends on Monday, November 16, 1931, she said:

I have collected during these years the work of American artists because I believe them worthwhile and because I have believed in our national creative talent. Now I am making this collection the nucleus of a Museum devoted exclusively to American art — a Museum which will grow and increase in importance as we ourselves grow.

In making this gift to you, the American public, my chief desire is that you should share with me the joy which I have received from these works of art.

It is especially in times like these that we need to look to the spiritual. In art we find it. It takes us into a world of beauty not too far removed from any of us. "Man cannot live by bread alone."

At the time Gertrude spoke these words, the Great Depression had begun. Today, other problems confront us: small but devastating wars; the spread of drugs, of violence, in our disaffected youth; the erosion of our cities, and the erosion, as well, of a moral climate in which to bring up our young. In the face of all this, one may well question the validity of Gertrude Vanderbilt's words, of the value of art itself. But I continue to believe that art is here to tell us who we have been, who we are, and who we can become. Whether its prevailing expressions seem dark and ugly or transcendent and sublime, artists, as always, remain our shamans and seers. They offer us the prophetic gifts of a Jeremiah, an Isaiah, or the Sibyl of Cumae. We are obliged to look and listen. Sometimes, to understand.

This is what I still believe, although, with the years, I've grown far less innocent and more pragmatic. As reality demanded, my early adolescent views altered. I came to see that artists and museums, like the church, in which I had also fervently believed as the force that could transform all of humankind for the good, were prone to flawed vision and human error. Yet, at heart, I still clung, and continue to cling, to the belief that creativity brings truth, that art inspires wisdom, not only for artists but for their audience. Even at its most uncomfortable and probing, even when bizarre and impenetrable, art remains an affirmation of life.

One answer to my current questions, then, is that the Museum supports this affirmation, communicating it to anyone who wishes to explore artistic vision and, in turn, to experience life in greater depth.

In my grandmother's time, it was simpler to do this. For one thing, she provided both the concept and the money. For another, there were far fewer artists.

Today, the Museum has become institutionalized, complicated. No one person can make all the decisions. A lot more money must be found to carry on its programs. As a result, and by definition, Museum policy involves many people. Along with their various skills and talents, they provide a diversity of viewpoints. Our discussions and decisions are spirited and sometimes heated. Yet those who give money are not always equipped to make judgments about the Museum they gen-

erously support. They may not know enough about art and they may not have time enough to learn. Moreover, those who are giants of industry are accustomed to control. When they meet the lively, free ideas of art, especially within the fragile institutions mediating between the public and the artist, it is not surprising that fierce struggles sometimes ensue.

Changes. Growth. Constraints. As in the earth itself, as weather and seasons dictate.

My views have changed since I began my story. Writing does that. Events of the more recent past have merged with older memories, with the Museum's history and with my own, becoming part of a more thematic, consistent progression. Ten years hence, would I write differently? Perhaps. All I can hope is that this time is the right time for me to tell my story.

My daughter Fiona represents the fourth generation of Whitney women to serve the Museum. Her devotion to the Museum is already bearing fruit, and her understanding is wise as well as caring. The Museum is now a public institution with a vast, existing, and untapped audience. I have faith that she will help it fulfill its promise.

Two

"Mama," my mother's mother — "Gamoo" to her grandchildren — was to me a vague figure, whose demands for her daughter's presence were nonetheless compelling. Tall, thin, elegant, Gertrude Vanderbilt Whitney remained almost a stranger to us younger children, although we loved her munificent Christmas presents, including, one memorable year, a typewriter I'd longed for, allowing me the unprecedented freedom of a typing class with local girls at the public school. It wasn't until I worked with B. H. Friedman on the biography he wrote, *Gertrude Vanderbilt Whitney* (Doubleday, 1978), that I came to know her well.

For my grandmother, her curls, unlike Samson's, symbolized the weakness of women. By cutting them off, as she described in her unpublished autobiography entitled "My History," she hoped to become a boy — to gain power and stature. Even as a small child, she understood her position through metaphors, and later, through different metaphors, she changed that position. Making sculpture freed her from a constricting world, her lovers represented the hurt and anger she felt at her husband's affairs, and her patronage, culminating in her creation of the Whitney Museum of American Art, became *her* expression of her family's wealth and power. Her idealistic, fervent belief in art, artists, and her country merged with her ambition to form the particular identity of the Whitney Museum of American Art, which, in turn became a metaphor for Gertrude herself.

For her daughter, Flora Whitney Miller, the Whitney *was* her adored mother. Her longing and then her mourning poured into the Museum, enriching it for more than twenty-five years and holding Gertrude's passionate commitment fast. Artists appreciated Flora Miller's devo-

tion and continued to feel, as they had in Gertrude's time, that the Museum was their special home. My mother held it as close and nurtured it as warmly as she had wanted to love and be loved by Gertrude.

For me — it's too soon, too hard, to assess. The metaphorical counterpart is Gertrude's, I think, rather than my mother's. Like an earthy stew simmering for years, by midlife I was ready for the table. Unlike Gertrude, I didn't have money or power — only desire, and the family connection. Tom Armstrong, the Whitney director for fifteen years, in his wisdom saw their value, and helped me to use them for the Museum's benefit. For those golden years, we teamed up to bring the Whitney to a new fruition: a conjunction of art and the public. When our team was sundered, I stayed on, I tried to mend fences, tried to make the magic live again. But my sadness weakened my ability to be an effective force. I love the Museum, and I always will, but there is little I can do for it today. Perhaps that's partly because it's no longer a metaphor for me.

What would the Museum become, without the family who gave it its persona? The men who run it now are capable and dedicated, but they can't project the Whitney's — Gertrude's — character. Their reasons for being there are different from hers. By the way they fired Tom in 1990, they betrayed the nature of a fragile institution. It has yet to recover. Perhaps, without the family, it would change unrecognizably. Perhaps it would even be better. But it could not be the same.

On the other hand, perhaps Fiona will become a significant part of the future Whitney Museum. She represents the new generation of women. Because she has a self-confidence her predecessors lacked, her metaphors are different. She doesn't *need* the Whitney for her identity. She already has her own. While she understands deeply the need for continuity and tradition, she isn't afraid of change. Well educated, very capable, and just as energetic and resilient as her forebears, she can lead without feeling guilt. She represents hope.

"I cannot remember when I first realized who I was," my grandmother wrote at eighteen in "My History." "At any rate when I was eleven I knew perfectly that my father was talked of all over, that his name was known throughout the world, that I, simply because I was his daughter, would be talked about when I grew up, and that there were lots of things I could not do simply because I was Miss Vanderbilt."

Why was this? And what did she omit from this abbreviated autobiography?

She left out, for the most part, her mother's family — the Gwynnes

and the Claypooles — who seem to have had little impact on her consciousness or her life. The energy and power that young Gertrude sensed, even as a child, came directly from the powerful men in her family.

Who were these men?

Jan Aertsen van der Bilt, of the Manor of Bilt, near Zeyst, Holland, emigrated to New Amsterdam in the mid-seventeenth century. Fifty years later, Jan's grandson Jacob moved from Flatbush, in Brooklyn, to a farm in Port Richmond, Staten Island. Jacob's grandson, Cornelius Vander Bilt, and his wife, Phoebe Hand — a capable, handsome woman of English descent — bought a larger acreage in Stapleton, Staten Island, where they farmed with the help of their nine children. The fourth, born on May 27, 1794, was Cornelius Van Derbilt, Jr., as he first preferred to write his name.

Sculpted in bronze, standing straight and tall in his fur-lined overcoat, he remains perpetually vigorous in front of his principal monument, Grand Central Terminal.

Following is family history taken substantially from B. H. Friedmann's biography of my grandmother, *Gertrude Vanderbilt Whitney:*

This Cornelius (never again Jr.), combining the strong physique of his father and the rugged, sharp features of his mother, would radically change the economic situation in his family. As a boy, growing up on the farm and on the Staten Island waterfront, he had tremendous vitality. His dark blue eyes, his hawklike nose, his strong mouth and chin, even the mop of wild blond hair all seemed to exude energy. At eleven he stopped going to school. Just over six feet tall, he was strong enough to become his father's regular helper on the farm and to assist him with some boating in New York Harbor. Within two years he was supervising the lightering of a ship; at sixteen he bought a sailboat for a hundred dollars and began ferrying passengers and freight between Staten Island and New York; and at eighteen, during the War of 1812, he had several boats under his command and received a government contract to provision New York Harbor forts. Except for money he gave his family, he invested the rest in more ships, and at the age of nineteen determined to marry his cousin and neighbor Sophia Johnson.

His success began early and escalated until the end of his long life. At first he worked for others, then for himself; his businesses — hotels, steam ferries, steamers, then steamship lines — succeeded each other

rapidly, and his family increased at the same dizzying rate: thirteen children, eventually. Battling monopolies, winning rate wars, he planned and worked incessantly, and in 1829, at thirty-five, he moved his family from Bellona Hall, his hotel in New Brunswick, New Jersey, to Manhattan. But penetrating New York society was more of a challenge for this entrepreneurial giant than making money. Tough and courageous, with a broad, clear vision, he had the reputation of sticking to any bargain he made. But "those direct, blunt qualities showed themselves also in coarse manners and speech. He was loud. He chewed tobacco. He used the slang and profanity of the wharves. What was admired in business was characterized in drawing rooms as 'pushy' and 'cheeky.'"

In the late '30s, defeated for the moment in his desire to be accepted in Manhattan, he left to build a mansion in Staten Island. His rejection rankled, however, and in 1846 he launched a luxurious yacht, the first *Vanderbilt*, and began construction of a large house in Manhattan on Washington Place. When his wife, Sophia, refused to move, it was reported in the newspapers that he had her committed to a private insane asylum — an extreme reaction, but emblematic of this powerful man who was certainly accustomed to getting his way. A few months later, the story goes, she came around and was released.

Cornelius, called "The Commodore," was now very visibly a millionaire. During the Gold Rush in 1849, he gambled his fortune developing a shipping line, the Atlantic and Pacific Ship Canal Company. He built eight steamers and a twelve-mile macadam road through Nicaragua to the Pacific, multiplying his investment many times over.

In 1852, he decided to take a long-delayed vacation. For four months he traveled with family and friends through England, Russia, Denmark, France, Spain, Italy, Malta, Turkey, and Madeira, on the North Star, his new, luxurious 2,500-ton, 270-foot yacht. The trip was a triumphant confirmation of his status, as he was received by royalty, feted and honored everywhere he went.

After returning, the Commodore went back to work making deals, outsmarting rivals, and further increasing his wealth. In 1862, when he was almost seventy, he initiated perhaps his most significant project: transferring profits from his shipping business into railroads, starting with the New York & Harlem, which he soon controlled.

Two years later, he finally recognized the ability of one of his sons, William, and named him vice president of the railroad and of all his

business activities. William was already forty-three. The Commodore's favorite son, George, had died, and he had rejected his oldest son Cornelius Jeremiah, a pitiful epileptic and gambler.

William Henry Vanderbilt had been a sickly child. At nineteen, against his father's wishes, he had married Maria Louisa Kissam, the daughter of a poor but refined Brooklyn clergyman. The Commodore had bought them a farm at New Dorp, Staten Island, and — to his surprise — they had made a success of it, increasing its size fivefold and then taking over the bankrupt Staten Island Railroad, which William quickly rehabilitated. Now, in 1864, as if to make up for lost time, the Commodore bought him a house on Fifth Avenue, and took his advice when William urged his father to extend their railroad system to Chicago.

In 1868 Sophia died, and the following year the Commodore, now seventy-five, married Frank Armstrong Crawford, a Mobile, Alabama, belle and a great-granddaughter of Samuel Hand, brother of the Commodore's mother. His energy still undiminished, he continued to expand his businesses and began construction of Grand Central Terminal in New York City. Eight years later, on January 4, 1877, the Commodore died at eighty-two, children and grandchildren by his side. His young wife led them in singing his favorite hymn, "Show Pity, Lord." In Friedman's words, "He left more than $100,000,000, of which about $90,000,000 went to William; $7,500,000 to William's four sons ($5,000,000 to the eldest, Cornelius, the Commodore's favorite [who was two-year-old Gertrude's father]); about $500,000 to each of his surviving daughters; $500,000 in cash, 2,000 shares of New York Central stock, and his New York home to his second wife; and $200,000 to Cornelius Jeremiah. Women were thus treated only slightly better than charities, to which there were no substantial bequests; indeed during his life the only such gift ($1,000,000) was to Central University in Nashville, Tennessee, renamed Vanderbilt University in 1875 when the two-part gift was completed."

When two daughters and Cornelius Jeremiah contested the will, William settled out of court, giving each of his sisters another $500,000. He paid his brother the income from $1 million, but not for long, since Cornelius committed suicide five years later.

Their reputations as "robber barons" notwithstanding, William and his father had believed in improving working conditions, equipment, and service, and when New York Central employees refused to join

the great railroad strike of 1877, William rewarded his trainmen and laborers by distributing $100,000 among them. An excellent businessman, he continued strengthening the New York Central with mergers and enlightened business practices, doubling his fortune in only six years to more than $200 million (about $2 billion in current purchasing power).

Now he gave thought to cultural matters, investing in a magnificent Fifth Avenue house that he filled with paintings, sculptures, and fine furnishings. He commissioned Richard Morris Hunt, the foremost architect of the time, to design a gilded neo-Byzantine mausoleum on the highest land in New York City — eleven acres in the Moravian Cemetery on Staten Island. Only those descendants with the name "Vanderbilt" can be interred within this elegant edifice. Peripheral family are buried in adjoining plots. Did he hope to perpetuate not only the name but the success and energy of future Vanderbilts? To maintain control from the grave? In its heyday, dozens of elegant carriages waited in the cobblestone driveway of this mausoleum, which in the '70s became a "make-out" site for teenagers, as evidenced by a *Life* magazine cover of the time.

Unlike his father, William gave generous charitable gifts in his lifetime: to Vanderbilt University, St. Bartholemew's Church, the Moravian Church at New Dorp, the College of Physicians and Surgeons, and the Metropolitan Museum of Art. He paid $103,732 to cover the cost of moving the Thutmose III obelisk (224 tons, 69½ feet high) from Egypt to Central Park. What, I wonder, did that thrusting symbol of ancient power mean to my great-grandfather? A monument more lasting than his money? A form symbolizing his virile power?

By the time of his death in 1885, William had delegated his two eldest sons to take over his leadership of the family business. He left $10 million to each of his eight children — four sons, Cornelius, William Kissam, Frederick William, and George Washington, and four daughters, Margaret Louisa (Mrs. Elliott F. Shepard), Emily Thorn (Mrs. William D. Sloane), Florence Adele (Mrs. H. McKown Twombly), and Lila or Eliza Osgood (Mrs. William Seward Webb). To Cornelius he gave an additional $2 million and $1 million in trust for Cornelius' eldest son, William. To his wife he left his home, the art in it, and an annuity of $200,000. More than $1 million went to institutions he had supported, plus other missions, churches, hospitals, the YMCA, and the Metropolitan Museum of Art. More than $100 million in his

residuary estate was divided equally between his two eldest sons, Cornelius and William Kissam. Thus, like his father, but less unfairly, he favored his strongest male descendants. This was probably with a view to preserving for future generations the fortune handed down from his father, in a modified version of the British tradition of primogeniture.

Cornelius, Gertrude's father, was the harder working of the two brothers and became, until his death, the head of the family. Hard as he worked, he found time for many philanthropic activities, as is often the case among men of third-generation wealth who seek social position as well as business success through patronage — because the Vanderbilts still represented "new money." He was a trustee of several hospitals, including the College of Physicians and Surgeons, of Columbia University, the General Theological Seminary, and the Cathedral of St. John the Divine; a manager of the Domestic and Foreign Missionary Society of the Protestant Episcopal Church; chairman of the executive committee of the Metropolitan Museum of Art, to which his most famous gift was Rosa Bonheur's *The Horse Fair.* He founded and built the clubhouse for the Railroad Branch of the YMCA. He was a warden of and generous contributor to St. Bartholemew's Church. And more.

Gertrude's mother, whose family I heard little about when growing up, was Alice Claypoole Gwynne, whose father, Abram Gwynne, was a prominent Cincinnati lawyer of Welsh descent. Alice's great-grandfather was a Captain Abraham Claypool (the *e* was added later), a veteran of the Revolutionary War and an original member of the exclusive Society of the Cincinnati, who claimed descent from Oliver Cromwell and the American romantic painter Washington Allston.

Gertrude Vanderbilt was born on January 9, 1875. Her parents had lost their eldest child, Alice, and had two sons, William and Cornelius. They were to have three more children: Alfred, Reginald, and Gladys. When Gertrude was three, the family moved from a town house at 72 Park Avenue to a French Renaissance chateau on the westerly block-front between Fifty-seventh and Fifty-eighth Streets along Fifth Avenue (where Bergdorf Goodman is today), which they later renovated and enlarged.

The Vanderbilts, although "talked of all over," as Gertrude wrote, were not socially accepted by "old New York" until Mrs. W. K. Vanderbilt's 1883 ball to inaugurate *their* new mansion at Fifth Avenue and Fifty-second Street, designed by Richard Morris Hunt. Certain she

would be invited, Caroline Astor planned a quadrille for her friends preceding the ball. When Alva heard of this she told a mutual friend she was sorry she could not invite Miss Astor since her mother had never paid a call. Now, finally, Mrs. Astor called. The ball was reported on the front page of the *Times* and was probably the most extravagant given in New York until that time. . . . Gertrude's father came as Louis XVI in a *habit de cour* with breeches of fawn-colored brocade, trimmed with sterling silver lace; a jabot, similarly trimmed; and a diamond-hilted sword. Her mother, as "Electric Light," was more dazzling still, in white satin trimmed with diamonds and a headdress of feathers and diamonds. In a famous photograph taken at the ball Mrs. Vanderbilt holds an electric torch above her head, possibly parodying the Statue of Liberty, then, though three years from completion, already under construction and well known to New Yorkers. Gertrude and her two older brothers were among the few children who made an appearance — she as a rose, in pink tulle, with a satin overdress of green leaves, a waist of green satin, and a headdress of white satin, fashioned like a bouquet holder; her brothers as Sindbad the Sailor and a young courtier. Thus, two generations after the Commodore had founded their fortune, the Vanderbilts were now social as well as economic news. Four years later, when Mrs. Astor's List was supplanted by the Social Register, the Vanderbilts were in it.

Gertrude, then, was the eldest daughter of the eldest son of the richest American family. Although the men controlling the family business and fortune were now custodians of their fortune rather than risk-taking entrepreneurs, Gertrude's identity was grounded in her father's, grandfather's, and great-grandfather's energy and drive. As Friedman says, "To their Dutch Protestant tradition of industry and piety there had already been added a sense of Puritan prudence and social service. . . . Having inherited 'success,' she would spend much of her life attempting to redefine it *as a woman*."

Gertrude's awareness of power came early.

"One of the first things I remember," she wrote in "My History," "was how I longed to be a boy. I was four years old when unable to resist the temptation longer. I secreted myself in my mother's room and proceeded to cut off my curls. This it seemed to me was what distinguished me most from my brothers; they said only girls had curls, so mine were sacrificed and all I gained was a severe punishment."

Yes, many doors were closed to women, especially those having to

do with money and business, which brought the power that Gertrude came to desire.

"I am not going to tell you much about myself until I was eighteen," she continued, "because my childhood passed almost without incident." Clearly, her education didn't include Freudian theory, but then neither did my mother's or mine. We were supposed to suppress or overcome by willpower whatever inadequacies, puzzlements, or depressions we felt — not by the remedies resorted to by less privileged, therefore weaker, folk. In Gertrude's letters, journals, and fiction a picture emerges of a young girl whose growth and self-confidence are constantly undermined by family and societal regulations. This young girl was forever questioning her heritage, wanting to be loved for herself and not for her wealth.

"That I should be courted and made a friend of simply because I was who I was, was unbearable to me. I longed to be someone else, to be liked only for myself, to live quietly and happily without the burden that goes with riches."

In a short story called "Arabella's Two Proposals," she wrote revealingly about Arabella, the daughter of the "strictest of mothers," who decided to "make the most of being a girl and be very undignified, not a bit sedate, although Mama, I know, thinks dignity a prime factor."

Alice and Cornelius: respected community leaders, benefactors, pious worshippers of their God. What were they like as parents? My impressions come from two sources in addition to Gertrude herself. Gertrude's sister Gladys's oldest daughter, Sylvia Szapary, adored her grandmother. "Syvie" wouldn't hear the slightest criticism of her. Apparently, Alice was a perfect mother to Gladys and her other children, and a wonderful grandmother too—loving, teaching them by example to be responsible and caring people.

I heard a different story from my mother, who had been sent with her sister Barbara to stay with her grandmother one summer when her parents were in Europe. Here are bits of my mother's journal from that year, 1912, when she was nearly fifteen:

"July 21. We got to Newport a little after 12 o'clock. Went to Grandma's house. Barby and I are going to stay there all summer. It rained all day. For lunch there was Grandma, Aunty, Uncle, Mamma, Papa, Cousin Ruth, Aunt Florence, Mabel Gerry, Larry, Barbie and me. It was the horridest lunch I was ever at. They gossiped and talked stupid things all the time. Oh how I wish we were back in New York.

"July 22. I had dinner alone with Grandma and after we each took turns reading a book. It was a horrid evening. The book is nice."

My mother was used to a less regimented life than she led at the Breakers, her grandmother's home. Her grandmother, she told me many years later, often summoned her to the formal drawing room to reprimand her for some infraction of rules she wasn't even aware of. For instance, when she sprained or broke her ankle and couldn't walk down stairs for a few days, she invited her friends, including a male cousin and some of her brother's friends, to visit her. Horrors! Boys in her room? Terrible, shocking. She was bad! Her own parents' rules were more casual, and Flora rebelled against her grandmother's strictness and lectures by sneaking in and out of windows and enjoying herself as best she could.

Although she undoubtedly didn't always feel so alienated from Alice, and later they became close, I can imagine Gertrude's early frustration with her mother. In her journals and letters, a cold, critical, and fearful mother emerges, who didn't seem to appreciate her daughter's accomplishments in school, her liveliness and imagination, or her outreach to new friends. Gertrude wrote, for example, in her journal of January 17, 1896:

"I shall put it down in black and white or die — I hate her. Her! Who? My mother. Yes, ha ha, I have never allowed myself to say it, to think it scarcely before. Now I know it is true and say it, I would say it to her if she gave me the chance. I am happy, am I not — oh yes, living in an atmosphere of worldiness and suspiciousness — no matter. . . . Oh God, riches make more unhappiness than all the poverty in the world. Keep me from being suspicious. . . . There is no more sympathy between us than there is between the table and myself . . . and I am young and longing and dying for sympathy, for feeling, for human love, and there isn't any for me — none — none."

Gertrude's father? There are few clues. But when his son Cornelius announced his intention to marry Grace Wilson, a slightly older woman who had perhaps been secretly engaged to Cornelius's older brother, William, he and Alice did everything possible to prevent him. They threatened young Cornelius, or "Neily," and Grace's parents with dire results, telling them that the marriage would "alter his prospects," meaning that Neily's father would disown him. Which is just what Cornelius did: when he died in 1899, he left his namesake $500,000 and the income from a $1 million trust fund — from an estate of $70 million.

(Alfred, the principal beneficiary, equalized this sum with that of his other siblings from his own inheritance.) Gertrude thought that the affair had caused her father's paralytic stroke in 1896, and much as she loved her brother, she sympathized with her parents in this matter. As she wrote to her cousin Adele Burden: "Neily knows it is his behavior that gave Papa his stroke, he refused to see him. Never took the trouble to walk across the hall & ask how he was. When he was told Papa's life depended on it he would not say he would even put off the wedding." Loss of "face" was so very important to these parents. A matter of life and death, in this case. Cornelius never really recovered and died in 1899.

Gertrude, from early childhood, was kept busy through an extremely full schedule. Perhaps her mother felt that lessons and other occupations might preclude the dangers she imagined lay in waiting for her lively, charming, and talented daughter. Men, primarily. Fortune hunters.

"I really have so much to do, with school, and studying, and music, and drawing, and walking, and Christmas things, and dancing, and writing, and thinking, that I feel as though I had no time to spare and if for a minute I find myself idle I feel it is a waste of very precious time. I have not been able to read one book since I have been here and do not intend to till the Christmas holidays, then I can feast on them."

This urge to use every minute stayed with Gertrude all her life. Many years later, she even used the hour-long drive from New York to her home in Old Westbury, Long Island, to crochet blankets for her grandchildren, to read, and even to write. Her energy and her will never weakened.

Despite the many absences caused by her family's European travels and their stays in Newport through October and often November, Gertrude did very well in school, especially in writing. She wanted to do well; she desired and needed the recognition that came from accomplishment. But when she received praise — when, for example, her much admired English teacher read her composition aloud in class — she denigrated it, writing, "You must not think too much of it. . . . Conceit." Her self-esteem wasn't helped by incidents like this one from a later notebook she entitled "Beginning of Autobiography":

"I was frightfully shy. At school this failing had caused me great suffering. No matter how well I knew my lessons when it came to being

called on to answer questions every thought went out of my head. By fits and starts I studied hard but even this did not help me much. One day, it was the beginning of the month and we had just been handed our monthly reports, a group of us were sitting around together comparing our marks. My mark in English was considered to be above my deserts and inspired a good deal of criticism on the part of the others. A red-headed girl who had a sharp tongue and who consequently always got the best of me remarked: 'If you weren't a Vanderbilt you would never have gotten an A.' There was a pause, during which all I remember was that I felt horribly guilty, and one of the other girls took up the subject. 'My father told my mother,' she looked straight at me, 'that your great-grandfather sold matches.'

"I had no idea if it was true or not. But I looked her in the eye and, as I was told later, shook my head of curls at her. 'If he did,' I said, 'they were the *best* matches in the world!'"

Gertrude also reproached herself for what she considered weakness — caring, for instance, about the boys who attracted her and were paying her court:

"You should be ashamed of yourself for thinking about [boys] at all. A girl of your age and so little able to control her thoughts. . . . I am ashamed of you, yes, do you hear, you have not the control and what is more you have not conquered but have been conquered. You have not grown, not by any means, you are weak, foolish and young, so there. Remember this, read it every day. When you think yourself attractive look in the glass."

What *did* she look like, at about eighteen?

Five feet eight inches tall, Gertrude was slim and graceful, her back straight as she'd been taught — though she'd been spared the steel rods that enforced her cousin Consuelo Vanderbilt's posture. Her brown hair curled softly over a long mobile face, with large green eyes set far apart above a long straight nose and wide sensuous lips. Although not classically beautiful, Gertrude projected a combination of eagerness, vulnerability, and reserve that was mysterious and compelling. She was elegant, with a bold and original style of dressing, and had a captivating charm beyond looks or easy definition.

At nineteen, "coming out" in society, she was still questioning her friends' sincerity. Her future husband, Harry Whitney, was at that time one of the few she trusted, partly because his family, if not as rich, had

a longer lineage than hers. She wrote him an unmailed letter (a recurring habit) with a theme she returned to again and again in journals, fiction, and letters:

"I am an heiress — consequently I know perfectly well there are lots of men who would be attentive to me simply on account of that. When I first fully realized that to be the case I was terribly unhappy and wished I might be a poor girl so that people would only like me for myself. Now I have become used to the thought and I face it boldly, as I must, and try to make the most of it. What I want to know is this — do you think it possible for anyone to love me for myself entirely? That the money would — no, could — make no difference? That anyone in all the world would not care for the money but would care as much as his life for me?"

In late-nineteenth-century New York, life for a young girl from a wealthy family was rigidly structured. Especially for Gertrude Vanderbilt. She could never be alone with a boy. She must wear specific kinds of clothes for each different occasion — lacy white morning dresses, low-cut silk and satin evening dresses, carefully tailored riding dresses, bathing dresses. In an 1894 journal, she lists thirty-two outfits under the heading "New Dresses This Year." It begins "Light blue crepon, white spots, trimmed with yellow (yellow hat)" and describes eight costumes in each of her favorite colors, pink and blue. Mourning a close family member meant no outside social life, and black clothes for at least two years, including jewelry; I still have a black enamel pansy pin that Gertrude wore in mourning. A young girl in society must make formal calls with her mother, and must be "at home" to receive visitors on particular days and times. There were so many "dos" and "don'ts" that it's a wonder anyone could remember them all. To her diary she wrote, at nineteen, "It is evening, 9:50, and I am waiting for the time to come to dress to go to a reception. My hair has been carefully arranged by the hairdresser so I cannot lie down. I come to you for solace. How I long for excitement, for emotions, provided they are of the right sort . . . a man chooses the path that gives him the most thrill. That is what I want. I want someone to make me feel, feel this is indeed life. Understand, I don't want to fall in love, that would be both bothersome and useless. But I want for a little while to live completely. . . . If I could but thrill tonight for a few moments, for one blissful second, how happy I should be. . . . I can count the thrills in my life, they are so few and far between."

As time went on, she became reconciled to her role. Faith was an important aspect of this acceptance, and she attended the Episcopal church — even if sporadically — all her life. "When I was eighteen I felt as if I could hold my head up under it, and that I would act my part well for God had put me there, just where I was, and if He had not meant me to have strength to go through He would never have put me where I was."

When her grandfather, William Henry Vanderbilt, died, Gertrude was ten years old and had often visited her grandparents. Even though she had taken their home and its furnishings for granted at the time, it's clear in her journals that the art she saw influenced her later appreciation. In 1890, for example, while visiting museums in Paris with her New York neighbor and future sister-in-law, Pauline Whitney, Gertrude was impressed by Pauline's opinion. "We talked about the fine pictures and other articles which belonged to Grandpa and now to Grandma. I had no idea Grandpa had such fine things. I knew of course they were very expensive etc., but I hardly thought of them as she said." Perhaps this was because, surrounded as she herself was by fine architecture and works of art, such things were givens.

In 1892, her promising and beloved brother William died from typhoid fever while a junior at Yale. In "My History" Gertrude mentioned but did not elaborate on the mournful event: "a very sad time after I lost my eldest brother which I would rather not dwell upon." Grief-stricken, Cornelius and Alice retired from most travel and social activities for the prescribed mourning period. Later that year, their house in Newport burned to the ground. The Vanderbilts, during this quiet time, became absorbed in working with Richard Morris Hunt on a replacement home, the new Breakers, a magnificent seventy-room mansion filled with French and Italian furniture and decorations and paintings and sculptures from both Europe and America.

Gertrude's young uncle, George Washington Vanderbilt, was probably the most cultivated member of the family. He spoke eight languages and read several others, he had studied architecture, forestry, and landscape gardening. In the early 1890s, he began planning an immense chateau designed by Richard Morris Hunt on 130,000 acres near Asheville, North Carolina. Using advanced and socially responsible theories of agriculture, forestry, and ecology, George worked with Frederick Law Olmsted to develop the property. Today, we can still enjoy Biltmore, since George's descendants have maintained and

increased their grandfather's original commitment to sound ecological practices, and have turned the estate into a lucrative business by opening it to the public.

With a large group of aunts, uncles, cousins, and friends, Gertrude traveled by private railroad car to Biltmore for its Christmas opening in 1895. Although its scale and grandeur must have been extraordinary — 250 rooms! — she hardly mentions it in her letters to her friend Esther Hunt, Richard's daughter, which is mostly about the people she talked with and the walks she took. This isn't as surprising as it might seem. I myself can remember visiting the Breakers, where my great-aunt Gladys was living, when I was about ten, but I can't remember thinking there was anything unusual about it. It was where my great-grandparents had lived, that was all. Not that my own family lived in such an ostentatious house! But I was conscious of the way former generations had lived. Gertrude, whose family lived their everyday lives in what now seems a fantasy splendor, would have expected and found normal the magnificence she found at Biltmore. One must, I think, keep this in mind when considering her life. Although she bemoaned her position as heiress, she took it for granted, too. The same year she visited Biltmore, she wrote in her journal:

"You don't know what the position of an heiress is! You can't imagine. There is no one in all the world who loves her for herself. No one. She cannot do this, that, and the other simply because she is known by sight and will be talked about. Everything she does or says is discussed, everyone she speaks to she is suspected of going to marry, everyone she loves loves her for what she has got, and earth is hell unless she is a fool and then it's heaven. . . . Of course, worldly goods surround her. She wishes a dress, a jewel, a horse — she has it, but not all the money in the world can buy her a loving heart or a true friend."

Gertrude learned French and German, languages then de rigueur for a well-educated young woman. On their travels, besides meeting the aristocracy of Europe, the family heard concerts and operas and visited museums, always with well-trained guides, establishing the groundwork for her later absorbing interest in cultural affairs. Balls, tea dances, house parties, and dinners bridged the Atlantic, and by the time she was twenty she had beaux in several countries and several marriage proposals. Few were of real interest, however, until Harry Whitney became a serious contender in 1896.

February 2: "Harry has been to see me quite often, twice last week.

He has a little dog whom I keep very often when he is at law [Columbia Law School]."

February 6: "Harry and I are having a desperate flirtation. It's splendid. We understand each other perfectly."

Since Gertrude kept all her papers, it is easy to trace their growing love. Sometime in February, Harry wrote to her:

"Of *course* it is possible for someone to love you simply and entirely for yourself. We have been made to go through an existence here, God knows for what — it is hard enough & unsatisfactory enough — but there is one, just one, redeeming feature & that is the possibility of love. . . ." The rest of this letter makes it clear that Harry was already in love. Soon she and Harry, with her parents and a group of young men and women, set off for Palm Beach in her father's private railroad car, Number 493, and attendant cars: first a smoking car, then the men's car separated from the women's by the dining car, and at the end, for the view, the so-called day car. Gertrude documented their romance in her journal: by the second day, in St. Augustine, they sat together at dinner and had "the sort of conversation it is impossible to repeat." In Palm Beach, finally alone with Harry on the piazza of the Hotel Royal Poinciana, Gertrude talked this time not to make conversation (as she often did with others, making lists ahead of time of subjects she might bring up), but to reveal herself. She told Harry of her long-time wish that she could have a better relationship with her mother. "It is not really anything that we say or do, it is simply that she does not understand. When it is like that, there is no use trying to have an understanding." With that, Harry turned suddenly toward Gertrude, and said, "Gertrude, shall we have an understanding?" Unable to speak, she gave him her hand, saying, "Oh, Harry." "Taking my poor, ugly hand he kissed it over and over again and yet over and over, saying 'No, no, Gertrude — it can't be. Oh no, Gertrude.'"

On the train trip home, in a rare moment together, "I suddenly looked at him and could not take my eyes away. He looked down — I could not. He looked at me again — and for the first time we looked right into each other's eyes and saw each other's souls. Then he leaned forward suddenly and pulled my hands to him. He said, 'Kiss me.' And before I knew it he had leaned over the table and kissed my mouth. A few moments later he said, 'I feel better now.'"

* * *

Why, when she was so doubtful of the motives of others, was it so easy for Gertrude to accept the sincerity of Harry's love?

Whitney roots can be traced much further back than those of the Vanderbilts, way back to Thurstan "the Fleming," who followed William the Conqueror into England and is even mentioned in the *Domesday Book* of 1086 as an extensive landholder in Hertfordshire and the Marches of Wales. Subsequent Whitneys included a knight as well as merchants, manufacturers, and entrepreneurs.

Like the Vanderbilts, the Whitneys settled in America in the mid-seventeenth century. In June 1635, John Whitney, a well-educated member of a freeman's guild, the Merchant Taylors Company, arrived in Boston with his wife, five sons, and 113 other passengers aboard the *Elizabeth and Ann*. Despite restrictive Stuart economic policies John had done well in England, unlike many Puritans, and as an Anglican he hadn't suffered religious persecution. But he was ambitious. He wanted greater opportunity and freedom to achieve his goals.

The community of Watertown, near Boston, where he came to live, was a place in which he could make good use of his superior education and legal expertise, and soon the Whitneys became prominent landholders and political, military, and constabulary leaders. By 1788, the family was well established, and General Josiah Whitney — the head of the family — had distinguished himself in the Revolutionary War, had represented Harvard in the General Court, and was a delegate to the Boston convention for ratification of the federal constitution.

The Vanderbilts, at this time, were farmers in Staten Island still struggling to survive.

Josiah's great-grandson, James Scollay Whitney, also a general (in the militia), and his wife Laurinda Collins, a descendant of William Bradford of Plymouth Colony, settled in Conway, Massachusetts, and from their small general store built a large cotton mill business. James became postmaster, a member of the Massachusetts House, and sheriff of Franklin County, then organized the Conway Bank and the Conway Mutual Fire Insurance Company, of which he was the first president. The family was, by local standards, rich and powerful.

William Collins Whitney, Harry's father, was the third child and second son of James and Laurinda's six children. It was William who advanced his family's fortunes as the Commodore did for his family, and who came to live in New York in a palatial home right across the street from Cornelius Vanderbilt II. However, unlike the Vanderbilts, he was

building on a solid family base of some eight hundred years of continuous achievement. He and his family were immediately welcomed by New York's business and society circles, and distinguished partners were ready to work with him along his road to success, unlike Cornelius Vanderbilt's father, William, who had to fight for acceptance. Although that acceptance came much easier to Cornelius II (Gertrude's father), I believe that the family's lack of a solid heritage of education, public service, and social position led to Gertrude's strict, conventional upbringing, and resulted in her striving for accomplishment, self-esteem, and appreciation.

William C. Whitney was a complex individual, a serious, attractive young man who had worldly ambition but loved to read and write as well. Tall, with large gray eyes, straight brown hair, and strong features, he studied the classics at Yale, leading a rigorous life in dormitories that lacked plumbing, heating, and adequate lighting. There he made lifelong friends, including his roommate Henry Farnam Dimock, who became his law partner and his sister's husband, and Oliver Hazard Payne of Cleveland, whose sister Flora he later married. Another friend, William Graham Sumner, wrote years later:

"Whitney's position amongst us . . . was, from the first, that of a leader . . . easily the man of widest influence in our Class and perhaps the College." When he was tapped for Skull and Bones, his more studious roommates complained about the constant procession through their room of Whitney's friends.

After graduating from Harvard Law School, clerking in a prestigious law firm, and passing the bar exam in New York, in 1867 he and Dimock set up their practice at 17 Wall Street. Oliver Payne arranged for him to meet his sister Flora, who had enrolled in an experimental seminary for women at Harvard conducted by Louis Agassiz and had subsequently traveled widely in Europe, North Africa, and the Levant, writing and illustrating remarkable journals and letters about all she learned and saw. Her father, Senator Henry B. Payne, one of the wealthiest and most powerful Democrats in Ohio, had published many of her letters in the *Cleveland Daily Record*. A student of archaeology, science, and languages, Flora was an exceptional woman, especially for her time. Her brother Oliver loved her dearly, and was convinced that she and William belonged together.

"So you are the Will Whitney that I have had held up to me for so many years?" the high-spirited Flora began their conversation. Dinner,

the opera, and visits between Cleveland and New York followed, and they were married in October 1869.

As the young lawyer's business grew, so did his interest in reform politics, which at that time meant allying himself with Samuel J. Tilden to get rid of the dishonest Boss Tweed. The Young Men's Democratic Club, which he had been instrumental in founding, contributed greatly to Tweed's defeat and the victory of clean municipal government. In a letter to her sister Molly in the summer of 1872 Flora described their lives:

"William is in *politics* and the first thing that kind of business does is take a man away from the bosom of his family. I submit, as I think it is the duty of young men to work when they are called upon in such a time as this. William is a natural politician, and takes to it as a duck to water, and is one of the leaders among the young men. About a hundred Committee men are to meet here Wednesday night and you can imagine the pow-wow."

Like Cornelius and Alice Vanderbilt, whose first baby, Alice, had died, William and Flora lost their first-born child. Then, in the spring of 1872, Harry Payne Whitney was born, and Flora wrote a long unpublished essay beginning:

"Never came a Baby into the world, more wanted, with more love ready to welcome him than our Boy. One little life had been given to us before. We had planned and hoped and been ready for it. . . . Then came the agony, and the birth, but the little voice would first be heard in Heaven, and not in the Mother's arms. So when I knew that life once more might be allowed to weave the child fancies in my home, just gladness filled me, gratitude, and joy without a cloud. I shut out every shadow from my life. The nine months should be millennium . . . He never in all those months was anything but a source of pleasure to me."

It was typical of my great-grandmother's intense feelings and tough mind that she began with the loss of her firstborn. "With her there is no glossing over, no forgetting, and by beginning with the lost Leonore, she makes her happiness and William's at Harry's birth all the greater. Not only in this little journal but in dozens of her own letters and William's it is apparent that they doted on this son" (Friedman). Four more children were to come; Pauline, William Payne, Olive (who died of diphtheria at six), and Dorothy. But Harry was always

special. Only Dorothy's relationship with her father, after her mother's death, was as close.

Meantime, William was becoming a recognized figure in New York, with a distinguished clientele. After a stint as corporation counsel, he struggled for and won the valuable Broadway street railway franchise. He contributed money and his considerable organizational skills to the presidential campaign and election of Grover Cleveland, who rewarded him by appointing him Secretary of the Navy, a key position at a time when command of the seas was strategically vital. During his tenure (1885–1889) he modernized the fleet and eliminated widespread corrupt bidding and contracting practices. Living part-time in Washington, the Whitneys were at the epicenter of its social life. Flora gained a reputation as a brilliant hostess, bringing together the intellectual, cultural, and political worlds of the city, creating fantasy environments for costume balls and other fanciful entertainments.

Both the Vanderbilts and the Whitneys had plenty of worldly ambition — but in contrast to the Vanderbilt men, William C. Whitney was profoundly conscious of the obligations of wealth, and gave not only money but time and work for causes he believed in.

William also pioneered in new theories about horses, recognizing the importance of mares rather than stallions alone in the speed and endurance of thoroughbreds. He was highly successful in breeding and racing as well as in his legal, business, and political careers.

As time went on, back in New York Flora felt increasingly isolated. She grew lonely and sad as William spent much time away from home pursuing political or business interests. The tender, loving letters she had written to William at first changed in tone as, often pregnant, she began hearing gossip about other women:

"I knew I was heavy and awkward, and not this last winter the lithe little lady you loved to caress; but it added to the hurts, and hurts grow into disappointments, and these into commonplace living, and then the angel of romance folds forever her wings, or turns and finds its waiting by the cradles of the sleeping children."

Flora was one of many educated, intelligent, and talented women of her time who found little outlet for their abilities. When pouring their emotions and desires into care for their families didn't entirely satisfy them, they felt guilty and depressed. William himself was prone to the moodiness and headaches prevalent in our family — especially in the

men. In their last years together they were both unhappy, although when Flora died in 1892, at the age of fifty-one, it was a tragedy for the whole family. At the peak of her life and marriage, she had been a beautiful, lively woman full of joy, with a marvelous sense of humor and play, delighting in intellectual pursuits, in people of many kinds, and in her family. Her journals and other writings have a fresh outlook and individual style, and I treasure the notes and fine drawings with which she filled a red leather volume while studying in Agassiz's seminar.

Harry was a greatly beloved son, and seemed to be living up to all his parents' high expectations. After graduation from Groton, he went to Yale, where he was on the *Yale Daily News* board, was a member of Hé Boulé, Psi Upsilon, and Skull and Bones, and was elected to Phi Beta Kappa. Besides his academic and social achievements, he became an excellent horseman and polo player. Handsome — very much like his father — he was energetic, sociable, and popular, with a boisterous voice and a hearty laugh. He differed from his father, though, in one important way: while William had struggled for his money, Harry did not have to. Given all he needed or wanted by his doting parents, he lacked his father's drive and energy, although at the time he fell in love with Gertrude he was thought to be heading for a brilliant law career.

No wonder Gertrude was enchanted. In addition to his fine personal qualities and charm, her dream man had more than enough money, a slightly better social position, and a more distinguished genealogy than hers. Gertrude could be sure that Harry loved her for herself. And, to make it all perfect, her parents were delighted with her choice. Only the tiniest hints in some of her writings foreshadow her future dissatisfaction with the life of a lady, give hints of the realization that, despite having money, a husband, and children, she needed fulfilling work as well. No suggestion then that Harry would find most of his satisfactions in sporting activities.

On August 25, 1896, at the Breakers, Gertrude and Harry were married. Guests were few, only about sixty — mostly family — since her father was recovering from a stroke, but flowers, fountains, and clothes were festive and beautiful. In the grand hall, the *Times* reported, there were "cascades of fine asparagus and maidenhair ferns, white lilies, hydrangea, pink and white roses, pink and white gladioli, terminating with ruffles of pink and white sweetpeas, and sprays of lily of the valley." Gertrude's bridesmaids and her two maids of honor, Gertrude's

ten-year-old sister Gladys and Harry's nine-year-old sister Dorothy, wore gowns of white silk covered by mousseline with inserts and fringes of lace. The bride's Doucet dress of white figured satin was trimmed with lace "that had been in the family for years" and she wore her mother's veil. The brilliant sun, the blue sky, the gentle breeze seemed auspicious.

These two young people seemed to have the world before them. They were rich, beautiful, intelligent, talented, and in love, with the moral and financial support of their parents. And yet, and yet — with the advantages of hindsight, the differences between them are so apparent. Differences that would become more and more important, dividing them, while love nevertheless remained between them and endured longer than any of their briefer passions for others.

Gertrude's parents, despite the family's immense wealth, had emphasized what we call today "family values"—the responsibilities of money, rather than its more frivolous and pleasurable uses or abuses. The necessity of societal customs and rules, the significance of developing the mind through education and travel, the importance of culture as accompaniment to all else. And always before Gertrude, the examples of those parents, in their relation with each other and with their children, and in their dedication to family, community, and work — in contrast to the original founders of the fortune, for whom work was the first priority.

Harry, too, had examples before him of dedication and hard work — but since his mother had been unhappy during much of his childhood, he must have blamed his father's absence, his devotion to his work, for her depression and perhaps even her death. Perhaps the very idea of work was tainted. On the other hand, he was very close to his father, and expected to follow in his footsteps in law, business, and politics. In his pursuit of these, though, he had little of William's persistence. The talents were undoubtedly there: Dean Keener of the Columbia Law School considered him "one of the most brilliant students I have known." By 1900, he was working with his father on several projects, including the Guggenheim Exploration Company, the New York Electric Vehicle Transportation Company, and quasibusinesses such as horse racing and rural real estate. John Hays Hammond, a senior executive of the Guggenheim mining company, described in his autobiography a trip to a silver mine in Colorado with three Guggenheim brothers and Harry:

"He followed me into the mine and all day scrambled nimbly up and down ladders and over piles of rock. His athletic prowess stood him in good stead. . . . I have never seen anyone make friends more quickly with the miners, prospectors, and other old-timers than Harry Whitney. He had a personal magnetism and a disarming friendliness that made him popular in the West as well as in the East. 'You could beat even Teddy [Roosevelt] if you would go into politics,' I used to tell him. Harry also had his father's good judgment and generosity."

Besides these work-related activities, Harry hunted, drove four-handed coaches, raced his sloop *Barbara*, played tennis, fished, and rode — proficiently. His stable was preeminent in both breeding and racing, and when in 1926 his health forced him to give up polo, he bought and raced a seventy-five-foot schooner, *Vanitie*. Before that, though, he played polo, an amateur sport, at what would now be a professional level, at a time when polo was our national sport — the equivalent of baseball or football today. His English and Irish polo ponies were famously good, and he insisted on fresh mounts for each of the eight periods in a game.

In 1909 Harry's team wrested the America Challenge Cup from England, which had held it since 1886. As captain of "The Big Four," as the team was called, Harry was featured daily on the front pages of British and American newspapers. Living with his teammates and his family in a rented castle, Oakley Court, Gertrude, Harry, and the children were particularly close that summer. Gertrude was involved and encouraging about the matches, even setting up a system of "nurses" for each player, while she took the part of "chief nurse," as Harry testified in engraved letters below the gilded image of a polo player on a silver pillbox. They punted on the Thames — at the foot of their lawn — they received and were received by the King and Queen and other members of the British aristocracy, and they had fun together. My mother told me of her happy memories of that summer, still vivid after more than sixty years. She kept her first diary that year, and recorded the Big Four's moment of triumph:

"Papa's side won. The score was 8 to 2. After the game the American players had to go on a platform where the Queen sat to get the cup. They all had to drink something out of the cup."

Yes, Harry was a recognized hero. Gradually, sports took precedence for him over business, law, and politics. Why was this? In part, I believe, because of his natural abilities and his preference, but also per-

haps because his parents made life easy for him. In correspondence, it sometimes appears that William wanted Harry to have all the benefits of his fortune without the effort of acquiring it. Was the money Harry inherited in 1904 when his father died, about $25 million, a deterrent to working? The money was plenty to live on, even if it wasn't the huge sum his brother and sister inherited from their uncle, Oliver Payne, a partner in William Rockefeller's Standard Oil. That story bears telling:

Oliver had adored his sister. He had showered Flora, Will, and their children with gifts and affection. When Flora died, although William waited almost four years before marrying again, Oliver was terribly angry, taking the remarriage as an insult to his sister. He broke his close, brotherly relation with William, and asked the four children, who at the time were surprised and hurt because their father hadn't prepared them for his new marriage, to choose between their father and himself. Two of them, Payne and Pauline, chose their uncle and became the heirs to his immense fortune, which still today provides their descendants with great wealth. Harry stuck by William, and Dorothy, who was only nine at the time, adored their father and stayed with him, too.

For whatever reasons, the fact is that Harry didn't fulfill his early promise, and this certainly contributed to the problems between him and Gertrude. Gertrude feared that her own life would become as empty as she felt Harry's to be, and in 1901, when she was only twenty-six, she wrote in her journal:

"I pity, I pity above all that class of people who have no necessity to work. They have fallen from the world of action and feeling into a state of immobility and unrest . . . the dregs of humanity."

One of Harry's nicknames was "Moody," and indeed he was. Perhaps, like several members of our family, he had bipolar syndrome. He was often ill; he was plagued, as his father had been, by headaches and depression; and despite his outdoor athletic life, his health deteriorated steadily, in part because of heavy drinking — quite usual for men in his social world. In 1930, at only fifty-eight, he died.

In 1903, pregnant and ill with Barbara, their third child, Gertrude wrote Harry a letter to be opened only in the event of her death. I found this sealed letter among her papers while doing research for her biography, and couldn't bring myself to open it right away. I finally decided that if she had kept it all her life, she must have wanted it to survive. Here is part of it.

Dearest,

One never knows what may happen in the way of an accident when one is ill most of the time and, as I don't want to die without you knowing a few things, I am writing this for you to read ... not being 'noble' but only very weak and human, I have succumbed to the temptation of telling what in life I struggled madly to hide.

It seems so long since I have known that you did not care for me that I can hardly fix a time when I began to realize it. . . . Over and over again I would cheat myself into the belief that it had not all gone. I don't mean all affection, but all love. At any rate, to proceed with a story which you already know, I must say the realization that you cared for someone else was what in the end *made* me believe that as far as I was concerned all was over. See how quietly even clearly I have written that and yet for weeks the dim thought of it was such agony that I could not stand it.

She wrote about the pain Harry's affair had caused her when she became certain of it.

If I could not hold you I had only myself to blame. . . . Much as I have always cared for you I was able for a while to frivol with Jimmie (Appleton.) You have always known that that was only frivoling and that you always have been the only person I have cared for . . . when you read this and all the little things have been swept away and only the great truths remain you will be glad that I have said it even though you know it. I really think, my dear boy, that this is the best thing that could have happened. Could I have gone on without that for which I pine the most? I doubt it and been a good woman. I love love and I need it as we all do and perhaps I would have taken it even if I could not give it, rather than starve forever.

I know you must have suffered but after this blow is softened you will be happy and you are not so old. After all you did care for me a good deal and we were very happy.

For heaven's sake remember that Flora [their daughter, my mother] is horribly sensitive. Give her lots of love and bring her up to be strong and good. She has the possibilities of lots of unhappiness in her, poor little tot, and she is closer to me today than anyone in the world. She will be moody and fanciful and inclined to think too much about things which will only make her unhappy, guard against these tendencies. Let her have lots of companionship. . . .

Good-bye dearest — remember I do not blame you. I believe that you could not help it. I only know that I had so much more love to give than you wanted that it used to choke me and that now I have confessed all and you can start fresh.

Many of Gertrude's journals also mentioned Harry's affair, and her need for love. In another long, unmailed letter to Harry in 1913 she suggested coming to an "understanding" very different from the first joyous one on the Palm Beach piazza:

It seems very obvious that we are drifting further and further apart and that the chances of our coming together are growing remote. I say this for several reasons — there is no inclination on your part to have explanations which might lead to understanding. Also our mutual indifference to the pursuits and pleasures of the other is leading us constantly to have less even to talk of and forms no bond on which we might try to bridge our difficult moments. Of course for a very long time we have done absolutely nothing together because we wanted to. . . . I am not going to throw the rest of my life away. I am going to face things and understand as much as I can, and then build on a solid foundation for I am tired of the sand that crumbles and will not hold my poor little house.

But the next year, in another unmailed letter to Harry, she wrote: "After this long time, dearest, I am going back to you and there is no joy in me, only depression. I shall be very happy to see you again, I care for you as much as ever, but dear, going back means so many things I hate. It will pass and after a while my spirits will come back, but now it is as if the world was on my shoulders. . . . I will at least try to be honest with you.

"I went back for a little time to a man who has loved me for three years and besides that I became infatuated with another man and I let him make the most desperate love to me. I loved you all the time but I was excited and unnatural and it did not seem to me to be very bad."

In a letter to William Stackpole, a long-term beau, she wrote in 1913: "I gave the big, unselfish love once in my life and I guess it is not there to give again."

Undoubtedly, she meant Harry. They had so very little in common, it seems to me — neither interests nor work — and yet their bond lasted. Why? A strong sense of tradition. The binding ties of family

and religion. And something else, I feel sure — a powerful physical attraction.

And Harry? How did he feel about Gertrude, as time passed? The only real clue is a note to her in 1919, in a large hasty scrawl.

Dearest,

I am nearly crazy. I have not slept a wink all night.

By the worst luck in the world — I would give ten million dollars if it had not happened — I ran across your Stackpole letters last night in the country.

You are the only person I have ever really loved. The only person that means more to me than anyone else, man or woman.

I believed in you & trusted you because you are true & big.

I told Harry (Davison) on Sunday that Monday was our 23rd anniversary & that we loved each other better than anything else in the world.

Now the bottom is knocked out of life. It's all lies. Are you all a lie? Are you all false? Is nothing real? I love you too much to let today go by, because I think it is your body & not your heart that did it all.

I have got to know how many men — of course I know Jimmie kissed you on the *Sheelah* [a boat they sailed on in the Mediterranean in 1901] — but I don't want names — I want *you*.

Harry

What happened? Did they finally have that open conversation for which Gertrude had wished? We can only know that they remained loyal to each other in times of need, illness, and pain. When, for instance, Harry's beloved father died in 1904, or when Gertrude's favorite brother Alfred was lost on the *Lusitania*, sunk by a German submarine in 1916. When their younger daughter Barbara, pregnant with her first baby, was emotionally and physically ill. When their second child, Cornelius (known as Sonny), was threatened with a paternity suit while at Yale. When Flora, after marrying Roderick Tower and having two children, decided to get a divorce. Always, they worried and worked on solutions together. A few weeks after his discovery, in a letter from Montana, Harry wrote:

"I wish I were home. Feel lonely and depressed. Even with such a bad wife, home is pretty good. Love, Harry."

And Gertrude wrote affectionately to Harry, with news that Sonny was ill, and that Flora wanted to marry Roderick Tower. Gertrude wasn't pleased, and wished he were there to help. "Love, dearest," she ended her letter, "& for heaven's sake come home soon. I can't handle all these family matters alone."

Near the end of his life, Harry's investments had lost money. If his children were to have a substantial inheritance, he realized that he must act, and in his most adventurous investment he developed a huge tract of land in Flin Flon, Manitoba, into the Hudson Bay Mining and Smelting Company, the large Canadian producer of precious and industrial metals. This daring speculation was his most successful, and it replenished his finances enough to leave money in trust for his children and grandchildren. Still, at his death, the newspapers were surprised by his estate's small size: about $75 million, compared to his brother Payne's $240 million — this because of Oliver Payne's bequest, of course.

I believe that these two people, despite all, loved each other best. Still, it was a turbulent marriage, and Gertrude's frequent misery impelled her to focus more intensely on her interest in the fine arts. Unlike Harry, she worked hard — on her sculpture, on getting commissions, and on her patronage — for many years in near obscurity, despite ambition and persistence. Surprising as it was for a woman in her position to work at all, she began thinking about it early. She remembered later how she had felt in 1898, after only two years of marriage:

"I couldn't free myself from certain feelings. I wanted to work. I was not very happy or satisfied in my life. . . . I had always drawn and painted a little, now I wanted to try modeling. My memory brings back a dream I had at this time, very distinct. I was in a cellar and modeling the figure of a man. There were a great many difficulties connected with my getting forward with the work."

She found teachers and studios, and she persevered in her efforts, and she began showing her work in exhibitions in both Paris and New York.

In 1904, already considering the new challenges of patronage, she wrote in her journal:

"Do not sink into a nonentity when the path for other things is open to you. And it is open. Go to your friends, to people who know you well and make them tell you what your good points are (everyone has

some) so that you may make something of them. Why should you waste these talents anymore than your money and position which are also talents."

By 1908, she was working steadily, sculpting in her studio:

"I love my work because it has made me happy and given me confidence in myself, and because it stretches into the future offering me always happiness. It is not dependent on humanity, it is something that I have made for myself and that I possess and cannot lose for it is a part of myself."

This, then, is an introduction to the woman whose faith in American art and artists led to the Whitney Museum of American Art.

Three

*D*uring our short summer stays in Long Island, I occasionally visited my grandmother, whose house was very near ours. We played "Exquisite Corpses," the Surrealists' favorite game, in which you draw a head, then exchange paper and continue with the rest of the body.

Later, in the '70s, during my years of research for B. H. Friedman's biography *Gertrude Vanderbilt Whitney*, I came to know my grandmother much better. For this emblematic figure in my life, what did art really mean? And what did she come to mean to me?

Imagine a very young woman, around the turn of the century, immersed in her life as a "lady," the mother of three children, and the wealthy wife of an equally wealthy sportsman-hero. With her abundant charm, energy, and intelligence, she yearned to *do* rather than just to *be*, but in her day almost all doors were closed to women. Especially to women in her social position. The male world of money and business, for instance. She entered a whole other world, an inner world that was to become an outer world as well.

When I immersed myself in research for her biography, I identified with my daring grandmother. When she changed her life, though, she managed to keep her old one. She had it all, as they say, whereas I left large shreds of my old skin behind when I left my home for a new world. Gertrude fought for her sculpture commissions, she sought recognition as well as self-expression. Ambition was surely part of my motivation, too.

In 1912, when she was thirty-seven, Gertrude recalled that earlier time in the "Beginning of Autobiography" notebook: "I couldn't free myself of certain feelings. I wanted to work. I was not very happy or

satisfied in my life. The more I tried to forget myself in my life the less I succeeded in doing so. . . . I had always drawn and painted a little, now I wanted to try modeling."

Sculpture would allow her to express her emotions, would give her a certain freedom, and would enable her to compete in a milieu where women had some chance of success. Although her husband didn't wholly understand her needs, he encouraged her to find the best teachers and to build studios or to rent them wherever they lived. Her favorite studio, however, was neither in Newport, nor in Westbury, nor even in New York, but in Paris, then the center of the art world. France, she wrote, was "the land where one moves and breathes and has one's being."

There she felt free to develop. There, and during a five-month trip to Europe and Africa in 1901, she felt inspired to change her life. To become an artist.

At twenty-six, writing in her journal about that trip, she agonized over her deficiencies:

"How marvelous is a really fine piece of sculpture and how can a person like myself dare to *dabble* in such things! It is a desecration. . . . I feel sometimes that I can never go on with my own work, that I am too old to begin with, that my aim would be too high for my knowledge, and that never, never in the world would I be willing to do mediocre things. . . . Technique takes time and time means the sacrifice of something, and the sacrifice of those things that perhaps cannot be sacrificed — who knows! There are some things that make us terribly unhappy but in the end these very things add a great deal to one's life."

A year or so afterward, Gertrude compiled another book of writings called *Travels in Foreign Countries and in the Mind*, a more mature reflection on what her voyage had meant to her. Perhaps she had intended it for publication; I believe it would still be of interest today. Aware now of her own transition to a different life and consciousness, she wrote that artists had "the sublime joy of giving themselves to the world. . . . And yet it is in the expressing that the real joy exists and not so much in the method. How else can one account for the bad pictures painted, the wretched books written, the weak statues constructed unless one takes into account the joy of creation?"

But Gertrude, convinced that she could never overcome the limitations of her upbringing, went on to say:

If one has been surrounded all one's life by a great high fence . . . then when . . . one is liberated from prison one's wings are so inconceivably weak that though one longs to fly one has abrupt falls which are painful. . . . My wings have neither grown nor have they spread. . . . The Anglo-Saxon temperament is the real constructor of high fences and in consequence the clipper and restrictor of wings. . . . What do the Latin races know of the inexpressible agony of the "shut-in feeling," the perverted self-consciousness of "reserve," the long, drawn out sorrow of the "unutterable?" . . . Though I may feel near to them, how cold my look which seems only to conceal my sympathy. I would rather die than show my real feelings once deeply touched, while they share with the world that which makes them so human and understanding. . . .

Would that we practical Americans with our love of money, our unbounded belief in ourselves, could cultivate an eye for the artistic in all phases of life. Not in art alone, though alas we need it sadly there, but in every part of our too full and hurried lives. If we could but rise in the morning artistically, to work or play artistically, to eat, sleep, and love artistically!

For Gertrude, art had become pivotal — not only as artist, but as patron. One seemed to imply the other, given the sense of responsibility her social position afforded. As early as 1904, she began thinking about the most effective way of becoming a patron. In her journal she advised herself:

> Take Harry into your confidence. There is no one who really will be more pleased to see what you want to do than he will. Because he is uninterested in your present life and aims does not mean that he will be in these. He has no real sympathy for your modeling. He may be right not to have — it is only developing a little talent and leaving your real power, which is your money and position, out of account; . . . first of all get Harry on your side. Talk to him about your aims, let it bring you closer together, let it fill the gaps in your life — it will lead you to happiness.
>
> To see artists and find out [their] wants would be a good start, . . . to found a Beaux Arts — with painting and modeling in connection. Tuition low. Scholarships. Exhibition rooms in connection. . . . Raise money for building. $1,000,000 at 7% interest [she crossed out 7 and changed it to 5]. $50,000 for me to pay. Work government to give some. Best teachers such as [she left a large space].

Money, even then, an issue. . . .

From that time on, the twin dreams of being both artist and patron coexisted in Gertrude's mind. The one fed the other. As artist, she hoped to be able to communicate her deepest feelings: "We can never really approach one another. Forever we strive to get closer and forever we cannot. . . . Everyone must have felt the longing to lay all bare, to be absolutely understood, to understand someone else, to know the bottom. Think if one could express that feeling. It would be a work of Art, for it is essentially universal and it has not been expressed so far as I know, and feeling it as I do, if I have the technical ability I will be able to express it. It is for that I work."

While in Paris, waiting for her new studio to be completed, she wrote lyrically of what she hoped to convey:

Love, hate, friendship, passion, faithfulness, suffering, joy, mental torture, conscience pains, jealousy, envy, longing, desire, cunning, self-sacrifice, hope, morbidness, etc. These are all things everyone understands. I have done despair, passion and paganism . . . my favorite idea of the separateness of humans in spite of all physical and even intellectual nearness . . . the satiety of the body in contrast to the eternal unsatisfaction of the mind. The big wanting of little things, the roads that lead to the unknown, the mystery of the future, the touch of genius, the big stagnation of riches, the wall that separates kings from the world, the "common touch." . . .

Then there could be just beauty — a simple standing figure of a man, so beautiful and so beautifully modeled that it need have no other meaning. . . .

A sarcophagus, I want to do for myself. The shape of the old ones and in the reliefs to represent my life symbolically. For instance, up to the present time (and I can go no further) the biggest items have been in my life — love and struggle. Struggle for the things I wanted and against the influences of stagnation etc. around me. So I should take these 2 splendid subjects for the long sides of the box. At the ends I should let "youth" meaning children be at one end and "pleasure" at the other.

In 1914, in a building at 8 West Eighth Street, adjoining her studio at 19 MacDougal Alley, Gertrude opened the Whitney Studio. Her friend, architect Grosvenor Atterbury, redesigned the building with two large rooms on the ground floor for exhibitions of the artists she'd realized had no place to show in a New York obsessed with European art and culture.

That same year, Gertrude obtained her first significant commission. No easy thing: "Time and time again I discovered that where a group of laymen had to decide between two people a question of assigning a commission to an artist, the woman of wealth lost out. And for no other reason than because she was a woman of wealth."

In her journal she wrote of her pride in making a monument to those who had perished on the *Titanic:* "When life is over and worms destroy, remember that the most foolish saying of your little soul will exist and in the face of the *Titanic Memorial* will be seen the love, the agony, the joy of my soul. I love what I have written, for it is the truth."

This granite monument stands today in a Washington, D.C., park near the Potomac River. Enlarged (and therefore simplified) by stonecarvers from Gertrude's clay model, the cruciform figure of a youth stands straight, arms stretched out, his head flung back in sacrificial heroism. He's Christlike, destined for eternal life, stepping forward to meet it. No pain mars his sensitive features, age has left his smooth young body unmarked. Not only does this figure express Gertrude's ideals, but also those of a nation about to plunge into a world war that would forever change that idealism. Never again would violence and war become romanticized. Gertrude's sculptures a few years later, depicting the men and women in World War I, already are different: emotions gouged from clay, she called them — men and women whose forms and details reveal her own anguished responses to heroism, agony, and death.

In 1929, as the last stones of her immense monument to Christopher Columbus in Palos, Spain, were being hoisted into place, she summed up her feelings about creation:

I was so tired the first days and I did not know why, now I do. It is only now that I realize I was living in emotions. . . . To see suddenly before you the real dream in great blocks of stone is overpowering. The cloud shapes one visualized come down to earth. God. The fascination of building, of creation! Now I see it all more clearly. At first it was just this is to be done, that, how can we get so and so to act, such and such to progress. Where will more stone men be obtainable, how shall cars, dredges, cement come into being — and always back of it the dream come true — the vision materialized.

And now, a week later, the tiredness is gone. . . . Why worry that old age has come if it has not come with atrophied mind and energy. The face may fall but the spirit may rise.

Tomorrow I will feel nothing recompenses for youth, but tonight nothing recompenses for expression.

Clearly, art had become Gertrude's central focus. Through it, she was able to find and express all the emotions and ideals she wished. Although she went on fervently searching for love, she declared herself and probably most fulfilled herself in art — in sculpture, in patronage, in dancing, and also in writing, not only in journals and letters, but also in one published and one unpublished novel, and dozens of short stories.

Today, Gertrude is remembered most for having founded the Whitney Museum of American Art. Her sculpture is seldom exhibited. In 1997, however, the Metropolitan Museum showed the bronze *Caryatid* it bought from Gertrude in 1913, the year she made it. Reviewing the show in the *New York Times*, Grace Glueck singled out the piece for mention. How pleased my grandmother would have been.

Today, we can see the passionate, creative side of Gertrude's nature in her sculpture. The Whitney Museum of American Art embodies her dream as patron.

Four

Flora Whitney Miller was the favorite child of both Gertrude and Harry.

"Flora Miller was a very exceptional person," writes her cousin, talented actress Beatrice Straight — Harry's sister Dorothy's daughter. "Growing up as she did in a world of great wealth and to say the least a somewhat eccentric world, she might have been overwhelmed by those around her. But she was encouraged by her brilliant mother whom she adored, to develop into an amazing woman in her own right, a woman of great purpose and style. She combined the qualities of warmth and openness, a fine sense of humor, plus the ability to carry through to conclusion such a vast and demanding undertaking as the developing of the Whitney Museum of American Art, at the same time raising a lovely family. She had the vision and strength, the business acumen to continue working for the growth of all these things she loved."

Her life as a child was unpredictable. As her parents made their plans, their children were included in trips or sometimes left with Gertrude's mother in Newport. For example, in 1912, Harry went to England, Gertrude to France. Harry took Barbara, not quite nine, to stay with him in Little Dalby Hall, his rented house in Melton Mowbray, Leicestershire, where she rode and her father hunted. "Barbie rides every day & looks awfully well & is very sweet," he reported to Gertrude. Sonny was a student at Groton, an elite boarding school in Connecticut, and Flora, fourteen, went to Paris with Gertrude. She had her own apartment near her mother's, with a maid and governess,

where Gertrude often brought artist friends to lunch or dinner before the opera or the theater. Flora wrote about her life in her journal:

> January 19: We went to see Mamma's studio. Then went to the school I am going to, to see about my lessons, Wednesday and Saturday mornings. . . . Had lunch with Mamma at her studio. It's awfully nice. I loved my first day in Paris.

School, ballet lessons, modeling in clay, piano lessons, riding lessons, roller skating, church, and the opera followed quickly.

> January 21: I like Madame Butterfly much the best. It's the most lovely thing I have ever seen, the music is wonderful.

> January 24: I like school much better than in New York but I don't *love* it.

> February 19: Lessons. After lunch I went to Poiret's with Mamma. I helped her choose dresses. I loved to see the people come in with all the clothes on, some are awfully funny and we liked them almost all. Mamma got two coats and 16 evening dresses, suits, and afternoon dresses. I loved all of them. Then we went to get my clothes. I got 12 dresses, one suit (blue), three hats, and four coats. I love them all. We went to get a present for Mlle., had an ice cream at Rumpelmeyer's and then came home. I had a fine day.

When she left to stay with her father in Dalby Hall, Gertrude wrote to her:

"I miss you awfully and wish you were still here. Paris is just about the same, only now I hardly ever go out as I work even more than ever."

After spending that summer in Newport with her grandmother, on November 12 Flora finally went back to the Brearley, in New York, the school her mother had also attended. Except for one day, she had missed school since January 9. No wonder she had a lifelong struggle with spelling and math! But in other areas, her knowledge was above average. She had a phenomenal memory, and could recite poetry for hours. In a game they both liked to play, she or her brother Sonny would recite the first lines and challenge the other to complete the poem. I have a few volumes of poetry inscribed with her name and the date: "To Flora

Whitney, Xmas 1908, from Mamma," a small leatherbound two-volume set of *The Golden Treasury*, well thumbed, with pencil-marked poems by Keats, Shelley, Browning, Rossetti, Wordsworth, Byron, Blake, Burns, and others; *French Lyrics*, from 1910; and a blue leather *Italian Skies*, with "Flora Whitney, 1913," tooled in gold on the cover, also well marked. In 1914, she probably took this with her on a trip to Italy, before entering the Foxcroft School in Virginia, where she was in the first graduating class.

Close as they were to become later, when she was eighteen Flora felt some of the same tension with her mother as Gertrude had with hers, as she wrote in a letter she transcribed into her diary:

> Just now, and indeed it happens quite often, "a change came o'er the spirit of my dream" . . . I fell to wishing I were the daughter of different kind of people and in an entirely different environment. My life would probably have been so much more worthwhile. I have a horrid feeling that when I am old and look back on my life, there will be no feeling of any satisfaction of having been of any use in the world. The powers that have been given to me, as well as to everyone else, will have been absolutely wasted and I will die, having lived a useless, flippant, and futile life. Pleasant prospect!! I don't know exactly what I would have done under other circumstances but at any rate I would have been sent to a public school and at 18 would have had a properly trained mind and a brain that worked a little instead of what I have now. It is disgusting! My love of music surely would have showed itself because of possessing a properly developed mind and of having been made to work hard I probably or rather might have been a music teacher and I rather like the idea. I probably would have studied music in Germany, it's very cheap, and then I would have seen and maybe appreciated all the beautiful pictures and other works of art. . . . Here comes my only real sorrow. I can't talk perfectly frankly to Mamma. I never feel that she understands or gives me the smallest bit of credit for any sense at all. She treats me as though I were about 12 and I don't ever feel that she makes any effort to give me a chance to say what I would like to. . . . I really feel much worse about not being able to talk to Mamma than anyone thinks I do. . . . Oh! It's awful. If only I could — I admire and respect and of course adore Mamma, but there is no companionship at all.
>
> I really want to work hard next winter. I'd like to stay in New York and study and go to lectures and concerts, play the piano a lot

and try and learn something. Then next summer coming out and Newport!! Oh!! Vile!!

Flora, then in the Adirondacks, had received a letter from Gertrude, who was in Westbury facing an operation for appendicitis:

"I would like all you girls to sleep *in* the camp while I am away . . . [rather than in the row of nearby tents, where the boys would sleep]. You take my place at the table and make everyone behave. Be very careful with the boys. You are older now and you must not be the least immodest or familiar. They will like you all the better for it. Don't ever let them touch you even jokingly. I know you know them all so well they seem like Sonny, but you are grown up now and you must have more reserve. This is not intended to be a lecture, but only to remind you of your extreme old age!!"

Perhaps these instructions aroused eighteen-year-old Flora's frustration and anger. But her feelings changed quickly, and by the following summer, in Newport, she confided to her journal:

"IT has happened. . . . Took Mamma out in motor and told her . . . oh! Ooh!! Ooooh!!!"

She and Quentin Roosevelt, Theodore's youngest son, had fallen in love. In the many letters they exchanged after Quentin went overseas as a World War I pilot in the American Expeditionary Forces, they copied poems they'd read and memorized together, they sent each other prayers, they fervently sang their love and plighted their troth. Soon after Quentin's departure in 1917, after dinner at the Roosevelt's home in Oyster Bay, Long Island, Flora wrote to his mother:

"Dear Mrs. Roosevelt,

"I tried last night to say what I am about to write but found I could not.

"After I left, you may have said — or thought —: 'ah, she seems so cheerful, it must have failed to touch her very deeply — and maybe now she will forget.' So I just want to say this. I never, never could forget for one instant; it has gone deeper than I imagined anything ever could — entirely new lands inside of me have been discovered by it. . . .

"I could *never* forget and I will never care the fraction of a feeling less than I do at present — and God knows I could not care more."

And here's part of a letter from Quentin to Flora, also in 1917, when he was stationed near Marseilles:

"My dearest of all,

". . . the life that I really live over here, the life of my thoughts, is centered in you. What I am doing now, the war and all, the misery and sorrow that it brings, is only a space between two parts of my life. Life became so very wonderful and new to me when I first knew that I loved you. Then I had to leave you, — and it was as if a window had been shut inside me, not to open until I am with you again. . . . I have no thoughts of the future at all that are not based on you."

On July 14, 1918, Quentin was shot down and killed in his plane inside the German lines. Flora was devastated. In a sculpture Gertrude made of her at this time, she sits listlessly in an armchair, her head bowed, her face drawn. She drew closer to Quentin's parents and sisters, finding courage in their quintessentially optimistic response to life — and even to death. And she discovered the traditional solace of work, beginning, as she later noted on a transcribed letter, for Theodore Roosevelt: "First letter written for the Colonel [as she always called him] while he was in the hospital and just before I was to begin regularly to work for him — a very few weeks before he died."

After this second death, Flora stayed with Teddy Roosevelt's daughter, Alice Roosevelt Longworth, while working for the Women's Republican Committee in Washington. In her diary she described the beginning of her adventure:

"Left for Washington on the 1:08 train in a state of suppressed excitement — arrived in a state of complete uncontrolled excitement and fright. Alice met me — it was too sweet of her — and informed me I was to be at 'work' at 9:30 in the morning at the Republican headquarters. I've only seen Mrs. McCormick [the head of the Committee] twice but immediately fell for her charm — oh I do hope this comes to something, it will just make all the difference in existence — to me."

Alice expected her to be present at the parties she gave almost nightly, which, while stimulating and fun, lasted until the wee hours of the morning. Mum told me later how astounded and impressed she'd been by the eminent visitors who poured in and out of the Longworths' home, but, since she liked a full eight or ten hours of sleep, she also recalled being constantly exhausted.

An old beau and lifelong friend, Thomas R. Coward (who later founded the publishing company Coward McCann), was also in Washington, working for the State Department. He wrote her eloquent and

ardent letters, calling her "Dearest Foufi," sympathizing with her, and giving a glimpse of my mother at that time.

> You are the one moving force in my life . . . *don't* marry someone else on practical grounds. It would kill me. . . . Oh, Foufi, I am so sorry you are so unhappy. I know exactly how you feel and *work* is the only solution.
>
> Why are *you, you?* And what constitutes your appeal. I think it really is partially your being a child with a woman's sophistication and cleverness. And then, of course, you are a delight to look upon and to *hear*. That voice!
>
> I believe utterly and entirely in your humanity, your generosity, your inability to be mean or petty, your fineness of perception — in a word your essential bigness of soul. If I had time I could relate that to the queer streak of the child in you which is so fascinating. It is at once your greatest charm and safe-guard.

But my mother moved back to New York, already committed to Roderick Tower, a Harvard graduate who had served in the army, and the son of Charlemagne Tower of Philadelphia, formerly United States ambassador to Russia and to Germany. Rod had been friendly with Quentin, and it seems likely that Flora married him in part because he could preserve her connection to Quentin. He was an oilman whose business ventures, after their marriage in 1920, took them to live in Los Angeles, where they had two children, my half-sister and half-brother Pamela and Whitney. Flora had always wanted to dance, and now she took dancing lessons at O'Dennishawns; met and dined with Pavlova, and watched her dance every night for a week, including a performance of *The Awakening of Flora;* attended dances by her mother's friend and teacher, Ruth St. Denis; and visited Douglas and Mary Fairbanks and Mary Garden. Despite these pleasures, she was lonely, as she wrote in her Line-a-Day, and delighted when an old friend, Alice Davison, came to visit: "We dined alone and talked till nearly 12 — mostly religion and sex!" She listed many books read, and kept notebooks of geology courses she took in order to share Rod's interests. But he was increasingly unstable, temperamental, and withdrawn. Flora spent more and more time in New York, and finally, in 1924, sought a separation and then a divorce. An essay she wrote then gives some clues to the problems in her marriage:

"If married people were more intimate — more openly honest —

more willing to allow the other to participate in innermost thoughts — there would be a better knowledge of human nature and therefore less misunderstanding. Sex would help and not hinder the relationship for it constitutes a supremely alive and vital portion of married life and can be regarded as a tie to a closer intimacy rather than perpetuating an estrangement."

Flora got her divorce quietly in La Bourboule, in the Auvergne region of France, and then, with her children, spent the summer of 1925 in her mother's studio in Paris. She began to sculpt there and subsequently in New York, exhibiting her work at the Society of Independent Artists and in the Whitney Studio Club's Tenth Anniversary Exhibition. She lived in New York and also in a house her parents built for her near theirs, in Old Westbury, Long Island.

Later in 1925, she met a charming bachelor, who was a talented artist and businessman: George Macculloch Miller, known as "Cully." His Miller, Hoffman, Murray, Lindley, and McKeever forebears were different from Flora's — they were even-tempered, solid citizens from Scottish, Swedish, and English stock, with American roots in Morristown, New Jersey, and New York. Not extremely wealthy, but very comfortable, these families distinguished themselves as professionals and businessmen, and took an active part in community affairs.

Martinus Hermanzen Hoffman, the first of my father's paternal ancestors to emigrate to America, arrived from Sweden in 1657, married Emeentje Claesen de Witte, and settled up the Hudson near Kingston and Rhinebeck. Franklin D. Roosevelt was one of their direct descendants, a Hoffman was dean of the General Theological Seminary, and yet another was a fine architect who designed the Villa Viscaya in Miami. Elizabeth Ogden Hoffman married an earlier George Macculloch Miller; they were my great-grandparents.

The first ancestor I know of on the Miller side was George Macculloch, born in 1775 in Bombay, where his father was a British major in the East India Company. Orphaned at nine, he was sent to live with his Scottish grandmother in Edinburgh, who arranged for his excellent education, including fluency in German, French, Spanish, and Italian. A businessman, he traveled widely in Europe during the Napoleonic Wars, and in 1800 he and fifteen-year-old Louisa Edwina Saunderson had their first child. After the birth of their second child, they married — in an unusual sequence of events, for those days — and two years later, emigrated to America and settled in Morristown, New

Jersey. Arriving with substantial means, they built an imposing brick home, Macculloch Hall (now a museum), on twenty-five acres facing what is now called Macculloch Avenue. George soon added to the house in order to open a school in it, which he ran for fifteen years. Macculloch Hall became a gathering place for the community, where George and Louisa gave dinners and led lively discussions of politics, philosophy, and religion. George wrote articles for newspapers and magazines on such subjects as slavery, debtors' prisons, freedom in Greece, and the political attitudes of Jérôme Bonaparte, and he especially enjoyed entertaining foreign visitors — no wonder, with all his languages! Realizing that the economy of the area was dependent on the iron mines and smelting furnaces, which, however, were devouring local forests for fuel, he designed and raised money for the Morris Canal, which for ninety years remained the principal route for bringing coal from Pennsylvania, and greatly furthered New Jersey's industrial development.

Their daughter, Mary Louisa, and her husband, Jacob Welsh Miller, a lawyer and politician, lived in Macculloch Hall with their nine children. Their fourth child, George Macculloch Miller and his wife Elizabeth Ogden Hoffman, had a son, Hoffman Miller, who married Edith McKeever, and my father was their oldest son. My paternal grandparents died before I was born, and my father didn't talk about them much — I wish I'd asked him more about his family, especially his mother's side, the McKeevers, about whom I know little.

I remember being intrigued by my father's paternal aunt, Edith Macculloch Miller, who left me in her will "one of my pins given to my great great aunt, Miss Murray, by General Washington, being a miniature of Washington set in pearls and with his hair." It lies in its original red leather case until, occasionally, I lift it from its surprisingly well preserved creamy satin cushion to look at the familiar countenance, to glimpse strands of chestnut hair in the minute pearl-mounted locket below, and to ponder my many-times-great aunt, Mary Lindley, who married Robert Murray and lived in the Murray house, Inclenberg, on Murray Hill in New York City (commemorated by a bronze tablet in the street at Park Avenue and Thirty-seventh Street). Mary Murray entertained Lord Howe at a tea party while General Putnam made good his escape from New York — and I suppose Washington sent her the locket to thank her for saving his army. She must have had courage, intelligence, and charm to succeed in such a risky affair. Robert Sherwood

commemorated it in a play, *Small War on Murray Hill.* Staying with Aunt Elizabeth in her Brookline house at seventeen, on a trip with my future husband to a Harvard football game, I'd never seen anyone so old and fragile. With her powdery face, small black-clad frame, and houseful of mementoes, Aunt Elizabeth gave me a sense of our family's reach back into America's history that was entirely different from the more prodigal family tales I'd heard from my mother. Rather than their forbears' money, Aunt Elizabeth emphasized their lineage, community service, and education: she spoke of teachers, ministers, lawyers, a few businessmen. They took pleasure in their families. The women stayed at home and cared for their husbands and children. Divorce was unknown. My father took pride in the generations of his family who had done well at St. Paul's School, a boarding school patterned on the English system in Concord, New Hampshire — one or two had even taught there after graduating. He and his two younger brothers had been known for their musical talent, and had sung together in the choir and in performances.

When Flora and Cully fell in love, my Miller grandmother, fierce and conservative, wasn't happy about her son's choice. The marriage would never last! My beautiful mother, as a divorced woman from a wealthy and notable family, spelled unhappiness for her beloved son.

As it turned out, she was wrong.

My mother was ecstatic, as she wrote in her journal: "Haven't been so happy in months and months and more months. Lay in bed all morning and drifted on a lovely pink cloud. I hope he lets me stay there just for a little while."

In early 1927, Flora and her children, Pam and Whitty, sailed to Egypt with Gertrude, who wanted to study Egyptian monuments before beginning to sculpt the model for her immense stone Columbus Memorial that stands proudly in Palos, Spain. A note from Cully followed Flora:

"Oh it's so hard to have you go my dear one. But of course when one can look forward to seeing you and seeing you and seeing you in only a month one should be grateful and patient — and I am, dearest. My 'tummy' is all going round inside first because you're leaving me and next because I am so happy at the thought of marrying you. Take care of your precious self — don't smoke too much please — in fact don't do too much of anything dear bad one."

Cully soon followed her to Cairo, where they were married, on

February 24, with an elephant hair for a ring. After a romantic cruise on a dahabeah on the Nile, and travels through Europe, they settled down in New York, where Cully and his old friend Auguste Noel founded an architectural firm, Noel and Miller. Although my father never made working drawings or became an architect, he conceived of and drew many buildings, mostly houses, and concentrated more and more on painting. My younger brother Leverett and I grew up with Pam and Whitty — we were one family, as far as I could tell. My sister always said that she was closer to my father than to her own. She wrote about him in "Flora," the memorial scrapbook created after my mother's death by her friends to celebrate her life.

"My stepfather Cully Miller spread fun and humor wherever he was — never at the expense of others, but always 'hitting the nail on the head.' I was very conscious of those 'vibes' between my mother and him. They were strong!!! He was just so devoted, patient, and supportive of her that it was a wonder. And, of course, she basked in the luxury of living with someone who gave so much. I feel lucky to have had such a stepparent, as he *never* interfered, except when asked, and gave us all mountains of laughs and fun."

I often look at a photograph of my father taken at about this time. He's in the Adirondacks, sitting on a wooden bench in the cabin he and my mother had built on the shore of Little Tupper Lake, looking west, down the lake, toward the often spectacular sunsets. Bliss, they named it. What happy memories that photo brings!

Camp Bliss sat in the middle of about 100,000 acres in the heart of the wilderness of the Adirondacks. William C. Whitney had bought and developed this property, managing it ecologically with Frederick Law Olmsted's advice, and building several camps for the family's use. My parents loved to go there, and they took us to the camp we children used, Togus, every August until we had gas rationing and took volunteer jobs during World War II. In the picture, my father looks peaceful and ever so young — it must have been taken right after he was married. One leg is flung up casually on the bench supporting the magazine he's reading, he has a full head of dark hair, and he wears trousers, plaid shirt, v-necked sweater, and moccasins. In one hand he holds a cigarette, probably an "MM," a snappy gold-tipped brand made with Turkish tobacco and imported to sell in the Park Avenue store where he was a partner, also called "MM." Behind him, leaning on the massive stone fireplace (where a fire is laid), are two alu-

minum cases that hold my parents' bamboo fishing rods. These were a clue to the reason for the lovely setting of Camp Bliss: it was close to Charlie Pond Stream, the very best trout fishing river in the world. That's what I grew up to believe, anyway. Hanging from a pole on that same bench I see my father's fishing hat, stuck all over with flies that he'd put there to dry after using them — little creations of feathers, fur, and tinsel, representing the bugs and nymphs the fish were eating at a given time. They remind me of my learning to make them, at ten, with the doctor who often fished with my parents, Carnes Weeks, and also with the eminent authority he arranged for me to meet, Elizabeth Gregg, who sold her creations to commuting fisherfolk from a little room at Grand Central Terminal cluttered with her materials. Since I was ambidextrous and could use scissors with either hand, I could tie flies without using a vise, a feat much admired by those in the know about such things, and this ability was definitely a feather in my cap. Carnes would bring me gorgeous feathers from his travels, especially during the war when he was posted to India, Burma, or China, and I can still visualize him spilling out fabulous bits of golden pheasant, brilliant silks, or tiger fur for me from his worn leather bag.

On a table, still in that photo, I see the ice bucket, cocktail shaker, and bottles of gin and vermouth for preprandial martinis, always part of my parents' evenings. And behind them is my father's watercolor box, with him wherever he went. Over the mantel is the monster trout that had taken my father forever to land — he'd named the springhole where he'd hooked it "Turtle," unable to imagine a fish so strong. I see the door leading to the kitchen, where Louis Duane, the guide who was my very favorite person for years, was probably starting the fire in the ancient iron stove so it would be ready for my father to make one of his special dishes, adding lettuce, onions, bacon, and cream to a silver can of baby Lesueur peas. With boiled potatoes and corned beef hash or fresh trout, we'd have a feast, in a very different mode from our usual meals that were cooked and served by chef and butler. How delighted I was to be able to wash the dishes, using water I'd carried from the lake, heated in the stove, and poured into a dishpan with a bit of soap. Seldom did I feel so useful. Seldom did I have such precious times with my father and mother — and Louis as a bonus.

Of course, fishing with them was also a special treat. After practicing with matchsticks and borrowed rods, the time finally came to actually cast a real fly for a real fish. I'll always remember the early morning

hush as we canoed upstream toward the springhole, mist over the water, the rising sun casting a rosy glow. Suddenly, there was a beaver, swimming toward his house with a big branch in his mouth until he saw us and dove, flapping his broad tail hard on the water. And there, around the bend, a graceful deer bowing her head to drink, then, startled, running toward the woods with her white flag up. Once a bear swam across our bow, huge and black as it climbed out and lumbered off. Big blue herons, white egrets, mallards, and kingfishers, too. As we started to fish, my parents' flies flew straight and true, landing with scarcely a ripple, while mine, at first, made a big fuss and scared the fish away. No one complained, though, even when I "caught the bushes," and in time I improved. How I loved to watch one of them catch a fish! My mother's dry fly floated on top of the water, and she'd pull it jerkily across the still water until suddenly, with a big splashy gulp, the trout came right out of the stream after it. Then came the struggle, the leaps clear out of the water of the glistening speckled beauty, who'd sometimes shake free and dive deep, free again. More often, Mother would raise the tip of her rod skillfully and hold him firm, bringing him close and closer until Lou would scoop him into the net.

Golden days, vividly re-created when I look at that photo of my father.

Until I was fourteen, my family lived in Aiken, South Carolina, in Joye Cottage, the house my great-grandfather, William C. Whitney, had bought and enlarged. Aiken was then a small village with a "winter colony" of northerners — "Dam' Yankees" as the locals said — whose income allowed them to live comfortably in a beautiful place far from city problems. When his father died, my grandfather Harry Payne Whitney inherited the house, and after he died in 1930, Gertrude gave it to her daughter Flora. My parents considered carefully the implications of my mother's life as a child: rushing from place to place, going to school when it suited Gertrude's and Harry's schedules, with one caretaker succeeding another and little consistent care, and they opted for a different way. This was to give their children the stability and continuity necessary for a beneficial life, while the adults could be satisfied as well. Aiken provided everything they wanted — it was a perfect place to ride, shoot, play golf, tennis, and bridge, and to bring up their children in a protected, healthy ambiance.

For us, Aiken was in many ways a paradise. We had a home that both spread out and embraced us, a climate that allowed us to ride every day, horses we adored, a small fine school, and few but good friends. My sister Pam gave the flavor in that memorial book compiled after Flora's death:

"Growing up Mum's daughter was great fun — never dull. We all moved a lot: in the winter to Aiken, where all the boys attended Aiken Preparatory School. But there was no school for the girls at the beginning of our years there. So, Mum and three of her friends started one — in our squash court!

"This traveling was an intricate business; we took all the dogs, canaries, and other pets, such as goats, all the children — we were four — nurses, a maid or two, the chauffeur, the cars. When we went to Aiken we took all the horses and all the household and sometimes ponycarts and buggies."

My brother Leverett and I weren't really part of Pam's and Whitty's fun. Being older, they had a "gang" of friends and rushed about the village in an independent way we never could. Lev and I felt distanced from our parents much as our mother and grandmother had, although I believe that they really tried to spend time with us. But our parents were so caught up in their own lives. Their friends! Their activities! Our strict British nannies loved us, and we were attached to them, too, but we always wanted more of our parents than we got. Is this a universal, unalterable situation?

How I longed, as a child, to confide in my mother! Perhaps I didn't know how to capture her attention. Whitty was handsome, funny, a marvelous athlete with a dozen close pals. Pam was clever, beautiful, and bold, with many friends and admirers. Chubby and solemn (until my 'teens, when I thinned out and became more self-assured), I grew to fear rejection; Mum might turn away, or laugh, or answer the telephone. Still, I took every chance I could to be with her. When the time came, though, it was Pam, not my mother, on a carefully planned buggy ride behind her high-stepping hackney ponies, who instructed me about the "birds and the bees." A few years after that, when Mum wanted to discuss birth control and sex with me before my marriage, I felt too embarrassed to respond. The moment had passed. When our relationship became close, as it did still later, it was nourished by the Museum, and never reached the intimacy she and my sister had maintained.

About 1940, when I was twelve, my mother first took me to the Museum. Just going to New York with her was special. To begin with, I had her all to myself.

Describing how she was then, I realize that my memories are intertwined with photographs, blended with her own stories and those of others, and mixed with later images, so my picture is the inevitable composite.

Flora Whitney Miller was beautiful right up to her death at almost eighty-nine. "Look at her lovely face, with no wrinkles," my father used to say with pride. Her carefully coiffed hair never turned completely white. Her huge hazel eyes were fringed with long eyelashes below abundant eyebrows.

Mum lavishly powdered her upturned nose, rouged her cheekbones, and wore bright lipstick on her wide mouth. She smelled deliciously of Chanel. Her room, her whole house, was fragrant with the fresh flowers that still live in my father's many evocative watercolors.

Her laugh was infectious. The men who visited our homes seemed wildly in love with her. No one, though, more so than my courtly and humorous father. Slim, elegantly dressed in his tailor-made double-breasted jackets, he wore horn-rim glasses behind which his blue eyes danced. His use of language was meticulous — when I called a basin a "sink," or curtains "drapes," he made satiric verses and watercolors to tease me. Sometimes, after predinner martinis and good wine with the roast, at dinner's end he liked to sing: "In the Wintertime, In the Valley Green" or

> When I walked along the Bois de Boulogne,
> With an independent air,
> You could hear the girls declare,
> He must be a millionaire
> You could hear them sigh
> And hope to die
> And turn and wink the other eye
> At the man who broke the bank at Monte Carlo!

Loud cheers from us all.

Despite a painful hip, my father was a wonderful dancer, in the style of his old friend, Fred Astaire.

"Cully" was also known for the funny verses any number of people and events inspired him to write and illustrate. After his death, we had

his book of "Jingles" reproduced, so his descendants could also know and appreciate this aspect of him. Often about ladies, they'd surely be considered politically incorrect today. For instance, while on board the *France* in 1963, he wrote this jingle and accompanied it with a graphic illustration:

> I'm awfully sick of women in pants
> Whatever they're filled with —
> Fannies or ants
> (There must be hundreds on the *France*)
> And most of them make me look askance.
> But whether it's ass or whether it's skance
> I still hate women in tight stretch pants.

In Paris, in 1965, he drew a picture of a doctor throwing up his hands in a gesture of helplessness. It illustrated this ditty, written after their old friend "Chip" Bohlen, then ambassador to "The Court of Charles de Gaulle," as Cully called it, had dined with them:

> Everything in France, I find, is very much de Gaulle.
> Politically, of course, but that just isn't all.
> One finds thus *Gauloise* cigarettes
> His face on boxes of *alumettes*.
> And when I had an awful pain
> The French "doc" said he would explain
> With that his face grew sad and sadder —
> He broke the news —
> *C'est* de Gaulle bladder.

"My dearest bug," Cully would say to Flora, "how is your sniffle today?" Then, looking at me, "Your mother is extraordinary, you know. She's curious about *everything!* What an interest in life she has! You'll never know *anyone* who appreciates things so much."

And that was true.

"Nooooo!" she would exclaim, as one of her beaux — Carnes or Tim or Bruce — would describe an adventure they'd embroidered for her, just to see her wide-eyed amazement. "I don't *believe* it!" Or, much later, I'd show off my new baby: "Oooooh!" she'd say, "Darling, how delicious, the cunningest baby ever."

My father's appreciation of *her,* though, gave her the solid base she

needed, a setting enabling her to expand and blossom. He was actually the more outgoing of the two. It was he the servants adored, he who had many close friends, he who arranged his and my mother's trips and parties.

There was anger, too. I well recall its sound.

Raised voices, mingled with the tinkling of ice. Angry voices. Before dinner, after dinner, words knifing through the silence of hurt feelings. Although I couldn't bear it, I sat there, watching, listening, learning to swallow anger rather than to risk the pain of confrontation. What did they fight about? My mother usually started it, I think. Some small resentment, some forgetfulness or mistake in planning, nothing much. But those martinis released underlying devils, swelled whatever emotions bubbled under their smooth masks and idyllic lives.

All gone, the next day. Except for the residue in the being of a child.

At a time when, according to *Popular Mechanics*, trailering was so in vogue that we were on the way to becoming "a nation of nomads," my father bought "Romanyrye," the sleek Art Deco sleep-in trailer in which they traveled all around the country, once as far as New Orleans. He had it fitted to their taste — elegant! When it arrived in Aiken, he wrote in "The Log of the Romanyrye":

> October 17, 1934. Much excitement on part of population of Aiken. . . . had cocktails served on board, much to amusement of the Wilds and Elsie Mead who dined with us.

> October 18. Most of day spent in loading equipment on board. Went to boys' school and took Whitty, Pam, and some of their friends for a ride.

> October 19. Left Aiken, en route New York.

Cully's paintings hung all over my parents' homes, especially in Aiken. Instead of the usual ancestral portrait in the living room, on the long wall over the bar stretched a large, fine oil of a young man, "J. D." In those long-ago days when segregation was institutionalized in the South by "Colored" or "White Only" signs on water fountains and movie house entrances, when public schools and churches, life itself, were racially segregated, to render a major portrayal of a "colored" man who worked as a "dove boy" for my father when he went hunting in-

dicated an unusually open mind. Full-length, handsome, J. D. stands in a corn field, his head held high. My father had captured J. D.'s dignity.

A pair of smaller paintings on the side walls showed Cully's humor. One, *The Night Before*, all in browns. A whiskey bottle. A decanter. A half-empty glass. The other, *Blue Morning*, held an assortment of blue bottles: Alka-Seltzer, Milk of Magnesia, an eyecup, a water glass with a measuring spoon.

My father was always painting, whether in a New York school — where he seemed to be the best artist, an inspiration for the whole class — in his studio in Aiken, in the Adirondacks, or in Hobe Sound, Florida, where he wintered later in his life and always kept by his side a watercolor pad and paintbox.

In Aiken, his studio was in the "Spooky Wing," as we called those otherwise unoccupied, dark, and scary rooms. You got to them down a long, wide red-carpeted flight of stairs — exactly how I still picture the entrance to hell. The room you eventually reached opened onto the garden and pool, and I can still see my father there in my mind's eye, wearing a long white coat like a doctor's, holding his palette, brushes bristling in his hand, emitting delicious smells of oil paint and turpentine. Swimming or playing in the garden, my brother and I knew we mustn't disturb him — but I doubt we could have, so focused was our father on his canvas.

In the Adirondacks, he used a log cabin way uphill from our noisy, child-filled camp, which we didn't visit unless invited. Then, he'd arrange a picnic; how many photos we have of Daddy cooking hamburgers and steaks over the wood fire outside his cabin, all of us gathered around, sitting on the cabin porch, or toasting marshmallows over the embers as loons called wildly and the moon rose over the lake, while someone told the terrifying ghost story, the "Windigo." But peeking inside the little cabin where we didn't go, I saw an easel, brushes, canvases, pads of Arches paper, an old smock hanging on a hook. Another life.

Later, during the first years I was married, he took me to his class in New York, where sweet Hungarian portraitist Maria de Kammerer counted on him to infuse her students with ambition and fire. Despite my lack of talent, I loved the experience of dabbing thick, sensuous oil paints on a canvas, loved seeing my father in his true element. He delighted in the models she provided, and the company, too, since he had

no circle of artists in his day-to-day life in Aiken. His paintings weren't the kind a museum would show. Not "significant" in terms of our society, not unique in style, only in the sensitivity he brought his subjects — lovely evocations of nature, people, flowers, still lives, Adirondack scenes, the rooms our family inhabited. Again and again, he painted Flora — sunbathing, fishing in the Adirondacks, doing a double-crostic in their Paris garden. When my brother Lev's first wife, Ava, Cully's voluptuous daughter-in-law — a favorite subject — posed naked for him, we were conventionally, ridiculously appalled. But Cully was inspired by beauty, everywhere he found it. Especially, and always, by the nude female body.

In Hobe Sound, my father did watercolors in a house by the Inland Waterway where every room was a studio, where every wall was enlivened by his images: an exuberant yellow hibiscus fills a page, a boat passes below the lawn, rooms in Aiken or New York spring to life, one can almost smell a vase of roses. In one watercolor, I'm sitting in a bathing suit by their pool, and looking at it I feel almost right there, as I was in 1972, writing a paper on abnormal psychology for college, the year Daddy died at eighty-five.

I have his hands: small, square, with soft little nails lacking my sister's and my mother's half-moons. I wished for long and graceful hands with hard nails shaped like almonds and painted scarlet, like theirs, and like my grandmother's, whose right hand cast in bronze sits on a table in our bedroom, looking, I imagined, like that of an artist. But today my squat hands please me. They remind me of my father and they reinforce my sense of him as an artist.

His paintings were the first I remember. To me, they revealed the importance of art, and showed me, by his example, the commitment that is the essence of an artist. My father's love of painting has infused my love for art all my life. My grandmother may be the source of my specific involvement in the Whitney, and for my feelings about the Museum, but from my father I absorbed the deep sense of art, its centrality to the artist, its abiding, fulfilling joy.

As I grew older, I became inwardly critical of my father's lack of ambition, because he didn't have big exhibitions or big sales of his paintings. I thought he was wasting his great talent, frittering it away in socializing, drinking, traveling. Never giving himself the chance to become a great artist, never concentrating on his painting above all else.

My faultfinding was, I fear, the typical arrogance of youth. My father

was full of joy much of the time, more than almost anyone else I've ever known, and in full measure he gave that joy to others. He did this personally and socially and also in his paintings. They are enchanting, lovely expressions of his life. I wish I had realized long ago, and had told him in time, how much he had inspired me, how watching him had given me a profound sense of the meaning of art, of being an artist.

My mother's immense charm made her the glowing center of any gathering, a magnet for friends, family, and the "beaux" who seemed accepted members of our household. Several doctors appeared instantly whenever she had a cold, or the faintest twinge, and she sat happily in bed while they fussed over her. Russian count Elia Tolstoy spent Christmases with us in Aiken, entertaining us with tales of adventure, always starting in foreboding words with his escape from the "Reds," "When I in Gobi Desert . . ." My sister and brother called him "Count Tallstory." My first "crush" was on Ronnie Bodley, the English writer who'd been a beau of both my mother and grandmother, whose little mustache and very British accent captivated my best friend, Marianna Mead, and me. We would prepare his breakfast tray with little vases of Mum's favorite lilies of the valley, and hover, waiting for his slightest attention. We learned the hard lesson of unrequited love early. An architect adored Flora. A gifted decorator. A brilliant publisher. And others, until nearly the end of her life. When they were both in their mid-eighties, Harlan Miller, one of her first beaux, and also her last, wrote on a card accompanying a bunch of birthday flowers,

> With affectionate cheers
> A unique, enchanting lady
> In whose heart mindless of the years
> There is a corner of endless spring.

While bridge was my father's game — and he was much in demand — my mother played Canasta, although she liked to reminisce about the high-stakes poker game in New York of which she'd become a member, a sophisticated, male, literary group that included Raoul Fleishman, owner of the *New Yorker*; Ralph Pulitzer, the members of the Algonquin Round Table, and other luminaries. She loved to stay up late, unlike my father, who went to bed early. After a play or a dinner or that poker game, she would go with a friend to the Stork

Club or El Morocco and stay until nearly dawn. Then she'd sleep until noon.

Strangely, Flora was drawn to boxing. Why does a person want to see one man hurt another? Like the ancient Romans watching gladiators? I could never imagine my mother at ringside, fiercely rooting for Joe Louis to knock out Max Schmeling. But I still remember her excitement over that heavyweight bout. Perhaps, like her poker games and her flirting, she simply had a very human attraction to danger. Was it also the sensual pleasure she felt, watching those splendid near-naked bodies dancing their way through their bloody struggle?

Mum loved to read, everything from Conrad to the latest murder mystery. When we children were sick, she would always read aloud to us from the same books her mother had read to her — Kipling, Twain, or Conan Doyle. Sometimes, in the slanting autumn sun of a long South Carolina afternoon, I would read to her. Sitting on canvas stools in a cornstalk blind, shotguns at our sides, as we waited for doves to fly in and feed on benne seeds, we'd laugh aloud at *Mrs. Lecks and Mrs. Aleshine,* we'd thrill to the *Adventures of Tish.*

As far back as I can remember, my mother was for me the essence of elegance, and as I grew up I discovered that for a great many people she represented that as well. In the country, she wore well-cut trousers with a bright print shirt. In the city, she was elegant in a Chanel suit, wedge-heeled shoes, and pearls. Suede gloves, a hat by Paulette, feathered or sequinned or veiled, and a snappy bag completed the look. Smoke perennially curled around her head from the Turkish cigarette in the ebony holder dangling from her long red-tipped fingers. Slim, with small ankles and shapely legs (my father always noticed other women's less lovely legs!), she often received compliments about her clothes. Always going to the "collections," as had her mother and grandmother, she ordered suits, day and evening dresses, blouses, and hats — in Paris at Chanel or Balenciaga, and in New York at Hattie Carnegie or Mainbocher.

I have often wondered why some women are obsessed with clothes. When I think of all the money those women, today as always, will spend on the latest and finest for each new season, I am bothered, perhaps because I recognize in myself the same tendency to want such garb.

"Clothes create at least half the look of any person at any moment . . . when you are dressed in any particular way at all, you are re-

vealed rather than hidden," writes Anne Hollander, in *Seeing Through Clothes* (Viking Penguin, 1978). But for some, "clothes," Hollander continues, "stand for knowledge and language, art and love, time and death — the creative, struggling state of man." Gertrude and Flora often chose avant-garde, exquisite, and daringly festive looks.

Gertrude and Flora, intimately connected to the world of visual arts, "creative and struggling," were natural leaders in fashion.

Besides, despite all her charm and abilities, my mother, just as millions of women before her, needed the shell of fashion to cover insecurity, to insure the approbation of others. This she also taught me. As a teenager, I learned to wear a girdle and stockings with my tweed suit when we went to the races or a polo game. Later, a "little black dress," with gloves and a hat, for lunch in New York; and a well-cut suit for meetings at the Museum. Thus garbed, I felt secure, just right for the image I wanted to project. I'm more relaxed now, but the urge for new feathers in springtime and autumn remains, and I still dress up in my best suit for meetings, or something spiffy and different for a party.

Only now do I finally perceive with clarity that I absorbed from Mum lessons in deceptive magic, passed on from one generation of women to the next. And it seems I've passed it on, too.

But whatever fashionable shell she chose, it could never altogether hide the woman within my mother. She was a vibrant person with strong feelings and opinions. I remember, for instance, the way our whole family would eat meals together every summer in the Adirondacks. "You can say anything you like," Mum would tell us all, "but you must be able to argue for what you believe. You must stand up for it." And we surely had some lively discussions at that long table — a few even better than the pies filled with juicy, wild raspberries we'd pricked our legs and hands laboriously collecting. When my brother Lev, for instance, wouldn't eat his boiled eggs, demanding that they be scrambled instead, our mother initiated a long-term, recurring argument on the rights of children versus adults. "How do you like your eggs?" became a metaphor, in our family, debated again and again on different issues, all the way from our bedtime to whether Whitty should leave Harvard to join the Air Force before our country joined World War II.

Diana Vreeland was a childhood friend whose memory of my mother was offbeat and poetic. This is part of her contribution to the "Flora" memorial book.

Flora, the Divine One.

Flora — beautiful, bewildering, and magnetic with an enchanting laugh. Her voice, her appearance, and her thoroughness in every form of charm was wonderful.

Flora was flirtatious and gave away charm beguilingly. She was naughty, very naughty. She loved fun and laughter as children do.

Flora was a very private person, almost mysterious. She was an elusive beauty and was not seen everywhere. Flora was unique, remarkable, and will never be replaced.

We will always miss her.

Captivated by my mother, always yearning for her approval and love, I absorbed whatever I could of her. Perhaps having her name intensified these feelings.

Despite their efforts to give us more attention than their parents had given them, my parents were often absent, in body and spirit, from us children. Before World War II, when we were small, they actively sought pleasure, fun, the good life. They ate, drank, and made merry. We often felt left out, and we were, abandoned to the strict nanny who taught us discipline, restraint, and humility. When very young, feeling lonely, I'd lose myself in books and horses. Later, as a teenager, I'd found it hard to make friends at bigger schools. In reaction to my rather isolated childhood, I was determined to give my own children every chance to have a "normal" life, with lots of classmates and varied activities. Sleepovers! Team sports! Culture! But today I value solitude. Time to read, to write, and to think.

I believed in God and in Jesus. Before each Sunday, our nurse would insist that I memorize that week's "Collect," marked with a purple ribbon in the prayer book with gold-edged pages my mother had given me. We would walk to the big white church in Aiken for the 11:00 service, then I'd recite or listen or sing, kneeling or sitting or standing, as the stately Protestant ritual prescribed.

Because my mother had been divorced, the Episcopal church had forbidden her to take Holy Communion, so we always left before that most sacred sacrament. Nevertheless, my mother and father wanted us to grow up in the traditional faith of their families, and at thirteen I dressed in white for the solemn ceremony of Confirmation. It turned out to be much more of a rite of passage than I'd anticipated, because my very first menstrual period began at the same time. My mother, sympathetic, mixed gin and hot lemonade into a kind of reverse mar-

tini for my cramps, while she warned, "Don't talk to men about it, not even to Daddy."

Yet another thing to hide! But, so it was. Our female curse must be borne in secret.

Woozy from her cure, I nearly fainted when the bishop placed his hands on my head. And I was terribly aware of the Holy Spirit, descending right into me!

I felt uniquely blessed. For days, I walked around in a prayerful haze. I made certain never to eat before taking the sacred bread and wine, and, after the confessional prayer and communion, felt altogether sure that my sins were forgiven.

Like most adolescents, I was searching for meaning. Christianity seemed to offer such a moral and also artistic way to live properly in our logical, ethical universe. God had planned it all, in His "many-mansioned" house. The beauty of the church's language, of its music, perfectly suited its lofty ideals. As I understood it, human perfection was possible, with God's help — one had only to want it enough.

Much later, disillusioned upon learning a lot more about the church's history of intolerance, I lost my faith. But my understanding of its doctrine remained, though still lacking perspective and life experience. Nevertheless, when our children were born, my husband and I wanted them to have the same opportunities for that choice we'd had. We attended church with them and even taught Sunday school. For me, though, the intensity of my early belief was gone.

Today, I find myself thinking through all these questions once again. For, despite everything, religion still remains a powerful source of humanism and hope.

Of course, there was another side to churchgoing.

The boys' school in town sat before us in neat gray rows in their designated pews. If we were lucky, my parents would invite one or two of the older boys to our home for Sunday lunch. That made the most boring sermon worthwhile!

Looking back, now, I see that our mother and father gave us an inestimable gift, the sense that happiness in this life is possible. That gaiety and humor and friendship and love are all-important. Yet we never connected any of this with money, perhaps because our parents were neither pretentious nor ostentatious. They gave us few material things, except for what we needed to learn what they deemed important — horses, shotguns, tennis racquets, classic books, fishing rods,

bicycles — but even these came only for Christmas or birthdays. Our monthly allowances were minuscule. Movie houses and movies were rarely allowed (too germ-filled and exciting, respectively) — no candy either, and, once in a very great while, an ice cream cone. Our lives were protected, monitored, and structured. We had no fabricated entertainment. We learned early to amuse ourselves.

Yet, just as one mercifully forgets the physical pain of childbirth, so it's difficult today to entirely recapture the full extent of the adolescent rage and frustration I remember feeling when I first became aware of the meaning of certain words that revealed a world I'd never been aware of: pellagra, segregation, concentration camp, torture, prejudice, holocaust. There were many others. All at once, the life we'd led seemed petty, oblivious to others, selfish, immoral. I can still recall how desperately, then, I wanted to take control of my life. To be a "grown-up" instead of obeying them. To begin the job of changing the world. Even today, looking back at the events of the '30s, at Hitler's rise to power in Germany, at the years of depression in our own country, I'm troubled by how removed we were from the suffering of that dark decade. A gauzy curtain seems to undulate between my fragrant memories of Aiken and my adult realization, now, of what life was like elsewhere. Early on, I felt that pain at the Whitney Museum, through the etchings and paintings of such artists as Reginald Marsh, Jack Levine, John Sloan, Rafael Soyer, and Ben Shahn, who illustrated graphically a wide range of societal ills and evils.

I've often wondered about the price of such a privileged childhood.

After emerging, ignorant, so long ago, into a bigger world, I'm still trying to grow up. I still have trouble recognizing and accepting the mix of good and bad in all of us. The struggle is endless. Still, I remain grateful for the firm grounding my parents provided, for their love, and for that blessed house from which we could expand and grow.

Five

In 1930, in a press release, Gertrude announced the new Whitney Museum of American Art:

"Not only can the visiting foreigner find no adequate presentation of the growth and development of the fine arts in America under a single roof; the same difficulty faces the native who wants to get what American art is all about. . . ."

Its primary purpose was, she said, "to discover fresh talents and to stimulate the creative spirit of the artist before it has been deadened by old age. . . .

"It is not as a repository of what American artists have done in the past that the Museum expects to find its greatest usefulness. . . .

"Ever since museums were invented, contemporary liberal artists have had difficulty in 'crashing the gate.' Museums have had the habit of waiting until a painter or sculptor had acquired a certain official recognition before they would accept his work within their sacred portals. Exactly the contrary practice will be carried on at the Whitney."

This, then, was the root and character of the Whitney: to show and to buy work by living artists. It was a museum for artists, with artists as both staff and board. Gertrude hoped to develop a comprehensive collection of American art.

The Museum was on Eighth Street, and it personified Gertrude. Everything in it came from her and represented her generous, ambitious, and energetic spirit, from the idealism of her concept to the sensuous beauty of the rooms, from the expansive spaces to the works of art themselves. Artists felt at home there, felt welcomed and nurtured. No other institution believed so passionately in their work, gave them

such support. Museums, collectors, and most of the few galleries then in existence focused on European art. In the limited world of American art, patron, artist, and curator were as close and natural together as they would ever be, in those years before the rush of collectors and galleries changed the stakes and heightened the tension.

In those days, so little money changed hands.

Artists were poor. Gertrude often paid a hospital bill, an overdue rent bill, or sponsored a trip to Paris at the right moment in an artist's career.

Always, she bought the work.

Her many conflicting responsibilities may have kept Gertrude from fully developing as an artist. When she and John Gregory, a sculptor with whom she'd had a romantic friendship and probably a brief affair, broke off their relationship in 1911, he sent her several revealing letters. Despite his pride, he'd borrowed money from her, but he was angry at her and expressed it in a letter, teasing her about:

"living and enjoying the simple life . . . Probably no one has ventured to find fault with you and I know I have done so often, but I plead that it was always because the situation impelled me to. . . . The trouble is that you act according to your station in life and I don't. . . . Your whole life you have imposed your will on everyone but your equals. . . . You offer me the sincere contact of one third of your life, for you have told me there are three worlds in which you dwell, in exchange for my completeness — I think that an imposition.

"Do you think I'm flattered to escort you to Bohemia?"

By "three worlds," he was referring to family, "uptown" society, and "Bohemia." Balancing these as best she could, Gertrude remained active and involved in each. But keeping them separate must have been extremely complicated. John Gregory, when he wrote this letter, felt categorized and discriminated against. Maybe others did as well.

During much of its history, the Whitney Museum, still reflecting Gertrude's complexity, has aimed to be both daring and conservative, sometimes in turn, sometimes simultaneously. While showing the latest trends in theme exhibitions or the Biennial, it also emphasizes its permanent collection and explores the work of earlier artists. It aims to serve a broad public, yet such favorite artists as Edward Hopper, Andrew Wyeth, John Sloan, Jackson Pollock, and Alexander Calder aren't always on view. It wants to maintain its original warmth and welcome,

its close ties to artists; yet its admission fees, nonexistent in both the Eighth Street and the later Fifty-fourth Street locations, now keep rising, and the exclusive benefits of the Museum membership program attract only those who can afford them. On the one hand, the Museum hopes to keep the intimate familial flavor it enjoyed on Eighth Street, while, on the other, it plans to expand and continues to add to a collection of which it can exhibit less than one percent.

Moreover, in Gertrude's descendants, it has the benefit of devotion but little money.

Going to the Museum on Eighth Street just west of Fifth Avenue was a big step toward a closer relationship with my mother.

What I saw there in 1940, at twelve, was much the same as it was on Tuesday, November 17, 1931, the day the Museum opened officially, as vividly described in the *New York Times:*

The Museum differs physically from virtually every other such institution in the country. The severity and bleakness which characterize many such institutions have been done away with in this latest addition to American museums. Instead of the uniform gray or white walls the museum visitor is accustomed to see, he will find here a variety of coloring.

The walls of the sculpture gallery are painted powder blue, against which marble and bronze are defined sharply. Two of the picture galleries have white walls and white velvet curtains, but two others have canary yellow walls, carpet and hangings, and furnishings which give it somewhat the effect of a drawing room. Two other galleries have been finished in gray, and two others have cork walls. Except in these two galleries, the sculpture gallery and in the hallways, the wall coverings are of woven paper, painted. The coloring of the walls, naturally, has necessitated careful hanging of the pictures in order to obtain the most harmonious effects.

Another feature of the Museum is the generous wall space devoted to each picture. Instead of the crowded walls characteristic of many museums, the visitor finds here each picture isolated from its neighbor by sufficient space to give the effect almost of pictures in a residence rather than a public institution.

Throughout, the Museum reflects the personal taste of Mrs. Whitney. In each case final choice of a work of art depended on her, since there is no board of trustees. This is a Museum founded, maintained and managed by artists, since Mrs. Whitney, the curator, and his assistants are sculptors or painters.

I felt at home there right away. Gamoo's own studio adjoining the Museum impressed me; its immense ropes and tackles, the rich, oily smells of plasticine, paint, and turpentine, the tall stands holding shrouded clay forms, a handsome model to one side of a raised platform, and, to the other, a studio assistant preparing a spiky metal armature.

My grandmother looked much as she had when the sculptor Daniel Chester French dropped by to see her statue of Buffalo Bill Cody: "She herself was more striking than the statue, in a gown of orange and dark blue flowered stripes, brilliant beyond reason. With her dark hair and white skin and crimson lips, she was by far the brightest thing on the landscape and very attractive as usual."

Juliana Force, the Museum director, was a decisive, vibrant woman with pretty clothes and red hair, who made up for her lack of training in art history with her intelligence, informed opinions, steely will, and wit. Gertrude had chosen her to run the Whitney Studio Club (1918–1928) and the Whitney Studio Galleries (1928–1930), antecedents of the Museum, and then to be first director of the Whitney Museum. Juliana admired, respected, and loved her "boss." As she carried out Gertrude's wishes, she too contributed to the Museum's distinctive personality. Fascinated by Mrs. Force's compelling presence, I was delighted when, on that first visit, she took me to see her exotic apartment upstairs. We walked along a carpet strewn with colorful woven flowers, arriving at a room with sofas and chairs covered in velvet and brocade with silken fringes, and tasseled curtains in deep, rich tones of gold and red. Folk art, animal ceramics, sculptures, paintings on every wall.

Back downstairs, Mrs. Force showed me the library for artists, with its Ouija board and easy chairs, then offered me sandwiches and sugar cookies from the varied supply always available at openings for hungry artists, along with drinks of every kind. She introduced me to her curatorial staff, artists Edmund Archer, Karl Free, and Hermon More.

Artists were very much at home there. Isabel Bishop once told me that they thought the Whitney was their place, a place where they felt relaxed, comfortable, and welcome. In fact, the Whitney *was* their place, formed mostly by and for artists, artists always at the very center — once they'd been asked to be in an "Annual," for example, they even chose the work to be exhibited.

A Ouija board for the Museum! Imagine! A metaphor, as I see it now, for that certain moment, for that faith that anything could hap-

pen. Who could really believe the scrawls on that magic block, and translate them to potency, glory, and happiness ever after?

Innocence and trust were not everywhere at that time, to be sure — Gertrude faced plenty of stupidity and prejudice in her life — but in the safe, soft ambiance of the Whitney Studio Club and the Whitney Museum the artist reigned, and my grandmother and her helpers placed supreme faith in that artist, and in his or her art. Gertrude's impact was tremendous, in proportion to these artists' acceptance at the time. As an artist herself, she understood and could assist with both their dreams and their problems. She encouraged them by showing and buying their work, and she helped with their personal problems. She was convinced of their talent and importance. She and Juliana Force were in the very midst of the then-tiny art world of Greenwich Village.

My grandmother's death in 1942 left my mother grief-stricken. It had been unexpected. Gertrude was working on a play; she had enrolled again in a writing class with Helen Hull at Columbia; she was planning sculptures — but after the death of her last remaining brother, Cornelius, in March 1942, she was sad, weak, and very thin. A persistent cough worried her doctors enough that they insisted she enter New York Hospital for tests in early April. Her condition was diagnosed as bacterial endocarditis, an infection of the heart glands that causes fatal clotting. Gertrude died on Saturday, April 18.

My mother found it extremely difficult to face the many necessary decisions. Her sister Barbara was ill, and her brother Sonny was in the Air Force in Africa. There was no one in the family to help her make financial judgments. She had never held a position of responsibility in the Museum, and taking the helm now seemed overwhelming. In the late summer Flora wrote to Sonny asking for help with the Museum, telling him of her distress:

"This year has been heart-breaking for me in many ways. Mama was not only my mother but my best friend. Her illness, her own tragedies were all things I had lived through with her and there was very little we had not discussed together. I will always miss her. We not only had the tragedies together but we had fun together — more fun than I have ever had with anyone else.

"This is the time of year I most enjoyed with Mama. We spent hours, nearly every day, sitting on her porch talking and laughing."

No help was forthcoming, however.

The Museum closed briefly, then reopened while my mother and Juliana Force continued for several years to discuss the possibility of a merger with the Metropolitan Museum of Art, initiated in 1940. According to Roland Redmond, the Met's president in 1948, Francis Henry Taylor, president in 1940, had visited Gertrude in her studio to plan a merger, encouraged at that time by Gertrude, who feared for the Museum's survival and was already concerned about its finances. But according to Juliana Force, who had been present at the meeting, Mr. Taylor had unsuccessfully endeavored to persuade my grandmother to merge the activities of the two museums. Gertrude had told him she was not interested in such a proposal, although she did not preclude its possibility at some future time. Mrs. Force insisted that Gertrude had never considered seriously the merger.

The newspapers announced the proposed coalition in 1943. During several years of meetings between representatives of the two museums, however, my mother came to realize how much the Whitney meant to the artists it had shown, bought, and supported. On February 3, 1944, she received this letter:

> Dear Mrs. Miller,
>
> A short while ago a group of us met to talk about the Whitney Museum. We all felt the deepest interest in its future as some of us literally grew up with it ever since the Whitney Studio Club days. We decided to form a committee of a few representative artists consisting of Peter Blume, Louis Bouche, Jo Davidson, Stuart Davis, Philip Evergood, Leon Kroll, Yasuo Kuniyoshi, Julian Levi, Reginald Marsh, George Picken, Katherine Schmidt, Henry Schnakenberg, Raphael Soyer, Eugene Speicher and William Zorach to discuss the matter further.
>
> The result has been that the enclosed letter was composed by the committee and it has been heartily endorsed by over one hundred and sixty artists. . . .
>
> Very sincerely yours,
>
> Henry Schnakenberg, Secretary

The letter they enclosed, printed in the *Times*, shows how these artists perceived the Museum.

Dear Mrs. Miller,

When the announcement came last year of the closing of the Whitney Museum of American Art each of us experienced a deep sense of disappointment and loss. The unexpected reopening of the Museum last fall brought back to us a renewed realization of the Whitney's significance, and it was marked by an extraordinary feeling of sentiment and affection, as though we found ourselves back in a home which we thought we had lost.

The tie between most museums and the artist is usually a tenuous and impersonal one. The traditional role of the museum has so long been that of a repository for the art of the past that the existence of the living artist has been recognized only with seeming reluctance or not at all. Museums now exhibit his work, sometimes award him a prize, more rarely make a purchase. But the pervasive feeling which the average museum has tended to communicate to the artist has been one of aloofness and relative lack of interest.

With the Whitney this has never been the case, and to the Whitney belongs the major share of credit for the more liberal treatment which contemporary American art has received from most other American museums. Since its opening the Whitney has set the pattern in this country for what a museum can do for the art of its own period. From its Whitney Studio Club days, through the various developments up to the present, it has been the greatest single force in support of support of living art in the United States.

The Whitney has always treated the artist with sincerity and respect. It did not award prizes. Instead, it has set aside a fund each year, within the limits of its resources, to buy as many works of art from its exhibitions and outside its exhibitions as possible. No living American artist was excluded from participation in its activities because of his esthetic direction, and all schools shared its advantages without discrimination. This democratic policy, wherein merit alone was the consideration, has had an inspiring effect on the young artists and an invigorating effect on American art as a whole.

In this way Mrs. Whitney and Mrs. Force did more than found a Museum. They helped to build faith in living American art. Mrs. Whitney's love of art and the wisdom shown in the form taken by her patronage have had incalculable results for the present and future of our esthetic culture. The country has made great strides forward since the days which marked the beginning of the work of

Mrs. Whitney and Mrs. Force. We artists understand the large debt
which the country owes to the Whitney for this advance. . . . We
sincerely hope that whatever changes are deemed necessary to
guarantee the continuance of the Museum, they may never inter-
fere with its unique functions and the ideals established and car-
ried on by Mrs. Whitney and Mrs. Force.

The signatures of 172 artists are appended.

My mother sympathized with the ideas they articulated. Under
pressure from her financial advisors and her lawyer, however, she had
to consider the expense of maintaining the Museum as an indepen-
dent institution. Still mourning her mother, still wearing the custom-
ary black (she even had her shoes and veiled hats dyed black, even
wore black jewelry), still struggling with the estate alone, her brother
still overseas, she agonized over her decision. More and more, she re-
alized that the Met had little interest in American art. But, if a proper
agreement were reached, the Met's vast resources held the potential
for expanding the Whitney's ideals.

The Met could guarantee the Whitney's future.

Nevertheless, in 1948, my mother decided to break off negotiations
with the Met and to keep the Whitney going herself. Minutes of the
trustees' meeting of July 1, 1948, say, "It became evident to the trustees
of the Whitney Museum that their primary objects were so divergent
that the eventual merger would ultimately destroy Mrs. Whitney's orig-
inal and dominant purpose in founding the Whitney Museum."

Lloyd Goodrich, director of the Whitney from 1958 to 1968, has de-
scribed a dinner he attended in the spring of 1948 at the Brook Club,
with representatives of the Met, the Museum of Modern Art, and the
Whitney. During this dinner, he wrote, Roland Redmond and Francis
Henry Taylor of the Met attacked modern art in general and the Whit-
ney in particular in a "hammer-and-tongs discussion" that continued
until two in the morning. Artists, Lloyd reminded us, were "still vul-
nerable, and attacks by established people like Taylor were tough
things for them." The Whitney's philosophy, he went on, differed
from the other two museums; it was more liberal than that of the Met,
though more diversified, more "catholic" than MoMA, with its con-
centration on "advanced art," i.e. European art, and American art that
was directly influenced by Europe.

It was not the first time that such an arrangement had failed before it

had begun. In 1929, Gertrude Whitney, through Juliana Force, had offered her collection of more than six hundred works of contemporary American art to the Metropolitan Museum. The then director of the Met, Dr. Edward Robinson, contemptuous of contemporary American art, flatly refused the gift before Juliana could even mention Gertrude's offer to build and endow a wing for the collection. This led directly to the founding of the Whitney Museum in 1930, with Juliana Force as its fiery director. She and my grandmother were a fine team. As much as Gertrude avoided the limelight, Juliana enjoyed it. Carrying out the policies and programs that Gertrude initiated, Juliana often chose the art and the artists, but Gertrude always remained there as a steadying power and a financial angel. Juliana had a difficult time holding to a budget. I can well imagine how much, after 1942, she missed Gertrude's guidance, her friendship, and her money. Besides, they had great fun together. As Juliana said, one of the cardinal rules of her job was "never bore the boss!"

Under their direction, the Whitney thrived.

My mother's decision to keep the Museum was a bold one. With fewer resources than her mother had, and mounting costs, she would have to count on her brother Sonny's and sister Barbara's help. At the very least, they would have to contribute the money their mother had left specifically for charitable gifts. And my mother would have to provide leadership. Aiken had become home for our family, but that would change, as the Museum absorbed not only more of her money but more of her time. Identifying the Museum with the "Mamma" she idolized, striving to continue her mother's stewardship of American art, she accepted a responsibility whose dimensions she couldn't possibly have imagined.

And so, undaunted and energetic at about fifty years of age, my mother embarked upon a new career.

The Eighth Street building was inadequate. It was too small; fireproofing and temperature controls were out of date. Most commercial galleries had moved to Fifty-seventh Street. "Uptown" seemed the place to be. Lloyd Goodrich, then curator and associate director, remembered the moment when my mother called him in May 1949 to say, "I've got the most wonderful news!" The Museum of Modern Art, with no solicitation, had offered the Whitney land adjoining theirs on Fifty-fourth Street between Fifth and Sixth Avenues. John Hay "Jock" Whitney, chairman of MoMA, my mother's first cousin and close friend,

had inspired this generous gesture. The Whitney quickly and grate-
fully accepted the offer.

It was in 1949, the same year the Museum decided to move and ex-
pand, that Lloyd Goodrich asked the consent of the trustees to sell the
Museum's collection of nineteenth-century paintings and sculptures.
The former purchase fund of twenty thousand dollars a year had been
reduced to a very inadequate ten thousand dollars, and he felt it was
crucial for the Museum to be able to add significant works to the per-
manent collection. Relatively few museums, he felt, were devoted pri-
marily to contemporary art, while interest in the American past had
greatly increased, along with prices for the historic works that were be-
coming ever rarer. In his press release, Lloyd emphasized that the
Whitney had always been primarily dedicated to the work of living
American artists — "in accordance with the aims of Gertrude Vander-
bilt Whitney." The Museum would, however, "continue to hold out-
standing historical exhibitions."

Knoedler's sold the collection for $150,000; the Museum netted
$120,000. When invested, this sum yielded about $8,000 a year. Still
inadequate. And, as it turned out, the Museum had lost its greatest
treasures. As Lloyd later wrote, "I've regretted the sale ever since.
The Homer *Bridle Path* alone is worth at least twenty times what we
received for the whole collection. . . . Advice to museums: never sell a
good work of art."

Auguste Noel, of Noel and Miller, the architectural firm he and my
father had started, had remodeled the three Eighth Street brown-
stones into the first Museum building, and then in 1939 had added
four new galleries, almost doubling its exhibition space, in the Whit-
ney's first expansion. Now he got busy designing the interiors and the
Fifty-fourth Street facade of the new Museum. Philip Johnson de-
signed the exterior of the garden side, which had to be approved by
MoMA.

The new Whitney opened in 1954. Hermon More, director from
1948 to 1958, had written about the Museum when it first opened, and
his words in the Whitney's first *Catalogue of the Collection* (1931), often
quoted by subsequent directors, were as appropriate in 1954 as they
still are today:

"It would be presumptuous to point out the road upon which art
must travel. We must look to the artist to lead the way, permitting him
the utmost liberty as to the direction in which he shall go. As a mu-

seum, we conceive it to be our duty to see that he is not hampered in his progress by lack of sympathy and support. It is not our intention to form a 'school,' our chief concern is with the individual artist who is working out his destiny in this country, believing that if he is truly expressing himself, his art will inevitably reflect the character of his environment."

To put that time in a little context: 1954 was the year of the McCarthy hearings; the year of thermonuclear terror, with both Russia and the United States testing more and more powerful hydrogen bombs; the first year when a number of Americans — 154 — made a million dollars or more as their annual earnings.

In the Whitney's first year on Fifty-fourth Street, attendance quadrupled.

And it was there on Fifty-fourth Street that I first became officially involved with the Whitney Museum of American Art.

Six

*A*t that time I lived in Connecticut, in a wood and glass dream house designed by my husband Mike for us in New Canaan, by a waterfall, with airy spaces and an open plan, symbolizing the way we hoped to live. Mike and I had a full and happy life, and we adored our four children. After Columbia Architectural School and apprenticeship in New York, Mike had become a fine and busy architect, earning a good living. My mother, always extremely generous to her children, paid for all her grandchildren's education, and also gave us gifts of money, making our lives so much easier — and depleting her fortune. (This we didn't know until after her death.) Mum loved to help us, as her mother and father once had helped her. I'm sure she never dreamed that her money could ever run out.

I had set goals for myself, and believed I was succeeding. Everything about my life seemed ideal. Why then did I sometimes feel unsatisfied? I longed for more time to myself, time to reflect, read, or write, undisturbed by the needs of little ones. How *could* I be so selfish? Impatient? Anxious? Exhausted? Why was it so hard to be that perfect person whose image already was becoming a bit blurry?

And what does all this have to do with the Whitney Museum?

I had always been restless, attracted to different kinds of people and activities. As I began to grow up during my marriage, to accept the needs I'd denied for so long, I espoused liberal political causes, demonstrating against nuclear testing, marching for equal rights, working for an interracial summer program; attracted still to difference. Intrigued by people black, French, Jewish, rich, poor, creative, energetic. Wanting to plumb their secrets, to understand everything in the world. A

"groupie," uneducated, but craving education, wanting to learn, still questing. Spending one day a week away from New Canaan at the Whitney Museum meant a great deal to me.

Juliana Force, the Whitney's first director, died in the summer of 1948. Museum minutes record that she was "courageous, swift in decision, prompt in action," that she had fought gallantly for the recognition of "progressive" art, and had lived to see her belief in it vindicated. She was "always on the side of art that was alive and against the reactionary and dead." Another big part of the Whitney's history was gone.

My parents were in Paris. Mike and I, with our first child, Michelle, were spending our vacation in the Adirondacks, in a log cabin within a family enclave of forests, streams, lakes, and rustic camps. My parents asked me to represent them at Juliana's funeral. My uncle C. V. Whitney, then a Museum trustee, who summered there as well, flew me in his plane to New York. I only had shorts and bathing suits with me for our month on Forked Lake, so my glamorous aunt Eleanor, a singer, outfitted me with a sophisticated black dress, gloves, and hat. Off we went to New York, and there I met for the first time a large group of artists, all mourning their great champion. As organ music swelled through the lofty chancel, as we sang the old hymns of life eternal, I sensed the deep feelings flowing around me. This compelling woman I'd barely known had even had an impact on me, and I too felt sorrow. Talking with artists after the service, I was very taken by what they told me of her importance to them and to their work, and realized then that this was a world I wanted to know better. I was, however, all too aware that its members accepted me merely because of my heritage. My grandmother.

From the very beginning, a mix of emotions, reasons, and motives informed my feelings about the Museum.

Until shortly before her death, all the Museum staff but Juliana had been artists, and Hermon More, the next director, was no exception. I remember him only as a quiet, gentle man with glasses, looking more like a banker than an artist. His curators, Lloyd Goodrich and John I. H. Baur, were the first professional art historians to hold positions of authority at the Whitney. Both were "old school" gentlemen, and both were vivid characters, while differing markedly from each other. Lloyd became director shortly after the move to Fifty-fourth Street, and Jack, associate director.

What was the Whitney like in the '50s, and why did I want to be part of it? Why was I following in the path of my mother and my grandmother, as, long ago, I had expressly decided never to do?

For one thing, as my children grew older, my feeling of loyalty to my extended family increased. So did my awareness that I might one day succeed my mother at the Museum — that she, in fact, was preparing me for that. I'd always backed away from identifying with my family's past. But what if I could bring the inheritance I'd rejected productively into the present? Into active change and growth? I'd be fulfilling a responsibility, not simply enjoying the residue of long-ago glory. I'd be earning my way.

For another, at the Museum I felt a tremendous charge of energy, a powerful emanation of ideas and possibilities. The art I found extraordinary, puzzling, intriguing; the people, compelling. And being there with my parents — because my father was a trustee as well as my mother — gave me a whole new relationship with them; for the first time, we were working together as equals. I loved that. I loved them!

My father, as architect "Gus" Noel's partner, had been involved in designing the new building and was very proud of it. I was, too. After walking by the beautiful sculpture garden at the Museum of Modern Art, one passed under the stylized American eagle our friend, the sculptor Lewis "Skinny" Iselin, had cast for the Museum's entry. On the left stretched a long counter, where, behind it, sat a striking woman, erect and dignified. Marie Appleton. "Miss Appleton," to my parents and to me. Dressed entirely in black, with a fluffy halo of white hair, a bold silver spiral Alexander Calder had given her pinned over her heart, she presented the aristocratic, elegant aspect of the Museum to all who entered. Sitting beside her, greeting people, in my first official role at the Museum, I was thrilled and proud to represent the Whitney. And I loved hearing Miss Appleton's stories about the old days on Eighth Street.

After visiting the galleries, people would ask questions, make comments about the building or the art, and then pay admission to enter MoMA through a passage behind the sculpture court — as they didn't have to at the Whitney.

Upstairs, a small windowed room with plants, a desk, and comfy sofas held sculpture by my grandmother. People enjoyed relaxing in this echo of the old Museum. I admired the galleries' modernity with all the latest in lighting, walls, and floors, and thought the whole place

more appropriate than the old building had been — but despite the design collaboration between my father's architectural firm and Bruce Buttfield, decorator of the old Whitney, the new interiors had lost, I now think, the intimacy and warmth of the old. Never mind; it all pleased me, and my mother too, who had been the most responsible for the new building.

How I loved hanging around the Whitney! Everyone seemed eager to help me learn. Wiry Jack Martin, with his Scottish brogue and great twinkle in his eye, installed exhibitions with immense skill and speed. I remember Ellsworth Kelly, exacting and critical, saying that thanks to Jack not one of his many exhibitions had ever been installed so fast or so expertly, anywhere, as at the Whitney. And then there was slender, energetic Margaret McKellar, who seemed to actually run the Museum while allowing the director and curators to think they were the bosses. Efficient, hard-working, in a trim suit and low-heeled black pumps, with a warm smile and wry humor, she oversaw the tiny staff — secretary, engineer, preparator, carpenter, guards — keeping a sharp eye on curators and numbers. Margie (with a hard "g") taught me precious details — I still address envelopes in her correct formal style — and she supervised my reorganization of the Museum's artists' files. Aha! Now, I thought, I'm approaching the heart of the matter. Familiar with art since childhood, predisposed to love it, in these photographs, letters, and documents I'd surely discover its secrets.

What I did find was some of the Whitney's history.

When, for example, I met Stuart Davis in front of his painting *Egg Beater, No. 1*, I already knew that he had first shown his work at the Whitney Studio Club and that my grandmother had paid for his only trip to Paris in 1928, a seminal experience in the development of his painting. His stay made him realize, as he's said, the "enormous vitality of the American atmosphere, as compared to Europe, and made me regard the necessity of working in New York as a positive advantage."

"Paris," John Russell wrote years later, "was wide open to the intelligent high-stepping American and the dollar went a long, long way." George Gershwin was writing his *American in Paris*, and Davis's paintings from that time were love letters, too. I knew, from the papers in his folder, that his drawing had appeared in the *Little Review* with the first publication in this country of an extract from James Joyce's *Ulysses*. I had read his recent interview with director Hermon More and curator Jack Baur, in which Davis said:

"The Museum in its early days played a unique role in giving the American artist the public importance that he actually should have had. . . . There was no other center where he was given any importance . . . it not only gave him a place to show his work but also did a great deal in tangible support, in buying paintings and giving money to live on. . . . Nobody else did it."

Thus certain principles impressed me right away. The worth of the *artist*, as well as the *work*. The relationship between Museum and artist, built on trust, supportiveness, friendship, and faith.

When, at another opening, I met Edward Hopper, I remembered the photographs and writings I had filed, including those about his first exhibition in 1920 at the Whitney Studio Club. Lloyd Goodrich, a close friend and one of the first to recognize the worth of Hopper's painting, had written, "It is hard to think of another painter who is getting more of the quality of America in his canvases than Edward Hopper." Hopper himself, agreeing with my grandmother's feelings about the specific character of American art, had written:

"Now or in the near future American art should be weaned from its French mother. . . . We should not be quite certain of the crystallization of the art of America into something native and distinct, were it not that our drama, our literature, and our architecture show very evident signs of doing just that thing."

And Hopper's words about artists brought me insights, not only into his work, but into all art:

"Great art is the outward expression of an inner life in the artist, and this inner life will result in his personal vision of the world. . . . The inner life of a human being is a vast and varied realm and does not concern itself alone with stimulating arrangements of color, form, and design. The term 'life' as used in art is something not to be held in contempt, for it implies all of existence, and the province of art is to react to it and not to shun it."

Inspiring words. How could I develop an inner life, when I could barely keep up with the outer? Look. Read. Write. Think. So I told myself.

A few years later, in the mid-'60s, traveling with our four children on Cape Cod, Mike and I parked our VW camper in a flat, deserted spot near Truro. We had just set up our tent and were heading for the nearby beach when a tall menacing figure came striding toward us across the cranberry bog.

"You're in my view!" he roared, bearing down.

The children stopped in their tracks. Mike and I recognized Hopper and rushed toward him, our hands outstretched. As soon as we identified ourselves as part of the Whitney "family," he greeted us warmly and invited us to his clapboard house for tea. We listened to Jo Hopper talk of their lives on the Cape, while Edward gazed beyond her at the landscape we had seen so often in his paintings. He took us to see his small bare studio, where a blank canvas sat on his easel by the window facing the sea. We hoped that the children would remember meeting this towering figure. I was glad to make a connection, through the Hoppers, between them and the Museum — I didn't want my two lives to be completely separated.

When Josephine Hopper died in 1968, a few years after her husband, the Whitney inherited Hopper's estate, more than two thousand works of art. I'm sure that the Hopper collection, one of our major treasures, is thanks to his long relationship with the Whitney and especially with Lloyd Goodrich. Now people flock to see Hopper's paintings, to ponder their meaning. I do too. Is the woman bathed in golden sunlight, sitting on an empty bed drawing on her stockings, blessed or abandoned by a lover? The serenity of *Early Sunday Morning* evokes spirituality in an ordinary street in an ordinary city, leaving it up to us to populate its spaces, or not. And the mysterious women on the porch of a country house in *Second Story Sunlight* — are they mother and daughter? nesting together, or living in that house as strangers? Do they await a man, or men? Hallowed by clear ocean light, or raked? Sexual, though remote, the younger woman stretches like a cat on the railing. We learn from Jo's notes that Hopper nicknamed her "Toots . . . a good Toots, alert but not obstreperous — a lamb in wolf's clothing." Later, Lloyd quoted Hopper: "This picture is an attempt to paint sunlight as white, with almost no yellow pigment in the white. Any psychological idea will have to be supplied by the viewer." Yes, one can spin tales endlessly about Hopper's paintings, but it's the paintings themselves that draw us in, compelling our attention with their spare intensity of design and color, and, above all, their light.

I'm especially fond of a photograph of my mother and Edward Hopper at the Whitney, both in profile, greeting each other with big smiles in front of *Early Sunday Morning*.

In the early '60s I worked with Jack Baur, and came to admire this scholar with a big handsome head, a craggy face, and a generous mouth.

He was then associate director, and later, from 1968 to 1974, director of the Whitney. Once a professor of English at Yale, he had come from the Brooklyn Museum to the Whitney in 1951 as part-time curator of painting and sculpture. From September 1, 1952, to September 1, 1953, he was paid one thousand dollars! Passionate about art and literature, Jack had a fine sense of humor and absolutely no pretensions. He soon became my friend and closest Museum counselor. Despite his dedication to the Whitney, Jack had put the Museum in its proper perspective and managed to keep it there. His family came first — three children and his intense, energetic wife Louisa, a Quaker and teacher. Even as director, Jack had no trouble leaving a trustees meeting if it continued past train time. He would simply get up, stuff his papers into his ancient briefcase next to a Trollope novel, don his raincoat and brown fedora, and depart.

Jack was a father figure to his young staff. Kind and supportive, he would suggest rather than demand, guide rather than challenge. Sometimes I would hear his exasperation when a curator's essay wasn't good enough, but that curator was only conscious of Jack's patience in improving it. It was Jack's way, to work with employees who weren't doing well enough rather than to replace them. In our private discussions, however, his criticisms could be wonderfully pointed and eloquent. Funny, too.

Yes, I was infatuated with the Museum. Enchanted by my new life there, I saw what I wanted to see. As usual, alas, it was the possibility for perfection. If only the Museum had more money, there'd be no limit to what it could bring to the world. Jack, of course, was central to this ideal.

Jack and my mother got along famously. He told wonderful stories about her: in 1951, when he met her in the old Museum on Eighth Street, for instance, he'd just been appointed curator and was "feeling quite grand," as he later wrote in the memorial book about my mother, the "Flora" book:

"In the opening hubbub I was talking to the sculptor William Zorach, and failed to hear the name of an effervescent lady who interrupted us to congratulate me on my new job. I shrugged her off, quite abruptly I'm afraid, then asked Bill who she was. When he stopped laughing, he told me.

"That Flora forgave me was a mark of her usual generosity. She had the great gift of putting people at their ease — even artists . . . one

could multiply examples of Flora's genuine concern for artists. . . . Her kindness tamed Philip Evergood's distrust of the rich and dispelled Charles Burchfield's social inarticulateness. After the latter's one-man show at the Whitney in nineteen fifty-six, Flora took his whole family back to Ten Gracie Square for a champagne dinner and bought his *Goldenrod in December.* Her spirit played a crucial part in establishing and nourishing the Whitney's policy of supporting living artists. We all loved her."

And my mother loved Jack. When he retired, she praised him in a ditty that also recalled the other directors she'd felt close to. The ditty ended with the lines "And Hermon and Lloyd and Jack and I/Were minced together like pie."

What a different ambiance, in those days! While we needed more money, that need was less obtrusive, less apparent. Jack's mode was gentlemanly. Not weak, but mindful of the past. His care for artists enabled him to make generous judgments about them, especially if they had shown at the Whitney for years. He honored old associations when, for example, selecting artists for the Biennial. In addition, his awareness and social concern for problems led him, in the '60s, to set up various programs for the disadvantaged.

In the late '70s, some questioned the validity of those programs. Why should the only museum of contemporary American art in the country, with its great influence and potential, spend valuable time and hard-to-find money on classes for a small number of troubled adolescents? How was this program relevant to the Museum's mission of showing and buying the best of contemporary American art and interpreting it to the public?

And should the Whitney, for old times' sake, continue to show artists whose work no longer seemed vital?

I admired Jack's integrity, his ideas, and his belief in the Whitney's traditional role, and, at that time, gave his policies strong support. Later still, working with a new director, I changed my mind about some of them.

When I first worked with Jack, he was curating the Bernard Reder exhibition, which opened on September 26, 1961. Today, I think of this exhibition and this experience as quintessential Jack: his distress over Reder's refugee experience, his respect for Reder's unrecognized sculpture, his enthusiastic response to the work and to the man.

Reder, a Hasidic Jew born in Chernivtsi, after many difficult

journeys had come to America during World War II. His sculpture, suffused with the religious traditions and mythology of his people, came filtered through his own vivid imagination. His big bronzes evoke marvels: flowers sprouting from cats, angels playing immense organs and cellos, voluptuous nude women, one bearing a vast house of cards, another blowing a trumpet looking more like a huge flower. They were joyous and exuberant.

Jack thought him a genius, so, of course, I did, too.

The whole Museum was given over to Reder, the biggest one-person exhibition the Museum had attempted since the move uptown. Special ramps allowed visitors to view the sculptures from all angles, in keeping with Reder's principles of "volumetricity." As Jack wrote, this was "the functioning of forms in the round — no frontality, no dominant views, but an organization equally meaningful from every angle and every elevation. . . . To Reder, this is more than an aesthetic credo. It is a principle of life and a touchstone of morality. It is the embodiment of coherence, from which any departure is a step toward chaos. By projection it is the harmony of love and the meaning of religion." His words reveal not only the essence of Reder, but, even more, the essence of Jack.

Armed with a brand new tape recorder, I went along to record Jack's interviews with Reder for the catalogue. To my horror, I later discovered I had pressed the wrong button and the whole tape was blank. It's a measure of Jack's tolerance that, with hardly a reproach, he gave me a second chance. Luckily, I did it right.

All this time, the Reders were becoming fast friends with me and my family, spending weekends with us in Connecticut and storing three big sculptures by our pond. In my photo album, our children perch within them. Gutza Reder, "Benga's" wife, explained that he started every day with "three soldiers": a radish, a scallion, and a carrot. He ate with the same gusto with which he lived his life, and he delighted our children with his stories and games. At one point he said, "Paper! Quick!" Inspiration was upon him and it couldn't wait. On a sheet of newsprint, he drew an angel with large breasts descending from heaven onto a horse; then he made a small clay sculpture, which he planned to enlarge to monumental size. Alas, he died before he could complete it.

Doris Palca, a marvelous presence at the Whitney for many years, whose ability and commitment brilliantly guided the Whitney's pub-

lishing program, recalls finding forty boxes, each filled with thirty un-sold Reder catalogues, when she arrived at the Whitney in the '60s. Her assistant labeled them "Reder's Naders"! I imagine they are still in a corner of the Museum's storage space, dusty reminders of unful-filled expectations.

Jack's influence, both on the Museum and on me, was strong. So were his opinions about art. Philip Evergood was one of his favorites, as were Charles Burchfield, Marsden Hartley, John Marin, Ben Shahn, and such disparate sculptors as Doris Caesar, Louise Nevelson, David Smith, Elie Nadelman, and Jacques Lipchitz. The list included some abstract artists — Jackson Pollock, Conrad Marca-Relli, Jules Olitski, Stuart Davis, Joan Mitchell, and Jack Tworkov, to name just a few. I think the artists he responded to most shared certain traits: a joy in tex-ture and material, pleasure in the craft involved; a feeling for nature; often, a strong social content or statement. I well recall "Nature in Ab-straction," a show of abstract paintings evoking the landscapes, moun-tains, rivers, and sea Jack loved.

A favorite image from a few days they spent with us in the Adiron-dacks: Jack and Louisa, utterly happy, paddling in a canoe through wa-ter clear as glass, the dawn light rosy, loons calling crazily through the still air.

Until an administrator joined the staff in the late '60s, Jack took care of most day-to-day responsibilities. The collection at this time was very much as it had been in my grandmother's time. The critic, Henry McBride, described it then in "Hail and Farewell," a piece published in the *New York Sun* after Gertrude's death:

"It is not an exaggeration to say that there is not a contemporary artist of note in America who has not been helped by her. Her collec-tion contains something by all of them, and it is constantly growing. Al-though I was probably its most jealous critic, due to my high ambitions for it, I never detected any arbitrary leanings on Mrs. Whitney's part, toward any special schools. She was completely liberal, completely open-minded and never demanding. Life to her, apparently, was an uncharted stream, and the artist-explorers upon it who returned with what John Masefield called 'cargoes' were gratefully received 'and no questions asked.'

"When her collection finally crystallized into the Whitney Museum of American Art it was definitely felt in all our art circles that at last we

were on our own, that we had cut loose from the apron-strings of Europe and become adult."

Lloyd and Jack continued the policy of broad collecting — something of everything — but as the number of serious artists proliferated, this procedure became more complicated. I can see, with today's perspective, that a kind of triage was necessary. Despite a new acquisitions committee providing both knowledge and money, the Whitney often made conservative choices, missing out on some of the early work of artists emerging in the '50s and '60s — most obviously, Jasper Johns, Robert Rauschenberg, Cy Twombly, and Frank Stella, but others as well.

Jack's theme exhibitions, such as "Nature in Abstraction," "Business Buys American Art," "Between the Fairs: 25 Years of American Art," illuminated the collection and included other contemporary art. Concurring with my grandmother's and Juliana Force's preference for realism, the most prevalent American style of their time, Jack continued to emphasize it, but with the help and encouragement of new friends of the Museum he also started to exhibit and to buy more "advanced" abstract works. And he also stressed the importance of the word: catalogues must be well written, designed, and illustrated. As educational tools, enduring documents, and historic evidence of the Museum's exhibitions, these catalogues must be literate, cogent, and illuminating. That they were not thicker and better illustrated came from a lack of money, not ambition. Until the '60s, the Whitney had never tried to raise money for any purpose but acquisitions, and that, only since 1956.

On January 30, 1958 — the year of the first credit cards and computers, of Eisenhower and Pope John XXIII — I was elected, at twenty-nine, to the Museum's board of trustees. Also on the board, besides my parents, were Walter G. "Watt" Dunnington, my parents' lawyer, who had succeeded my grandmother's lawyer, Frank Crocker; my aunt, Barbara Whitney Headley; and my uncle, Cornelius Vanderbilt Whitney. Neither my aunt nor my uncle ever showed up for a meeting. (They resigned, respectively, in 1962 and 1971.)

At first, I had protested. "I really don't have the time," I told my mother. "The children . . ."

But she was adamant. "It's the right moment. You can come in once a week, or even once every two weeks."

"I don't know enough," I went on, assuming a thorough grounding

in art to be the most necessary attribute for trusteeship. (One of many assumptions I had later to rethink.)

Lloyd Goodrich, about to become the new director, answered that one. "Look," he told me. He was standing in front of Jackson Pollock's *Number 27, 1950*. I'd first seen Pollock's work in a Whitney Annual on Eighth Street, in 1946, and had been intrigued, drawn to it, but mystified too. "Just look and keep on looking. You'll have plenty of time later to read and to listen to others and to learn, but the essential thing is to look. Your eye will develop. You'll start to see."

And, as I did, a dance, a rhythm, started to appear in the swirling colors.

Michelle and Duncan, ten and seven, were in school. Cully, three, and Fiona, three months, were still at home.

Michelle, born in 1948, was a perfect baby. Her skin looked and felt like rose petals, she smiled with joy when she saw not only her Mummy and Daddy but any friendly human. She took her first steps in the garden of my grandmother's — then my mother's — studio in Paris, where my parents had invited us to stay in 1949 while Mike was in architectural school and had summers off. I still have blurry home movies of her wobbling around on the pebbles, and some of pushing her in a stroller with a blue polka-dot sunshade through the Luxembourg Gardens and the Bois de Boulogne. I ascribe the ease with which she learned to speak the language and her affinity for all that is French to that early exposure! As Miche grew, her creativity delighted us: she loved painting, dancing, music, reading. And animals — especially those upon which she could ride. First, she rode our black Labrador retriever; then a donkey, "Shaggy"; and then a number of ponies and horses, who often escaped. We'd get calls at five in the morning: "Your piebald pony is waiting to be picked up at the gas station on Route One-twenty-three." Because New Canaan was a fairly small town, everyone knew the parentage of not only children but horses, dogs, and cats. That was nice. But there were negative aspects of New Canaan. A conservative, Republican stronghold, its makeup was mostly Protestant and lily-white. The good public schools that had drawn us there reflected this lack of diversity, and we opted for an excellent private school with a broad scholarship program.

Another of Michelle's qualities showed in the eager welcome she extended, at three, to her baby brother Duncan. After several

miscarriages, we had moved into my parents' house in Long Island so I could stay in bed for weeks and hang on to Dunc. I still have a giant horse pill my doctor, a family friend, gave me as a joke with a card, "All the pills in one." Born in 1951 on Easter Day, we called our baby "Bunny" for a while in recognition that he symbolized the Easter "newness of life." Right away, he and Miche were so very close, jealousy was never an issue. When Dunc went off to nursery school at four, his first friend was Ralph Salomon, who now, more than forty years later, is still one of his best friends — a measure of Dunc's loyalty and constancy. Later, the "D team": Duncan, David, and Dickie, camped out in our woods, cooking hot dogs, winding dough on sticks, and holding them over hot coals to make bread. Later still, with added members, they formed a band, and often practiced in our house, which resounded with "Turn, Turn, Turn," or "Mr. Tambourine Man" in the Byrds' style. At school, Dunc played lacrosse, ice hockey, and other team sports with skill and enthusiasm.

After more miscarriages — was I rushing about too much or was it genetic? — in 1955 we had another beautiful boy: Macculloch Miller Irving, named for my father, born without a doctor (who'd fallen back to sleep after my call!). I remember a couple of panicked student nurses saying fruitlessly, "Stop! Stop! You can't have the baby yet!" Cully was immediately alert, and smiled at us at only two weeks. He and Duncan bonded immediately and forever. Cully had a phenomenal memory, learned to read early, and was a voracious reader. He loved certain movies and songs — he could sing the whole score of "The Music Man," for instance, or "Oliver," after playing them only a few times on the record player. Like his brother, he had many friends and a band, this one including a drummer with a huge drum set — the sound when they practiced was quite astonishing. A natural at sports, Cully was an especially good ice hockey player, excelled at lacrosse, and became a long-distance runner.

When Fiona came along, in 1957, the doctor said "Flora, you'd better stop here. Each one gets smaller, and four and a half pounds is going too far." Fi had to stay in the hospital for a couple of weeks; when I visited, caring nuns were feeding her in a rocking chair and tying an orange ribbon in her bit of hair for Halloween. Cully took her under his wing and was marvelously protective, but at the same time he was involved with his own big brother — and Miche, then ten, was soon to become an adolescent whose pressing concerns didn't include a baby

sister tagging along! (Later the two sisters became extremely close, and remain so today.) So Fiona became independent and savvy early on, developing her own interests and talents. Figure skating (she went to skating camps in odd places, took national tests, and became an expert ice dancer), ballet, riding, sailing, a wide variety of friends — she seemed to know how to parcel out her time, and to enjoy life a lot.

As I look back, I remember, most of all, the happiness. Time has blurred the inevitable mistakes I made from immaturity, frustration, or anger; the sorrows, squabbles, illnesses, worries, and near-disasters. My perpetual exhaustion, during the years of never enough sleep, when babies would awaken for bottles, or nightmares would bring small bodies to our bed. "Mom, I forgot my homework at school!" and off we'd go for a twenty-minute drive there and another twenty back. Once Cully's friend John Sargent, running through our hallway, crashed through a plate-glass window and I had to rush him, streaming blood, to the hospital. I'd tied his wounds up, who knows why, in the silk scarves my mother had brought me from Paris, and had nearly thrown poor Fiona at my kind neighbor to keep. (John was terrified but OK after many stitches.) Another time, the house we were staying in while skiing in Vermont, an old inn that belonged to my cousin Douglas Burden, burned down on New Year's Eve with all of us and my sister-in-law and her children asleep inside. We barely escaped, some of us jumping out second-story windows into a blizzard in our night clothes. A really dreadful experience — but even that has faded, today, like an old photograph whose colors are muted and soft. The pain of childbirth, the children's and my emotional roller coasters, while still in my memory, are outweighed by past joys and overlaid today by the actualities of grandchildren.

But then it was very different. With our house, our garden, an assortment of dogs, cats, guinea pigs, hamsters, chickens, a goat, even a pony, and with very little help, I was needed at home. And I wanted to be there.

I had grown up in a world where everything was done for me: I'd never entered the kitchen, unless invited by the chef (which was rare) or at four in the morning after a debutante ball, when Mum would cook scrambled eggs while we told her all the juicy details of the evening. I couldn't cook, sew, clean, or do laundry. Had no idea how to manage a house and absolutely no knowledge of babies. Changing a diaper was further from my experience than looking at a painting. And

I had no idea at all about money! So I was pleased with my progress. I'd learned many of the skills necessary to be just what I'd wanted to be: an "ordinary" housewife. Now I could cook pretty well, sew, do laundry. Our children were wonderful, I could adhere — sort of — to a budget. I felt wanted, needed, loved, by my husband and our children.

In 1958, when I decided to become a trustee, to do some work at the Museum, I worried. Would my absence from home, even that little bit, cause all kinds of problems? Was I jeopardizing our children's sense of security, of self-confidence — the very thing I had tried to avoid? Would they fail in school? In life? And all because I had this urge to explore another world? Was I being inconsiderate? Selfish?

Despite all these concerns, I couldn't help but see the trusteeship as a big step in my life, and I was honored to be thought ready and worthy. The prospect of this new work filled me with excitement.

I accepted.

I could hardly wait to begin.

I don't remember asking anyone what they'd expect of me, beyond attending meetings. Surely not money, since I had little to spare and had no idea how to raise any. Surely not great knowledge about art or the art world. I see now that I was supposed to follow my mother's ways, representing the family, being supportive, learning the traditions I'd uphold. These I absorbed quickly as the character of the Museum emerged: it was inclusive, flexible, enthusiastic, playful, responsive to current art, and adventuresome up to a point. But there were differences between my mother and me.

Mum had money to give. She continued to make up the deficit, every year, as long as she could. Could I consider that money a family gift, and feel it was partly mine? When I knew it wasn't true?

Our personalities were different, too. She was charming, beloved by all. Despite her modesty, she projected a queenly, aristocratic image. I was of another generation — idealistic, unaccepting of the status quo, eager to work, hoping even then to have an impact on the Museum in some significant way.

Meantime, within me, there was luminosity. Just going in the door was magic. The building smelled wonderfully of plaster, paint, and clay, sounds of hammering and sawing in the basement were intriguing, and I sometimes couldn't resist running my fingers over a marble or bronze sculpture, the better to absorb it, or going so close to a painting I'd feel my nose right up against it. Art and people were enchant-

ing. For the lover, the beloved is perfect. And this glorious institution yielded to me, becoming intimate and tender, without, it seemed, the dangers of a forbidden liaison. In the glow of a good cause, with the imprimatur of all my family, I felt a part of the Whitney's radiance.

Trustees meetings in 1958 were extremely informal. We'd listen to a few reports and discuss forthcoming exhibitions. After these meetings, Lloyd and my mother and father would drink martinis on the sofa behind the big table we'd just left, laughing and smoking as they recalled the old days on Eighth Street. Oh, those parties, when Juliana Force would tap her favorites on the shoulder, the secret sign to go upstairs to her private apartment, that Victorian wonderland where Shaker chairs met pleated lampshades, where folk art and fine art hung in harmony, where talk, music, dancing, and drinking went on till dawn! Whenever my mother and father and Lloyd reminisced, they brought those days to life for me.

Lloyd, a bundle of energy, drank a lot, loved to talk, seemed to be everywhere; the most important things in his life were art and the Whitney. He was fun to be with, and he gave me confidence in my future role, saying I was like my grandmother, that I'd be a good leader for the Museum. Garrett McCoy described Lloyd's "great hooded eyes and great prow of a nose . . . the rumble of that confident, gruff baritone . . ." He was the first person I knew who'd been psychoanalyzed. Awed, I imagined this explained the ease with which Lloyd could express emotions, strange to me then but appealing. (Maybe it was the martinis, too!) Devoted to Ryder, Winslow Homer, and Thomas Eakins, for years he was the outstanding authority on their work, lecturing and writing major books on them. But always he emphasized the primacy of the eye. Look, look, and look again, he maintained. "Lloyd was a lover first, who became a scholar later," I said in my tribute to him at the Whitney after his death in 1987.

Much of Lloyd's time was spent on the American Art Research Council, an organization he'd founded in 1948 at the Whitney to deal with problems of authenticity in American art. He was also involved in those government agencies that dealt with art policy; sometimes he assumed leadership, for example, on the Council on Arts and Government, predecessor organization of the National Endowment for the Arts. In lectures and articles, Lloyd articulated the Museum's philosophy — Gertrude's philosophy — in stirring phrases: "This pluralistic

art of ours is the appropriate expression of a democratic society, free and fluid, allowing wide scope to individualism."

Within the family, we wondered if he was spending enough time at the Whitney, but agreed that by using his talents as spokesman and roving ambassador he was more valuable than if he sat in his office all the time. And we knew Jack, a fine manager, was actually handling the day-to-day work.

Lloyd was instrumental in enlarging the Museum's base of people. "We needed a select membership of individuals vitally interested in American art," he later wrote, and, toward that end, he drafted the proposal for forming the Friends of the Whitney Museum, the institution's first membership group, which stated:

"One of the greatest needs facing the Museum today is to increase its purchasing funds so that it can fill many serious omissions in the permanent collection and do fuller justice to the vastly expanding field of contemporary American art. A central aim of the Museum has always been the prompt recognition of creative ability in the one way that brings prestige, encouragement, and material aid to the artist in equal measure — that is, by purchasing his work and exhibiting it as part of the Museum's collection while he is still living."

The living artist — key to the Museum's history and policy.

In 1956, David M. Solinger became the first president of the new Friends, nineteen in number, soon to multiply many times. Annual dues were $250. A joint committee of staff and Friends spent the money on new acquisitions.

For the first time, people other than staff were involved in choosing art for the permanent collection. This was a necessity in order to raise money, said Lloyd and Jack. If we were to continue to buy art. And what is the point of a museum of contemporary art, if it can't do that?

Since its founding in 1931, the Museum had changed. By the late '20s, the Whitney Studio Club was no longer the only institution responding to the needs of contemporary artists: new galleries, collectors, and even museums were realizing the worth of American art. The Whitney began to be more selective upon becoming a Museum, and still more so when it moved uptown. The number of American artists was growing fast. Impossible, now, to show or buy them all, even to know them all. Instead of helping artists directly, as Gertrude had, the Museum's relation to artists necessarily became more diffuse, indirect, filtered through exhibitions chosen by professional curators. Increas-

ingly, the Museum was directed toward the public, toward providing a venue for recognizing our culture. Traditional "viewings" continued Gertrude's catholic approach, however, until the late '60s, by allowing any artist to bring a work to the Museum, knowing curators would look at it on a certain day of the week or month, and possibly include it in an Annual or a group show.

Another change: until the move to Fifty-fourth Street, the Whitney accepted no gifts of art or money. Why? A reluctance, I believe, to turn down a work of art, or to be obligated to donors, whether patrons, artists, or dealers, with the implied compromises of the Museum's authority and integrity. But the urgent need for more money to add works to the collection impelled the Museum to abandon that policy. Soon, it gladly accepted, and then sought, contributions for other purposes.

What did all this mean for the Whitney?

First, it meant survival. Without enough money, the Whitney would have shrunk in size and in function. It would possibly have remained as a historic museum of the first half of the century, with no way to show the glorious blossoming of those early years. The staff would have left. What self-respecting directors or curators would be interested in working for such a static institution?

These changes brought about a dissemination of authority. Decision-making by groups or individuals sometimes less knowledgeable about the traditional values of the Whitney, or less committed than the family had been to the traditional values of the Whitney. To balance this, a freshness, a new excitement, entered into our deliberations, enriching the Museum.

How did these changes evolve?

To encourage the inevitable growth, Lloyd recommended the expansion of the board of trustees, and suggested the inclusion of non-family members who could bring financial support.

This was a turning point, key to the Museum's survival as an independent entity. It started a new chapter in the Museum's history.

And in my own.

Seven

*M*any years later, as my second husband, Sydney, and I lived in Taos, I remember watching dramatic cloud formations under a New Mexico sky change from pale rose to salmon pink to deep gray-black as we sat with a group of friends, eating, drinking, talking. There was Vija Celmins, whose paintings evoke sea and sky and desert, mysteriously, ravishingly. Kevin Cannon, sculptor of smooth sensuous leather pieces reminiscent of thighs and breasts, argued that sculpture was the essential visual expression. Happy Price showed us the delicate clay cups she'd molded and fired, and we looked at work by her husband, Ken, the ceramic artist: large globular nodules in phosphorescent hues, like meteorites, glowing, compelling.

Agnes Martin invited us to visit her in the small studio near her home where she paints five-foot-square abstractions. She showed us her latest paintings, taking them into the light, leaning one on the other as we gazed, enraptured, at their bands of color glowing in the late afternoon light. Permeated by their beauty, and by the feelings of joy and serenity they inspire, we wondered at the woman who could create such magic. Agnes is both ethereal and earthy. She loves to be with good friends, but she also spends much of her time alone, meditating, waiting for inspiration. She has written about art in words that are like poems — here are a few lines from "Beauty is the Mystery of Life":

"When I think of art I think of beauty. Beauty is the mystery of life. It is not in the eye it is in the mind. In our minds there is awareness of perfection. . . .

"Our emotional life is really dominant over our intellectual life but

we do not realize it. . . . I have been talking directly to artists but it applies to all. Take advantage of the awareness of perfection in your mind. See perfection in everything around you. See if you can discover your true feelings when listening to music. Make happiness your goal. . . . Find out exactly what you want in life. Ask your mind for inspiration about everything. . . . You must find your own way.

"Happiness is being on the beam with life — to feel the pull of life."

And in another piece, "Reflections":

"I'd like to talk about the perfection underlying life/when the mind is covered over with perfection/and the heart is filled with delight/but I wish not to deny the rest."

Barbara Haskell, the curator of an exhibition of Agnes Martin's work shown at the Whitney in 1992, wrote this about her in the catalogue:

"For her, perfection is neither otherworldly — something separate from and transcending the temporal process — nor is it a holiness that inhabits physical matter. It is the intensity of absolute beauty and happiness experienced when our minds are empty of ego and the distractions of the everyday world. In these flashes, worries dissolve and we feel enormous exultation and peace, not unlike the state of grace in Christian theology. However elusive and fleeting these experiences are, they are nevertheless available at every moment to everyone. The task, as Martin defines it, is to further our potential to see the perfection within life."

How extraordinary it has been for us to be close to Agnes, to hear the stories she tells in her silvery voice, to take long drives into her beloved mountains where she used to camp for months at a time; to absorb her wisdom; and to see her total dedication to her art. And also to laugh, and eat, and drink with her — because she enjoys all that is good. Sydney and I felt her presence as a delight and an inspiration as, during those enchanted summers in Taos, we struggled to find our own voices. Her paintings and her ideas helped us to work through our goals and think through the way we wanted to live.

In considering the contrast between our circumstances during my most intense Whitney years and those in New Mexico, I realize that the Taos years wouldn't have been possible without the Museum years, just as my own life wouldn't have been possible without the lives of my forebears. The one, with all its excitement and complexity,

resulted in the other, with its uncomplicated stretches of peaceful time.

But why so long, so long, before arriving at this place, this time, where to write seemed natural? How did my grandmother manage to work at her sculpture, be head of her museum, see her artist friends frequently — while also functioning as wife and mother?

Different times, different personalities, different circumstances.

At the Whitney, while working on projects with Margie or Jack, almost as a staff member, I learned about art and artists. I met the artists themselves. Pretty soon I began to understand the Museum's basic premise, that art and artists are vitally significant; that without them, life is hardly worth living; that it is they who illuminate meaning — good and evil, joy and misery, beauty and ugliness, love and hate. What about churches? Has the artist, or the museum, replaced them? Not exactly, but museums have become centers for ideas, where people talk of serious things while looking at serious works of art.

All too soon, the pressing reality of the Museum's need for money became apparent. My responsibility was to address that reality, the need for money, while recognizing, understanding, and trying to articulate the other, more urgent reality. My task was to work not inside the Museum, but outside it. Of course, that awareness didn't arrive suddenly. Today, though, I see how the need for money gradually but relentlessly infiltrated all I did at the Museum, for better and for worse, influencing my judgment and mixing my motives. We never seemed to have enough.

Thus the Museum came to exert different, ever-growing pressures, carrying both delight and anxiety.

Eight

Many years after my mother's death, some letters I found clarified the reasons for the Museum's precarious financial state. I also understood why my mother found it so difficult to make the decision to expand the board.

My grandmother had left $2.5 million to the Whitney Museum, plus the forgiveness of all its outstanding debts to her, and a general instruction that "the remaining estate shall be devoted to such charitable and educational purposes, including the encouragement of art, as my children shall determine to be most worthy and deserving."

Clearly, she had hoped that her children would give the remaining estate (upward of $3 million) to the Whitney Museum, but she was reluctant to chain them to her beloved project. According to all who knew her, this gesture typified her liberal spirit. She didn't want to exert control from the grave.

In the end, the only one of her children who gave her share of the money to the Museum was my mother. Closest to Gertrude, devastated by her death, she wanted to do all in her power to memorialize her adored Mama. Flora pressed her brother, Sonny, who came up with relatively small sums from time to time, but gave the bulk to his personal interests, especially to provide for a wing of the Buffalo Bill Museum in Cody, Wyoming. He somehow convinced himself that, since one of her biggest and best monuments, her statue of Buffalo Bill, stood right in the middle of Cody, the museum there was more suitable than the Whitney to give this money to, to memorialize her. This despite his knowing the Whitney had been central to his mother's life

and work. Was he jealous, perhaps, of his sister's inheritance of the Museum? Of her closeness to their mother?

My aunt Barbara, Gertrude's younger daughter, gave fifty thousand dollars to the building campaign in the '60s, but, influenced by her manipulative husband George Headley, she used most of her share for a museum in Kentucky devoted to the "bibelots" he made.

My mother struggled to carry out what she felt sure were her mother's wishes.

Here's an excerpt from a letter to her from lawyer and Museum trustee "Watt" Dunnington, written as the Museum was planning the move uptown from Eighth Street. With a few name changes, this letter could have been written at many other times throughout the Whitney's history:

> You have probably received Mr. More's [Hermon More, the director after Juliana Force] letter of August 15th giving his report.
>
> I am sorry he made any reference to the financial condition of the Museum because in the first place our income for the past fiscal year was abnormally high due to extra dividends, which we cannot reasonably expect in the future. In the second place, our expenses when we move to 54th Street will be greater and it is going to be hard to make both ends meet. Aside from this, if other people are of the opinion that the Museum is in a good financial condition it will make it all the more difficult to obtain gifts [from the family]. . . .
>
> I am anxious to get the finances of the Museum entirely away from Mr. More as soon as we can diplomatically do it. I do not think he knows any more about that end of it than I do about art, which, as you know, is about all I can say.

Already, besides the financial crisis, a conflict reminiscent of that between church and state was surfacing — as it would many times over the next forty years. Trustees, with their fiduciary responsibility, versus directors, trying to fulfill the Museum's mission.

By July 1954, when the Whitney was actually moving, Flora had given her share of the income from the trust to make the new building possible and would eventually give the principal as well. Watt Dunnington advised her to try again with Sonny, saying, "Turn the heat on him when you get to the Adirondacks."

Mother probably didn't. She disliked confrontations, and preferred

asking him by letter. Sonny's reply to Flora, after the Museum had moved to Fifty-fourth street:

My dear Flora,

At a meeting of Mama's Trust last Tuesday, Barbara and I considered your letter to me about the Whitney Museum. We agree that we have a moral commitment as far as the extra costs of the glass ceiling and lighting for it are concerned, and we are prepared to pay the $110,804.54 involved.

We have some very heavy commitments of our own, including a $250,000 gift to the Buffalo Bill Museum at Cody, Wyoming. . . . this will attract millions of visitors to the Buffalo Bill statue.

In the autumn of 1959, drafting a letter to her brother and sister, Flora expressed her outrage. The cover page indicates that she wanted this letter summarizing the situation kept for the record:

Letter to Sonny & Barby autumn 1959 asking for $5,000 from Mama's Trust for Museum

In her flowing hand, she copied the letter itself on paper from a small pad:

This is an appeal of two sorts. The monetary side of it is important as evincing an interest, as well as fulfilling an obligation that you either recognize or deny.

The Whitney Museum is a unique institution in that it is regarded by the public as a family Museum, and it is. (There are only one or two in the whole country and they are not primarily for American Art.) The formation of the "Friends of the Whitney Museum of American Art" barely three years ago has shown us how many people prominent in the art collecting world are interested in the Museum, but it has also posed a few problems, one of them being that they will want representation on the board of trustees. They know it is a family affair but they also know that it is practically an inactive board. I feel very strongly that I would like to keep it a family affair for as long as possible. As a memorial to Mama it is something that her wisdom and foresight created when no one else was interested in the American artist, and most of the concepts that are incorporated in its charter are now recognized as fundamental in Museum organizations. It is in every sense her Museum. It

seems to me it is a frightful shame that it is not supported by the family.

I know that it is impossible for you to come to openings, or to be involved in any of its activities, but it is not impossible to support it in other ways. There are approximately 160 Friends bringing in $40,000 a year, all the money (except a few thousand dollars) going for purchases. Our needs are also for general upkeep and hoping for a fund for better publications. I give varying amounts — about $17,000 this year when we started the Pension Fund. All I am asking for is $5,000 a year that I had hoped between you, Barbie, and the Trust you could give. With the $10,000 I have promised we can do very nicely.

Some time we hope to be able to divert some of the Friends' money to other usages. More exhibitions — longer hours for the Museum to be open — but at present those things are not possible. The enormous increase in its activities since moving uptown has put a tremendous strain on the staff, but it is difficult to increase it much owing to insufficient funds. If we did more about our various rich Friends I think we would get money for some of these other needs but I am much against this at the present — being always hopeful that we will squeak through.

I hope you and Barbie will come to the opening of the Zorach show on Tuesday. As you know he is one of the outstanding sculptors of our day — & they are not very "modern!"

It is unlikely that her brother and sister came, even though they did give the money. "Got it, FWM," appears in my mother's hand at the top of the page. This trust contained the $3 million in Gertrude's estate, to be spent by the three children for charitable purposes. Flora had already committed her share to the Whitney.

For the moment, the Museum remained a "family affair," limping along financially, with an overburdened staff. That staff, however, was buying paintings, prints, sculpture, and drawings of variable quality — as always, with contemporary art — thanks to the Friends' intellectual and monetary support. And a Museum's permanent collection, after all, is its primary responsibility.

In 1959, the same year my mother wrote to her brother for money, the Friends' Acquisitions Committee gave ten paintings and drawings, including James Brooks's *Rasalus*, Stuart Davis's *Paris Bit*, and Conrad Marca-Relli's *Junction* — works only possible for the Museum to acquire through the Friends.

Besides these gifts, members and others individually gave important paintings that year, as they have in most years.

In the late '50s and early '60s, I began to know the leaders of the Friends. I liked them; their interest in and commitment to the Whitney impressed and moved me. Mostly, they formed a world of successful businessmen or wealthy individuals who had managed to keep their interest in art and ideas alive, while working hard toward personal success.

The Friends saw the Museum's weakness in decision-making, in funding, in leadership. They wanted to help. And they wanted a voice in policy, in deciding how much money to raise and how to spend it; in determining whether our building was adequate and well situated for our mission; in examining the possibility of expansion.

These were the main characters:

Arthur Altschul, a partner in Goldman Sachs, had a family fortune of his own from his Lehman relations. He collected mainly French Nabis, American Pointillists, and "The Eight." Since the Whitney's collection was rooted in "The Eight," the so-called Ashcan School of artists who had made "ugly" paintings, as critics at the time often called them — realistic scenes of daily life, not glamorous or sentimental — Arthur was drawn to the Whitney, although not to its more contemporary purchases. With his distinguished German ancestry and his respected business position, Arthur was a natural aristocrat. We remained good friends until the '80s, when he became disenchanted with Tom Armstrong, the Whitney's director, and with the Museum's waning commitment to artists whose work he owned and loved. (Essentially a museum of contemporary art, the Whitney did exhibit those historically important artists, though not as often as before.)

B. H. Friedman was then an executive in his uncles' construction firm, Uris Brothers. "Bob" was already writing the books and articles soon to become the center of his only profession. Close to artists and writers, he and his wife, Abby, became our friends as well as associates at the Museum.

Roy Neuberger, head of the investment firm of Neuberger and Berman, eventually gave his collection to the State University at Purchase, New York, where Governor Nelson Rockefeller named the museum for Roy. A small, intense, ambitious man, with a gimlet eye and a genial manner, Roy had strong views about art — and everything else, too.

David Solinger, once a painter, now a collector, was a lawyer heading the firm of Solinger and Gordon. Careful with words, eager to take the lead in deliberations and decisions, David was critical, opinionated, but dedicated to the Whitney, giving generously of his time and money. Along with the others, David's voice was authoritative on the Friends' acquisitions committee. One legend has him saying to Willem de Kooning, who was painting *Door to the River,* one of the Museum's icons: "Put down your brush, Bill! It's finished! It's the Whitney's!"

Alan Temple was a distinguished banker and an exceptionally thoughtful collector. Alan's gentle voice and firm, wise way impressed others at meetings, especially those about budgetary matters. He became the Museum's first treasurer.

These were the men Jack and Lloyd had picked to become trustees.

But before any such major change could transpire, a behind-the-scenes controversy took place. Not everyone was in favor of adding nonfamily members to the board. My parents' advisors were cautious, urging the family to keep control of the Museum.

Between 1959 and 1961, thirty years after the Museum's founding, my mother still struggled with these conflicting points of view, bringing me, now, into the deliberations.

Lloyd Goodrich had pushed for the change.

For some time I had felt, about the structure of the Museum, that our board of trustees should be larger. This idea was not at first agreed with by my colleagues on the staff, nor by our trustees; and I understood their reasons. We were in a fortunate position. Our trustees, all but one of whom were members of Mrs. Whitney's family, had been associated with the Museum for many years. They had never tried to control the staff too much, as so many Museum trustees do. They had never failed to back us up. We couldn't have had a better board. I must say that all of us, both trustees and staff, when we finally came around to the idea of enlarging the board, had many qualms; we felt that we might be giving up some of our independence. But it seemed to me we had to widen our support; I couldn't see how we could continue to grow without doing so.

How I wish I'd asked Lloyd later if, indeed, he felt he'd given up some of that essential independence.

Watt Dunnington, shocked by the proposal, wrote his thoughts to my mother in May of 1960. She and my father were leaving to spend

the summer in Gertrude's Paris studio. Dunnington sent his letter to the *Liberté,* "so you and Cully will have a chance to think [my thoughts] over and you will not discuss them with anyone until your return next September." He advised her to destroy his memoranda, "as I would not like to take any chance of their reaching the files of the Museum." Opposed to the concept of nonfamily trustees, he suggested instead an operating committee, such as existed in most corporations, which would report to the board.

Then his condescension grew evident. "I believe such a committee would serve two functions: First, it would give Lloyd Goodrich recognition that he seems to want. Secondly, it would let the Friends and also Flora have an opportunity to discuss various projects concerning the Museum and art in general. I think it would serve to stimulate their interest."

He intimated that Lloyd Goodrich was more "concerned with his position in the art world" than with the Museum's future and should not be made a trustee. "Mrs. Whitney," Dunnington continued, "in creating the Museum wanted its policies controlled by her and then she wanted you and her other children to control the policies and future of the Museum; consequently, she did not want to have a large number of trustees. I feel that Lloyd has to realize that we want a unique Whitney Museum rather than just a big Museum where there are lots of people, many of whom are not desirable. If the Museum ever gets away from the Whitney family its purposes will be defeated and you will never be able to restore them."

Finally, he advised my mother to have a frank talk with me. He thought my interest should be encouraged, although I was "too easily influenced by Lloyd, Mr. Solinger, and the members of the Friends. I think they try to get at her believing she will be able to influence you."

My parents' trusted office manager, J. S. Mackey, wrote in a similar vein, "Surely a way can be found to appease the Friends of the Whitney without increasing the number of trustees, which seems such an unnecessary and dangerous proceeding."

Both men offered valid arguments about the negative aspects of institutionalization. However, I sense underlying motives, including a desire to maintain their own control over family decisions and family fortunes. Probably, too, these ambitions were reinforced by anti-Semitism, glimpses of which I caught from time to time. My mother had no racial or ethnic intolerance. She accepted or rejected people as

individuals. So it happened, at that time, that many collectors of contemporary American art found a warm welcome at the Whitney lacking at other museums and cultural institutions.

Reading these letters years later, I realize that, while I reject Watt's prejudice, his predictions were accurate. The Museum could never again be the unique institution it had been — an institution with a tiny, family board, a board that trusted implicitly in its staff and shared its vision, a board that each year made up the deficit with no complaints, a board that never, never tried to influence programs. A board that thought it all great fun, as well as vitally important. But this board no longer had the capacity to fund this institution. And the institution could no longer survive without more money.

Although I found him insensitive and his thinking out-of-date, Watt Dunnington was right about one other thing: I had an influence in this key decision. And my mind was made up. The Museum needed these intelligent, committed men, already an intrinsic part of my enchantment with the new world I was entering, as trustees. These new friends were good. Good for the Whitney, good for me, too. They would revitalize the inactive board, they would ensure the Museum's future.

My mother listened to my passionate advocacy, along with Jack's and Lloyd's reasoned opinions, and agreed that the Museum could become a truly public institution, as Gertrude had wished it to be, only by expanding the board.

But what did "truly public" mean?

Supported by the public, certainly — in proportion to its accessibility and accountability to that public.

In May 1961 the board approved a statement of thanks to be made on its behalf by my mother at the annual meeting of the Friends:

"The contribution which the Friends have made by their purchases to the Museum's permanent collection has been of vital importance; without it the Museum could not possibly have done justice to the quality and variety of contemporary American Art. In all of their other activities, such as their loan exhibitions and their aid with publications, the Friends have strengthened the Museum's program incalculably."

At the next trustees meeting, on June 21, 1961, we chose nine "elective" trustees, meaning they had no say about the Museum's quasi endowment, a distinction abolished in 1964. Besides those named above, in addition to the existing seven "permanent" trustees, three insiders joined the board: Lloyd Goodrich, Jack Baur, and my hus-

band, Michael H. Irving, who during the Museum's next move was to become associate architect of our next building. I was delighted that Mike was now on the board.

Roy Neuberger wrote to tell my mother about his pleasure. "As you know, I believe that the Whitney Museum has done more for the American artist since its founding than any other institution, and I will attempt to help work toward this end."

And Bob Friedman wrote, "I am pleased to accept this honor, and look forward to participating actively in the work of the Museum. This work has, in the past, and will, I am sure, continue to be a great source of satisfaction to me."

The election made news.

"How interesting that four of the five trustees you appointed are Jewish," a reporter said to my mother.

"Really?" she replied. "We simply asked those members of the Friends who were the most interested and involved." An honest answer. Mum just didn't think as many others did — although she realized how unusual her attitude was for that time. Other cultural institutions had few, if any, Jews on their boards. Still, following its tradition of embracing new and sometimes controversial art, the Whitney remained open to new patrons from different worlds and backgrounds.

Trustees' meetings were different now. We had agendas, we set dates, we tried to be more formal. Meetings were longer, more substantive, livelier. We talked more and more of expansion, of moving. In a letter I told my parents how I felt after such a discussion: "The meeting was fantastic — like watching a superb basketball team . . . they tossed the problem like a ball, back and forth, for about two hours, without stopping or ever interrupting each other, and came up at the end of it with this great idea."

Assuming this brainstorming to be a technique used in business meetings, I was impressed by the level of participation and of ideas. Now that I've been to thousands of meetings, I realize how much time can be consumed in this way. I understand why directors and staff were sometimes irritated when their informed knowledge on a given subject was drowned out by trustees' eager "off-the-top-of-my-head" chatter. In the beginning, however, the mutual respect between staff and board made such meetings quite productive.

As my mother chaired them, I could see how important this was to her. Shy yet engaging, she would greet each trustee, and recognize

each raised hand. I once watched her speak at a fund-raising lunch, knowing how nervous she was while seeing how persuasive her words were.

Our relationship was changing.

When we were together, we talked much more about the Museum than anything else — more than about my siblings' marriages or divorces, more than about my own children.

When Mum and I planned together, I felt the intimacy I'd missed as a child. I was happy. I believe she was, too. She had read Kipling to me, the Mowgli stories we both loved, and perhaps we were a bit like those jungle beasts confronted by a strange animal needing help to grow up. My mother and I drew together around this separate entity, as she had done with her mother. The Museum was the center of our relationship.

Like proud parents, we celebrated each new step, sharing the Museum's joys and problems, unaware that one day it would grow so far from us.

Mum sat at the head of the table like a queen. Though she was neither distant nor autocratic, others, nonetheless, saw her as a regal presence. Gradually, too, they felt her warmth, they saw her enthusiasm. Through the veil of well-brought-up politeness, which bound me, too, she made each trustee feel her personal charm, the warmth of her approval. To each suggestion, to each gift, she responded with intensity. "Ooooh, David, how *wonderful!*" she would breathe, and you could see this formal, cautious lawyer begin to thaw. "Arthur, you *didn't*, oh, that's too marvelous!" and Arthur's "successful businessman" mask would melt away.

I watched, critical, wishing she'd be brilliant, instead. Witty. Tough. At the time, I suppose I thought I could do better. Probably I was a little envious, too — everyone admired her so! I wrote to my parents, in Paris that summer: "The party at the Museum was quite terrific and full of celebrities — but so many people asked me where you were that I began to feel like a has-been, or isn't-yet, or something! Really you were very missed and finally, in desperation, I began saying '*I'm* here instead!' which startled people a little!" And I knew how hard it was for her, too. She didn't want this public role. It was really painful for her. With immense effort, she would prepare for days, making notes on little pads of paper or on the agendas themselves, discussing

the meetings with Jack and Lloyd, and planning with her maid what she would wear — which suit, which blouse, which hat.

She led the meetings — and the Museum — beautifully. A natural politician, she made the disparate group of trustees work together as one board.

Every so often, during meetings, Mum would glance at my father, who would smile reassuringly, then return to doodling on his pad, making sketches I wish we'd preserved. He caught the flavor of the discourse, capturing each of us with an affectionate, satirical, flowing line.

In 1962 my cousin, Barklie Henry, took the place of his mother Barbara Headley on the board. He was perhaps the biggest influence on my thinking about the Museum in those days. At the time, he was living in Washington, winding down his involvement with the CIA (for which he'd worked briefly), running a laundromat, driving racing cars, being interested in art, making films and music, writing.

Barklie had lived in our house on Long Island during the war, when we were both teenagers, while his mother was ill and his father was an officer in the Navy. He was my idol. He looked very much like our Vanderbilt ancestors, those who had made the family fortune, with his strong features and a big, slightly hooked nose. Funny, intelligent, and outspoken, he planned to become a doctor, and during summers home from Exeter he worked as an orderly in the operating room at the Glen Cove hospital. Arriving home in blood-spattered clothes with a burst of energy, he'd head right for the old Victrola in our living room and play jazz records at top pitch, much to my parents' dismay. (He himself played bass fiddle; Whitney Balliett, now the distinguished jazz critic for the *New Yorker*, was his close friend.) "But Auntie Flora, these records are beautiful, and really valuable. Just listen for a few minutes, please?" But Bark could never really communicate his enthusiasm to such unwilling ears. His toeless, battered, bloodstained sneakers were another source of my parents' irritation, but my father's teasing only elicited Barklie's hearty belly laugh, shaking his whole body, as they begged him at least to change them for dinner. All I wanted was to spend hours with Barklie, learning about life, especially sex, about which I felt he knew everything and I nothing. He, however, was understandably more attracted to my beautiful older sister, Pam, who had come back home with her baby while her husband was overseas in the army. He probably hoped to get much the same from her as I did from him. I was overjoyed when, replacing the Polish workers who had gone

off to war, I went to work on my uncle's farm plucking chickens. In the evenings, I could sit there all day and listen to Pam and Barklie's jokes and conversations. Or drive with them in my aunt's electric car to the movies in the village, a rare treat because of gas rationing. Or, best of all, ride behind Barklie on his powerful motorcycle — *that* was a thrill.

Close friends and associates in the '60s, Barklie and I conferred regularly about the Museum. His life in a bigger world, his distance from the Museum and from my parents, had given him a perspective I didn't have. All too aware of the insular world I'd come from, I was often unsure of my thoughts and capability. So I valued Bark's advice and came to rely on it. Convinced our grandmother would have approved, he was all for broadening the board even more and for expanding the Museum.

In long, thoughtful letters after board meetings, he often criticized what he saw as weakness in my mother's running of those meetings and her reluctance to accept what the new members were offering: not only money, but their ideas about organization, committees, responsibilities they were willing to undertake, leadership they were eager to provide. But there was no follow-through on those ideas and offers, Barklie worried, after these meetings. He had a vision of the Museum as wide as my grandmother's original dream, and he felt it could only come about with more money from the new trustees — from still more trustees, in fact. I agreed. I had, after all, been a prime mover in the original decision to enlarge the board. But now I was learning its consequence: inexorable growth. Finding it good, finding it exciting, I failed to understand the necessary concomitant of that growth: an endless need for money.

Today, if I could, would I change the decisions we made then?

Probably not.

But I wish I'd fully realized the scope of our need for money.

Yet Barklie believed family leadership was crucial, and that I must be ready to provide it. That scared me! I wasn't ready, either for the responsibility, or to leave home for the amount of time needed. And Barklie worried about his role. Considering his ambition to be an artist, he was reluctant to be part of an institution passing judgment on artists. Still, he felt he could find time in his life to "contribute something serious and honest in counterweight to what is so prevalent today around museums and galleries: pretense, fraud, social ambition, careerism."

He thought our meetings were too "loose." "This 'looseness' I speak of is a delicate matter. Naturally you want to preserve informality. On the other hand, I feel that the new members would respond to a more purposeful sort of atmosphere and would accept demands on their own time (and money) in some proportion to their feeling of momentum and purposefulness about the meetings. . . . It has most to do with your mother and the embarrassment and modesty she naturally feels as chairman of that high-powered a group."

They all adored my mother. Revered her, really. Especially Bob Friedman. He likened her to a literary character he greatly admired, Proust's Duchesse de Guermantes. Once, when they came in to a meeting together, Mother said with huge enthusiasm, "Oh Bob, I heard you last night on Long John Nebel, you were *marvelous!*" Bob said, horrified, "Oh Mrs. Miller, surely *you* weren't listening! Were you shocked?" "Oh no," said Mum, "I'm fascinated by all that, I always wondered what it would be like to take drugs, and you spoke so eloquently. . . ." Bob, looking abashed, explained to the other perplexed listeners that he'd taken part in an experimental program at Harvard with Timothy Leary and Richard Alpert to explore the effects of hallucinogenic drugs on creativity, and had been interviewed about the experience on a popular all-night talk show. Mum often awoke and turned on her radio in the middle of the night; this time, she had happened to hear Bob. The use of hallucinogenic drugs was extremely controversial and unconventional, and Bob was flabbergasted that my mother not only accepted his experience but found it intriguing. Her response cemented their friendship forever.

And years later, my mother trusted Bob to write about *her* great heroine — her mother.

The new trustees, including Jack and Lloyd, wanted to make the decision to expand, to move. We were losing our identity to that of the Museum of Modern Art, they said. People weren't sure where the one ended and the other began.

Moreover, our building wasn't nearly big enough for the grand Museum they envisioned. They wanted more space for the collection, for performance, for lectures, for sculpture, for temporary exhibitions, for storage, for a library — the list went on and on.

Soon, even my mother became convinced. I already was. The fund-raisers we consulted were dubious, looking at the fairly meager

fortunes of board members, but they became more optimistic as we added other members. And despite their relatively small assets, those early trustees were incredibly generous. Bob in particular stretched his gift to the utmost, hoping to inspire those with larger means to give more. Mum's "Oooohs" became more fervent, and with reason.

Which new trustees from those days remain vivid in my memory?

When Barklie and I couldn't persuade Mum's cousin Jock Whitney to join the board, Jock offered us a substitute: his right-hand man at J. H. Whitney & Company, Benno Schmidt, a powerful, determined Texan who undoubtedly did Jock's bidding. Benno, a dynamo with a drawl, was used to having his own way. He respected my mother, was rather scornful of the rest of the board, and immediately undertook to raise our standards. He invited my parents, Mike and me, and Lloyd and Jack to dine with Laurance and Mary Rockefeller. We needed "clout," he insisted, if we wanted to raise big money. Giving me an appraising look, he suggested a new dress, hinting that a more revealing one would help. I was seated next to Mr. Rockefeller, who immediately put me at my ease, and soon we were happily chatting — about what? Wilderness, travels, maybe art. It was a pleasant evening, and Mr. and Mrs. Rockefeller quickly became Laurance and Mary to us. It must have been a success from their point of view, too, since Mary soon agreed to become a trustee, and stayed on the board until she retired in 1989, having contributed both time and money to the Whitney's education programs. Over the years, the Rockefellers supported our expansion with both encouragement and money, although the Whitney never became their primary interest — how could it have? They were committed to conservation and education, to the YWCA, to social and environmental causes.

Many times, however, our family had difficulty enlisting friends and relations in a cause those friends just didn't care about. They were often offended by the Whitney's exhibitions, or at least didn't understand them. Why should they give money, even if they liked us a lot?

I remember a lovely woman, my mother's goddaughter, who helped us, in the '80s, as chairman of a benefit "Flower Ball." After its success, I hoped she'd become a trustee, but she said, "I wanted to do it for you, for your mother, and for Tom (Armstrong, the director at that time), but I can't do any more. I just don't get what's on the walls."

And a cousin, Michael Straight, once vice-chairman of the National Endowment for the Arts, was deeply distressed at turning down our in-

vitation to be a trustee, and said, "I can't believe in what young artists are doing today."

The Rockefellers were one of Benno's gifts, but there were others, too. He entertained lavishly for the Whitney, bringing in donors to whom we had no access. Jock had received an equity-related security of Global Marine — an oilfield services company — worth a million dollars, which he turned over to the museum. His contribution put our $8 million campaign over the top.

Benno's performance amazed my parents, Lloyd, Jack, Mike, and me, since we saw no evidence that he loved the art the Whitney showed. He was loyal to the family, because of Jock, and he certainly admired my mother. We were impressed, grateful, and a bit wary. Benno was our most powerful trustee, yet the nature of his commitment bewildered us.

What was he doing at the Museum? Surely loyalty to our cousin wasn't enough? All the other trustees cared about contemporary American art, had collected it for years. Wondering about this, I woke slowly to new realities — about motives, about people.

Who else made us curious about their motives? Armand Erpf, recent president of the "Friends," nicknamed the "Wizard of Wall Street," a partner in Kuhn, Loeb and a highly educated, idiosyncratic man who loved art. His apartment and his upstate home and grounds in Arkville were filled with paintings and sculpture. Armand, reputed to be extremely right-wing, traveled in exalted intellectual circles. I remember once facetiously suggesting André Malraux as a speaker for a fundraising event; Armand snapped his fingers, said, "Yes, a great idea, I'll go call him right away." And he did! (Although Malraux didn't come, Armand's friendship with him pleased me to no end.)

Another time, at dinner at his house, I was seated between Armand and Jacob Javits, U.S. senator from New York, and heard their rather horrifying political discussion, with Armand stating unequivocally that Hitler had been one of the world's greatest leaders.

My mother and Jack Baur put their heads together and concocted a persuasive letter from Mum to Jacqueline Kennedy, inviting her to join the board when Jack was president. She wasn't on any other art museum board, and it would be a tremendous coup for the Whitney to have the First Lady with us — especially one so intellectual and popular, so identified with increasing America's awareness of its culture. We were ecstatic when, in 1962, "Jackie" joined the board. What a

statement about the significance of American art! What a validation of the Whitney's goals and ambitions! She was quiet and supportive, looking lovely and perfectly turned out, smiling, and speaking softly, if at all. She usually sat next to my husband's cousin, Harry du Pont, distinguished elderly scion of Winterthur, the magnificent house he had built in Delaware filled with his collection of American antiques, and advisor to the Kennedy White House on its collections. Although neither of these luminaries helped us financially, their presences were impressive and positive in other ways.

Knowing my daughter, Michelle, who was then at boarding school in New Hampshire, would be interested, I wrote her a short description. "Well, Jackie K. was very nice and friendly, and I hope we'll get to know her better. We're planning to ask her for lunch, and a private tour of the Museum, in a couple of weeks. She wore a very simple two-piece white dress, and two beautiful turquoise and diamond pins, and her hair hadn't been done too recently so she looked nice and natural, and acted that way too. She seemed tired, though — I wished I could ask her to the country with her children for a weekend of sledding and peace and quiet."

Most of all, Mike and I enjoyed the Friedmans. So did Barklie.

Bob is tall and intense, very good-looking, and under a smart, sharp wit, genuinely kind. His conversation could dazzle and ignite a whole roomful of guests. Off we'd all go for a drink after meetings — vodka martinis were then the thing — and talk and talk about the Museum. Soon Bob and Abby invited us to their house in Turtle Bay for dinner with some of their friends, people I'd dreamed of meeting: Bob Motherwell and Helen Frankenthaler, then married to each other, Philip Guston, Alfonso Ossorio.

What always engaged me about the Friedmans was how central art was to their lives. Even their bathrooms were filled with paintings by their friends. How eloquently they talked about art, with what passion and discrimination they acquired it. Bob had already published both fiction and nonfiction. Art and writing seemed to take precedence over everything else. They were at the center of a circle of creative people. We, however, lived far away, we weren't really part of that world, and I knew it. Exciting as it was, like Jack Baur, I had other priorities.

When, in November 1962, we embarked on a campaign for a new building, my mother once again asked her brother to help:

Dear Sonny,

We have been through a very difficult year trying to find a way of letting the Museum of Modern Art acquire our Museum which they very much want and which we would be most willing to let them have if we could see our way clear to the purchase of other land. A very attractive and desirable piece of property has just become available on Madison Avenue and 75th Street. The price is $2,600,000. The Modern is offering us $1,600,000 for our building. We would have to raise about $4,500,000. The reasons for wishing to move are: First: When the Modern completes its vast building program we will be jammed into its complex and appear to be only its annex. Second: we need more space and if we add two floors by going up higher it will cost about $800,000 and we would have to raise another million to take care of the extra staff (and our now underpaid staff.) This project would not have much appeal in a fund raising drive.

Our new trustees are very much in favor of acquiring this land and they feel that with a well organized drive we could, in time, raise the money.

Last Friday two of our trustees told Lloyd Goodrich that they would give $100,000 each and they suggested we call a special meeting for Tuesday the 27th so as to inform the other trustees of the great advantage of getting this property, and of the need to organize a drive as soon as possible.

At this time I would hope that the family could show some solidarity, even if they are not willing to make a definite pledge. I know that you did a very fine thing in Cody, but New York was Mamma's home, where she lived and worked all her life — and worked to encourage the artists of her time, just as she would be doing had she lived now — whether you, or I, like some of the art that is shown has really nothing to do with it.

The "Friends of the Whitney Museum," (there are nearly 200 now) have shown their interest in many ways and we are quite sure that some of them will respond to this in a substantial way. But, as the children of the Founder of the only Museum devoted to American Art of this day, it would be a sad thing indeed if we could not give to perpetuate this vision of Mamma's.

The answer came quickly in his own hand.

Dear Flora,

I have your nice long letter re plans for the Whitney. I'm truly sorry I cannot help you as I am full of admiration for the way you have

worked on this and the splendid things you have accomplished. None of these things are easy and they take up a lot of time and energy.

On the whole we have had a wonderful year. . . .

A year or so later, Sonny wrote to my mother again, having heard she was ill and hoping "it is all over by now." He continued: "We seem to be completely out of touch these days, tho why I do not know. Evidently we have some type of feud going, which would seem to me quite unnecessary, and which certainly has no current raison d'être that I know of. True, our paths don't cross often, but is there any reason for coldness? Wish I knew. . . . I follow your plans for the new Whitney with wonder at your energy and ambition. . . ."

He never realized how much the Whitney meant to his sister, and why.

Nine

*I*n 1963, the Museum acquired land at Seventy-fifth Street and Madison Avenue for a new building. A perfect lot, already excavated, saving both time and money. And a good deal — $2,050,000. Ian Woodner, an artist and collector, had been forced to sell this prime real estate. He'd had tax trouble, and was pleased to have us be the beneficiaries of his misfortune. I called my mother in Paris to tell her, and she wrote an excited note:

> May 22, 2:45 P.M., *Three quarters of an hour after talking to you.* SO exciting, darling, to hear your voice as if we were in the same city — just so clear! We got a big kick out of it. And of course, the news! Well there it is for better or for worse and I will pray all goes well. Only thing I can't remember is what Mr. Erpf did thru John Loeb? And what the time element was on the $200,000 from the Modern trustee? [An anonymous gift.] It certainly is nice of Mr. Woodner to give us $50,000 over next three years. I'm sure all the trustees, especially David & Arthur, are thrilled over the whole thing. Hope some of them give something now so we don't have to borrow quite so much on our Museum securities. I figure we can pay the $100,000 down payment on signing the contract when Mr. Mackay gives and lends mine — I figure it this way

Auntie Barbie's	20,000
me	20,000
me	50,000
me	150,000

Bob's securities	100,000	
	———	
	340,000	
Beg, borrow or steal	1,710,000	how ghastly!

At 2:30 on June 4, 1963, the building committee met and interviewed three architects: I. M. Pei, Louis Kahn, and Paul Rudolph. Meeting one of the others as he left, Kahn turned back angrily. If he'd known he wasn't the only choice, he would not have come, he said, destroying the splendid impression he'd just made. Yet I still remember the fine sketches he did while we talked with him. Since he believed in using natural light in museums, in our case, in order to orient galleries to the outside, he'd have needed a narrow, high tower. Otherwise, he'd have been Bob Friedman's first choice. I soon heard from Mike that the building committee was enthusiastic, after interviewing him, about Marcel Breuer. My mother had been there and had liked him and his ideas a great deal.

Things seemed to happen much faster in those days than they do today. Smaller groups, less bureaucracy. Decisions made and acted upon right away. On June 10, Bob Friedman reported to the trustees the building committee's recommendation for the appointment of Marcel Breuer and one of his partners, Hamilton Smith, to design the Museum's new building, with my husband Mike as consulting architect.

Marcel Breuer was born in 1902 in Pécs, Hungary. He went to the Bauhaus in Weimar, Germany, right after it was formed and stayed from 1920 to 1928, the last four years as teacher (Master) and head of the Carpentry and Furniture department. At the same time, he was painting and studying architecture. Breuer's broad interests and research motivated him to redefine architecture — to investigate and design for our whole environment. He moved to Berlin in 1928 to practice architecture, but the great German economic crisis soon stopped all construction, and he left in 1931 on a circuitous journey that brought him to Cambridge, Massachusetts in 1937 to teach design at Harvard University's School of Architecture. He built his first houses in the United States (after a number of apartment houses and theoretical projects in Europe) and moved to New York in 1946 to direct his energies to architecture and planning. Although he never stopped building houses, the scope of his work changed mainly to large proj-

ects, public buildings, and the planning of whole communities in the United States, in Europe, and in South America. He expressed his architectural philosophy eloquently. Here are a few of his words about how the "inanimate object gains an organic quality."

"That world of stone behind stone, of vistas, of weight and material, of large and small cubes, of long and short spans, of sunny and shady voids, of the whole horizon of buildings and cities; all that inanimate world is alive. It is as close to our affection as good friends, the family — right there in the center of emotional faith. . . .

"They are alive, like people. They have also their cycles of vigor, strength, beauty, and perfection. They have also their struggle with age, with decline, with circulation troubles, with sagging muscles, with wrinkles. There is one difference though: they can be beautiful even in old age, even in ruins."

Although Breuer had never built anything in New York, he seemed to understand the Whitney and its program. Once the motion was accepted, the fund-raising drive and the design work started immediately.

I have a letter from Mum about the decision. "Just thrilled to get your letter last evening — and I'm very happy about Breuer — somehow had a feeling it would be him even tho' I hadn't seen any of the others. . . . And your champagne celebration with the Friedmans after! What fun! . . . I did wish I had been there — it must have been very exciting. And now for all the hard work. Money etc. OH!"

Most trustees pledged from $50,000 to $100,000. Arthur Altschul and his family pledged $200,000.

My mother soon increased her pledge to $500,000, subject to the successful sale of *The Smoker,* the Manet painting that had always hung in her mother's and then her own living room in Long Island. The painting was sold, at Parke-Bernet (now Sotheby's), for $450,000 on October 14, 1965, and my mother gave the money she realized from the sale to the Whitney. After changing hands again, it now hangs prominently in the Minneapolis Institute of Art.

On November 12, ten days before the assassination of John F. Kennedy, Breuer presented plans to the trustees and, in the hope of involving them more deeply in fund-raising, three officers of the Friends: Allan Emil, David Prager, and Eloise Spaeth.

The plans were well received.

We were a tiny band, trying to raise $8 million. We had plenty of

energy and ambition but few rich patrons. Committees were formed to raise money, plan parties, enlarge our basic constituency. I served on most of them, although I was a neophyte at this business.

Following her mother's example, my mother gave lavishly to her children, to her friends, and to the Museum. If we were going on vacation, she'd slip us an envelope of cash. If we built a house she'd help, so we didn't need a mortgage. She paid for her grandchildren's and even her great-grandchildren's education. We were very comfortable, if not extremely rich. Since there always seemed to be enough money for important needs, we'd felt secure. I'd never asked for, or borrowed, money.

Now, in my new persona, I felt an urgent need. But the Museum seemed like family, and why, after all, should strangers support my family?

I couldn't distance myself enough to see the Museum as a separate entity, benefiting the public. Because of this, the pathway the Museum provided to a creative world became weighty, as well as joyous.

So, in those days, I wasn't good at raising money. I didn't like it any better than my mother did. Besides, like my mother and grandmother, I had no old friends with both money and an interest in art.

Why was this? Very few rich people from old "society" families seemed to like or to understand contemporary American art. Perhaps much of it was threatening to those who still believed in and lived by the customs and values of earlier times, forgetting that those too, once, were new and hard to accept. Those who did appreciate newer forms of art preferred the more professional, intellectual, aristocratic, and international milieu of MoMA to the Whitney's artist-oriented, low-key, very American ambiance.

Also, most of the Whitney's American art held little value on the open market, compared to MoMA's mostly European collection, whose high monetary worth gave the whole museum a status far beyond the Whitney's. Of course, by then most of the Impressionist, Fauve, and modernist painters had died. Their deaths conferred yet more status and, therefore, higher prices, on their remaining work.

Still, I tried. We invited Connecticut friends to Museum events. We attempted, to some extent, to integrate our country and our city lives, not wanting the two to be totally disconnected. I remember my struggle to balance both worlds. While my mother was in Paris, for instance, I rushed to New York from my New Canaan home to sign a

check in seven figures to buy the land for the new building, staggered by taking responsibility for such a sum; then I rushed back to New Canaan to pick up kids from ice hockey and piano lessons and cook dinner for the family.

In 1964 Uncle Sonny astounded me with a letter saying that after a visit with Mum, he'd decided to give $100,000 to the Whitney "on account of your great interest in it." "Pass this information along to the people at the Museum," he continued, "as I wish you to get the credit for raising this sum."

He ended the letter with his hope that our family would be in the Adirondacks the following summer "with lots of children," as, he said, "both we and our children enjoyed so much last year having you there."

I was flabbergasted. Why did he change his mind? Probably that "pleasant visit" with his sister, the first in years, was the answer. Maybe our children's new friendship in the "Ads" with his wife Mary-Lou's four children also helped. We'd had fun organizing the sailboat races with them at their camp, Deerlands, and they'd come to Togus for picnics and water-skiing. Or maybe Marylou wanted a closer relationship with Sonny's family. . . . Whatever the reasons, I was grateful for the support.

Sonny's recognition that I needed "the credit" for being able to bring in money was a revelation. All too aware of that new need, I'd had no idea of his sensitivity to my new position vis-à-vis the Whitney. No longer was it enough to be Gertrude's granddaughter. I had to earn my way, just like everyone else. I was expected to do that now by the new trustees, and had come to expect it of myself, too. Especially if I were to lead the Museum, some day.

Longing perhaps for the more private life she'd had in Aiken, in Long Island, in Paris, fishing on the Gaspé Peninsula, or in the Adirondacks, my mother tried bravely to live up to her role at the Museum. By December 1964 she wrote of nosebleeds, of many doctors' visits, and finally, on December twenty-eighth, of the death of their beloved brown standard poodle, Banco, who had traveled yearly to Paris on the steamer with my parents, who always sat up straight in the front seat of their car next to the chauffeur, to whom they talked as a friend, and whom my father had often painted.

While apparently excited and happy about the building and the

plans, Mum looked forward most to her travels with my father. She seemed, as president, to enjoy the new trustees, and they loved her. But whenever she was back in New York, it didn't seem to agree with her — she appeared listless, depressed.

My father and I were concerned. Mum had begun to skip meetings. At sixty-seven, she was in good health but didn't want to see many people. What was wrong? Wanting to perpetuate what her mother had begun, hoping to immortalize her, my mother had become president of the Whitney. But the very qualities of modesty and reticence that made her a beloved leader were also the ones that made it so hard for her. Her public role went against her own nature. Although he and I were all for it, my father said she would never consider a psychiatrist. Depression is so openly talked of today that it's difficult to remember how recently many people considered it weak and shameful. People in my parents' world kept it a secret if they saw psychiatrists. My mother never did see a psychiatrist. How I wish I'd had the courage and wisdom at the time to insist, because I believe she was tormented by bouts of depression for the rest of her life. Instead, I kept quiet about it, even with Mum, certainly with the Museum world. I'd been conditioned, too. It took a lot more life experience for me to open up.

She did acknowledge problems, though, to her little red leather Line-a-Day. In 1961, the same year non-family trustees joined the board:

Friday — feel awful but up & around.

Tuesday — 4:00 — meeting about price of our museum

Wednesday — still feel horrid.

Thursday — stayed in bed. feel awful.

Friday — bed

Saturday — bed

Sunday — bed

Monday — Russians big bomb. still feeble.

Also, at about that time several of her close and good friends died, people with whom she'd loved to talk, to sit up late at night, to laugh and play. (My father, like me, went to bed early and arose early. My

mother liked to sleep until noon.) Bruce Buttfield, her beloved and brilliant decorator, was one. Tim Coward, one of her first loves, intellectual, passionate publisher, founder of Coward McCann, was another. Carnes Weeks, her seductive doctor and a drinking companion with whom she used to sit until all hours at the Stork Club, passed away. Her closest woman friend developed a disease we now call Alzheimer's. While Mother was as beautiful, elegant, and charming as ever, the awareness of aging, the losses that we all suffer as we grow older, and thoughts of mortality surely added to her anxiety.

I think she felt somewhere in her heart that she'd let go of the reins too soon, that the Museum was out of the family control when it shouldn't have been. She perhaps felt that she had failed her mother, who had wanted the family to run her museum without outsiders.

Reflecting on this today, I don't agree. Gertrude was a pragmatist. She would have known the Museum couldn't survive without infusions of money and people. Competitions and struggles to get sculpture commissions and to complete them, long leadership of the Museum, and Gertrude's native determination had impelled her to learn the trade-offs necessary for accomplishment, change, and growth. My mother didn't know them. She had chosen a calmer life, far from ambition. To be faced with a public life at this stage was uncomfortable, if not alarming.

Logic wouldn't have swayed Mum's feelings. She was instinctual. She believed in things invisible, in astrology and space ships and extra-terrestrial beings, in life after death, and a throng of mysteries. She loved baseball.

My mother put on a good act. No one at the Museum realized her feelings.

As for me, still innocent of institutional politics, still curious and idealistic, still yearning, I had yet to find my own way. The Museum was different for me than it had been for Gertrude or for Flora. Rather than a personification of either of them, it represented a real, attainable paradise filled with all I felt I lacked: art, intellect, accomplishment. Somewhere inside my self-deprecating being lay the hope that I could become a person with those qualities. Since I was the only interested and involved family member besides Barklie, who I knew would leave someday, the way was open to me.

Despite my excitement, however, the money business frightened me. I knew I'd have to work as Gertrude and my mother never had.

I began taking more responsibility, running meetings, discussing their content with Lloyd and Jack, making decisions. In a letter to Michelle, still at Woodstock school in Vermont, I described the trustees meeting in September 1964. "I passed my first test at the first fall trustees meeting at the Museum — there were about 20 men there, more than ever before, and I was very severe and rapped my gavel a lot, and after the meeting they all clapped and said, 'You ran a tight meeting,' which apparently they like. We are really going to have to work hard this winter and raise a lot of money, if we are to be able to pay for the building, which has already started to be built. It will be a *very* hard job especially for me since I hate asking people for money."

And I worried. About Mum. About money. About my own family, as I spent still more time in New York. Miche was in boarding school, but the other children were at a peak of activity in a school that asked for lots of parental involvement. Running the "Toss a Sponge at a Teacher" booth at the Frogtown Fair. Driving a carload of boys to a lacrosse game in Greenwich. Making costumes for the Mother-Daughter Dinner. Conferences with the children's teachers. All this, important and good. And then the day-to-day business of getting and cooking meals for ever-hungrier children and their friends, driving to parties and lessons and friends' houses, being a cub scout leader, a Sunday School teacher — it added up to a busy life.

Still, I worried about putting businessmen like Benno on the board, those who weren't much interested in art and who might try to change things without knowing enough. About the precious but potentially threatened independence of the director and curators. About the hunger for power around me I increasingly began to sense at meetings.

About *change*.

Already, despite the allure of the new, I was becoming more cautious about the speed of that change. Maintaining the Whitney's traditions, as I'd learned them from Jack and Lloyd, seemed vital. That meant continuing the liberal policy, in effect since my grandmother's time, of showing a broad spectrum of American art. Exhibiting the young and emerging but not forgetting the older artists. Keeping in the Museum a spirit of joy and adventure. Maintaining the Museum's close relationship with artists. Perhaps the Biennials symbolize many of these traditions. The Whitney has always drawn criticism, ranging from "intellectual sterility" to "trendiness," from being "too conservative" to being "too avant-garde."

Barklie was the one I counted on most for advice. We could never lose, he said, by being daring and taking risks — only by conservatism and fear of change. He made me feel more confident in my increasingly demanding role.

From Suriname, around 1964, when I worried about both arguments and jealousies simmering, about the evident tension between David Solinger and Benno Schmidt, Barklie wrote about leadership, describing my own role.

> . . . no matter how various individual cards are played, it looks pretty much to me as though the real inside leadership will come (over a period of time) from those who really like the *subject*, first, and the peculiar Museum challenges second. I don't think the *social* need ever dominate the Whitney. And I predict that the "Bennos" are not a real threat because they lack the passion (re the subject) and will burn out fast. They can change the atmosphere — cool it a bit — but that won't stop people who really care. Like at first a pause for inserting a diaphragm is pretty unromantic but pretty soon you adapt and accept the little realities. In fact, they can add spice as Benno has in his own way — See, I don't think Benno really wants to wake up some morning to find that the Museum is *his*. He wants to be heard . . . to get close to the power center. He may even want to get in some good arguments — So many of these businessmen develop a pattern of going as far as the other guy will let them — for the zest of it, not with malice — as a sport without much purpose. They are bluffers. Their excitement comes from the close calls, the infought strategies.
>
> Most of them don't know what the hell they're really doing. You have to remember this. They find out while they're at it, fists flying. . . .
>
> Who *are* the passionate ones? They shall and should inherit the Whitney, whoever they are — and *of course*, yours and my . . . point all along is that *most* of the passion at any one time is in the professional staff & it's our job to see that it is . . . protected.
>
> You and I are a little different in that I kind of like fights and arguments because I like people to show their colors. You like people to get along happily — And what I want you to believe is that all the protagonists would not have *at all* the same level of disagreement, etc., if you (& your mother) were not felt and assumed to be somewhere *at the center* and *reliably non-partisan* and protective of the Museum in the long run.

Only a month later, back in Washington, Barklie wrote a sharply critical letter. We had agreed, he reminded me, that family and staff should act in harmony — but we weren't talking together, ahead of time. "A concealed iceberg of implications" was left dangling. "Not yet having had any sustained discussion about the Museum with your mother, I am at a loss to know where she believed a harmony of our views might begin to be based," he wrote, adding that he had for her the greatest respect and would always, "repeat always, publicly (or in any meeting with others) defer to her view. . . . I don't think the credit due her for what the Museum is in the process of becoming can be overstated."

What Bark didn't realize was that we were protecting Mum from just the kind of analysis he wanted. She didn't want to confront the issues he longed to discuss, she didn't want to have a conversation with him at all. I found it impossible to tell this to my dear cousin. Wrongly. He was giving us his best ideas, his commitment, and it seemed bizarre to him that we'd go off with my parents for dinner after meetings and not include him. And I never explained why. How could I have been so silly? So afraid to tell him. To hurt his feelings. Or was I afraid he'd reject me, and therefore the Museum, for my wrongheadedness or sentimentality?

The question of board responsibility for policy and board involvement was key to our success, according to Barklie. His letter continued.

> Two areas of the meeting especially interested me in terms of my tired old saw about the importance of the board being brought into basic policy matters during our money drive and as we are about to make some sort of a big leap forward: The discussion of admissions, membership, turnstiles, hours open, etc., where, after some fumbling around, Lloyd mentioned that the staff is in the process of a study of these matters. Whereupon David, I think, asked that when the study was complete it be presented to the board for approval and discussion. There it is in a nutshell! Perhaps you noted the several nodding heads as Lloyd agreed to do this . . . and A RESULTANT FEELING BY MEMBERS OF THE BOARD THAT THEY WERE CONSULTED, THAT THEIR OWN IDEAS HAD A HEARING, AND THAT THE MUSEUM GENERAL POLICY HAS BEEN SET BY THEM AS ACTIVE BOARD MEMBERS. *But,* of course, I felt a certain dismay that

this *just happened* at a meeting rather than that it was specifically anticipated and led into by the chair . . .

Another instance, of course, was the general discussion of our opening show in the new building. Two things were wrong with that, and I'm sure I wasn't the only one to notice them. First, there was no statement by the president making clear the distinction between the board's right to determine the *character* of so important a show for the Museum and the staff's right to have a completely free hand in the *execution* of the show. Don't tell me this is implicit and understood by all. Schmidt for one was beginning to enter the area of telling the staff how to gather such a show and when to get started. Secondly, there was no relating of a board-level discussion of the *objectives* for an opening show to a board-level consideration of the Museum objectives in, say, its first year of shows. I know I wasn't the only person to wonder — Are we all to assume that the board having spoken in one instance, that the staff will just proceed as during the past years in general programming of exhibits in the indefinite future? Good God!

He went on to delineate areas in which he felt the board could be involved, without impinging on the staff's autonomy. Jack Baur could present, say, a three-year philosophy of programs for the board's consideration, with ideas about a balance of permanent collection and temporary exhibitions, historic and contemporary. He could then ask for the freest possible hand in determining the specifics of that philosophy. *If*, that is, Jack, the staff, and ourselves, desired an active, committed, and enthusiastic board.

Barklie concluded, "I wish we could lie out on some sunny beach for a few days free from distraction of little ones, etc., and have a half stream of consciousness, half brainstorming about much of the above and much more. It always seems so rushed when I see you."

Yes, it certainly did — but my life didn't allow for those few days on a beach. And while I thought very highly of Barklie, neither of my parents approved of many of his ideas, and Jack and Lloyd were wary of them, too. Perhaps, to them, he was a "troublemaker," someone who stirred the pot unnecessarily. Perhaps, for my parents, it was still those sneakers!

And so we didn't address many of the basic issues he saw so clearly, and which would resurface from time to time, never more so than in the late '80s. In the '70s and '80s, I thought I was dealing with them,

but in retrospect, I believe I didn't push or dig deep enough. In the '90s, their accumulated weight had to be faced, and those who lead the Museum today have tried to resolve them in their own ways — the ways they know best, from their business experience. More specificity in the by-laws, tighter organization, committees to address ethical and legal issues, increased power for the board through its president and chairman. More structure, a bigger institution.

A year or so later, judging by a letter in November 1965, we must have paid attention to some of Barklie's suggestions.

"Leadership of this sort of board, I believe, IS a continuing expectation by its chairman of individual creative effort of each member. There must be an atmosphere of nothing being sacred, nothing being beyond discussion, of every policy being open — open to a current thoughtful judgment of its rightness-under-the-circumstances."

We were "really in wonderful health," he continued, saying this had a great deal to do with me, more than I myself realized. "It has long since gotten to the point where I cannot imagine this enterprise without you. If this occasionally makes you feel claustrophobic, I hope it also makes you feel engaged and proud."

His words indeed gave me pride. But he was right. If I could have accepted the "fights and arguments" as valuable lessons, and heard their underlying themes, I might have been, in the '70s and '80s, far more helpful to the Museum. If I had stayed nonpartisan. I covered a lingering insecurity by being stubborn rather than wise. Dedicated, hard-working, but too easily influenced.

Now, though, excitement was growing about the new building. Breuer's own words best encapsulate his hopes that it would be appropriate to its purpose and site:

In the designing of the project and after establishing its workings and its program, we have faced the first and most important problem: what should a museum look like, a museum in Manhattan? Surely it should work, it should fulfill its requirements. But what is its relationship to the New York landscape? What does it express? What is its architectural message?

It is easier to say first what it should *not* look like. It should not look like a business or office building, nor should it look like a place of light entertainment. Its form and its material should have identity and weight in the neighborhood of 50-story skyscrapers, of mile-long bridges, in the midst of the

dynamic jungle of our colorful city. It should be an independent and self-reliant unit, exposed to history, and at the same time it should have a visual connection to the street. It should transform the vitality of the street into the sincerity and profundity of art.

Tuesday, October 20, 1964, in another letter to Michelle I describe laying the cornerstone. "Lots of people sitting in the middle of the street, which was blocked off to traffic! Mayor Wagner sat right next to me, and made a very nice speech about the Museum — and Bani [her grandchildren's name for my mother] made a short speech and everyone clapped. . . . We're having a terrible time raising money — and this is supposed to help by giving us some good publicity. The building is being built, anyway."

People were highly curious about Breuer's first building in New York City. The details were intended to reflect the Museum's earlier buildings, and to continue the original Whitney spirit of welcome and intimacy. Parquet floors in small galleries on the second and third floors were thickly carpeted. With pearwood walls and ceilings, comfortable sofas, handsome desks and tables, they were inviting spaces. The "family" — trustees, Friends, and staff — appreciated the structure's boldness. We admired its forceful, elegant — some said "brutal" — stance on Madison Avenue, and its remarkable details: the granite stairs, the bush-hammered concrete, the bronze hardware, the granite sheathing. We knew the excellence of the circulation patterns and servicing systems. The democratic arrangement of office space appealed to us; everyone seemed to have equal position, windows, and square footage. We felt grateful to Jack, Bob, and Mike, largely responsible for the workable, functional planning, as well as for holding costs to a minimum. And, most important, we found the galleries superb.

To keep a little flavor of the old Museums, Connie Breuer, Marcel's wife, chose furnishings for some of the galleries. A desk for one room, a few sofas, benches, chairs. For upholstery and carpets, she chose Breuer colors — brilliant blue, red, yellow, elegant gray. Bit by bit, show by show, curators, disliking distractions from the works they installed, removed them. Visitors, however, enjoyed the casual ambiance they helped to provide, and I'm sorry those bright bits of furniture are gone. Apparently, "growth," in our case, meant "cooler"; a new distance between informal and formal, between private and public, between amateur and professional.

Soon after the opening of the newly built, newly created Whitney Museum in 1966, glowing reviews filled the architectural press, while the popular press remained cautious, sometimes negative or mocking. In time, the building became for most people a monument of Modernism, an icon of New York City.

There was, however, no space provided, as there was on Fifty-fourth Street, for my grandmother's sculpture. It was put in storage. I supported this decision, assuming that my grandmother wouldn't necessarily have wanted to put herself and her work in a central position any more. If she hadn't been my grandmother, I would have had no problem with honoring her work as founder of the Museum. I neither understood nor thought through her central importance to the Museum. In my youth and excess of discretion, trying to be fair, I pulled back from what would have been the right decision — to acknowledge and signify our beginnings. To show our pride in the Whitney's founder! The most significant aspect of the Museum's history and philosophy was thus invisible: my grandmother's unique roles in furthering American art, in the Whitney, and as an artist. My judgment in this matter was wrong, and, I believe, destructive to the Museum, since its founding has always been such an intrinsic part of its mission and character.

The balance between public and private, between old and new, essential to the strength and longevity of institutions, has always been difficult to maintain and understand at the Museum. We have swung wildly from emphasizing one to focusing on the other. In the '60s, the excitement of the "new" won the day. Instead of a room to honor the founder and provide a peaceful respite for visitors, we gave valuable space to a Friends' dining room, symbol of our new priority: the need for money. (Not well patronized, it was soon converted to other nonpublic uses.)

I realize today how easily I could have swung this decision the other way. But I was intent upon our new patrons. For their Museum potential, to be sure. There was, of course, my own pleasure in a new life, with new "friends" I saw as entrées into the exciting world of New York. But there I was again, following the same pattern of wanting to please, just as I'd pleased teachers and parents as a child. Too quick to dismiss too much of the past.

We also began to charge admission to the Museum, for the first time. I opposed this, convinced that Gertrude would have, too. The Whit-

ney was never about making the experience of art contingent on having or spending a certain amount of money.

I hated the connection between looking and paying. I didn't think of art as entertainment, comparable to the movies. It seemed all wrong. Think of the theater, the ballet, the opera, said my friends on the board. They were persuasive, pointing out it was the only way the Museum could come close to a balanced budget, with the increased expenses we expected: more space equaled more guards, more staff, more exhibitions, more visitors, more everything. "Wasn't the whole idea to welcome everyone, have American art free to all? . . ." "Yes, but . . ." And there seemed nothing to say. I wasn't capable of making the forceful arguments that might have convinced them. What, compared to them, did I know about money? "As soon as we get on our feet, raise more money for endowment, we'll go back to free admission."

The subject still recurs, and when I was president we raised money to make free admission possible for nearly half our visitors. But the basic prevailing policy is to pay, more and more all the time.

We always hoped to add to the $2.5 million endowment my grandmother had left, so that the income from that money would increase, but immediate needs often took precedence. Does having to pay money, one's first experience on entering a museum, alter one's experience of the art? For me, it was hard to erase that first impression, and it continues to be a difficult concept. Even Gertrude had to cut back on funding for her Museum, but the concern as well as the cost has grown with each move, each expansion, each year. What is the solution? To cut back on programs? On acquisitions? On space? On staff? On salaries, already low? Or to raise more and yet more money, requiring more development staff and richer trustees?

Difficult, unresolved issues.

But what a great time I was having, despite the worries!

Marcel Breuer —"Lajko"— and his wife, Connie, became our good friends. Lajko was a stocky, attractive man with sharp eyes, and a wide smile often spreading across his broad face. Connie was tall, with hair pulled back from her handsome oval face, dark clothes graceful on her slender body. She expressed her views with precision and clarity.

We saw a great deal of them in New York, in New Canaan, and in

Wellfleet, Massachusetts, where they had beautiful houses designed, of course, by Breuer. He prepared delicious chicken paprikash from old Hungarian recipes, and we met the I. M. Peis, Tician and Judy Papachristou, artists like Constantino Nivola, and patrons like Rufus and Leslie Stillman, who eventually commissioned no fewer than four Breuer houses. Around a square granite table set with delicate Japanese plates and lit by candles in massive bronze holders originally designed by Lajko for Saint John's monastery in Minnesota, we talked, we learned. Breuer's architecture, in elegant but simple materials, flowed naturally, beautifully, through light-filled spaces. The apparently effortless control of the environment, the serenity he created, pleased us greatly. These evenings, these conversations, fostered our growing intimacy with these new friends. Impelled to keep some kind of record, I see now from my notes how much it meant to us.

Another time, Connie called. Could we come to Lajko's surprise birthday party in New York? When we saw the surprise she'd organized, we were as amazed as he was: a friend of theirs had come to entertain him with her best belly dances. She was a pro. And how delighted he seemed! We loved seeing the earthy side of Breuer — such a sensual man, appreciating beautiful women and raunchy stories, too.

We visited the Breuers in Wellfleet, where I played chess with Lajko — as I did again later when he was ill. He was an excellent player, yet kind enough to humor my inexperience. I can see him in my mind today, in a silk robe, at the end of his life, concentrating on his next move, cheerful despite his weakness.

One of my last glimpses of him in public was at the Whitney in a small exhibition of Robert Venturi's work. This architect represented the antithesis of all Breuer had worked for in architecture: a modernist purity of language and ideal, translated into the finest materials. Bob Venturi was glorifying the vernacular expressions of mainstream America. And yet there was Lajko, at the opening, saying, "Well, I don't believe in his ideas, but I respect him. He's very bright, very talented. He's the future. We must look and think about what he's doing."

I admired his open-minded tolerance, and wanted to emulate him.

People of Breuer's caliber made me increasingly aware of a deeper imaginative and examined life. Through the Breuers, my self-confidence grew.

Once, ending a long evening at the Museum, we went to "Yel-

lowfingers," a disco near Bloomingdale's. After everyone else had left, we persuaded the manager to put on a Viennese tape, and Alfonso Ossorio waltzed me around the empty floor. Twirling, spinning, I was enchanted by this elegant, handsome artist of Filipino-Spanish-Chinese descent. The best dancer imaginable, Alfonso was also the most educated man I'd ever met. He offered to guide my reading, he lent me books, and talked of them with total recall.

After spending a weekend with Alfonso in Wainscott, we realized that his house and his collection were major works of art. In the portico, festooned with flowering plants, bright parrots greeted us. I'll never forget walking into the music room for the first time and seeing Jackson Pollock's *Lavender Mist* over the refectory table. The painting's powerful, otherworldly beauty seemed to open up childhood feelings and memories in me, feelings of yearning, happiness, and loss. Just thinking of that painting brings back those intense emotions, and also the excitement of being with Alfonso, of feeling myself in the presence of an extraordinarily gifted person. There were exotic objects everywhere in that house: a Turkish shoe-shine box, its brass fittings gleaming; an art deco vase, etched in gold, filled with dried grasses from the dunes; a small de Kooning painting; a group of prehistoric pots; chairs bristling with horns and antlers; a painting by Clyfford Still; a richly decorated altar; oriental jewel-like carpets. Alfonso's own work, paintings, sculptures, drawings, and prints, as original and dazzling as he himself, was expertly installed in the house Albert Herter, the early-twentieth-century muralist and portrait painter, had built. It looked across the whole length of Georgica Pond to the Atlantic Ocean beyond. Alfonso's big "congregations" seemed to watch us: glass eyes embedded in bright plastic, wooden shoe forms, shells, crosses, every imaginable detritus of nature and modern civilization, combined in myriad forms. Metaphors, I thought, of humanity in its infinite variety, displaying exaltation, joy, despair, cruelty, faith, and horror.

Alfonso and his longtime companion, Edward Dragon, a dancer and musician, presided over the household with grace.

To end the evening, we walked out under the stars to the pond's edge where pale swans glided, stately on the dark still water. Our final image of Alfonso's magic castle.

Alfonso's generosity, the information he shared, his strong opinions, his energy, and his very example helped me to further understand the creative life. But in Bob Friedman's *Alfonso Ossorio*, the frontispiece

shows Alfonso with a slight frown, a questioning look, giving an uneasy sense of a man whose lifelong search hasn't brought him all he'd hoped. Alfonso epitomized both the advantages and the disadvantages of wealth for an artist. He certainly took pleasure in his large and well-appointed studio, in the ability to focus on his work without worrying about the humdrum details of daily life, his beautiful surroundings and gardens. But in his lifetime he never achieved the recognition he deserved. I was to learn more about that, later, while doing research about my grandmother. About her endless struggle for acceptance. "Dilettante," they said, "not in earnest, just playing around."

Apparently, rich American artists are seldom taken seriously. We have other myths — like Horatio Alger.

Still determined to be different from my grandmother or my mother, to really be there for my children, I nevertheless was becoming more and more involved with the Museum. Although Mike and I wanted our children to be aware of what their parents were up to in New York, we were glad that their interests were focused in their own developing worlds. We didn't want the formidable names of Whitney and Vanderbilt to give them false values. I didn't want them burdened with the ancestral identity some of my relatives still clung to.

Recently, I asked two of them, long grown-up now, how they had viewed Mike's and my times at the Museum, away from them.

"I thought," said one, "it was all about social events. Parties."

"It was all about money," said the other.

"Why did you think that?" I asked.

"Because you always talked about raising money, how much the Museum needed, when you came back."

Neither remembered minding the time we'd spent there.

Did I have to choose one role or another? Or could I continue to be a "perfect" wife and mother, and also a "perfect" trustee? Which was my "real" life? I'd been a brooding, introverted child, but with marriage and children, I found very little time or energy left over for thinking. So I slipped gradually into this double life. Looking back, I'm certain that I was reaching out for a bigger world, a greater challenge. That I'd been simply one of the countless women who loved their families, but wished for a fuller life.

The friends I've described were helping me build a strong foundation for all my subsequent beliefs about the Whitney. And building

it on my early love of art, coming originally from my father and his painting.

I love the photograph of my mother cutting the ribbon at the dedication ceremony of the Breuer building on opening day — Tuesday, September 27, 1966, at 1:30. With Jackie Kennedy, head of our new National Committee, smiling at her side, she beams as the ribbon falls from her scissors, her arms outstretched in a wide gesture of welcome.

Flora spoke briefly.

I cannot tell you what this moment means to me. It is the culmination of a dream that my mother had nearly sixty years ago. As I cut this ribbon my heart is full of gratitude to the devoted people, our trustees, our staff and others, who helped with such generosity to give that dream, that vision, reality. It seems a fitting moment to dedicate this building, and at the same time to rededicate ourselves, to the ideal which the Whitney has always stood for — the service of this country's living art.

Like my mother, I, too, was always more comfortable with written pages before me. Did I fear sounding inarticulate or stupid? Or was I afraid of what I might blurt out — some dangerous truth or opinion? At the trustees meeting later the same day, she read more informal words.

This is an exciting moment! Our new building is beautiful beyond words. I doubt that it will ever seem more so to me than now — when all of you who made it possible are meeting here for the first time.

It seems like such a short time ago, doesn't it, when we first met together as trustees? We knew we were there to plan and build something new — something, I feel, totally consistent with my mother's ideals on behalf of the American artist.

This board's first important decision was to build our *own* Museum — away from the shadow of any existing institution. Not long after that decision, I remember when David [Solinger], heading a Planning Committee, told us we would have to raise $8 million to accomplish this — and even more amazing, saying that we could! This seems like yesterday — in spite of the fact that a year ago I wondered if the time would ever come when we weren't *completely* preoccupied with fund-raising. I think that time has come. Not that our campaign is completed — there is still much to be done. Not that ever again will there be a time when this board is not searching for new sources of support.

But that *now* we can balance our awareness of *this* against the responsibility entrusted to each of us to assure that this Museum plays an expanding and vital role, because I think all of you, as you feel joy at the beauty of this building, also feel the seriousness and depth of the challenge it imposes on us.

You are marvellously dedicated trustees — you have been unbelievably generous with your time and your money. Again and again your talents, creative and organizational, have been indispensable to our progress. Truly this is your Museum. It is the product of your vision and your hard work.

Then she thanked people individually. Finally, she ended on this rousing note:

The new Whitney Museum is capable of greatness. Because *you* who have been entrusted with its ideals — and now its beautiful new home — *you* are capable of greatness. Four years of our association on this board have convincingly demonstrated this. I hope charting the development of our Museum in the years ahead will be exhilarating for you. I'm sure it will be more fun than just raising money — and every bit as important.

Thank you all so much.

These words are nostalgic — bittersweet, in their trust, their joy, their underlying melancholy, and their implicit farewell. "Truly, this is your Museum."

Ten

*I*n 1967 my mother was ready to resign from her position as president.

In my photograph album my parents, Mike, and Jack Baur linger over wineglasses and fruit around a table on the porch of our house in Connecticut. It's a lovely fall day, maples blazing red and gold behind the waterfall. Laughing at the camera, they are relaxed as always with each other. With the board, Mum could be rather formal. Only we on that porch, perhaps, could sense how tense was her big smile, how strained her too polite words, how hard she worked to deliver her customary warmth and friendliness — all, of course, for the sake of the Museum.

That day in New Canaan, we discussed the succession. We'd create the new position of chairman for Mum. She'd hold it as long as she lived. The title would imply no work, no responsibility.

Would I now become president?

Please, please, said my mother. Looking at Mike, at the children playing below the house, I said no. I just couldn't give it all it needed, couldn't spend enough time away from home. Waving my arms at all that lay around us. Mum, I could tell, was bitterly disappointed.

Was I afraid?

Continuous fund-raising would mean reaching out to people I didn't know and had no idea how to find. It would mean a different relationship, too, with those I already did know — demanding ever more work and money from them. Perhaps I might jeopardize my new friendships.

I didn't want that.

And again, I remember thinking that asking for money seemed like asking it for myself. I identified with the Museum, as had my mother.

My mother's self-image was closely related to that of her illustrious family. The Whitney was part of her, to the point that when she felt things weren't going well, she'd get sick. Names are so magical, so powerful. Spells against darkness and oblivion . . .

Gertrude had been tougher. When her name seemed a disadvantage to her career, she wished she'd been born into a more ordinary family, but she also knew how to use her position for what she wanted. Fighting for her sculpture commissions, she was often asked to contribute her services, but she always demanded to be paid as a professional. And she grew hardened to criticisms (both of her own work and of the Whitney's exhibitions) by her teachers and by critics. My mother, with a less passionate nature and a quieter lifestyle, was more vulnerable.

Learning to raise money, then, meant learning to separate myself from the Whitney. This was easier for me than for my mother, because I'd always been ambivalent about my connection with the family. Had downplayed it. Had moved away physically and also emotionally. Perhaps the isolation I'd felt as a little girl had strengthened as well as distanced me.

That semiconscious pushing away from the social position implicit in being a Vanderbilt or a Whitney eventually enabled me to push away, too, my identity with the Whitney Museum. Loyalty to the family and to the Museum had buried my recognition of these feelings, parts of the many secrets it had become a habit to keep. When I needed to, later, I found I could ask for money. I even enjoyed it. I enjoyed the power.

Thinking of these generations of women, I see us as emerging from each other, fitting together like those Russian "Matrushka" dolls. Using our collective past to go on to an independent future. Gamoo's and Mum's lives, revealing and concealing in a perpetual dance, weave in and out of mine.

"Life can only be understood backwards, but it must be lived forwards," Kierkegaard said. None of this was clear to me then, nor, I think, to Mike or my parents. Jack not only sympathized with my family reasons, but agreed with my suggestion that David Solinger deserved the title and the honor of being the first nonfamily president. He was *not* a Russian doll, far more like the proverbial new broom. First president of the Friends, David had led the fund drive — not in giving,

but in organization and hard work — and for that alone we owed him. But he was prickly. My father, who had strong instincts about people, had little faith in him. And a close friend, Dick Salomon — father of Duncan's friend Ralph — who knew David in other contexts, warned me to be careful about giving David a position of power at the Whitney. Dick felt Solinger couldn't inspire the trust our institution needed, and too many people disliked him. I didn't then know why, but I respected and believed my friend.

Could Jack, who would soon be director in the normal, traditional succession at the Whitney, deal with David? Yes, Jack could, he insisted, and it was the only fair thing to do. That was Jack. Equitable, living out his ideals.

But what about Benno? Our biggest donor, our best fund-raiser. In the big world, our most powerful trustee.

But how could we have someone who didn't really care about art as president? What would artists and the art world think? That the Whitney's nature, its commitment to art and artists, had changed? That now, money and power were more important? No, Benno could not be our choice.

And Bob Friedman, whom we'd all have preferred, had gone off to Cornell to teach. Besides, the job would take too much time from his writing.

"It's time," I said, "to show we really mean it when we say it's not a family museum any more. What could be a better way? A stronger statement?"

We avoided discussing one cogent reason for the change.

Quite simply, that the family could no longer support the Whitney Museum.

Our resources had dwindled, through a combination of bad management, lack of sibling solidarity, and a dearth of entrepreneurial energy. Bright and spirited as my generation was, none of us had earned a lot of money. Although my mother was comfortable, her grandparents' and great-grandparents' enormous fortune was dissipated. I didn't understand why. In our family, we talked of money even less than we did of sex or death. For us, as children, the source of our daily bread had been as mysterious as that of babies, and still remained so. Not until I did exhaustive research about my grandmother for a book, not, really, until my mother died, did I discover the facts about our "downwardly mobile" journey.

Fund-raising was now a necessary job for the president. David, for this reason, was an unsuitable choice. For me, though, the fear of feeling guilt if we didn't choose him overrode the good of the Museum. What would he think? (Of *me*.) What would he say? (To *me*.)

The decision made, David was delighted. For three or four years, we told him. Until I was ready, was the implication; another important thought unspoken, left unclear.

When my mother and I visited Benno in his office to give him the news, we were staggered by his reaction. David! That twerp? How could we give our Museum over to *him*? He couldn't believe it. Why wasn't I taking the job? He'd support me, help me all he could.

We reeled out of his paneled office and leaned on the elevator bell, and I feared Mum would faint onto the thick carpeting. Why was Benno so upset? He must have expected we'd ask *him* to be president, Mum and I agreed. And that, as I remember, was nearly the last we saw of Benno at the Museum, although he remained on the board until 1984.

Looking back, I believe that Benno, a powerful businessman, knew David lacked a platform from which to attract people with money to the Museum. Therefore, he couldn't lead the Whitney successfully.

As I couldn't easily come to New York the day of their appointment, we agreed that Mum could tell Roy Neuberger by herself, thinking he'd be pleased. He was horrified, too. And Mum was shaken again. Roy felt he deserved the honor more than David. A few years later, after we'd turned down his suggestion that the Whitney be renamed for him if he gave it his collection, he left us for the Neuberger Museum in Purchase, New York.

Benno's angry rejection probably changed the direction of our board expansion. Choosing David Solinger, in retrospect, relates to those other decisions not to merge with the Metropolitan Museum, which, while ensuring our financial survival, would have denied our principles. Benno would probably have been an excellent president. Besides, he would have respected Mum's wishes.

Without Benno, we had little access to bankers and businessmen, so we concentrated on finding patrons with new money and new collections who were drawn to the Whitney's art, as well as to its cachet.

Today, I recognize the varied reasons people may have for wishing to join a board such as the Whitney's. Social ambition, business con-

tacts, diversity, a desire to influence programs, idealism, wanting to fill up time — and still more. This is reality. A genuine love of art may or may not accompany any of these compelling drives.

The presidency of an institution is a highly political job, requiring insight, intelligence, experience, ambition, a certain ruthlessness, and the individual's dedicated time. Of course, the director needs to be even more perfect, taking big responsibility but receiving minuscule pay compared to a corporate executive. Small wonder there's such a high turnover in directors today. Wealth was, and remains, the primary condition for election to the board. The Museum has always needed more money — immediately, upon moving to the new building, and progressively ever since. Our endowment is still small in relation to our expenses; therefore, most of the yearly budget must be raised. Much of it comes from the trustees, who have been extraordinarily generous over the years.

Until recently, hoping to identify members who would genuinely care about the Museum, we required that prospective board members sit on committees for at least a year before being elected. If a "big shot" can't wait a year or so to join the board, that individual will not prove helpful in the long run. And institutions *are* for the long run.

Mum, as chairman, came to meetings when she could, and the tone of the meeting changed with her presence. Egos were submerged in a sharper perception of our responsibility to the Museum. Engendered partly by the awareness of its history, as my mother projected it, these good feelings also came through her encouraging, enthusiastic personality. She always made a big effort to look well, to be at her very best.

Much later, when she no longer came to New York, I would take new trustees, staff, or patrons to meet her at home in Old Westbury, where she welcomed them with the same courtesy and zest. I'm sure they found the experience memorable. I recall when Mum first met trustee Brendan Gill. He, as were many who met her, was enthralled by my mother.

The ultimate conversationalist and charmer, Brendan gave her a wonderful time, telling stories, responding to hers. She reacted with an almost childish delight. "Oooh, what a marvelous man!" she said later. "I hope he'll come back!" This was true praise, not given to many new people at that stage of Mum's life.

* * *

David, as president, kept the Museum within its budget, ran efficient meetings, and gave his time and money as generously as his nature enabled him to. The Whitney was his biggest interest, always, and his biggest commitment. The Museum, in turn, enriched his life.

As soon as David became president, our relationship seemed to change. In soothing, rhythmic tones, he began patronizing sentences with "Well, you must understand," or "Flora, I must tell you I don't agree." I was naive, he reminded me, as if it were a given.

I was vice president, but he was president.

Although I was ready for more involvement, for more responsibility in preparation for taking the role myself, David Solinger believed that the Museum was no longer a family affair. In fact, the less it was identified with the family, the easier it would be to raise money from others who would then be convinced that Whitneys were no longer supporting the Whitney Museum. Perhaps we should even consider changing its name.

Jack disagreed. He believed that the Museum's health resided in its history and in the family's commitment.

Upset by David's rejection, I made an appointment to have lunch with him, to discuss things openly. Although the day he chose was inconvenient, I was right on time, and settled down to wait in Giovanni's, a wonderful Italian restaurant, a favorite of my parents. A half hour later a message came: David would be another half hour. Annoyed, I waited, only to get another message: could I come to his office, he was tied up in a meeting. Hungry and mad, I walked a few blocks to his office, waited another half hour without seeing David, and finally left to catch my train back to the country. I had gained a painful sense of my position in relation to David.

He was intelligent and dedicated but shadowed by a lack of grace.

In 1980, after I had been president of the Museum for a couple of years, David said, "You've done a superlative job as president, Flora. Really better than several of us thought you could have done."

Recently, meeting David at the Met, although elderly and almost blind, his razor tongue was still intact. "Oh, Flora," he said, "It's so nice to see a trustee looking at art. That's so rare these days."

The Museum was probably the most important thing in David's life. He gave it his best. He maintained the Museum's stability during the transitional years in the new building under new leadership. And he

led a very significant project: the purchase of a middle building on Madison Avenue, south of the Museum. As I wrote to my parents in Paris in 1967, "The building involved is much smaller and rather run down. However, those present felt it was the key to the whole block and necessary in order to prevent someone else 'assembling' all the others and building a huge apartment building. I was the only mild objector, and then only on the basis that we'd become slumlords, after David's description of the inside of the building, which wasn't so great — and as this apparently must be a great secret, we can't very well go in & fix it all up! However, this objection was quickly disposed of by the illustrious trustees present: Benno, Alan, David, Roy, Mary, and Mike — a pretty good group to decide such a thing — and David had spoken to Bob on the phone. He was very much in favor."

I was certainly glad that we now owned the whole blockfront, ensuring the possibility of expansion to future generations.

In general, David's presidency was a time of consolidation. However, the recognition of American art and artists created unprecedented opportunities, in those years, for those artists and for our museum, still the only major museum of contemporary American art. While some of our programs reflected this flowering, the board, in terms of new patronage and new money, only took advantage of it later. David made some fine additions to the board: Susan Morse Hilles, daughter of Samuel Morse, a major benefactor of both art and money, and Charles Simon, a generous and devoted trustee from 1972 until he died in 1995.

In 1968, another change at the Museum. Lloyd Goodrich had been director for ten years. His age left his energy undiminished. He relished the job. But Jack Baur was getting older, too, and it was his turn. He was virtually running the Museum, with Lloyd turning increasingly to outside activities and writing. Barklie and I discussed the succession with Lloyd, and he reluctantly became director emeritus, continuing on the board, with an office and secretarial help in the Museum. Jack became director.

Both Lloyd and Jack understood the Museum's basic mission. They supported showing *all* American art, rather than just the realistic work that not only they, but also my grandmother and Juliana Force, much preferred. In retrospect, I see that their understanding was extraordinary, given the public's lack of acceptance of abstract work. That

which is most popular, most accepted, is often not what lasts the longest. I am grateful for the example set by these four heroic figures for me and for the Whitney. I hope we'll never abandon the "liberal principles," as Lloyd called them, that Gertrude espoused, the rock on which she had founded her Whitney.

In 1973, one of Jack's dreams came true: the Whitney opened its first branch museum.

Bob Friedman helped to find space in a new building at 55 Water Street built by his uncles, the two founders of the development company, Uris Brothers, in the culturally deprived downtown area of the city. Hilton Kramer, always antagonistic, even gave the first exhibition there (of the permanent collection) a rave review in the *Times*. As head of the Museum's education department administering the branch, David Hupert said that exhibitions would feature items concerning New York and its environment, experimenting with "things not ordinarily considered art," as, for example, New York subway mosaics, with and without graffiti.

One exhibition featured the work of Mierle Laderman Ukeles, official artist of the New York City Department of Sanitation, who handed out buttons empowering all viewers as collectors of garbage or toilet cleaners or street sweepers, at a time when few artists were addressing sociopolitical issues. It's easy to understand why many people asked, "But is it art?" In this context, it was, and Mierle, most definitely an artist.

Contributions from the corporate community downtown paid for this branch; students in the Independent Study Program curated shows. In the late '60s and early '70s, the education department also sponsored the Art Resources Center, in a building on Cherry Street almost under the Williamsburg Bridge, where young people had their own studios and interacted with artists and others. These kids were mostly minorities, mostly doing badly in school. During the long teachers' strike, some would walk all the way across the bridge from Brooklyn to get to Cherry Street. Pleased by their progress, we had an exhibition of their work in the Lobby Gallery of the uptown Whitney.

Although the audience for most of our exhibitions had never been and still was not large, a record number came the first year, attracted by the Breuer building: 741,408. The following year, 1967, the Andrew Wyeth exhibition drew the largest daily attendance of any show ever at

the Museum: 4,787 a day. This crowd overtaxed our building and staff. Admission revenue wasn't large unless we had "blockbusters," and they were usually unpredictable. The Museum stepped up its focus on membership as a way not only to make money but to build our audience.

Meanwhile, a new group of young curators working under Jack created, in the gray granite and slate of our austere, serious building, a series of intellectually challenging, spatially innovative exhibitions, including large-scale work, minimalism, Pop, multimedia, film, music, performance, "happenings," and more. It was a time for social consciousness, too: such exhibitions as "Human Concern/Personal Torment" responded to the agonizing issues of the Vietnam war and to the civil rights movement. A show of black artists was highly controversial within the black community: some artists dropped out, and one group picketed the Museum, declaring that the very act of segregating black art was discriminatory. Defending the show, I wrote that "the Whitney has chosen *its* only means of expression . . . it acted upon its convictions." Those exhibiting would be looked at seriously, as artists, I insisted, no matter what their color. Perhaps I was wrong and perhaps Jack was wrong, too, to have approved an exhibition that put artists together because of their color; but at that moment it seemed timely, right, and even courageous, since it emphasized the numbers of fine black artists who enjoyed little or no recognition.

We watched the Breuer building accept forms of art that the curators and Lajko himself couldn't possibly have foreseen, marveling at how well this new work looked — a great tribute to our curators' skills at installation, as well as to the architect. Gray might be our color, but seldom now were we the "good gray Whitney," as critics had described us on Fifty-fourth Street.

There were, however, ever-decreasing funds available for purchases, while prices for major artists were beginning to soar. The Whitney couldn't hope to buy these works, unless someone gave or raised a lot of money. No one did until Howard Lipman, an adventuresome collector who had recently joined our board, stepped into that role.

In 1970 the Museum launched the New American Filmmakers Series, to showcase films of quality that would not be shown commercially. Until 1976, when the Jerome Foundation of Saint Paul, Minnesota, began providing major grants, it was primarily supported by the National Endowment for the Arts and the New York State Council

for the Arts. My cousin Barklie, a film buff and aspiring filmmaker, was responsible for this program, arguing cogently for an experimental film department with a full-time curator, different from MoMA's emphasis on classic films. He made an analogy with the Biennials,

> where we present, in effect, the thinking of our art department which exists 12 months a year — we don't just "show painting" — and therefore the show is the most important art show of each year in the USA, however imperfect. It is selected by experts in the field, and is based on their whole year's gallery and studio visiting. In any historical sense, we will accomplish nothing with film . . . unless we adopt this point of view.

And he contrasted the Museum's performing arts program as just "showing music and dance without there being a real critical intelligence, . . . a grade B effort at best.
Barklie continued, in this 1971 letter, to define his vision of the Museum's role:

> In order for Jack to get this far, he must change his thinking from the idea that the Museum is really about painting and sculpture — but that we occasionally do other things . . . the strongest thinkers today no longer do. Let Howard Lipman articulate this. . . . Hell, he is the most committed collector of contemporary sculpture in the country — (and Gamoo would have grooved on Howard) — but he says and believes that film is the art form of this age — Well, shit, of course he wants any museum he is committed to to have a distinguished film program — like he wants it to be *alive* —
> This is why I wanted the Whole Earth Catalogue to be sold in the Museum, as it is. This is why I wanted Soleri [an avant-garde architect and philosopher whose show at the Whitney was extremely popular] to be shown, and why I rejoice in our having an architecture and city planning committee. The concept of discrete and separate fine art is no longer where our heads are supposed to be at — God is dead. Our world is a mess. And we are all supposed to be looking for liveable and workable alternatives to past patterns and categories we have become frozen into — and, yes, a museum can be this hip — and must be, Flora — because there are enough of us there who know this is the feeling it should have — and who don't need the nostalgia or past-patterns trip. The Museum must grow like an organism — and in doing so reflect the growing con-

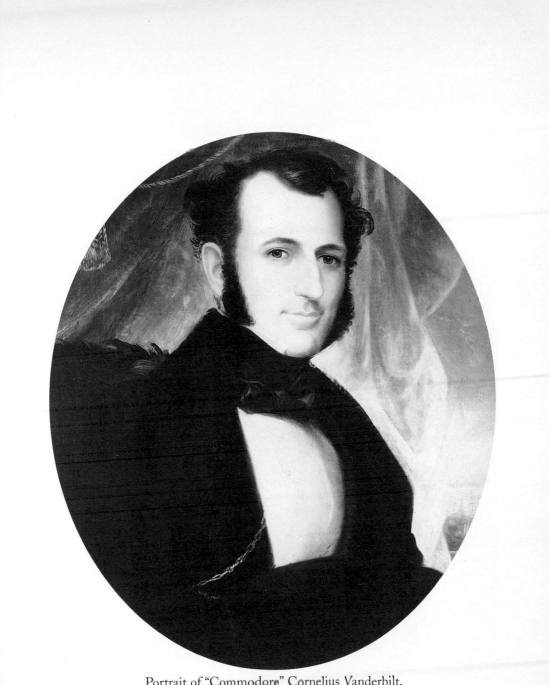

Portrait of "Commodore" Cornelius Vanderbilt,
painted from life by Henry Inman in 1837.

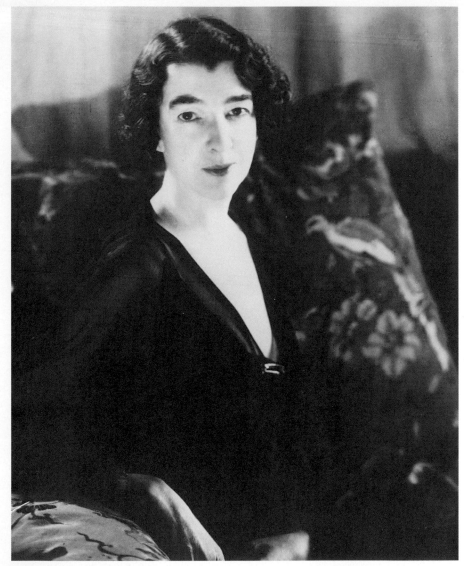

Gertrude Vanderbilt Whitney, just before the Whitney
Museum of American Art opening, November 17, 1931. *Edward Steichen,
reprinted with permission of Joanna Steichen.*

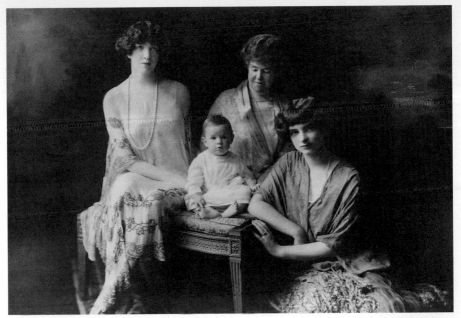

Four generations: *(from left)* Gertrude Vanderbilt Whitney (Mrs. Harry Payne Whitney); her granddaughter, Pamela Tower (Mrs. Thomas LeBoutillier); her mother, Alice Gwynne (Mrs. Cornelius Vanderbilt II); and her daughter, Flora Whitney Miller (Mrs. George Macculloch Miller).

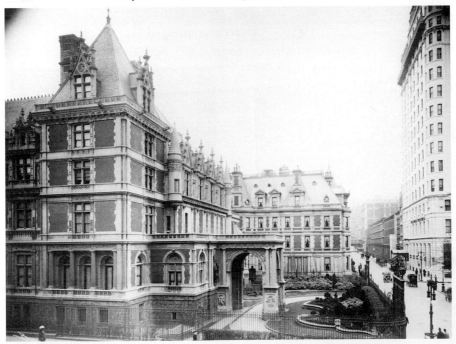

Home of Mr. and Mrs. Cornelius Vanderbilt II at 1 West 57th Street, 1908. Also visible: the Plaza Hotel, Fifth Avenue, and 58th Street.
The Byron Collection, Museum of the City of New York.

Interior of Mr. and Mrs. Harry Payne Whitney's
(Gertrude Vanderbilt's) house at 871 Fifth Avenue.

Gertrude Vanderbilt Whitney with
her dog, Loup, in Paris, circa 1914.
Boissonas & Taponier.

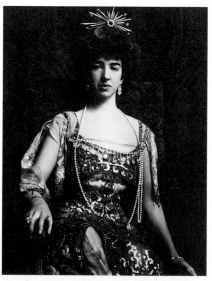

Gertrude Vanderbilt Whitney,
circa 1909. *Bradley.*

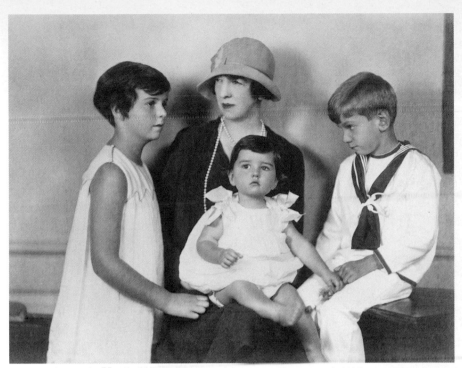

Gertrude Vanderbilt Whitney and three of her grandchildren, 1929:
(from left) Pamela, author Flora, and Whitney.

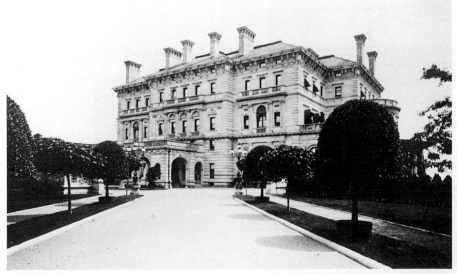

The Breakers, Newport, Rhode Island, designed by
Richard Morris Hunt, completed in 1895.

Gertrude Vanderbilt Whitney
working on a figure for the Arlington
Fountain, circa 1913.

Chinoise, by Gertrude Vanderbilt
Whitney, 1914. Photograph copy-
right © 1997: *Whitney Museum of
American Art, New York.*

Mother and Child, by Gertrude Vanderbilt
Whitney, 1935. Collection of *Whitney
Museum of American Art, New York.*

Gertrude Vanderbilt Whitney's studio in Old Westbury, New York. Designed by William Adams Delano, 1910–1913. In the foreground, her Arlington Fountain.

Close-up of Arlington Fountain by Gertrude Vanderbilt Whitney, 1913. Photograph copyright © 1998: *Whitney Museum of American Art.*

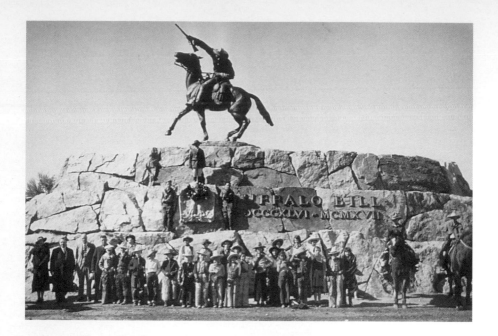

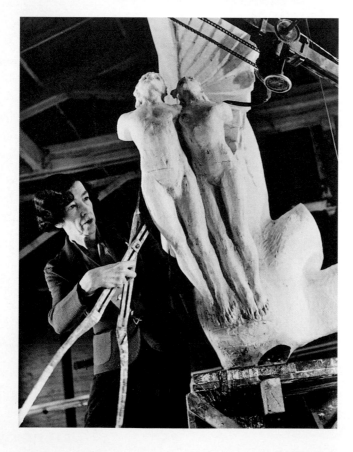

Above: Dedication of *Buffalo Bill Monument,* by Gertrude Vanderbilt Whitney, Cody, Wyoming, 1924.

Gertrude Vanderbilt Whitney working on *Spirit of Flight,* 1938, for the 1939 World's Fair in New York. *Walt Sanders/ Black Star, NY.*

Above: John Sargent's drawing of
Gertrude Vanderbilt Whitney in
her Léon Bakst costume, 1914.

Right: Gertrude Vanderbilt
Whitney, circa 1913. *Baron de
Meyer.*

Above: First home of the Whitney Museum of American Art, 8 West 8th Street, 1931. *F. S. Lincoln.*

Juliana Force, first director of the Whitney Museum of American Art, in her apartment above the Museum. *Cecil Beaton. Copyright © Whitney Museum of American Art.*

The opening of the Whitney Museum of American Art in 1931. *Frances Mulhall Achilles Library, Whitney Museum of American Art.*

"Cully"—George Macculloch Miller, Flora's husband—in the Adirondacks.

Above: Flora Whitney Miller,
circa 1930. *Cecil Beaton.*

Right: The photograph of Flora Whitney Miller
at Camp Deerlands, in the Adirondacks, that
her husband "Cully" always kept on his desk.

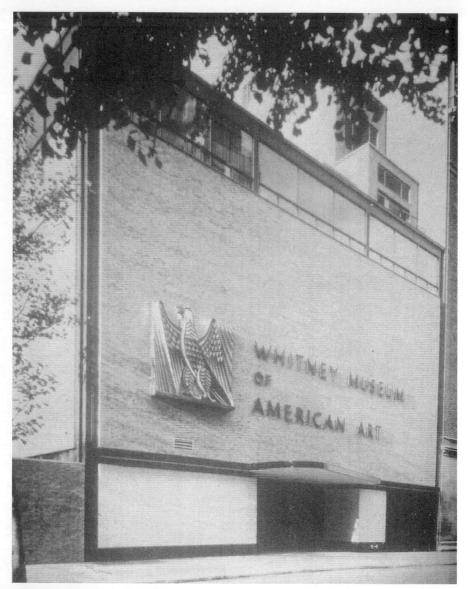

The second home of the Whitney Museum of American Art, 1954, designed by
Noel & Miller, at 22 West 54th Street. *Ezra Stoller. Copyright © Esto.*

sciousness all around us that everything else is an organism — that all the parts are related and therefore relatable. If we say this each year about art-in-life and art-of-life — which is like *vital* to be saying in the midst of the biggest and wildest and sickest and in a sense most beautiful city in the world — we are really saying something, then. WE ARE REALLY TAKING OUR RESPONSIBILITY TO PLAY AN EDUCATIONAL ROLE SERIOUSLY.

How prescient, this letter. Barklie *felt* the sensibilities of those times. And yet, the Museum failed to act on his grand vision. Pieces of it, perhaps, but not with his all-encompassing view.

Through Barklie, I sensed the possibilities. More cautious, insecure, I longed to be as passionate, eloquent, and forceful. It was relatively easy to strongly support the film and video program, and I did. It was much harder for me to criticize existing programs, such as the performing arts program or acquisitions, which also would mean criticizing Jack as director. My unconscious fear of losing love, I now see, was eroding my judgment capability.

We did raise money from patrons who often didn't appreciate the somewhat arcane film and video program, but who realized that it was becoming an important part of the creative world. They were wonderfully trusting. I remember, for instance, climbing up about six flights of stairs in Greenwich Village with a tidy uptown group who were intrigued by the Videofreex and their funky, lively videos. And despite Barklie's prognostications, Jack was entirely supportive, even though funding was difficult and a large audience lacking.

Barklie was certainly right about the centrality of film to our art world. Today the film and video department has become an integral part of our program. It has increasing visibility in Biennial exhibitions, and occasionally its own floorwide exhibitions. For twenty years, until 1996, John Hanhardt, the leading scholar in that field, was its superb curator. Despite being on the cutting edge, it has seldom drawn adverse press, as our other exhibitions often do. Is this because reviewers of film and video understand their subject better than do reviewers of painting and sculpture? Is it because avant-garde film and video isn't popular, therefore isn't controversial? Is only popular art controversial? I'm not sure — but I was glad for the good reviews.

When I became president in 1977, budget problems were forcing us to take a hard look at programs that did not generate enough support

to sustain themselves. Determined to somehow keep the floundering film and video program going, I asked John Hanhardt to let me know when there would be a film appropriate for the board. Surely one or more of the new trustees could be enticed to fund this wonderful program. The film coinciding with our next board meeting had been made by an eighty-year-old Wall Street stockbroker. Perfect! After my enthusiastic introduction, over half the board followed me to the auditorium after the meeting.

After about a minute, it appeared that the venerable filmmaker with the double career had surprised us with one of the most erotic films I had ever seen. One by one, shocked and embarrassed trustees slunk out of the darkened room. It had not occurred to me to screen the film ahead of the meeting. I learned the hard way from that moment on to screen *everything* trustees were to see at the Museum. Luckily, I was still in great favor as the new president. No one held this pornographic viewing against me, as far as I know, and so life went on.

In 1982, the first major one-person video exhibition ever held at the Whitney, or anywhere in the world, took place. Nam June Paik was the best known video artist of the time, and all of us at the Museum were in a state of excitement about the opening. Born in Seoul, Korea, in 1932, Paik had graduated from the University of Tokyo with a degree in aesthetics and a thesis on Arnold Schoenberg, and had then traveled to West Germany to pursue his interest in twentieth-century music. There he met George Maciunas, the founder of Fluxus, which can be defined as "a movement against the perceived tyranny of fixed definitions and categorizations of what constitutes art making and its history," as John Hanhardt says in the Paik catalogue. "The distinctive features of Paik's art — influenced by Fluxus attitudes — were the active exploration and incorporation of randomness and chance and the appropriation of found objects into his performances and the making of objects." In these central aesthetic strategies, he was influenced greatly by John Cage and Marcel Duchamp, whose writings and art he transformed into performance, composition, sculpture, and video sculpture.

"At 50," wrote Robert Hughes in his review of the show in *Time*, "Paik is the sage and antic father of video as an art form — the George Washington of the movement. . . ."

Unlike our usual video programs, there was lots of publicity — the exhibition was a real breakthrough, and signaled the Whitney's commitment to this relatively new art form. Nam June is a charismatic, de-

lightful person, and his friends were gathering to celebrate — John Cage, Merce Cunningham, and many other artists. I went every day to watch the installation and knew right away that it would be a zinger!

Relations between the actual and the represented jumped out from *Video Garden*, for example, as I looked down from a platform at dozens of upturned television screens projecting colored images, like summer blossoms, on the sea of lush green plants mingled with them.

In another part of the exhibition Charlotte Moorman, an accomplished classical cellist, performed her famous *TV Cello, 1971* live, topless, alongside TV screens carrying video collages of other cellists and herself playing. As John Hanhardt, the curator, wrote in the catalogue, she is "playing with the form of the sculpture and the video images. Thus the objects and screen images present metaphorical forms — synecdoche, metonymy — and irony which constantly jostle with each other."

We invited Kitty Carlisle Hart, chairman of the New York State Council on the Arts, major funder of the exhibition, to visit the show with Paik. We spent a long time with *Video Fish*. The catalogue summed it up well.

"The real environment of the fish placed over the recorded one of the television set causes the monitor to become a fish tank and the fish tank to become a monitor — an added dimension to the metaphorical strategy implicit in all of these works. The visual quality and colorful playfulness of *Video Fish* belie its serious commentary on the nature of video as a representational medium and recording instrument. Here, representation and reality join together as equals."

We passed big tanks hanging on the wall, full of bright tropical fish swimming below a sequence of monitors on the ceiling. Beautiful Kitty in her elegant pink suit and high heeled red pumps, ready for any adventure for art's sake, lay down on her back with us, thin foam cushions between us and the flagstones, and gazed up at the ceiling of the darkened gallery where television screens played a videotape of the fish. A magical moment. All around, couples seemed happily entertained and engrossed. "I think," said Nam June in his Korean-accented voice, referring to the supine audience, "many babies born this year." And roared with laughter, as did we.

Nam June Paik, a visionary, an innovator, was the first artist to see the possibilities of video for artists. I was personally so proud of the Whitney for showing his work.

The *Video Fish* installation transported me back to 1958, when Mike and I had gone to Mexico for a week and then to the Caribbean to spend another week with my parents on a big motor yacht. Snorkeling, I'd become enraptured by the variety of brilliant fish, and by the fans, ribbons, and tangles of seaweed and coral formations over pearly white sand in the aquamarine sea. I didn't want to ever leave this ravishing world. But, as most mothers do, at the same time I worried about our children. We'd left our household in good hands, with kind caretakers, but we never went on such a long trip again.

Art was increasingly intertwined with my daily life, affecting me in different ways. Walking around New York, I'd really look when my eye lit upon an old door with peeling paint, or a rain-soaked piece of newspaper, or an oily puddle with rainbow colors. And I'd associate the sight with a childhood fear, or recall a tender moment with a friend, or suddenly feel extremely sad or incredibly happy. In Nam June's show, *Video Garden* seemed to open up rivers of feeling for my family. The effects of art are so mysterious and powerful. How important they are to us all! And that is what a museum is about, after all the rest is dust.

By 1970 our two oldest children had become adults. Michelle was married, and although her marriage didn't last because her husband was a Scientologist who cared only for that cult, she had a beautiful baby, Anthony. Duncan was at Ithaca College, and since it was the time of the Vietnam war, we worried that he'd be drafted. We were opposed to the war and so was he. Luckily, our draft board was headed by a man who announced he'd never allow a genuine conscientious objector to be drafted — and he didn't. Cully was boarding at Middlesex School in Massachusetts. Fiona was the only one at home. Hard for me to believe. Although everyone came home for vacations, usually with friends, our house now seemed too big. We moved to a Victorian one with enough bedrooms for the whole gang on the main street of the village of Rowayton, a part of the town of Norwalk, Connecticut, on Long Island Sound, near where we kept our boat. I decided to pursue a long-term goal: a college education. At Manhattanville College, only a half-hour drive from our home, I soon became immersed in books, homework, papers, and exams. Difficult as it was to awaken my mind to hard study, I found that I could keep up with others half my age as well as with my contemporaries — for about a third of Manhat-

tanville's student body were, like me, enrolled in "continuing ed" programs.

"Well, Mom, that's why you're supposed to go to college when you're eighteen!" the children would tease when I complained about homework. However, the whole family was extraordinarily helpful, quizzing me for exams, editing my papers, cooking meals, and being patient with my moods. I'm as grateful to them today as I was then, remembering the long hours of study and writing when I was away from them in spirit, if not in body. There was even the year when, hoping for a career as a psychologist, I worked in a mental hospital part-time, coming home with horrendous tales of electric shocks and suicide attempts. Yes, my husband and children put up with a lot. In a positive aspect of my new involvement, on the other hand, I didn't cling to the children as they grew away from their home and developed their own lives. And we had more to talk about, more in common, than ever before. I relished that. Somewhere, too, I expected to banish my age-old feelings of inadequacy, and join the ranks of those who earned respect outside the home.

Eleven

*I*n the early '70s, my life changed again.

In a college seminar, I was assigned to write a paper on a woman who had influenced me. I asked my mother if she had any material on Gertrude. She sent me to the attic of her house in Long Island, formerly her parents' house, and there, in boxes, closets, trunks, and scattered about on the floor, I discovered thousands of photographs, letters, journals, writings, and works of art. Even clothes: hats, shoes, feathered fans, beautiful Paris dresses, suits, coats. Gertrude's wedding dress. Monogrammed footmen's and coachmen's uniforms. Antique Chinese robes. A fabulous fantasy of a grandmother's attic. I had never lived there as a child — and only sporadically as a teenager, when I wouldn't have been interested.

I had come upon a treasure. I strongly felt that a biography of my grandmother was in order. After some discussion with Mum, I asked Bob Friedman if he'd be interested in writing Gertrude's biography. Despite having just completed his biography of Jackson Pollock, *Energy Made Visible*, he accepted — on condition that he'd have free rein, and that I would work on it, too, doing research, obtaining entrée to people we needed to interview, places he needed to see, and arranging the material I'd found.

Organizing this mass of stuff was harder than I could have imagined, and figuring out who was who in Gertrude's complex life was like unraveling the ultimate mystery story. Sometimes, I worried that Gertrude would have minded our intrusiveness, but I told myself that she'd have destroyed her journals and letters had she not wanted them to be found some day. All the protagonists were dead, anyway — and, by then, it

was too late to change my mind. I was completely caught up in her life, in her personality. I also enjoyed witnessing the writing process.

Along with earning college credits for this work, I took other courses. I remember driving in to New York to meet with Bob, notebook on the seat next to me, trying to memorize the digestive system for my physiology exam.

Slowly, we reconstructed my grandmother's world.

In the summer of 1972, at eighty-five, my father became ill with emphysema from years of smoking, even though he'd stopped smoking in the '60s after learning of cigarettes' deathly toll. He wasn't sick for long, but with his weakened lungs, he wasn't able to recover from pneumonia, and died in the Doctor's Hospital in New York. He'd painted right up until the end, although a bad hip pained him considerably.

That very year, just after his last birthday, his beloved cousin, Betty Tuckerman, sent me a package of letters he had written her. In thanking her, I wrote, "he surpasses himself constantly. I can never get over his enormous capacity for appreciation and enjoyment of all facets of life and people — it's miraculous, and catching, don't you think? And I just know what an effort it must be for him to even get out of bed in the morning — yet the pleasure he provides for others never ceases, on the contrary it always seems to increase. . . ."

Feeling ever closer to him, I had never thought of my father as being old. With his youthful spirit, it seemed he could never age and die. Always ready to hear news of the children, wanting to know about my studies, my friends, and my life, he'd comment and advise pertinently. He saw the amusing and bright side of everything and was never gloomy. After his death I kept finding bits of his life — a paintbrush, water cup, and sketchpad; his clothes, which fitted my sons Duncan and Cully, who still wear some of them; his humorous rhyming, illustrated "jingles," full of his love of beautiful women and his teasing, funny thoughts about them, wonderful today in their political incorrectness. And everywhere, on walls or leaning against them, in drawers, or in closets, his watercolors. Jewels, like my father's living self.

We missed him terribly. For our mother, the loss was crushing. After an initial effort to be gallant, to travel, to keep up with friends, she withdrew more and more.

We worried. About her loneliness, about her depression. As Bob and I moved deeper into our project, we realized how much we needed her

memories. Suddenly our research became a pathway to renewed interest for Mum. We wanted to make Gertrude fully human, to include whatever faults we might discover along with her virtues. Moreover, we wanted my mother to agree, and to hear our discoveries. To my surprise and delight, Mum was fascinated by everything we found out about her adored mother, including her lovers.

As the book took shape, I would read it aloud to her, flying to Hobe Sound two or three times during the winters so she could keep up with it, tape recording our interviews, or taking notes, which she much preferred. She objected to almost nothing. The wording in Bob's account of an early relationship, a hint of a lesbian friend, offended her, and Bob softened it. Otherwise, she remained marvelously open to all I'd learned, to the passionate letters I read to her, to all the romance of her mother's life, its joys and sorrows. So much she hadn't known.

Those were precious times for me.

They brought me a different sort of renewal than they did for Mum. As I studied its origins, from its genesis around 1907 through its early years as Whitney Studio, Whitney Studio Club, Whitney Studio Galleries, and finally as the Whitney Museum of American Art, the Museum came to new life.

And, as I learned about my grandmother's weaknesses, I became more forgiving of mine. While investigating her strengths, I reached for my own. Gertrude's adventures and passions stirred within me. They made me feel that I could, and should, carry the flame.

I was living in part in the early 1900s, absorbed by my grandmother's ardent "crushes" and the beginnings of her life as a sculptor, and also, in part, in the '70s, protesting the Vietnam war and the draft. The Museum stayed fixed, a continuing presence. During these years around 1972, I met a man who would become one of the most significant figures of my Museum life.

Anne Zinsser, an old and dear friend, invited Mike and me to meet a brilliant couple who, she said, were closely involved with art. Anne knew Sally Ganz through their work as public school volunteers, and had invited her and Victor Ganz to Connecticut for the weekend. So, one winter night, we all sat around the fireplace, with Murdock the parrot a talkative presence in the background.

Sally, a petite beauty in her early sixties, had dignity, elegance, great warmth, and an especially wonderful smile. I was immediately drawn to her. Then when Victor greeted me, I felt his intellect and intensity

flow right through his handshake and into mine. At once, I noticed the direct gaze of his brown eyes; behind horn-rim glasses, they gave me the once-over. Victor's compact energy suffused the room like smoke from the fire. If we had a few moments of small talk, I don't remember them. As soon as possible, Victor gave me his views about the Whitney Museum. He had come prepared. I sat almost silent. By the time we left, I was shattered. Could Victor possibly be right? He was so convincing. He seemed to care so much.

The Whitney, said Victor, had every opportunity to be a great museum. This was America's moment in the sun: Paris had been the center of the art world, but was old and tired — few young artists were emerging there. All the excitement was right here, and the Whitney wasn't looking. We hadn't bought the best artists when they were young and cheap, and we'd probably never be able to catch up now. We'd had the opportunity, we'd had the responsibility to the public, and we'd completely muffed it.

Victor went into detail, with harsh criticisms of Lloyd's and Jack's conservatism and aesthetic myopia.

"How can you allow this situation?" he finished. "Why do you want it to be the 'good gray Whitney?' With all there is *right now* to see and show?"

Anne was shocked to see my distress. Yet, despite feeling the criticism so deeply and personally, I was more and more interested in all Victor said. His words stayed with me through all that followed in the next years.

A few years later, when he became a close friend, when he became a trustee of the Whitney and gave it so much of his caring intelligence and leadership, we talked of that evening.

At that moment, though, his rebukes just simmered inside me, awaiting the right moment to respond.

How come I didn't know, had never even heard of, the Ganzes?

In the '30s, '40s, and '50s, Victor and Sally had assembled a major collection of Picasso's work; when it became too expensive, they had started in 1961 to collect young American artists. Victor's educated, seemingly infallible eye had led him to Jasper Johns, Robert Rauschenberg, Claes Oldenburg, Eva Hesse, and Frank Stella before most connoisseurs had recognized them. Now the Ganzes were collecting, among others, Dorothea Rockburne, Richard Tuttle, and Mel Bochner. The Ganzes' world revolved around the artists they collected, the art

historians and critics who wrote about them, and the curators and deal-
ers who showed them. As a trustee of the only museum of contempo-
rary American art anywhere, I certainly should have known about
Victor and Sally Ganz.

Meanwhile, to better organize the Whitney, to keep it within its bud-
get, David identified, and Jack hired, capable and lively Steven Weil,
the first person to hold the position of administrator, who took over
much of the day-to-day running of the Museum. Steve also initiated a
series of events heretofore considered peripheral to our main purpose:
concerts, poetry readings, dances, just when artists like Jasper Johns
and Robert Rauschenberg were creating and participating in mixed-
media performances and "happenings." Everything from Twyla Tharp,
to John Cage, to Moon Dog (a street musician), to Duke Ellington, near
his life's end — how well I remember his intent, serious expression, the
grace and style with which he played, as we sat on the bluestone floor
on gray foam rubber squares, hushed, near reverent. In another mode,
Grace Slick and her band, Jefferson Airplane, almost caused a riot, so
many people wanted to come, including our own family; during the in-
termission, I remember, the band retired to the trustees room for a few
drugs, sending the staff into a panic! It was marvelous to find ourselves
dancing around in the huge fourth-floor gallery, cleared of art and di-
viding walls, to Gracie's pounding rhythms.

Steve's presence gave Jack more time for art. At the time, he was
working with the Museum's most generous patron since my grand-
mother, a man who gave more sculpture than anyone ever had: Howard
Lipman. A partner at Neuburger, Berman, Howard, like his partner,
Roy Neuberger, had once hoped to become an artist himself. He still
identified strongly with sculptors such as Alexander Calder, Louise
Nevelson, Lucas Samaras, and David Smith. Head of the Friends' ac-
quisitions committee in the early '60s, Howard, a trustee since 1969,
was passionately devoted to sculpture, and wholly committed, as well,
to the idea of public collections. He'd set up a foundation with his wife,
Jean, to acquire work, mostly by young artists, mostly for the Whitney.
Howard and Jack made a great team. Because of them, the Whitney to-
day has a comprehensive collection of contemporary American sculp-
ture. The Calders alone are extraordinary. In the memorial book about
my mother, the "Flora" book, Howard recounts his first meeting of the
Friends' acquisition committee, giving a glimpse of my mother's effect
on people:

"I carried with me to this first meeting, with some concern, some photographs of Alexander Calder's new, large stabiles. Calder was well known at that time for his mobiles, but in 1961 his large stabiles had had just one small exhibition in New York. . . . I nervously awaited a response while the photos were passed around the table. The response took a long time to come, finally from just one person — Mrs. Miller. Her enthusiasm was exciting and for me inspiring. I instantly realized a warm appreciation and affection for Flora Miller that was to continue for the rest of our relationship — till the end of her life. As the meeting broke up, the last as well as the first word was from Flora Miller: 'Don't let that Calder get away from us.'"

One purchase that astounded and displeased a few trustees was Robert Smithson's *Non Site (Palisades, Edgewater, N.J.)*. A big painted aluminum box, hollow but with bands on the edges to look like drawers, filled with rocks from the Palisades. A box of rocks? Outrageous! Ridiculous! But even about such an "ugly" work, Jack's and Howard's eloquence persuaded most doubters. No longer unconventional today, it looks like an elegant precursor to much "serial" art, and "earthworks" too.

Always, I felt close to the curators.

Especially to Marcia Tucker. At first, through her articulate love of art, and then because we became close friends. She cared passionately for the most advanced art — Richard Tuttle's, for instance. The insight she gave me about his work was so important to my own search for understanding — a measure of Marcia's qualities as well as Tuttle's.

His dealer, Jock Truman, a prescient sensitive soul, had first introduced me to Richard, and also to his work. Drawn to his intensity and searching mind, I was intrigued by his curious poetic pieces: thin slabs of wood leaning on the floor against a wall; octagonal hemstitched, dyed, wrinkled fabric; a tiny wire on a big wall; a series of delicate watercolors. Difficult, at first, because they were unknown, unpretentious, fugitive.

Richard installed a piece in our apartment, a white paper octagon he cut out and smeared with paste on the dining room table, then ran down the hall to press on the bedroom wall before the glue could dry. I loved the way it changed the room, white free form against a white grid of the bricks, deep space magically expanding that small room, changing with the light and with my perception. Was it part of the wall? Was the wall part of it? Was it a drawing or a sculpture? Was it sit-

ting atop the wall or was it a white void, like Nirvana or death? With it nearby, the last thing I saw at night and the first thing I saw when I awoke, I seemed to dream deeper, and the day held unlimited potential.

In 1975, Marcia Tucker curated an exhibition of Richard's work for the Whitney. No catalogue was planned until later, since he'd be making three different installations during the time of the show. I couldn't stay away as he glued or hung or placed his pieces. Marcia was the first to tell me, and Richard the first to convince me, that the viewer must contribute to the work, providing half the experience.

The bit of rope Richard nailed on a wall changes, then changes again: at first, the tiny, ragged threads are *me*, lost in the vast, smooth, impenetrable world of the wall. Later, the rope holds the huge white wall, with enormous power. Rough against smooth, little against big, it holds the promise and the contradictions within us all. In pieces made with wire, pencil, and shadow, Richard confounds boundaries between art, reality, and illusion. He transforms my perception of a cloud or a crack in the pavement or a weathered painted wall — I see beauty, suddenly, where I've never seen it before. Looking at Richard's work, talking with him, I feel enlightened.

Accustomed to viewing framed paintings on walls, or sculptures on pedestals, now we're seeing new possibilities. Art can be anywhere, can be made of anything. Using ordinary materials for art objects transforms their ordinariness, and makes the common precious, makes it *ourselves*.

I remember that show so well. During an installation, someone, maybe Marcia, asked me to try to calm down a fractious reporter who was scorching mad, saying he was being fooled by a charlatan, and by a Museum that didn't deserve the name. "The emperor's new clothes," he seethed. I begged him to be quiet, saying the artist could hear him, but he didn't give a hoot, and I guided him to the elevator as quickly as I could. "Why," I asked him as he left, "do you think you're so upset about work which means, as you say, nothing?"

He was, finally, speechless.

Reviewing Tuttle's exhibition for the *Times*, Hilton Kramer wrote the first of a series of hostile articles about Whitney shows. Hostile, not because they were critical, but because they denied the work the status of art, robbed the artists of their dignity, and were personally vindictive about artists, curators, and the Museum. Kramer's review of

Tuttle's show kept many people away, preventing them from making up their own minds. I resented this, and still do today, when Richard is widely recognized throughout the world. The ideas he introduced strongly influenced younger artists — the use of modest materials, the ephemeral nature of art.

Richard was dismayed by the negative response, a feeling that remains with him still. He was trying to express something tender and innocent, and he found the responses, the aggressive articles, letters, and people, disturbing. He has described going to visit his mother in wintertime on the train, during the exhibition at the Whitney, and how he stood freezing between the cars because he'd been so horrified by the critical attacks of strangers. He couldn't bear to be with people he didn't know.

Richard and his wife, poet Mei Mei Bersenbrugge, and their daughter, Martha, lived near us in New Mexico and now in New York as well. We have become good friends. Richard is as intense and creative as ever, whether building an adobe house on a mesa, playing a game with his daughter, making art, caring for his beautiful corn snake Olivia, or baking a pie with flour he's ground himself from posole or millet.

Although Marcia did many memorable exhibitions, none was more so than "Anti-Illusion: Procedures/Materials," co-curated with Jim Monte, and still written about today as having identified a new movement in art. Including film, music, and extended time pieces, as well as sculpture and painting, artists used such materials as felt, hay, ice, chalk, graphite, air, and tissue paper to create works in situ, works the curators wouldn't see until they were actually made. This was a radical departure. As Jim Monte wrote, the new materials were not the issue: "The acts of conceiving and placing the pieces take precedence over the object quality of the works."

Attempting to explain the new movement, Marcia wrote that the exhibition challenged our assumption that "our understanding of a work of art is equivalent to our grasp of the formal or conceptual order inherent in it." Artistic perception could frustrate our "tyrannous drive to order," could help us to see that the irrelevant might, actually, be the most relevant.

The artists in this exhibition altered perceptions with their ideas about time, order, and the changing, ephemeral nature of art and

therefore everything — visual artists such as Carl Andre, Eva Hesse, Barry Le Va, Robert Morris, Bruce Nauman, and Richard Tuttle, composers such as Steve Reich and Philip Glass.

Each artist was given a space of his or her own. One, Rafael Ferrer, chose the concrete bridge leading to the Museum. On it, he placed straw and huge chunks of ice, which slowly melted. The wet and the dry, decaying at different speeds, reminding us, before we even entered the Museum, of the passing of time, the passing of the Museum, the passing of ourselves.

Arriving at the Whitney's enormous elevator, or exiting from it, visitors found the passage almost blocked with an immense rock, placed there by the same artist. Not so easy, perhaps, to *really* enter the Whitney, to penetrate what we'd see there!

With her energy and intelligence, her streaming dark hair, angular face, and slightly protruding eyes looking deep into painting, into life — into me — I still imagine Marcia Tucker flying away from the Whitney on a great black motorcycle into the night. She remains a close friend, who's taught me so much about contemporary art and its sources. Once I was a guest at her women's group, a new and consciousness-raising experience for me; I had never imagined such an intimate connection with a group of women or heard such open, trustful conversations. I found myself opening up, too, laughing and crying, recognizing the feelings women share. Before that, I hadn't been aware of feminism, as it might apply to me. Now I felt the power and affection that movement could generate.

My grandmother had never identified with women in this way. While competing for her hard-won sculpture commissions, then maneuvering to complete them the way she envisioned them, she had often been faced with the condescension and arrogant demands of men. But she hadn't bonded with women for support. And she'd never had to deal with powerful men within her Museum. My mother had never entered a competitive world. For her, men were delightful beings meant to beguile, to play with. Needing strength I didn't yet have to deal with the powerful men now at the Whitney, I recognized in Marcia's friends a possible source.

Despite a distance from the board provoked by David Solinger's not wanting family involvement, I felt deeply committed to the Museum. I realize now that the experiences I had during those years with curators and artists were invaluable. I was learning more all the time about

the nature of our "business," our "product." I was storing away my growing awareness of the intensity, beauty, unpredictability, passion, and chaos at the heart of the artistic experience. And I was learning, too, more about myself and my feelings, about how much I wanted to have friends in this world I was coming to love so well.

Twelve

*I*n 1972, Jack told the board he had decided to retire early, in 1974. He wanted to use his skills to write and to curate special exhibitions about artists he admired rather than to continue as director, a job requiring more administrating and fund-raising than direct contact with art.

David Solinger had been president for six years. In a letter to my parents from that time, I see that Bob Friedman was in favor of asking Benno Schmidt to replace David as president: "He could put the Museum on a sound financial footing that would last for years." But David's inability to personally bring in more substantial contributors wouldn't be addressed for another year. A big issue, now — most of my letter concerned money. Describing the recent trustees meeting, I wrote, "David was concerned about the level of trustee giving, which is *very* low compared to last year." Since trustee gifts were, and still are, a principal source of income for the Whitney, and since they are the direct responsibility of the board president, we needed someone who could raise money. Bob himself, chairman of the acquisitions committee, had persuaded that group to give $40,000 worth of art, that year — "Incredible!" I wrote. With the Friends' dues now needed for general operations, with no money in the budget for acquisitions, asking individuals for gifts was currently the only way to acquire art — despite the fact that those acquisitions were one of the Museum's main functions.

David appointed a search committee to find a new director. Wisely, he chose Howard Lipman as its chairman. Howard identified candidates, arranged lunches, wrote letters to friends he respected in the art world, asking for suggestions, and added other members: Arthur

Altschul, Jack Baur, and me. Howard did not share David's views about family involvement. I was highly pleased to feel, once again, closer to the Museum.

For the first time, there wasn't a natural progression within the institution — associate director moving up to become director — so we wrote a job description, a simple one:

Personal qualifications:

Approximate age: 35-40

Strong character to deal with:

A. staff, B. trustees, C. Public relations

Needed: Vitality, imagination, flexibility, awareness of rapid changes in current art world, relationship of Museum to community, awareness of extraordinary degree of change in the past decade in modes of creative expression.

Career Qualifications:

Depth of experience in 20th Century American art

Some experience in 19th Century American art

Some experience as director of a museum

Howard wanted a young and adventuresome museum, a museum like the art he loved so much. But he worried greatly about money, and this worry, I believe, leaked into the purity of his deepest instincts. For those people coming in to replace the family, the responsibility weighed heavily.

Within the Museum itself, two candidates emerged: Steve Weil and Marcia Tucker. Their letters on the functions of a director are interesting today, as, with a little perspective, I again look over the reasons for our eventual choice.

Steve listed three qualifications, adding "it is my feeling that an art historian is not necessarily the only type that can meet these requirements." He described himself as a politician/statesman, whose functions would be:

1. To mediate the conflicting demands for space, budget, and personnel of his various department heads. No one can possibly be expert in all the fields in which the Museum today operates. . . . the role of the director is to harmonize their efforts and energy into an overall museum program.

2. To serve as conduit between the staff and the trustees. As such, he must be able to sympathetically interpret each to the other. He is the pivot around which policy is turned into program. . . .

3. Finally, he is the Museum's chief representative to the outside world: donors, foundations, professional organizations, government and the general public. He must be able to articulate the Museum's policies and program, understand its role in relation to the larger society and — as spokesman for them both — embody the aggregate decisions and desires of both his staff and his board.

Steve was David's candidate but not Howard's. Too much a manager, too little an artist, Howard felt. But Steven's letter remains an excellent summary of the essential abilities a director needs, of the role itself.

Marcia's letter reflected her own liberal ideals, as well as her experience, under Jack's leadership, of the Museum. A few excerpts follow:

Jack Baur has been an ideal director, since he has in no way interfered with curatorial responsibility once the decision to do a show has been made by a consensus of opinion at our regular staff meetings. . . . the curatorial staff [should] continue to be granted complete freedom as to personal schedule, since much of our most important work is done outside the Museum and outside regular Museum hours. . . .

Someone who is a capable and experienced administrator, with some degree of art-historical training, would be ideal. If it is a matter of choice, I prefer a good administrator with little art background to a person without any administrative experience.

On a personal level, I prefer someone who is not temperamental, sexist, domineering or self-seeking, that is, someone who will devote himself to the interests of the Museum as a whole rather than to his own interests. I would also like to have a director who is non-monarchial, who will concern himself with the operation of the Museum at the "lowest" level and will familiarize himself with the problems of guards, secretaries, and art-handlers as well as those of the curatorial and administrative staff. I am, in short, asking for a

democratic orientation toward the running of a museum, in order to facilitate communication among all employees and aspects of the institution.

Just as Jack hadn't interfered with "curatorial responsibility," so trustees, I thought, should not either: they should have no say in what art is shown, accepted as gifts, or bought.

Why not, one might ask, since it is they who provide the money to buy the art?

Because, I'd answer, that's the way Gertrude set it up. So the staff would have autonomy. So her museum would be professional, not just a rich woman's whim. Within the limits of available funds, the staff would decide on the program. Gertrude herself formed the original collection, with input from Juliana Force and her staff of artists after the formation of the Whitney Studio Club in 1918, but most of that collection was in place before the Whitney as museum was even conceived.

Today, one might give the current reasons: there should be no possible conflicts of interest between collector and public institution. If, say, Mrs. Jones owns ten paintings by emerging artist Roy Smith, for which she paid a thousand dollars each, and if she then gives one to the Whitney, its acceptance means the value of the painting will immediately double or triple. While it's impossible, of course, to completely avoid such situations, it's important to make the effort, to protect both Museum and patron. In acquisition committees, members choose from works brought before them by curators. Many museums have exhibition committees, but not the Whitney.

Marcia supported her deeply held principles by putting them into practice.

Members of the search committee admired and respected her, not only for the ideals she expressed in her letter but in her wish to show more "advanced" art than the Whitney had heretofore exhibited. But while her goals worked extremely well for her as curator, if she became director, they thought, those same goals put into practice might well prove too radical for the Whitney, always, heretofore, a middle-of-the-road "liberal" institution, trying to do justice to all aspects of art and politics.

What did I think? I loved Marcia and would have gladly supported her if the others had, but Jack and Howard strongly influenced me.

With hindsight, it's obvious, judging from her letter, that Marcia would face problems with the next director. The museum she founded a few years later, the New Museum of Contemporary Art, in Soho, embodies all she described in that letter. It's an extraordinarily democratic institution, where all staff members have a voice in programming, and where trustees, too, are involved in the decision-making process.

Howard moved things along briskly, as I see in a letter he wrote to our committee in September 1972: "As you are aware, Tom Armstrong became director of the Pennsylvania Academy of the Fine Arts [a venerable museum in Philadelphia with an art school joined to it] less than a year ago. His board approved Tom inviting a group of seven consultants to study the Academy on a three day schedule in April of 1972. I was fortunate in being invited to join this consultants committee.

"I am sending you the enclosed as an indication of Tom's executive capabilities in handling this group."

There follows Tom's summary of the Pennsylvania Academy's history, collection, and school; his detailed program for the three-day visit, including seating diagrams for dinners and lunches; and requests for specific advice from the qualified experts Tom had invited as consultants, in order to plot the future of a venerable institution in need of renewal. Howard had been extremely impressed by both his ability and personality.

So, pretty soon, the search committee lunched at the Stanhope Hotel with Tom Armstrong, a tall, well-spoken young man with black-rimmed glasses and a high balding forehead who reached out to each of us, asking about our interests in art, gardens, architecture. His enthusiasm for the Whitney, his openness to new ideas and plans, pleased us.

A little later, Mike and I visited him at the Pennsylvania Academy. We enjoyed Tom's sense of humor, and were especially impressed by the obvious familiarity he'd achieved so rapidly with the Academy's collection. In the storage area, he pulled out painting after painting, extolling their virtues, describing their acquisition, subject, artist, and significance. His excitement about the paintings was infectious, and since I felt the Whitney's collection was the keystone of our museum, I was especially captivated by this aspect of Tom. The plans he had initiated with such dispatch for his building and institution were ambitious and imaginative. He, in turn, was impressed by the knowledge

and deep commitment he'd sensed in the Whitney trustees he'd met — never, he said, had he worked with a board that contributed so generously of themselves, as well as money.

Has my first impression of Tom — of his energy, intelligence, curiosity, and warmth — changed?

Time has left his assurance, his humor, his charm, unchanged. If anything, Tom seems more intelligent. Underneath, though, after all the battles there's a new wariness, a hesitancy. A sadness in his eyes, the disillusionment of a wounded warrior. The contrast between the old Tom and the new clarifies my memory, at those first meetings, of a wonderfully self-confident, exuberant soul, marching to his own tune, ready to take on the world. Exactly the person we were looking for!

The search committee was quick to make a recommendation to the board, and, early in 1973, we presented Tom to the trustees and their spouses at a cocktail party, giving people a chance to talk informally with our candidate. (We always hoped and believed that being a trustee of the Museum was an involvement outside business hours, social in nature. It should be fun. So we tried to have many events that included spouses or "significant others.")

Tom wrote the next day "on the metro":

> Dear Flora,
>
> Bunty [Tom's wife] and I had great fun at the Whitney last night and I want to tell you how encouraging it is to see members of a board really working enthusiastically for the success of an institution. . . . I am very excited about the future and anxious to get with Jack and learn how the Whitney works. . . .
>
> Hope everything goes well at the meeting and that I get voted in — I'm looking forward to working with you and Mike to make the Whitney as great and effective as it can possibly be. . . .

He was unanimously approved at the April 1973 board meeting.

I wrote my mother, "The museum meeting went fine, and Tom Armstrong voted in with no apparent problems. I do so hope you'll like him, and will have a chance to meet him soon. Really, I think you'll take to him — he's full of charm and vitality — he comes in September as associate director for a year."

Associate director. A frustrating year for Tom, although he never complained, not to me, at least. I didn't realize that Jack kept him very

much on the outside, giving him little authority or responsibility. Maybe Jack regretted our choice. Mostly, Tom waited.

But he didn't even wait until September to begin working for the Whitney in his own way. Right after he was voted in, before the Whitney Gala in May, Tom gave a dinner at the Knickerbocker Club. I remember being surprised, because I'd thought of the "Knick" as a bastion of the "old days," a place where I had to wear a skirt if my father, who had been a member, invited me for lunch. Even though I had pleasant memories of dining there with my father, I didn't anticipate it being a welcoming place to my new friends. Not where I'd be spending much time now. But Tom, rather than rejecting his previous habits and lifestyle, enlarged and embellished them to encompass the events and friends of his Museum world. It's one of the things I admire about Tom. Now he sent me a list, with detailed descriptions of each guest, their possible use to the Whitney, and a handwritten note in his usual breezy style: "Here we go — this should be fun — never mind all the heavy preparation. . . . met the staff yesterday — including lady in restaurant (got staff discount) and everything positive and *good* — see ya —"

Useful to the Whitney, elegant and lively, this dinner typified many more to come. One of the guests, Barbara Millhouse — who had founded an excellent museum of American art, Reynolda House, in her family home in Winston Salem, North Carolina — became an active, helpful trustee and is still a member of the national committee.

In September, the Armstrongs spent a weekend with Howard and Jean Lipman in their house in Connecticut, where they kept their folk-art collection and many sculptures. As we lived nearby, we gave a small dinner for the Armstrongs with friends we hoped might become patrons. Our guests were much taken with Tom and Bunty. Bunty was beautiful, glad to be moving to New York, and interested in everyone she met. Tom was the perfect guest, asking questions and really listening to the answers, telling wonderful stories, wanting to know about everyone and everything, remembering it all, too — he even sent a packet of miniature daffodil bulbs to our neighbors, David and Penny Bergamini, after discussing horticulture with them. He charmed us with his informal ways and his compelling interest in the Whitney. In a prompt bread-and-butter letter he wrote: "Our weekend with you and the Lipmans will always be considered the start of our life with the Whitney. . . . Things begin officially on Monday and

Bunty and I are very excited . . . we look forward to the future with great anticipation."

In November, Tom invited us on a notable trip to Virginia, where he had previously worked as associate director of the Abby Aldrich Rockefeller Folk Art Center. He hoped to interest some of the many friends he and Bunty had made in the Whitney. We had never experienced such organization, such luxury, such sheer fun. The visit was a precursor of many national committee and trustee trips. The itinerary lists the people we met, showing the broad range of Tom's friends — including those in the art world. His graphic notes told me everything I needed to know. For instance: among Tom's guests the first night at the Commonwealth Club was Tennant Bryan, head of Media, Inc., whose newspaper had denigrated Sydney and Frances Lewis, our hosts, the following night. (Finally rising to Tennant's bait — sarcastic criticism of northern "left-wingers" and inordinate praise of southern politicians I considered to be racist — on the very steps of his club, at midnight, I fear I snubbed his views with a succinct but definitely rude word, "Shit!" which apparently surprised that charming southern gentleman.) Seated by me was the president of the Virginia Museum's board, a man who had also insulted the Lewises by not inviting them to join his board.

Who were these Lewises?

Tom's notes: "Best Products — [the Lewises'] mail order business — give merchandise to artists in exchange for work — James Wines designed their showrooms — both work in the business as well as their children and Frances' mother — support Blacks, etc. . . ." This capsule barely begins to describe the Lewises, a good example of the caliber of people Tom attracted to the Museum.

Sydney and Frances were major collectors of contemporary art, architecture, furniture, and art nouveau. They had started their own business and watched it grow as they commissioned avant-garde architects to build their many warehouses — the one in Richmond, by SITE Inc., looked as if it were falling down, or else just being built. People attracted by its looks stopped, then stayed on to buy. Friendly with most of the artists they collected, the Lewises lived in the heart of Richmond in a landmark Federal-style house built in the '50s, surrounded by very contemporary works of art and extraordinary art nouveau furniture. Their hearts were as big as their intellects. They'd send a plane for their New York friends to come for a magnificent

lunch in Richmond, with cakes and pastries baked in the shapes of art pieces. Once, they invited us to their Virginia Beach house, right on the water, with a group of architects and artists for a weekend of swimming, lively conversation, and many laughs. However, despite their generosity, they were unable to find like-minded spirits in their conservative community to share their interests. Richmond society and the Richmond museum snubbed them. Only after becoming figures in the New York art world, and Whitney patrons, did such generous souls as the Lewises become acceptable to their own museums.

Tom and the Lewises were close friends, and they soon became our friends, too. One of the first major gifts Tom obtained for the Whitney came from Sydney and Frances: $250,000 to buy contemporary art, the largest single purchase fund in the Museum's history. Frances joined our board in 1976; she was a thoughtful trustee with provocative, stimulating ideas and firm budgetary principles.

Thirteen

*B*y the end of 1973, David Solinger had been president for seven years. There was nothing in the Museum's bylaws about the length of a term for presidents, so Mike and I visited David in his office to talk about that. I'd recently stopped coloring my hair, and it looked like a Rothko gone wrong — gray, red, and brown stripes — so I wore a black wig. "You have a new hairdo, I like it," said David. I let the compliment pass and told him what a great job he'd done. That originally we'd asked him to take the presidency for three or four years (no, he didn't think so, he interrupted) but since he'd done so well, no one had wanted him to go. He smiled.

And then I became so outspoken I surprised myself. Change was necessary. We had always intended that the presidency rotate. Seven years was a long time. We must discuss a successor.

But David had no memory of our original proposal. He saw no reason for a change. (Especially, I imagine, one initiated by me.) The Museum was in fine shape. The budget was balanced. I thought about, but didn't mention, the lack of money, which meant we could neither make acquisitions, nor start the education programs Jack had planned. When I suggested Howard Lipman as president, David bristled. "David," I answered firmly, "except for my grandmother, Howard is the greatest patron we've ever had. Howard deserves the honor. He'd be a fine president."

In the end, David agreed.

But Howard didn't want to be president!

Today, twenty-five years later, I understand. Howard loved the niche he had carved for himself at the Whitney. Spending lots of time

with art and artists, with Jack and the curators. Molding the sculpture collection, thinking about it as a whole. Buying the perfect Calder or David Smith. Searching through Louise Nevelson's black palace for the most beautiful wall. Trusting Lucas Samaras to call him when he'd made a breakthrough. Still at Neuberger and Berman, he knew that becoming president of the Whitney would mean retiring as an active partner of his firm and would involve lots of fund-raising. Also, lots of time.

Barklie and I visited Howard in his office. Eloquently, persuasively, Barklie argued with Howard. He had our grandmother's spirit. He understood the Whitney. He had identified Tom, he could work with him better than anyone. Only Howard could steadfastly remind us of the Whitney's purpose, only he could lead us through the years of change ahead and inspire us to make the right decisions. Balancing the old with the new, keeping the best of the past.

Finally, we both pleaded, the Whitney needed him.

Finally, Howard agreed. He would take on the presidency, but only for a limited time.

Barklie and I left happy, feeling we were on the right track. Despite the need for money, we would be an institution open to new ideas, new art, and new people.

In May 1974 Howard became president of the Whitney.

Things started happening right away. New people, for instance. From 1965 to 1969, no new trustees had been appointed; in the next two years only two were, and one was Howard, himself. By comparison, in 1975, the first year Tom was director, seven trustees joined the board. (Could we absorb them? Adjust to such sudden growth?) It was David, however, who, as a trustee of the Johnson Museum at Cornell, had known Steve Muller when he was a trustee of Cornell, and who had persuaded him to join the Whitney's board. Steve, a brilliant young man who had escaped from Nazi Germany and settled with his parents in Los Angeles, was then president of Johns Hopkins University, including the medical school. (He'd also been a successful child actor in Hollywood, and was embarrassed when I told him we'd seen one of his movies on TV. But he'd made enough money that way to finance his education.)

I quickly came to admire him, to like him a lot. Howard now picked him to head the new long range planning committee.

Howard and Tom thought that the Museum needed a hard look

from creative, intelligent outsiders. The committee would meet over convivial dinners, discuss the Whitney's place in today's world, and recommend a plan for the future. Tom was the only board member, and the final report was really his. Howard, as president, attended all meetings ex officio.

The others were:

> Wilder Green, an art historian, then head of the American Federation of Arts.
>
> Philip C. Johnson, outstanding architect. With incisive wit and the eye of a true connoisseur, he has an insider's knowledge of art, artists, and the art world.
>
> W. Barnabas McHenry, head of the Reader's Digest Foundation.
>
> Barbara Novak, artist, writer, professor of art history at Barnard College.
>
> Jules D. Prown, Professor, founder of the Department of American Studies at Yale, art historian with a special interest in eighteenth- and nineteenth-century American art. A trustee of the Whitney from 1975 to 1994.
>
> Theodore E. Stebbins, Jr., museum curator and director.
>
> Martha R. Wallace, businesswoman, head of the Luce Fundation.

Their report was given the following year, considered by a board committee, debated at length, and finally adopted as board policy in 1978. This report was key to most of what subsequently happened.

One of Tom's mentors, the art historian E. P. Richardson, wrote widely on American art and on the need for more study and understanding of our culture. His thinking influenced Tom. Here's an example from the *Archives of American Art Journal,* in 1977:

"The Americans are today the least known of all the world's great peoples. Their imaginative and cultural life is unknown to the world at large, because it is only partially known to themselves. This lack of attention by our so-called educated classes is a form of betrayal of their function, which is not merely to interpret the rest of the world to this continent, but to understand, to clarify, and to render articulate the vast, potent, deep-rooted, mysterious, and creative life of the people to which they belong."

Tom agreed.

His vision for the Museum was far reaching. The Whitney, a great public institution, well-funded for its ambitious program, would become the conduit for this awakening. To quote the long range planning committee report, the Whitney would now "give added priority to interpreting the art it has collected and preserved." In moving "systematically and purposefully toward the collection and exhibition of twentieth-century American art," some of the permanent collection would always be on view. A curator for the collection would be necessary.

"The primary criterion for selection in all exhibitions should be quality." Not only was this a reference to the old practice of occasionally showing artists for reasons having little to do with art, such as need or tradition, it signaled a change in the present philosophy for exhibitions and purchases. The Whitney, especially in the Biennials, was known for showing "emerging" artists. Curators were champions of the new and untested. This sentence, then, was a red flag, to them, and to me, as well. Why should the Whitney change its nature so drastically? Become a conservative institution like the Metropolitan Museum?

The education department, the report continued, would be expanded and better integrated with the curatorial staff, instead of operating far downtown in an independent fashion.

For trustees, the most ambitious aspect of the report was the physical and budgetary expansion it mandated. Space was "inadequate . . . the building . . . too small to function as the major center for the permanent exhibition of American art of the twentieth century, as a showcase for temporary exhibitions, and as an educational center . . . these policies will require significant expansion of the annual budget of the Museum, as well as the possibility of new capital funds for construction. Above all, the Museum needs a professional staff of the highest quality. . . ."

More building, already? Yes, we clearly needed more space. But could we raise the money?

Yet the idea that the Whitney might well become a great international museum of American art was heady, and, despite the difficulties, I was all for it.

Tom and Howard established a modus operandi, a model for the undefined, complex relationship between a salaried chief executive of a

not-for-profit institution and the part-time volunteer who's the boss. The institution's health depends on this delicate balance. Happily for the Museum, in this instance Tom and Howard trusted each other. They discussed things. And, although Howard didn't interfere with Tom's handling of staff and Museum affairs, they made decisions together. Moreover, they shared an unshakable love for art and for the Whitney. As a result, their standards, both of dedication and hard work, were kept high.

I was pleased to be included in some of their talks and meetings. As expansion became likely, we explored its possible financing and thought about acquiring the brownstones adjacent to the Whitney as a necessary first step. We strengthened our board with members who could help.

We included major collectors:

Lawrence Bloedel, of the big Western and Canadian lumber company, an old-time Friend now living in Williamstown, Massachusetts, who willed the Whitney half his collection. Kind and gentlemanly, Larry loved his art and his garden.

Frances Lewis, already mentioned, of Richmond, Virginia, whose love of art was balanced by her remarkable financial sense, both qualities important to the Museum.

Edwin Bergman, of Chicago, a committed trustee until his death. Most of his magnificent Surrealist-oriented collection is now at the Chicago Art Institute, which, as with the Lewises and the Richmond Museum, had largely ignored the Bergmans until the Whitney recruited him.

Sondra Gilman (now Gonzalez-Falla), early and prescient collector of high-quality photographs as well as paintings. A loyal trustee to this very day, she became chairman of the painting and sculpture acquisitions committee during its '80s heyday.

Important businessmen who were also collectors joined us, too:

Charles Simon, bond trader extraordinaire of Salomon Bros., who became treasurer of the Museum. Open-hearted, overweight, moody, and lovable, Charles was one of our most idiosyncratic, opinionated, and generous trustees.

Daniel Childs, private investor, married to Margaret, one of my Burden cousins. While he did not stay long on the board, he was helpful on our budget and finance committees.

Joel Ehrenkranz, successful lawyer, partner in Ehrenkranz, Ehren-

kranz and Schultz, a firm specializing in taxes. When I became president, he became my vice president, and chairman of the budget and operations committee — a key position.

William A. Marsteller, head of the big advertising agency Marsteller and Burson. He led our first development committee, which expanded our membership category — the original Friends — both upward and downward, giving us sources of income and a pool of people we could draw on, both of which we needed.

Norborne (Bunny) Berkeley Jr., chairman of the Chemical Bank and a personal friend of Mike's and mine.

Robert Greenhill, an officer at Morgan Stanley.

Geanie Faulkner, opera singer, community leader, director of the Harlem Cultural Council, and our first African-American trustee — although her interest was mainly in music and she didn't become as involved as we'd hoped she would.

Leonard Lauder, head of his family's cosmetic empire, who would become an extremely important Whitney leader. One of his first proposals, which Tom eagerly accepted, asked for a new drawing committee. The Museum, they both felt, should specialize in areas other museums had more or less ignored. Drawings are especially appropriate for a Museum with an outstanding sculpture collection, and many of the Whitney's best drawings have been done by sculptors. This new committee would embody Tom's ideal: trustee committees would enable the Museum to increase the quality and number of purchases in all areas. Tom hired an adjunct curator with a quality-oriented, fine personal taste, Paul Cummings, and invited a group of connoisseurs to come together to talk about the drawings Paul would find, and to acquire significant examples for the Whitney. Jules Prown became chairman of this lively group. His skill at eliciting members' often divergent opinions, encouraging debates, and ultimately reaching a consensus was extraordinary. It's a skill I tried to learn and emulate, but I never did as well as he. Paul presented us with a wide choice of drawings, testing our connoisseurship to the utmost. He summarized the committee's work in his publication *DRAWING*, March–April 1985:

A specialized collection demands careful thought. Stylistic changes in drawing, the uneven nature of taste, the critical values that attempt to influence a brief given moment of history, and the paucity of quality literature on American art all combine to enhance the charming nature of the risks that

animate this venture. Quality, that ever shifting conjectural aspect, which guides tough decisions, lurks in admonition after the fact. While regionalism, American surrealism, the numerous manifestations of abstraction, and figurative art in all its guises continue to play off one another, the collection has by now taken a form of its own against which each new acquisition must be judged. It is in the spirit of that challenging and stimulating ambiance that we continue, with our patrons' aid and succor, to build the drawing collection at the Whitney Museum of American Art.

Tom's strong points were becoming more and more apparent. With Howard, he was starting to raise significant amounts of money for acquisitions of art or for annual giving. He enlivened the Museum with gala events — openings, talks, meetings — and he was a whiz at parties! Using their own apartment for the Whitney's benefit, Tom and Bunty were out every night they weren't giving a dinner themselves, meeting everyone of consequence in the city, talking to them about the Whitney, enlisting them if they could help. Completely involved with the Whitney and his job, Tom redressed the smallest deviations from perfection, in the building itself, in installations, catalogues, flowers, even in dinner seatings and place settings. And he arranged great trips to meet potential patrons in other cities.

On one of these, in 1975, I went to Florida with Tom. The trip, filled with visits to collectors, ultimately led to a gift from Bob Friedman's aunt, Mrs. Percy Uris, of major works from her collection.

Tom signaled his abiding interest in the Whitney's history with a wonderful exhibition curated by Lloyd Goodrich and Tom's talented young assistant, Jennifer Russell: "The Whitney Studio Club and American Art 1900–1932." Our family and many of the Whitney's old friends were grateful for this renewed recognition of Gertrude and her accomplishments. The catalogue announced the show as "designed to chart the main currents of American art in the first three decades of our century, as represented by works mostly from the collection of the Whitney Museum of American Art; and to show, through photographic and documentary material, the part played in these developments by the Museum and its predecessors, the Whitney Studio, the Whitney Studio Club, and the Whitney Studio Galleries."

Tom believed that this show bore witness to Gertrude's seminal role in bringing about the recognition of American art by its own citizens and also by the larger world. By the mid-'70s this awareness had pro-

duced many more artists, galleries, and collectors. For the first time in America, artists could actually make a living by their art. Only a few, to be sure. But to be an artist had become newly respectable. And the Whitney Museum of American Art, through Gertrude Vanderbilt Whitney, was in large part responsible.

Despite the many positive aspects of the new regime, difficulties were brewing.

In Tom's first *Whitney Review*, the 1975 issue, he reported a deficit of $310,000, calling it a "serious concern."

In the first big exhibition under Tom's aegis, Mark di Suvero's enormous metal and wood sculptures were installed in all five boroughs from November 1975 to February 1976, enabling a citywide public to see the work of this wonderful sculptor. The artist had preferred to postpone the exhibition, originally planned for 1972, because of his feelings of protest about the war in Vietnam.

Di Suvero, whose parents were of French and Italian descent, was born and spent his childhood in China at an especially turbulent period of its history. The family escaped from China in 1941 and came to the United States, where Mark found his vocation for sculpture at the University of California at Santa Barbara — although he also continued to study philosophy after transferring to Berkeley. In 1960, doing odd jobs to make a living, he was moving lumber on top of an elevator when the elevator failed to stop in its ascent and Di Suvero was badly crushed. His survival was a miracle of spirit and physical constitution. Doctors said he'd never walk again. In a wheelchair for two years, he sculpted extraordinary small metal pieces in his lap, an asbesto apron covering the lower half of his body, using heavy pieces of steel and the traditional welder's oxygen and acetylene tanks and cutting and welding torches. By 1965 he walked without crutches, and was once again making large abstract pieces, often weighing tons, with both fixed and moving parts. Di Suvero encourages people to climb in and through these sculptures, to swing in them and slide down them, and when a barrel-shaped element of *Lady Day*, installed in Battery Park, was inhabited for a time by a homeless man, Mark was pleased. He wants his work to be available to the widest possible public, and so it was especially appropriate for eleven pieces to be installed in parks all over New York. Although so very large, their forms are familiar and inviting. Irving Sandler has written of them:

"One of di Suvero's favorite forms is the bucket of the steam shovel. . . . Clawing or grasping, the bucket resembles the cupped human hand, harking back to the first wax, plaster, and bronze sculptures that di Suvero exhibited. But then all machines, whose fragments he salvages, are extensions of the hand."

Mark especially likes these lines from Emily Dickinson's *Of All the Sounds Despatched Abroad*:

The Wind does — working like a Hand / Whose fingers comb the Sky.

He himself has said, "I am of the opinion that my life belongs to the whole community, and as long as I live it is my privilege to do for it whatever I can. . . . art is a gift which we give to others." Affirming his conviction, he formed the Athena Foundation, and from a wasteland near his studio in Long Island City he created a garden. Unemployed neighborhood boys cleared this beautiful site overlooking the East River and Manhattan, and now Socrates Sculpture Park presents work by known and unknown artists to the community and to an international art audience.

In his art and in his actions, di Suvero gives us in full measure what he hopes the Park will bring to others: "the energy of hope, the embrace of paradox, the overcoming of despair."

Trustees were pleased by all the publicity about the di Suvero show, and proud of Tom's bold outreach to a broader public.

But the cost to the Museum was phenomenal.

Tom hadn't taken into account the added expense of placing the work outside the Museum, as well as inside. His decision to do that led to the biggest deficit the Museum had ever incurred, more than $500,000. Both old and new board members were horrified. Joel Ehrenkranz and his budget and operations committee expressed their anger.

Howard was especially distressed. He had a minor stroke in 1976, and it seemed to all of us as if the Museum's financial problems had been part of the cause. I remember how his wife, Jean, shielded him from all contact with the Whitney. She wouldn't allow me to talk with him.

And Tom must have felt lost without his mentor and supporter, without Howard's guidance and wisdom.

Howard recovered, but he was never able to resume his active

presidency. His passions seemed muted, his frequent advice to me was "Wait, there's no rush." His love for art, artists, and the Whitney itself had to adjust to his physical weakness, as the Lipmans spent more and more time away from New York. Howard finally told me he had to resign as president.

Fourteen

*I*nevitably, in almost half a century my life had changed dramatically. First, from a stable, disciplined childhood of love, lessons, and considerable loneliness to a brand-new domesticity, requiring order, hard work, and all the self-reliance my British nanny had tried to instill in me. There had been more than a few moments of despair. A child with an agonizing earache, a crying baby, the inconsolable misery of a teenager, coming all at once, and all to the wild rhythms of a son's rock band.

I well remember the unrelenting concentration of tending small children all day. I couldn't do it, I told myself, not without more sleep! I was incapable of giving enough love, enough energy, enough selflessness, enough *anything*. And then, unexpectedly, would come the reward. The baby's smile, its warm, clean smell, and strong suck . . . or the irrepressible giggles of a small, happy child . . . Cully telling a joke he'd made up, at dinner, while we all roared. I was so proud of Duncan, his mind quickening, connecting a current newspaper headline to his American history lesson. Playing her guitar, Michelle sang haunting songs, sweetly, fervently — "Blowin' in the Wind," or "Parsley, Sage, Rosemary and Thyme" — with the others joining in for the chorus.

And the whole summer of *Oliver*. 1963, I believe. Directed by Anne von Ziegesar and me, with rehearsals in Anne and Franz's garden, it had all started when we'd seen the play in New York, and both Cully and his classmate Lisa von Ziegesar had wished they could be in it. We decided that since we couldn't make that happen, we'd do it ourselves, with both families and a few others taking part. Cully played Oliver — he was about eight — and I can see him still, so small and brave, singing his heart out or begging for porridge in the most pathetic voice,

"Please, Sir, may I have some more?" Dunc as leader of the boys was wild, fierce, and handsome. Miche was bold and brazen in a tight red dress, as the hussy Nancy, and her song rang out clear and lovely. Fiona, the littlest "boy," took a fearless stance as she belted out "Food, Glorious Food" with the others. All our friends came to the actual performance, and we served them "hot sausage and mustard" at intermission, as the words in the song mandated.

The feelings our family gave me, for instance, when we sat together, a blizzard raging outside, and ate with pleasure the spaghetti I'd made, were to me magical moments. Then the goodness of life would stir from deep within. And sometimes would stay for a long while.

I wanted those meals to be different from the ones I remembered as a small child, seated at a little table in the corner of the big dining room in Aiken. Seeking distraction from the tiresome company of little brother and nurse, pink and green majolica captured my eye. The high sideboard held stippled green plates, bowls, cups, a teapot. I was especially intrigued by the cups, bubble gum pink inside, with narrow perforated shelves on one side. Hard to imagine a long table filled with men sipping delicately, their mustaches held carefully from their coffee on these ceramic supports, but that's what my father had described, so it must be true. Our meals often consisted of bananas and rice, a cure, according to a new theory, for my brother's debilitating asthma and allergies. Whenever more interesting meals appeared, so did our older brother and sister and their gang, stealing the best bits despite our pleas.

Later, we frequently enjoyed meals with the grown-ups. But I remember Mother telling me that when I was three or four, I refused to eat.

"We went abroad on the *Bremen*, that year," she said proudly, "and I fed you all your meals. That's when you began to eat."

She didn't seem to wonder why I'd stopped.

Eating. A basic need, also a metaphor for love.

As the children grew up, the precarious balance between my family and my outside interests would sometimes tip. The Museum, college, the *GVW* book, new friends, beckoned. But why did I consider leaving safety once again, leaving the warm, familiar world my husband and I had built?

I was moving, in the '70s, away from that world and from my good,

loving, moral, and supportive husband. Some of the reasons are private, not for this memoir, which is about the Whitney Museum. As our interests were growing in different directions, and I was drawn to other people and other worlds, I was not giving our marriage the attention and nurturing it needed in order to flourish. Increasingly absent, both physically and emotionally, I felt guilty. With reason. Mike and I had shared so much. Not only our children and the Museum, but our extended friends and families, who loved us as a couple. When I broke the bond that had given us so many satisfying years, I betrayed his love and trust. Had it all been false?

No. Those were fruitful years, filled with true joys. I hold them dear and value them highly. They were the central years in both our lives, years during which we developed and became who we are. We grew through the love and support we gave each other.

Our children and their spouses, our eight grandchildren, our great-granddaughter, remain the linchpins of my life. The binding straw, as in the adobe bricks of the Taos house, that ties me to this earth. The connection from past to future.

I have asked myself often about this time of separating from our life together: was it inevitable? And I answer differently at different times. I could have turned to the inner world of study and writing that attracts me still. I'll never know what that choice would have meant. Instead, I chose New York, exchanging one responsibility for another. The Museum over my marriage. Perhaps, although there were other factors leading to my decision, I was starting to recognize the part of me that sought accomplishment and recognition in the bigger world — the world of my grandmother.

I knew it was my turn to take charge. Here's a journal entry I wrote while visiting my mother in Hobe Sound:

> Today, we called on Permelia Reed, she talked of a sermon she had heard "about decision — you can't go on forever sitting in two chairs without falling in between them." Ah yes. Always I have been ambivalent . . . my standards have been too high since childhood, for myself and consequently for others, and I do believe I can change this, at least. . . . Read more of Chinese philosophy. . . . I am going to try to be alone more, to think and relax and write more. . . .

> . . . I am unable to concentrate on anything but household mat-
> ters [later, at home in Connecticut]. . . . *No one* is requiring this of
> me, quite on the contrary, really. It's as deep within me as a root.
> But so is the desire to work. . . . I might as well not try and tell . . .
> I am like Gertrude in that way. I hide things deep inside so people
> can't hurt me by laughing at them or just not taking them seriously.
> It all seems to show how difficult it is for me to take myself seri-
> ously.

For some time, I had been upset about Tom's attitude toward certain
curators to whom I felt close, curators who had worked at the Museum
for years, curators who were bright and energetic. Tom, however, the
first director to come from the outside, had virtually no connection to
them. Their way wasn't his way. He wanted his own team. Later, I
came to understand this better, but in those days I refused to hear crit-
icisms of the curators or of any other staff members.

First, Elke Solomon, upset over her deteriorating relationship with
Tom, offered to resign. Tom accepted with alacrity. Elke, intending
her offer only as evidence of her distress, was appalled. So was I. I tried
to talk about this to Tom, knowing he could and would make his own
decision. But to let go of Elke, who had taught me so much? Cared so
much? Elke, with her special knowledge and sensitivity? It made no
sense. At the time, I probably didn't take the Museum's money prob-
lems as seriously as I might have. They were surely affecting all Tom's
decisions.

Soon after, Tom announced to the executive committee and the
budget and operations committee, meeting jointly to consider the
alarming deficit, that he had fired curator Marcia Tucker. I was aghast.

Among the justifications for his action, he told us that when he'd
asked Marcia what she'd recommend buying from the last Biennial,
she'd said, "Everything, because the artists need that so much." She'd
voiced exactly the policy Tom wanted to change — no longer must the
need of artists be primary, but the quality of the art. This account may
well have been exaggerated; still, it represented a historic attitude
Tom was determined to change.

What Tom didn't realize was that for me, Marcia represented what
the Whitney was all about. By firing her, Tom seemed to make clear
his intention to drastically decrease the Whitney's commitment to the
developing artist. Although he had the technical right to make all de-

cisions about staff, taking such a controversial action without consulting the board was a slap in the face, and I feared it would demoralize the Museum's staff. I was terribly hurt that he hadn't even told me about his decision to fire Marcia, that he hadn't asked my advice.

He proposed to replace Marcia with Tom Hess, distinguished scholar, writer, and later a curator at the Metropolitan Museum. Others at the meeting, however, objected to Hess's personality. Uninformed, in anger, I voted with them against Tom's proposal.

Only later, regretting my vote, did I realize what strength Tom Hess would have brought to the Museum. We needed such a curator, whose experience, education, and connoisseur's eye would have helped us toward the goals stated in the long range planning committee report. He would have filled the role of senior curator. But Tom had not articulated all this, had not prepared the way.

Increasingly dispirited, feeling deep loyalty to Marcia, I informed the committee after that meeting that I could no longer work with Tom. I would resign from the board.

Two days later, a delegation comprised of Bob Friedman and Arthur Altschul visited Mike and me on Sixty-sixth Street, in our apartment on the second floor of my great-grandfather's carriage house. Bob and Arthur expressed serious concerns about the Museum's welfare, and reminded me of my family's responsibility to the Whitney: "Directors and staff come and go, but your family remains. Trustees remain."

That was the crux of their argument.

While they agreed that problems existed, while they regretted Marcia's firing, they urged me to reconsider my resignation. They wanted me there. I was so angry that I didn't completely hear them, and it would be years before I realized the long-range implications of their insistence — a lifelong commitment, regardless of the circumstances. Finally, however, I accepted their suggestion that, as leader of the Museum, I could, with their support, arrange for Tom's orderly departure better than anyone.

I see now that my reaction was about more than Marcia. First, I hated confrontations. And then, surely I sensed that it wouldn't be the last time I couldn't control a situation. That I was entering a world where my sentiments and experience wouldn't help me deal with this intransigent world, with its manipulations and cruelties. That I might be well out of my depth. Yet, in deciding to remain, I tacitly agreed to

enter this world, to participate in some of the practices a good part of me wanted to reject.

On October 1, 1976, Tom came to see me on Sixty-sixth Street. He began by expressing his worries about the budget. Then he went on to Marcia. She was only interested in unknown artists, he said, and she brought her radical, feminist political agenda into her selections. And she was always out of the Museum, in artists' studios. He could never find her.

I argued.

Our conversation, nervous and guarded, resolved nothing.

I went on seething as articles in the press began to appear about Marcia, as letters arrived from her supporters.

And one from Marcia, too, addressed to all the trustees:

> As you know, I have been relieved of my responsibilities as curator at the Whitney Museum of American Art effective December 31st, 1976. I will leave with a deep sense of loss and regret. I have been told by Tom Armstrong that the reason for the termination of my services is a shift in the emphasis on contemporary art toward its acquisition and preservation, and away from its exhibition and written scholarly evaluation. I have also been led to understand by him that my continual involvement with artists outside the Museum is no longer viable in terms of the Museum's present and future direction.
>
> When the Whitney Museum was founded in 1930 by Gertrude Vanderbilt Whitney, its purpose was to encourage, support, and preserve the best art being made by living American artists. I have, since my appointment as curator here in 1969, done my best to maintain and enhance the tradition for which the Museum has achieved prominence.
>
> As a scholar, it has always been my conviction that it is the Museum's responsibility not only to reflect the consensus of educated opinion by which art history is made, but also to seek out the best work at its source, rather than only after it has attained commercial exposure. . . .

Marcia told me more. Then I began to get new information.

About how the staff was uneasy, now, sensing a lack of conviction and direction in the Museum.

About how Tom criticized his predecessors, saying the Museum was

disorganized, the curators, weak, exhibitions and catalogues, second-rate.

About how staff, as well as board members, criticized Tom for his extravagance and his "obsession with celebrities."

About how David Hupert, head of the education department, disagreed with Tom's emphasis on the permanent collection, his most dearly held goal, saying other museums had better collections of American art, and with our budget, we could never catch up. Tom, Hupert was convinced, confused education with public relations. And the Whitney had a "big heart and a small head." It should be the place where people could see what was going on; it should give contemporary art the support of a major institution, while retaining its identity as the place viewers can find out what contemporary art is and how it develops.

At the same time board committees complained about Tom's aloofness, saying he had no respect for them.

"I don't have time to fuss around with trustee committees," Tom told me, and that was increasingly obvious. A few months later I understood what he'd meant. The committees themselves were the problem. They, with the years, had become overloaded with nontrustee members whose interest had flagged, who contributed neither funds nor knowledge. We badly needed to revitalize these committees.

Tom's priority, then and always, was the good of the Museum. Courageous enough to face the difficulties of its becoming an important public institution, he saw more clearly than most of us what would be required: more quality-oriented programs, trustees and committee members to give more money, and more space. And he didn't mind whose toes he stepped on along the way.

At that time, I was angry at Tom's seeming condescension toward the many people who had helped us to this stage, and for our past accomplishments. But Victor Ganz's criticisms still reverberated, balancing this anger.

Then, Arthur Altschul summarized *his* theory. Tom had a basic personality problem. It stemmed from his inferior artistic professionalism and administrative deficiency, so he rode roughshod over both staff and trustees. He was insensitive to the value of trustees who lacked money but brought other qualities to the board: scholarship, knowledge, historical involvement. Surprisingly, however, Arthur concluded that, all this notwithstanding, Tom was perhaps the right man in the right place at the right time.

Tom neither knew Arthur's history at the Museum nor understood how much his earlier commitment had contributed to the Whitney's growth and its present building. Still, Arthur wanted to be one of those Tom favored.

Most people did.

I wanted to stick it out. But I doubted my ability to improve matters. And I could barely speak to Tom.

Marcia, meantime, decided to start her own museum (the New Museum of Contemporary Art in Soho) and said she would love to work with me, if I decided to leave the Whitney. A tempting offer, but I shelved it.

Then I wrote a rough draft of a statement I planned to read to the board, ending with these words: "I have lost confidence in our director, and at this time would like to ask the board, after discussion, for a vote of confidence in Tom, and then proceed from there."

Even then, with my lack of experience and know-how, I sensed the proper procedure for such a drastic action as dismissing the director. I knew the whole board must be informed and involved.

But before I could act, before the next trustees meeting, Steve Muller asked to meet with Tom and me. He felt he could help us to resolve our problems. Reluctantly, out of respect for Steve, I agreed. He arranged for dinner in a fine restaurant, and over drinks and food we relaxed and started to talk.

Steve was skillful, probing gently for problems, unearthing spiky truths, enabling Tom and me to safely confront each other.

I was furious about Marcia.

Tom had been afraid to tell me, he said, fearing my emotional reaction. (Such emotions were always difficult for him to deal with.) He considered her insubordinate.

Then Steve said, "If you work together, you can be a great team. You balance each other temperamentally, emotionally, in style as well as substance. This museum has infinite potential. You both know that. I believe the two of you can lead it to where it should be, the finest museum of American art in the world."

I walked home with renewed faith, greatly surprised that this should be so, and thankful to Steve. Although it took another dinner and subsequent meetings with Tom, and also more time, this was the beginning. Tom and I were on the way to establishing a rock solid partnership.

* * *

Since then, I've sometimes wondered why I so quickly changed my mind.

Undoubtedly, I was subconsciously ready to accept Tom's view that the Museum must change in order to take its place in a changing world. My new friend, Victor Ganz, already had prepared me for this attitude. A shift in emphasis was inevitable. The sheer number of artists and new galleries in New York made our former mission hopeless to fulfill. We couldn't possibly show all emerging artists, couldn't possibly buy and store their work. Only a museum such as the one Marcia was going to found could attempt it, a museum that didn't collect. But the Whitney was already burdened by a collection it couldn't show and hardly had the space or the money to store. This collection represented a unique, valuable overview of the first half of the century. If we were to continue collecting, we must focus on quality, exclusively — no longer on one of everything. In addition, by the late '70s, much of the new work had been found and shown by a number of sophisticated, competitive galleries. Adhering to its worthy but now unrealistic ideals, the Whitney had missed out on some of the greatest art of our time. (I say that from my perspective today, flawed as any such short view must be. Who knows what will be considered "quality" in a hundred years?)

All in all, the Whitney's top priority was now to show the very finest of American art. And Tom believed we could best serve the public by focusing on just that, which meant, of course, making judgments. And judgments can be flawed.

At dinner with the Ganzes, sitting among their Picassos, Stellas, Johnses, Rauschenbergs, Hesses, I listened as they told stories of these artists, of these acquisitions, and — most significantly — discussed their meanings. Home again, I sat up half the night reading Leo Steinberg's *Other Criteria*, stirred by ideas that seemed to apply to the Museum as well as to art: "Contemporary art is constantly inviting us to applaud the destruction of values which we still cherish, while the positive cause, for the sake of which the sacrifices are made, is rarely made clear. So that the sacrifices appear as acts of demolition, or of dismantling, without any motive."

Victor let me know he thought the winds augured change. I must stay close to the Museum, must support that change. But when I asked him to join the board, he said he'd never allied himself with any one

museum, and he didn't think he could begin now. Secretly, I heard that as a challenge.

Soon after, the president of the Museum of Modern Art, Blanchette Rockefeller, invited me for lunch. Blanchette encouraged me, warned me, counseled me. You'll need people with lots of money, she said, but be careful, find people who really care. It was important advice.

My schedule was already changing. Now, opening my calendar for 1977 at random, I find January 27:

> 9:30, meet with Walter [Polechuck, director of development]
>
> 10:30, meet with Tom
>
> Lunch with John Hanhardt
>
> 2:30, David Hupert
>
> 4:30, Budget and Operations committee at Dan's office
>
> 7:30, dinner, Tom and Bunty, Louisa Calder [Alexander's widow], her daughter Mary and husband Howard Rower.

A typical day.

I knew it was the right time, this time.

No one had formally asked me to be the next president of the Whitney except for my mother and Howard, but somehow this intention became known and accepted. (The choice of a new president would never again be so casual.) A letter thanking my mother for money she had sent me for Christmas so I could begin to prepare for my new job reminds me of my qualms:

". . . that amazing check, which should make it physically possible for me to do the job at the Museum. Whether I have the other qualities it takes, is a whole other question — I'll surely need everybody's faith and prayers and help. As soon as we get back [from a family sailing trip in the Caribbean], I'll start working in earnest — as I think most of my work on the book should be finished in a month or so. Your wanting me to do it, and thinking I can do a good job, makes a tremendous difference — so, thank you for all *that*, as well as for all the $$."

And to my lifelong friend since childhood, artist Clare Chanler Forster, with whom I exchanged letters that approximated journals, I wrote: "The upshot of it all was that I decided to have a go at being

president of the Whitney for a while. . . . I had to make a decision to either resign from it altogether or take the responsibility; at any rate, that's what I thought. So — am in the midst of a kind of maelstrom of meetings, telephonings, letters, lunches, people, talk, talk, talk. I fear my lack of executive experience and financial training, but hope for some on-the-job training. It's quite awesome to be responsible for such a big budget; not to speak of the policy part. I also fear the lack of time to reflect, and a kind of loss of identity. . . . But there are things I enjoy — mostly, people. It's certainly challenging; whether it's possible to keep some of the spirit of the place in spite of all the $$ problems and pressures is the big question."

Clare, in her typically generous way, wrote back, "Dear Flora, that's wonderful news about you being the president of the Museum! I'm sure you'll do an excellent job. Who could do better, really? For a long time I've thought there was another race of people older, smarter, more experienced. Now I know that isn't true. We are them. This is it."

I was excited. Proud. Intimidated. Happy. All of these, all at the same time.

Since, unlike my grandmother and my mother, I'd have little money to give the Museum, the job would require all my time, energy, and strength. I'd have to live in New York, at least during the week. There were too many evening events I couldn't miss. Mike had supported me in the decision to become president, but we both realized the difficulties and questioned my decision. I wrote as much to Clare, after we'd both read a memoir by Liv Ullman about giving up one's profession for love: "in the long run that idea of giving up doesn't work, I suspect, because, after all, 'what we are' is not what we were born with but what we do with ourselves, and one has to develop to be anything. . . . Sometimes I wonder why I'm putting myself under all this pressure, jeopardizing to some extent my relationship with Mike, whom I love, struggling and getting exhausted and tense — and I suppose it's a feeling that I must catch up, or it'll certainly be too late to become whatever my potential allows me to become."

But, to me, in 1977, change seemed inevitable. Why was this? Was it ambition? My desire for a bigger world? A bigger part in the glamorous life I was glimpsing? And added to that, a belief that only *I* could help the museum to its next phase? Was it sheer ego?

All of these, probably. Perhaps our marriage, Mike's and mine, had a

certain lifespan. As our lives diverged, what had once fulfilled us, occupying us wholly, was no longer enough. Filled with a new, willful energy during this transition, I fled the familiar.

Eventually, in 1979, Mike and I agreed to divorce, as we both sought and found others who complemented the new desires and different directions of our middle years.

How and why did I become involved with the Whitney Museum? While my involvement may not have sprung directly from love of art, it began there. And from that involvement it had grown steadily, sustained through good times and bad, through challenge and satisfaction.

It became about art. More and more, I realized the centrality of art, curators, and artists to my life.

In the '70s, I felt a tingle, a buzz permeating the art world. It was a time of change, diversity, and excitement. Philosopher and art critic Arthur Danto has written about it.

"The seventies in America . . . was certainly socially and, in a view I am becoming increasingly convinced of, artistically the most important decade of the century. It was the seventies in which the objective pluralistic structure of the art world first began to show itself as something distinctive. It was the seventies in which indeterminately many directions began to show themselves as available to artists without any historical possibility of showing themselves as *the* historical direction for art."

All around me, a wondrous multitude of directions. The variety and excellence were astounding: such artists as Donald Judd, Elizabeth Murray, Bruce Nauman, Eva Hesse, Richard Tuttle, Richard Serra, Brice Marden, Mary Miss, Robert Irwin, Ursula von Rydingsvard, James Turrell, Robert Smithson, and many more.

Philip Guston, painter during an earlier generation, became central to the '70s when he stopped painting abstractions and made work related to his much earlier figurative mode. His new paintings, like much art of the '90s, were wild, angry, and cartoonish. He said once, "There are so many things in the world — in the cities — to see. Does art need to represent this variety and contribute to its proliferation? Can art be that free?" In 1966, before the change in his work, he had spoken of some shift: "It has to be new and old at the same time, as if

that image has been in you for a long time but you've never seen it before. . . ."

Henry Hopkins, director of the San Francisco Museum of Art, organized a Guston retrospective, revealing the wide range of Guston's work. The exhibition traveled to the Whitney in 1981, and Hopkins as curator wrote for the catalogue:

"When I finally arrived at Guston's studio in 1978, there it was: the next body of work, painting, after painting, after painting. Whatever psychological dam had been blocking Guston's creative surge had burst. Self-revelatory, self-deprecatory, urgent, tormented, dumb, sad, humorous, anything and everything but pretty, the hand and the heart were moving with a will of their own."

This work was emblematic of that time. I was excited by it, and by other artists' too, — by their ideas, by meeting and talking with some of them. Some, such as Robert Smithson and Michael Heizer, were making art out of the earth itself. Some, Robert Irwin, James Turrell, and Maria Nordness, made it out of light. One, Richard Serra, threw molten lead against the Whitney's walls. Some were dancing, making music, writing on walls, walking on ceilings. I was delighted when the Whitney's print curator at the time, Elke Solomon, invited me to take part in a performance. Some used traditional materials in a new way, some were still doing abstractions — it was a time when anything seemed possible.

A scrawl from my cousin Barklie encouraged me a lot.

"In the remainder of this page I'm going to convince you that you're going to be the best president of what's-left-of-that-dream-museum so far. Just be clear on (and keep privately reworking) *the basics:* What is the Whitney *for?* Who are the real *family* of the place — who feels family feelings? How would my dream-president *lead* us through, guide us (in the Adirondack sense)? and most of all — YOU earned it. . . . Anyway, Flora, have fun with it. Be true to yourself, trust your instincts, go for it!"

Rereading these words, how innocent, how impossibly naive, they sound! And, at the same time, how right.

Fifteen

*I*n 1977, at the annual meeting of the Whitney Museum of American Art, Joel Ehrenkranz, chairman of the budget and operations committee, reported a surplus of $445,000 for the first nine months of the fiscal year. He attributed this money almost entirely to attendance at the exhibition "Calder's Universe." The eighteen trustees present at that May eighteenth meeting were pleased and impressed. Although I still felt the same about preferring free admission, the good news tempered my immediate view. Alexander Calder's retrospective, during which, sadly, he died, was more than popular; it was critically acclaimed.

Tom reported on the 1976 addition to the staff of an associate curator for the permanent collection, Patterson Sims. Despite this welcome emphasis on the collection, the appointment had been controversial, since Patterson had no advanced degree and no museum training. His professional experience had been limited to working as assistant director of O. K. Harris, a commercial art gallery. Tom's instinct was sound, however, in choosing a bright and articulate young man with a passion for art. Patterson learned quickly. He studied the collection, and used it in many fine exhibitions; he spoke widely and well about the Museum, its history, and its collection, and, reaching out to a wide audience, he made hundreds of new friends for the Whitney. Lithe, pale-skinned, with wide blue eyes, Patterson wore his tender orange-red beard like a flag. It lent him a maturity that belied his years: he was in his late twenties and bursting with the energy and idealism that are intrinsic to his personality. Intense, prone to strong emotions and loyalties, he soon became a close friend.

Patterson delved deep into whatever interested him, which was almost everything, and this was evident in his work. Besides his larger-scale exhibitions and the courses on aspects of American art that he taught at the Whitney, in 1980 he gave direction to the Museum's plans for expansion in his series of one-artist "Concentrations" for the lobby gallery in celebration of the fiftieth anniversary of the Whitney's founding. These shows revealed the Museum's commitment to certain artists it had collected in depth over the years — Charles Burchfield, Alexander Calder, Maurice Prendergast, John Sloan, Ad Reinhardt, Georgia O'Keeffe, Stuart Davis, and Charles Sheeler — thus emphasizing through the Whitney's strengths its character and history.

John Sloan, for example, had his first one-man show at the Whitney Studio in 1916. Afterward, he wrote to thank my grandmother: "Due to the prestige which my exhibition at 8 W. 8 established . . . I have passed through the most successful winter of my career. . . . Mr. Kraushaar is to handle my etchings and paintings as well — his attention was quite surely attracted to my work by my Whitney Show."

A charter member of the Whitney Studio Club, founded by Gertrude in 1918, Sloan exhibited in almost all its group shows. He had a one-man show of etchings in 1931, the year the Whitney Museum opened, and continued to show there regularly all his life. In 1952, a large retrospective of his work, organized by Lloyd Goodrich, opened at the Whitney. As Patterson wrote, the 1980 show "charts a relationship between Gertrude Vanderbilt Whitney, the Whitney Museum, and John Sloan and his work which has flourished vigorously for sixty-five years."

One could trace the same commitment with the other artists shown in this series. Charles Sheeler and his wife, for example, lived for several years in rooms on the third and fourth floors above the Whitney Studio Club's galleries at 10 West Eighth Street. Besides the professional relationship, in those days there was almost always a personal one as well.

At that same 1977 trustees meeting, Tom also reported progress toward another goal: the number and quality of acquisitions gained in the past year had been the greatest in the history of the Museum. He'd accomplished this without using the Museum's budget, but by raising money from new sources.

Then Howard Lipman announced his last meeting as president. He went on to say how pleased he was by the Museum's progress in implementing the report of the planning committee — the expanded

membership, the strengthened board, the regularly exhibited permanent collection. He proposed a resolution to especially thank Barklie, now retiring from the board, for his contributions to the Whitney. (Barklie was about to move to the West Coast.)

Finally, Howard gave the nominating committee report, proposing my mother as honorary chairman, himself as chairman, David Solinger as honorary president, and me as president. Joel Ehrenkranz, head of budget and operations, a lawyer and collector who would become president of the Museum in the late '90s, and Daniel Childs, a member of the finance committee, would become vice presidents, protecting the Museum in my weakest area, the financial.

The slate was accepted.

Moving to the head of the oval granite table, I felt, flooding me, simultaneous sensations of anxiety and joy. For a moment, I could hardly speak. Would I be able to do it? Would anyone listen? Would the board recognize my fears and frailties? Such a public role was unfamiliar, awesome. But no — I would not be fearful. I would conquer my insecurity and fulfill the role I had accepted. Besides, look at the splendid attendance — nearly all the trustees had come to welcome me. They were my friends, coworkers for the Whitney's illustrious future.

I didn't waste a minute, but got right down to business, restating the Museum's long-term goals: more space for the permanent collection, for offices, and for an auditorium. To accomplish this, I emphasized that a great deal of money for building and endowment was necessary, and proposed the beginning of a major fund drive to coincide with the fiftieth anniversary of the Museum in 1980.

At least $100,000 more must be given by the board annually, I said — knowing it would be my job to ask for it. After all, an additional $250,000 was necessary to keep the budget in balance.

After inviting all trustees to attend meetings of the executive committee, so it wouldn't become a kind of insiders' clique, I concluded my opening speech: "I care very deeply for this Museum. It's a part of my history, as well as our country's, and I promise you all to work hard and to do all in my power to fulfill its promise." How fervently I meant this, only I knew.

That evening, the Museum held a party to celebrate the past presidents of the Whitney: my grandmother, my mother, David, and Howard. Mum, raising her glass, made a wonderful toast:

"There is only one good thing I did. I don't know if any of you knew this and I might not say it if I hadn't had such a good time and such good . . . [nodding at her friends and family]. My mother left the Museum to me and said that if I didn't want to keep it as a museum I could — sell everything. Obviously I wanted to keep it. And I just want to say that I can imagine how happy my mother would be to know that her grandchild had become president thirty-five years after she died."

Tom revered my mother. For Tom, Mum was everything a lady should be — charming, elegant, warm, and faithful. Moreover, he and everyone knew that the Whitney had survived only thanks to her. Since Gertrude's death, my mother had kept it going, sacrificing time and lots of her remaining fortune, then making the Whitney a public institution, so it could continue to grow and flourish. It had been a heroic act. And Tom adored my mother, her style: her husky voice, her slightly flirtatious but dignified manner, her polished nails, her black evening suit covered with shiny paillettes. When, during an opening party, he arranged for a '20s-style chanteuse to sing torch songs in the Whitney's big elevator, he'd had my mother in mind, and indeed she loved it. The most special favor he could offer potential patrons was a visit to Flora in Long Island. She represented the Whitney as no one else could — certainly not much-more-casual I, who would sometimes appear for meetings with Tom in my running shoes, because I'd just jogged around the lake in Central Park for exercise; whose nails had never seen polish, because I didn't take the time for that; who argued with him, who was all too serious, who was always trying to reduce expenses — the Museum's as well as my own.

Still, Tom and I were getting along pretty well.

We met at least once a week, talked on the phone almost daily. We examined endless lists, searching for additions to the board or to committees. We planned dozens of meetings and parties. I personally took care of most trustee and committee affairs, making sure to meet with members at least twice a year for breakfast or lunch, calling them with relevant news, giving or arranging dinners where they could meet each other and new members, too. I wrote hundreds of letters, thanking, asking, informing — trying a little desperately to do whatever it took to keep us a "family." Tom promised to keep me posted on everything to do with the Museum, so there would be no further surprises like Marcia. I, in turn, agreed not to interfere with decisions in his bailiwick

and to protect him, as best I could, from trustee interference by acting as a buffer, or, when necessary, a mediator. We wooed new members together, most of them from Tom's lists of people he'd met or had heard of from those in the art world. Both of us always met with potential new trustees.

I was now spending at least five days a week in New York, and sometimes weekends as well — there was that much work to do. My mother's Sixty-sixth Street carriage house, ten blocks from the Whitney — an easy walk or run — was my headquarters. With new desks in the spare bedroom, with a part-time assistant on the Museum's payroll, I would arise early, have an English muffin and a cup of coffee, and dress in a big hurry before the arrival of John Ellis, my indispensable helper. Still in his twenties, he had graduated with honors from Williams College. He wanted to act and to write. Although I had always written my own letters, and for the most part continued to do so, John now typed them. Pretty soon, he learned to write many that sounded like me, only better. He made phone calls, scheduled appointments, and quickly caught on to who was who. Organizing my life was much easier with John to help. As the years passed we moved to a room in a building on Sixty-ninth street, and finally to two different offices in Museum-owned brownstones on Madison Avenue.

Charlie Simon gave the Museum a generous gift so I could entertain. Inviting guests, both to restaurants and to my home, while expensive, was essential if we were to increase the Museum's income by finding new patrons. It was typically sensitive of him also to recognize my financial limitations. Moreover, he gave me excellent advice during our lunches at "21," where I still remember the "Sunset Salad" as we discussed the fund drive for endowment and an expanded Whitney. It seemed like his club. He had the best table, the full attention of the owners, and constant greetings.

"You can't do it," said Charlie bluntly, referring to expanding the Museum.

"Why not?" I asked. "I believe in it. I have confidence in our board — it's enthusiastic about the project, and there's lots of money there — and I'll work hard —"

"Bullshit," Charlie exploded. "You have to be a tiger. A shark. Willing to do anything. And you're not."

I was crestfallen, but I recovered quickly. Too quickly, perhaps. I hadn't taken him seriously enough. Working, for me, was sometimes a

refuge from the thinking that precedes intelligent decisions. Action was easier than sitting still, reaching deep inside for understanding. While working often had good results, I wish now I'd taken more time for reflection.

Charlie's generosity was legendary. After admiring his shirt or suit, a curator or even Tom would find himself being measured by Charlie's tailor the very next day. He overwhelmed me once when he brought me fabric for a skirt from London after I'd complimented him on his flowered Liberty tie. He would invite a group of us out for dinner after meetings or openings, always including curators, secretaries, or other staff members. One memorable time, early that summer, as we sat around a table at Les Pleiades (a restaurant that was a club for the art world), all the lights went out. The great blackout of 1977 had begun. Soon, candles appeared and we finished our dinner in a newly romantic ambiance. With no radio or TV, we had no idea what had happened. All telephone circuits were busy, New York was isolated. As far as we knew, the blackout could have extended everywhere in the world. The streets without traffic lights were eerie. Buildings were dark. Of course no elevators were running. And Charles lived on the twenty-fifth floor. Then in his seventies, very overweight, he'd recently been ill. There was no way he could climb those stairs. "You must come home with me," I said.

"I couldn't possibly! What would your husband say?"

But there was no alternative, so we walked down to Sixty-sixth Street and up the one flight of steps to our apartment. Installing Charles in the bedroom was another struggle — he pushed hard for the living room sofa — but he finally gave in. We had just sat down for a nightcap by candlelight when stones began to pelt the living room windows, at which Charles leaped up, waving his cane and shouting, "They're attacking! The Communists are attacking! I'll murder them!" But it was only some of my son Cully's friends, who came for some food and drinks, then left again to investigate New York's dark streets.

Other trustees were also helpful. Joel Ehrenkranz, the first to invite me to lunch at *his* "club," the elegant barroom of the Four Seasons, assured me of his support. "Anything I can do, any time, just let me know." I looked around the room at the big publishing moguls and peered into the corner to see who was lunching with Philip Johnson that day. I did ask Joel to teach me to read and understand the budget. Thanks to his skill and his patience, I learned a lot. Even though I

never achieved his lightning-fast comprehension of those arcane sheets of numbers, which sometimes seemed to dance like jumping beans on their white sheets of paper, I did end up recognizing potential problems as deficits leaped off the page and alarmed me.

Larry Tisch was our most powerful trustee in the financial world. Compact, with a disproportionately large, balding head, blue eyes, and a serious mien, he was soft-spoken and courteous. His manner was kindly, almost fatherly. Larry asked me to meet with the finance committee; he was chairman. Right after I became president, I agreed, and arranged to go to his office at 666 Fifth Avenue. His office was large but plain. Larry's desk was altogether clear. He exuded the sort of controlled calm that sometimes accompanies success. The phones on his desk had been silenced. The only sound I heard was the click-clack of the ticker tapes, keeping Larry apprised of stock market transactions the world over.

We must, he began, do something about the Whitney's endowment. And he explained why. At a time when it was quite possible to double or triple values, the J. P. Morgan bank's conservative policies had kept the Museum's money stagnant. Howard, as an outsider aware of our strong family tradition of investing with Morgan, had been reluctant to move the funds. On that day, though, Larry told me that the whole finance committee had advised me, for the sake of the Museum and its need for more income, to take immediate action. Larry, head of the committee, urged the change.

It was up to me.

I was sure he must be right, especially since Morgan's had not done well with the small trust fund they administered for me. I arranged to see Lewis Preston, then chairman of Morgan Guaranty Trust Co. A small matter for them, I thought. Fifteen or so million, when they deal in billions.

I had always known Lew Preston. Our parents, even our grandparents, had been friends. His stepdaughter, Linda Bartlett, who'd grown up with Lew and her mother, Patsy, after their marriage, was married to my brother, Leverett Miller. Lew cared about my family, about the Museum, and also, of course, about his bank. And he was experienced, intelligent, and moral.

But the bit was in my teeth and I was running with it. My finance

committee was smarter than anyone. It had the best interests of the Museum at heart. No chance it could be wrong.

In Lew's paneled office on Wall Street, I listened to his understated way of addressing issues. His comfortably assured manner, his relaxed humor, our shared background, were wholly familiar. I had grown up with them.

Lew couldn't have been nicer, but I could tell my plan to move the money distressed him. Well, there was no rush, he said. There was plenty of time to decide. He could help me sort things out. Would I meet with him again? Along with a couple of other bank officers, too, so I could hear their views? Of course I agreed.

But my mind was already made up. Closed, really. I'd never met such brilliant financiers as those on the finance committee. And then, I remembered my small trust fund.

When I reported back to Larry Tisch, he reiterated his arguments, probably to strengthen my resolve.

Then, at 1:00 on August 1, 1977, in an austere room at 9 West Fifty-seventh Street — Morgan's uptown offices — a formidable group assembled. Lew himself joined us, attentive, as top officers presented sheets of figures, comparing Morgan's performance over many years with that of investment firms and other banks. They suggested a number of ways to improve the Museum fund's returns. The men were impressive, their arguments persuasive. But when I took their figures back to the investment committee, Larry's numbers were even more convincing. The committee was unanimous about moving our money — and insistent.

I called Lew to tell him of our decision to remove the fund and divide it among several investment firms. "I'm really grateful to you," I said. "I appreciate all your help. But I must go along with Larry and the committee."

I still remember Lew's final words exactly as he said them: "I believe you're making a mistake. I urge you to think longer about severing ties with Morgan's, and to reconsider your choice of advisors."

He saw the removal of the Museum's funds as a crack in the long-time association of the Whitney family with Morgan's, or so I thought then. A few family members still had deep pockets — my uncle, some cousins from another branch — and I imagined the possible loss of their money caused Lew's unhappiness with my decision.

Looking back, I well understand why Lew doubted Larry's long-term commitment to the Whitney.

For that moment, though, my very first action as president was to put my faith in our new trustees, especially in Larry Tisch. It seemed absurd to think that his lack of interest in art could in any way limit his capacity to give the Museum financial advice. He didn't really have to care about our mission. Larry would surely give the Whitney his best.

How often, since I now live with their consequences, I've wondered about my decisions and actions.

My upbringing had led me to believe daily life was consistent and predictable.

By the time I realized it wasn't so for everyone, I'd already learned to trust. Though I chafed under their discipline, adults were *there*. And they cared.

Perhaps the trust I had in others was implanted in my being during my early years. Both my parents were trusting souls. Innocent. Trust became as natural as breathing, laughing, or crying. Although I had been trusting, as they were, for a long time, experience eventually brought home the reality that none of us is perfect. That it was irresponsible to go out into the big world with the wide eyes of a child. That even those I thought I knew could behave differently if a great deal was at stake. That I must be wary.

Deeply motivated, I now felt free to telephone anyone at all, known to me or not, make a date, and discuss the Museum. I reached out to heads of government, corporations, social and community leaders, the media. At first, I felt uncomfortable with my sudden power — like being in someone else's skin.

Slowly, I gained assurance. The board supported me strongly, as did the staff. Insisting that I become a more public representative of the Whitney, Tom pushed me to the center as we raised money and attended meetings, press conferences, openings, and other events. If this was how I could be most useful, I determined to develop that persona, and practicing made it much easier. As we relentlessly pursued funding for exhibitions or acquisitions, to my surprise, I discovered that I enjoyed the hunt — especially when we succeeded.

It always surprised me when people I hardly knew were suddenly so friendly! I accepted as many invitations as I could from important figures in the worlds of business, politics, and art. Having up to then

known so few of these, it was a good way to identify new patrons for the Museum — but following up on each event took lots of time.

Was X, Y, or Z likely to be interested? Able to help significantly? Already committed to another museum? I had to learn to engage in endless phone calls. To arrange invitations to lunch or dinner, tours with curators, or in some cases with Tom himself.

While by nature I was shy, I found myself enjoying the challenge of drawing people closer to the Whitney. My deep sense of mission was driving me.

However, it was all more complicated than it had seemed initially. Everyone, it seemed, wanted something from me, friends as well as strangers. Calls, letters, visits. And I had to answer all of them, had to be available to anyone with a question, a complaint, or a demand. This aspect of my new position became a daily challenge. There were times I felt discouraged, overwhelmed.

A friend of a friend's daughter would like a job at the Whitney; I'd talk to her, then decide whether to put her in touch with our personnel department.

A member of the Friends of the Whitney wanted to borrow a painting not on the approved list. Could I arrange it?

Artists sent slides. Should I pass them on to a curator?

A guard was in debt. He was sure I could lend him money; after all, wasn't I a Whitney?

A friend of a trustee wanted tickets to MoMA's sold-out Picasso exhibit. Should I bother my friend, MoMA's president?

Jeannette Watson, the owner of Books & Company, a bookstore in a brownstone the Whitney owned, was worried by rumors she'd heard that her building would be torn down for our addition. Could I reassure her? If not, what would she do?

A gallery owner or even a trustee couldn't understand why we didn't buy or show a particular artist they admired or collected. Should I tell Tom? Deal with it myself?

How could we have such a dreadful exhibition? That one was easy.

Most recently, a video artist complained to a friend of a friend that his exhibition at the Whitney hadn't been reviewed. Outrageous, he maintained. Could I do something about it? This time, *I* was outraged. I had no control — nor should I have had — over the reviewers.

The intensity of my daily schedule was engulfing me. My appointment books often show eighteen-hour days, varying from Museum ac-

tivities to book business. Trying to keep fit, I ran a mile or two in Central Park every other morning. There were moments that summer, however, when I worried about having abandoned the concentrated work on my grandmother's biography for a more active role in the world. Moments, too, when I wished for more time with the family.

Michelle had remarried and was living in Oregon, where her husband was studying to be a computer programmer — a prescient choice of career, since its possibilities have grown immensely. Her new husband, Bill Evans, a part-time ski instructor, was a charming, warm, rock-solid young man, and we were all delighted by Miche's new happiness. He loved her son Anthony and had adopted him, since Anthony's birth father had virtually disappeared.

Duncan had also found his mate, beautiful and intelligent Linda Stern, intensely loving and loyal, and adored by Dunc — and by us all. They were living in Connecticut while rebuilding an old wreck of a house from the ground up. Duncan was starting a flourishing business as a carpenter-builder, and soon, in 1980, they were married in Linda's parents' apartment in New York, with a gala party after in the garage under our carriage house apartment on Sixty-sixth Street, which we'd filled with flowers, tables and chairs, and music.

Cully had graduated from Yale in June, and was working as an investigative reporter for the *Hartford Courant*, a job he greatly enjoyed. Cully met his future wife, Libby Cameron, a lovely Washingtonian who has now become a renowned interior designer, the same year. Still in school, she hadn't yet decided on a career, and in 1980 she went off to Gerald Durrell's refuge on Jersey, a Channel Island near France. There she cared for endangered animals: tapirs, tamarind monkeys, crowned pigeons. When a lowland gorilla mauled her, she decided not to be a zookeeper! Cully went to meet her in London, and they traveled in Europe for a month before he started working for Stuart McKinney's congressional campaign in Connecticut. All the family hoped a marriage was in the offing.

Our youngest, Fiona, taking time off between semesters at Barnard College in New York, had chosen a wide menu of activities to expand her world. She'd gone to Paris on a "semester abroad" and, besides taking courses at Reid Hall, the Paris extension of Barnard, she learned to cook a number of complex dishes. Back home at Christmastime, she produced a gorgeous *Bûche de Noël*. After a spell as a waitress

in my brother Leverett's restaurant in Palm Beach, she joined the crew of *Maroufa*, one of the Tall Ships racing from Bermuda to Newport in 1976 in celebration of our bicentennial year. We'd sailed to Newport to see the ships come in, but with such bad weather reports we huddled around the radio on our boat, waiting anxiously for *Maroufa*'s arrival. Ship after ship appeared, flags flying, crews saluting from high in the rigging, as the waiting crowds shouted their hurrahs from sea and shore. Finally *Maroufa* rounded the bend and we bellowed our cheers. Apparently Fiona and her good friend Jackson Friedman, Bob and Abby's son, were the only crew members not to be completely laid out by seasickness, and they'd taken charge of the huge ship during the worst storms and waterspout dangers!

Now, in 1977, Fi was back at Barnard, living in a Columbia dorm, working part-time for the Columbia radio station, WKCR.

By the fall of 1977, troubles at the Museum were brewing.

After every Museum meeting, a trustee or a staff member would take me aside and complain about Tom's inadequacy. What weak choices he had made in Patterson Sims and also in our new administrator, Palmer Wald. How much time Tom wasted on seating arrangements for parties. How he'd offended this one or that one. People seldom took me aside to praise, mostly to blame. I listened seriously to everyone. I guess I hadn't yet learned that most of us focus on the weaknesses we see; somehow we think we help most by pointing them out. But, being inexperienced, I took all I heard to heart. And I worried a lot. The honeymoon was over.

Trustee and art historian Jules Prown felt Patterson's exhibitions of the permanent collection showed a lack of scholarship and judgment. When I discussed this criticism with Tom, he replied that Jules's experience as a professor and university art museum director didn't necessarily apply to a big city museum. The Whitney needed to appeal to a wide public. We should have a senior curator, Jules thought, grounded in all periods of art scholarship. Before we undertook extensive planning toward expansion, he insisted, this issue must be discussed and dealt with. Surprisingly, he did have confidence in Tom's and my collaboration. But he was concerned about our direction in expanding the board — we were overemphasizing money and success in our candidates. I knew that, while Tom and I always tried for a good

balance of types, we were definitely trying to add trustees with both money and clout. Rightly so, we felt, considering our needs, goals, and vulnerability.

Jules also found fault with our catalogues: they were unprofessional, lacking in scholarship and connoisseurship. But I found them excellent in scholarship, scope, and design — though sometimes offbeat. For example: when Tom asked Michael Crichton to write the Jasper Johns catalogue, he justified this unusual choice by pointing out the number of intellectuals who'd recently published work on Johns. A fresh look by an intelligent, lively writer, Tom said, might bring new insights about Johns, perhaps be better able to reach the broader public we were hoping for. I certainly found Crichton's book very good — and Johns himself approved. In a similar thrust, Tom chose many other unorthodox writers for catalogues, including Roland Barthes, for example, who wrote so clearly about Cy Twombly's work.

Palmer Wald, the Museum's administrator, weighed in, too, with his criticisms.

Palmer liked to laugh. With a tidy mop of gray curls above a cheerful pink face, and a sharp sense of humor, Palmer enjoyed his life outside the Museum as well as inside. But mellow as he was, Palmer was becoming increasingly concerned. Tom, he told me, wasn't having serious discussions about policy with senior staff. Curators, many of whom were inexperienced, needed more time, too — more guidance.

Still, Palmer felt encouraged by Tom's and my partnership and saw the Museum, and Tom, more positively than others I had spoken with. Although some trustees were demonizing him, Tom, like all humans, was neither entirely perfect nor entirely imperfect.

Then, Joel Ehrenkranz visited me at home, early on the morning of November 16. We drank coffee and I listened to him. Would I talk with Tom and convey the criticisms of him with enormous tact, all the while emphasizing the positive aspects? Tell him that within three months we must have an associate director in charge of artistic matters, giving that director the authority to make all decisions in this area. If he didn't agree — we still had to do it. Anyway, Joel thought, since Tom liked the job, he probably would agree eventually. People always do best what they like to do.

I promised Joel I'd discuss the matter with Tom, and I did. I didn't agree with Joel, however; Tom didn't need an associate director. Tom's job was to run the Whitney as he thought best, including organizing

and hiring his staff. By second-guessing him, we'd weaken his ability to lead, and he'd lose the enthusiasm and energy we prized in him. By telling Tom to hire an associate director, I'd undermine his authority. I couldn't do it. I did discuss Joel's ideas with him, but it was clear that Tom wanted the artistic portfolio as part of his directorial responsibility.

The idea of a senior curator had been a recurring subject of conversations between Tom and me. Other museums with senior curators were bigger than the Whitney. Since Tom had assembled his own team of fine young curators, he knew just how he wanted to work with them. Tom, originally at Howard Lipman's request, now at mine on behalf of the trustees, searched, interviewed, sought the counsel of others, without success. Meantime, the young curators he had hired produced exhibitions of high quality, and as the years passed they grew and flourished. (Most have gone on to illustrious careers as directors or deputy directors in prominent museums.)

I recorded all this in my journal, along with names of the many trustees who had called me to complain about Tom's faults in areas of art, communication, organization, extravagance.

Change and criticism at the Whitney, I was beginning to realize, were two sides of the same golden coin. It was up to me to flip that coin with luck and wisdom, to protect its precious substance. Could I do it? How did I feel about the criticisms?

Since some of the people who had encouraged me to become president and work with Tom were now complaining so vociferously, I felt they were undermining me. I trusted Tom's motives, his ambition for the Whitney, and his vision. I leaned on his broad shoulders. Those who criticized, after all, didn't have the ultimate responsibility. I had to rely upon my own judgment. But as new president of the Whitney, I trusted in each person's accuracy and integrity. I gave equal weight to all complaints. By assessing and disregarding some of them, I could have achieved a solid position of authority for Tom and myself. Only time and experience taught me much later to discriminate.

At that time, I worried, and when Bill Marsteller — head of his advertising company, Marsteller Burson, and trustee head of our development committee — offered to lend the Museum one of his best officers, I accepted. Elias Buchwald was to study the relationship of the public relations department to the rest of the Museum. The group of trustees I worked with closely — officers, mostly — saw this as a

first step toward addressing complaints, something that Tom could accept. Not too threatening. But Buchwald soon found other problems: the staff lacked a shared view of the image the Whitney wished to project, he said. Some found Tom inaccessible, lacking in respect for them, immersed in irrelevant details, and unwilling to delegate responsibility. On the other hand, "Bucky" pointed out, Tom had a strong and clear idea of what he, Tom, wanted the Whitney to be: a place for the permanent collection with better facilities for exhibiting it, so that the Whitney might be the preeminent home for American art generally and American twentieth-century art in particular. Tom believed he must attract money from rich people in order to buy art that would make the collection the best in its area. Therefore the details he'd become involved in, and for which he was criticized, such as the napkins for a dinner party, *were* relevant.

On December 1, the Museum's officers — Howard, Joel, Dan Childs, Charles Simon, and I — met to discuss Bucky's report. After I had conveyed its essence, I asked each officer to comment.

Charles, brutally honest as always, said it was exactly what he himself had perceived. Tom was "colder than a frog's rear end," it was difficult to reach him, and all the staff felt this. I listened, remembering that at other times Charles had seemed very fond of Tom indeed.

No one, Howard said, was perfect, remaining mostly inscrutable. Why, I wondered, had his great affection for Tom, his support of him, lessened? This is something I still wonder about, and perhaps will never resolve.

As for Joel, he found Tom arrogant, and said he alienated many people.

Almost all agreed that the most important project at this time was the acquisition of neighboring buildings. We should deal with that *now*. To control this site secured the Museum's future.

After the meeting, driving home, Charles, Howard, and I agreed that we were the three active trustees with the greatest emotional commitment to the Whitney. Was Tom, in their opinion, representing the Whitney to the public as a proper leader, I asked? Howard was silent. Had I asked him a few months ago, said Charles, he would have said yes. He was far more uncertain now. The Museum had changed, much as Salomon Brothers, Charles's old firm, had. How, I asked.

The board, said Charles, had gone from being idealistic and committed to public service to becoming a board of self-interested, tiger-

ish, youngish businessmen. The older Whitney trustees, like Howard and himself, knew about American art, cared about younger artists, and wanted the Museum to remain supportive of these artists. They had no hidden agendas, their motives were pure; they had a genuine love of art, and faith in the Museum. They wanted to include in the Museum family other patrons who also loved art, not simply those with money. But the others didn't understand the Whitney's original ideals. To them, "bigger" was invariably "better." They liked publicity and parties. They wanted to use the Museum and their contacts there for their social and business purposes.

And Tom, in Charles' opinion, was the same way.

Was my role, I asked, to provide the leadership that would maintain the Whitney's true nature?

Yes, said Charles. But he questioned whether I had the sophistication or the battle scars to confront Tom, either to change him, or to ask him to leave. Art was becoming a big business. Artists, often pushed by their dealers, were now making decisions based on their capacity to earn money, making career-oriented choices, instead of working steadily and patiently to develop their talent. I'd be bucking the new system.

While taking all this seriously, I wondered about those former ideals. What were they? To collect, preserve, and exhibit American art, the best we could find, of the twentieth century. To serve the artist and the public. Had this changed? Weren't we, in fact, doing just that? I thought of the exhibitions up at the moment: in October 1977, for instance, a retrospective of Jasper Johns opened. Perhaps some trustees had other-than-noble reasons for wanting to be on the board, but after all, most of us had mixed motives. Including myself. So what? Human beings are all imperfect.

I knew, too, how high Tom's ideals were for the Whitney. How all he did was directed toward achieving those ideals. He *had* to operate in the new world of which Howard and Charles were so critical.

For the moment, the Museum's destiny was hooked to Tom's speedy engine. As we careened along toward the '80s, I decided to hang on for dear life.

Despite all the criticisms, I felt good about the Museum and my work. Tom and I complemented each other and modified each other's weaknesses: he encouraged me to be a public leader of the Whitney, to speak with conviction, and to appear confident and resolute, to reach out to the important people who could help us; I encouraged him to

pay more attention to each trustee, as well as to those members he found unsympathetic, who were potential patrons. More powerful by nature than I, Tom was a born leader. Once he was sure of his goals, he pursued them with a single focus. Whatever insecurities he may have harbored inwardly, he outwardly radiated assurance. Then, bit by bit, he assembled a team of talented young men and women whose enthusiasm and abilities almost matched his own.

On December 8, after the executive committee meeting, Tom, Steve Muller, and I repaired to Café Nicholson — my choice for our next heart-to-heart talk. This restaurant, in sculptor Jo Davidson's old studio, was unique. It opened only at the whim of the owner-chef. Skylights lit its airy space. Brilliant birds in cages hung from the ceiling. On the marble floor, between life-size nude sculptures and potted trees, tables stood, generously spaced. A patrician woman in austere black, with a chignon of blonde hair, recited the unvarying menu, culminating with a chocolate soufflé.

Complaints were normal, Steve thought. Especially when a major project involving physical expansion and a campaign for millions lay just ahead. People, those with deep pockets, became anxious. They questioned everything, hoping to find a reason not to give. And the staff, naturally, were anxious about their jobs, assuming that Tom would want his own team. Was I hearing complaints from Tom's new curators, he wanted to know? I wasn't.

Since I knew Steve had raised so many millions for Johns Hopkins, his words reassured me.

And Tom was convincing, too. Together, we would accomplish miracles. We would buy the brownstones next door. We would build a splendid collection and house it in a splendid building. But the unhappy trustees, I asked?

We would win them over, Tom assured me. Although he didn't suffer fools gladly, if at all, from now on he would be more patient, give them more attention. He'd remember that the stakes were high. As for me, well, why should I feel insecure? Look what I'd already done, the money I'd raised, when no one thought it possible!

Tom was referring especially to a pledge I'd been able to win from Bob Wilson, a member of our finance committee, and a crackerjack investor. He'd started with almost nothing, and made a fortune. Since he

became both a close friend and a key trustee, I'll say a little more about him.

My present husband, Sydney, and I traveled in India with Bob, learning his ways: his yoga straps for exercising that he used every day without fail, making a growly noise like a rolling bowling ball. His disciplined diet, by which he's maintained his trim figure despite his love of fine wines. His conservative political views, to which he sticks, as he does to his many liberal friends. He's a mass of contradictions. He abhors "losers," he says. Not having achieved fame and fortune, we fit rather neatly into his definition of such, but he's genuinely fond of us — as we are of him.

Bob stands tall and straight, with sandy hair. His plain face is alert and attentive. His intelligent eyes give you a thorough once-over. He says what he thinks. He's attracted to certain works of art, and scornful of others, no matter how highly endorsed they may be, and he'll make that quite clear.

Bob's other passions center on the opera, on monuments of the past, and on beautiful birds. He travels the world over, searching out the finest of each. And he really knows about them. He's been chairman, for instance, of the New York City Opera, where he put a shaky institution on sound financial footing, without sacrificing quality. Once committed, he's extremely generous and supportive; the Whitney has benefited by his leadership, as well as by his major gifts.

Bob gives exquisite dinners for ten to twelve carefully chosen guests, usually leaders in their fields, at which he often guides conversation so as to bring out the diversity of their opinions, encouraging quite vehement but seldom acrimonious discussions.

Bob has no pretensions. I like his habitually casual, tieless garb, his dry, acerbic humor (but not his racist jokes). He's idiosyncratic, a complex and memorable friend.

I'd planned to talk with Bob about his giving money toward purchasing the neighboring brownstones. We'd made a date.

I felt comfortable with Bob. But I was nervous. I'd never before asked for big money by myself. I'd asked Bob to become part of our "family" — meaning, to become a trustee — to be committed with us to the idea of expansion, to pledge $100,000 to help buy the brownstones. That seemed like a huge amount, especially from a nontrustee, and Bob, after listening carefully, had said a polite but firm "no." He

didn't like to give away such large sums all at once. I wasn't surprised, but I was disappointed by my failure.

The next morning, I went to the Regency Hotel, owned by Larry Tisch, for a breakfast meeting of the finance committee. There we sat, grandly isolated in the middle of the big room Larry had reserved. Everyone but Bob. "Where is Bob?" asked Larry. Someone remarked that he never went to breakfast meetings. "Oh, in that case," said Larry, "he definitely won't be here. He *never* changes his mind."

After the meeting, I walked back to Sixty-sixth Street. When I opened the door, my daughter, Michelle, visiting from San Francisco, called excitedly down the stairs. "Mom, do you always get messages like this early in the morning? Someone named Bob just phoned and said, 'Tell your mother I've decided to give the one hundred thousand dollars after all!'"

Leaving Café Nicholson, I felt that same burst of joyful pride.

Yes.

We can do anything.

Sixteen

*T*om, I decided, was the best director the Whitney had ever had. I was determined to make a go of our partnership. Henceforth, we would talk out our problems and deal with them. One of my mandates was to develop and maintain close relationships with trustees and they, in turn, would support our plans and warn me of trouble.

Our specific goals emanated from specific assumptions. First, that New York had become the capital of the art world. Second, that the most significant art in the Western world was now coming from the United States. Third, that the Whitney, therefore, should be the pre-eminent showcase of American art, just as the long range planning committee had said in its report. Fourth, for that to happen, we needed to expand qualitatively and quantitatively, to upgrade the collection, and to double or triple our space.

This was Tom's vision for the Whitney's expansion:

A permanent installation of the collection, including concentrations of works by certain artists the Whitney had collected in depth — for example, John Sloan, Maurice Prendergast, Edward Hopper, Alexander Calder, Louise Nevelson, and Elie Nadelman. Ultimately, we hoped to add David Smith, Agnes Martin, Georgia O'Keeffe, Jasper Johns, and others. In addition, we needed to identify the masterpieces we didn't own and proceed to acquire them. In an appropriately expanded building, visitors would be able to walk from this historic exhibition directly into galleries where temporary exhibitions would illuminate specific aspects of the collection — or, conversely, from current to historic exhibits. Our ideas would move freely. An installation of Edward Hopper's works, for example, might lead to a show of

contemporary realism, or to a selection of films influenced by Hopper's paintings.

Besides a theater for film and video, we'd have a small auditorium, so that our programs for performances, dance, poetry, and music could grow. Space for lectures and symposia, housed awkwardly now in our restaurant, would also be much improved. Further, an up-to-date library would make our fine collection of books and periodicals on American art accessible and useful to scholars. The developing master plan included a gallery for works on paper, a Hopper study room, and other specialized spaces.

Once people gained a better understanding of American culture through its visual arts, Americans at last would have a firm context that provided them with the means to comprehend and appreciate their heritage.

I'll quote from two Museum documents, in order to compare the Whitney's goals when it first opened as a museum to those in the '70s and '80s. First, from the introduction to the *Catalogue of the Collection*, written by Hermon More in 1931:

"The idea back of this institution and its predecessors is based upon the belief that America has an important contribution to make in the arts, that in order to make this contribution effective, a sympathetic environment must be created in which the artist may function to the fullest extent of his powers. Motivated by such a belief it is natural that the Whitney Museum of American Art should be primarily concerned with the work of living artists. . . ."

And this, from the long range planning committee report of 1978:

"The primary necessity at the present state in the development and understanding of our cultural heritage is to increase public awareness of the significance of American civilization of the twentieth century.

"The Whitney tradition of encouraging and fostering the work of living American artists will be continued. It is important that the Museum present one-person shows of the works of contemporary artists. . . .

"Free admission was the policy of the Whitney Museum until 1966; we would prefer to see this policy restored. Since financial circumstances, now, make this impossible, we commit ourselves to a return to more free days as soon as practicable. . . ."

A difference in emphasis, to be sure, recognizing that through the growth of the art world and the tremendous success of American artists, the need for "support" had changed. Our mandate was to be

more selective, to show and collect the highest quality of American art, while still maintaining the traditional commitment to the living artist.

In the spirit of Gertrude, and through the generosity of those we'd gather around us, together, we'd build a greater Museum as a gift to all Americans. We'd make our dream come true.

First, though, we had to infuse our benefactors with the same dedication we felt. That wasn't always easy. So much money! So much time! Too big, said some. Go slow, said others. But we did find a solid core, and it was already enthusiastic enough for us to persevere. Still, we needed the whole board with us, and Tom in his wholehearted commitment often grew impatient with the laggards.

In preparation for all this, Tom consolidated and centralized. He aimed to make the Whitney coherent, strong, and stable — to collect masterworks, and, hoping to avoid earlier mistakes, to continue the Museum's emphasis on young, excellent artists, buying their best work while it was relatively new and inexpensive. With Joel's guidance, we tried to improve the budgeting process and, more importantly, to stick to the budget.

But it was far from easy.

Meantime, the art world was changing. In the February 1978 *New Yorker*, Harold Rosenberg's article "Inquest into Modernism" discussed "post-modernism" and described the current art scene:

"The absence of an avant-garde — or the low level of interest in what presents itself as an avant-garde — has begun to seem a normal condition of contemporary art. . . . Despite the present 'lull' in creativity, the art world has never been in better shape. The art public keeps growing; museums are packed; in disregard of economic gloom, new galleries open, it seems, daily; government and industry support for 'the arts' increases each year; the art market continues to outpace the Dow . . . a transformation of values has occurred: novelty in art appears unessential. Even the idea of a vanguard is repudiated."

It seemed the perfect time to give the Whitney's permanent collection more attention. To exhibit it in new ways, to acquire those missing masterpieces. And for important American artists to have one-person exhibitions.

In only a very few years, the Whitney — while devoting a whole floor to the collection and mounting retrospective exhibitions of under-recognized artists like Marsden Hartley and Milton Avery — gave one-person museum shows to major, or soon-to-be major, living

artists such as Georgia O'Keeffe, Andy Warhol, Jasper Johns, Cy Twombly, and Alexander Calder, among others.

The media had discovered the arts at the same time as those in the business sector were evaluating art as they did any other product, sometimes even promoting art as a commodity. A few artists became stars, subject to the same joys and miseries as Marilyn Monroe or Jacqueline Kennedy. What did that stardom mean to these artists? For one thing, they were paid enough so they could live without part-time jobs. That was positive. But creativity implies being alone and concentrated. Stardom can mean that the inner world is invaded by the outer, the private by the public. While recognizing the risk to them of losing privacy, Tom and I also saw how, potentially, artists might well attract many more rich and powerful people from the business world to the Whitney. Suddenly, everyone wanted to meet an "artist star," to touch one. We at the Whitney joined in, inviting willing artists to meals, openings, and parties with potential donors.

Educational opportunities were provided for both board and Museum members. We slotted art information into meetings, introduced stimulating courses and lectures by curators and outside speakers, initiated a pioneer program with docents culled from many volunteers and trained by our curators, and planned a wide variety of trips focusing on American art to satisfy different membership groups.

We sought a careful balance on our board of men and women representing business, scholarship, and art, like Leonard Lauder, a businessman, and Jules Prown, an art historian, who despite their different disciplines always contributed creatively and positively to the board. My grandmother hadn't wanted the board to interfere in Museum programs, and had mandated a strict division between staff and board responsibility. Determined to maintain that tradition, we searched for sensitive trustees who would understand and accept how the Whitney gave its professionals a free hand in their areas of expertise. Trustees, for example, had never voted on exhibitions. For acquisitions, committees voted only on works brought before them by curators — they didn't bring works themselves, and they didn't decide whether to accept gifts. Trustees, however, always hoped for a bigger attendance and more members; both had a major effect on our budget. Therefore, to raise those levels, they urged occasional popular exhibitions and the use of advertising techniques — both new concepts for the Museum. Very few shows of American art could be certain either of rave reviews

or of mass appeal, so the pressure for "blockbusters," while always simmering, seldom boiled over.

With the constant need for more money, trustees were bound to explore every means, from improving the products we sold in the bookstore to advertising and special membership drives.

Tom's energy, vision, and marvelous sense of play carried us along. Constantly on the brink of alarming deficits, we often managed, sometimes at the last moment, to find generous donors. Projected shortfalls didn't always materialize. But they were dreadful to anticipate, considering the danger of demoralizing the trustees and decreasing our already too-small endowment, and gave us a powerful impetus to search for new money. Tom and I became the Museum's chief fundraisers. Despite our inexperience, we did well, bringing in a great deal of money and, in the process, developing an even closer professional working relationship.

But I was walking a tightrope. As a trustee, I identified with other trustees; still, working so closely with Tom and the staff, I often felt more like a staff member. Trustees may have seen this as a danger to the Museum, threatening to tilt the necessary balance between board and staff, between professionals and volunteers. While temperamentally I'd always felt close to curators, administrators, and directors, art and artists remained at the forefront of my priorities. Only now do I see that my "dual allegiance" may have led trustees to believe they were inadequately represented by a president too close to the inner workings of the Museum and, in their view, too far from the board's concerns.

Seventeen

*I*f we were to continue to grow, buying the brownstones next door to the Museum was our next goal. We had to own those buildings, almost the whole board agreed. Long ago, we had prevented developers from assembling the other half of the block by buying two "spoilers" — two buildings in the middle of the block. Now we needed the others.

With Bob Wilson's pledge in hand, Tom and I went to see Laurance and Mary Rockefeller. Mary was on the board at the time. On that Monday, the rain poured and poured and no taxi was in view. We sloshed through ten blocks of puddles to the Rockefellers' Fifth Avenue building and shook our wet selves in the pristine lobby. I must have looked pitiful, and the doormen gave me withering looks as I emptied my galoshes and put on the dry shoes in my bag. Upstairs at last, still working on my appearance, I brushed more drops from my hair, and settled into an armchair by the Rockefellers' cozy fire.

But Laurance wasn't there! "It's all over," I whispered to Tom, when suddenly the door opened. Laurance strode in with big hellos, and we breathed more easily.

Talking about our project over tiny cucumber sandwiches and Hu Kw'a tea, Tom and I waxed eloquent about our hopes for the Whitney's future, acting a bit for each other. Laurance listened and asked probing questions: Did we have other sources of support? Who was on our board? What was our timing?

Mary was quietly sympathetic to us, smiling her encouragement.

"What would you like from us?" Laurance finally asked.

"Two hundred and fifty thousand is what we hope you might give." I didn't recognize my own voice. A definitely new me.

"That's just what I thought. I can do that over three years, and I would like to. You must control that property for future generations, if not for now." As a real estate entrepreneur, Laurance was captivated by the idea of the corner property, seeing immediately that it was key to our plans and to the Museum's future.

I gushed our thanks and our appreciation at Laurance's understanding and generosity. It wasn't just the money, I told them. It was also their confidence in us and in our project. The example they set made the whole thing seem so much more possible.

Then Tom and I left and danced through the rain to Tom's club, the Knickerbocker. Its architect, William Adams Delano, who had designed my grandmother's Palladian studio in Long Island, had also served briefly in the '30s as a Whitney trustee. Happy memories of lunches there with my father made me relax in its gracious rooms; I'd relished the "Knick's" creamy rice pudding so much that, in the hospital after the birth of Michelle, my father had brought me a brown crockful. And, while researching Gertrude's life, I'd found dozens of notes from her many beaux scrawled on the Knick's thick ivory stationery; now I noticed the same restrained blue engraving at the top of the same paper. The Knickerbocker was part of my past. Tom and I, with potential donors to the Whitney, lunched there often.

We knew that George Weissman would be the next chairman of Philip Morris, one of our most steadfast and generous corporate supporters, in whose building just across from Grand Central Terminal on Forty-second Street the Whitney was soon to open a branch. On June 9, 1978, Tom, trustee Bob Greenhill, and I met George in the "Ladies' Dining Room" at the Knick. George, surprisingly, ordered white wine with a splash of 7-Up, a company Philip Morris had just that week acquired in its drive to diversify. After a financial discussion, during which George told us how ruthlessly he always had to cut the company's budget (a good example for me), I steered the conversation to the Whitney. "Ah yes, you see I've done my homework," said George, pulling a piece of paper from his pocket. "I want you to know we will support the Hopper exhibition in 1980 with two hundred forty thousand dollars!" We were delighted, but to George's astonishment I said, no, no, that's not what we wanted to talk about, and launched into my I-hope-you'll-be-a-trustee invitation. He personified cooperation between business and the arts. George smiled and said he'd had no idea. Then he told us he'd think about it. A few months later George

agreed. And Philip Morris did sponsor the Hopper exhibition, which was both beautiful and popular.

After our memorable visit with the Rockefellers that rainy afternoon, we sank into the Knick's deep red leather chairs over celebratory drinks and Tom and I plotted and strategized.

Who would we ask for money next? What new tycoon could we lure to our web?

Soon my cousin Jock Whitney gave us $250,000, significant help and another big boost for my fund-raising confidence. Family support! Important and wonderful!

Trustee Susan Morse Hilles, a bright, eccentric woman who painted and had a fine collection, helped. Married to a Yale English professor, Sue was forthright with both criticisms and praise. She was very generous to the Whitney and we became good friends. I drew a picture in my journal of Sue at a dinner we gave in our apartment for her on February 9, 1981, a cold winter day, noting that she had worn two dresses. When she felt warm enough, she casually removed the top one and handed it to a waiter. Quintessential Sue!

In March, Tom and I visited Larry Tisch. Perhaps the Rockefellers' generosity would inspire him. Leaving Fifth Avenue's noise and color, we entered his office at Loews, with its muted creams and beiges, their controlled climate softly humming.

Larry rose with a smile and a handshake, offering tea, coffee, chairs. Again, his desk was bare. So were his walls.

"Perhaps you'd like to borrow a few paintings from the Museum?" Tom suggested. "We could easily arrange it."

Thanking us, he said he'd think about it.

Noncommittal, I thought. A bad omen.

I explained why we had come. Tom and I did our dog-and-pony act. We asked for $100,000.

That was a lot of money, Larry said. We were a lot more tense than he seemed to be. Although he'd be happy to work with us, he said, and to help when he could, he wasn't for the expansion project. We'd never be able to raise so much money, he believed, and the Whitney's endowment couldn't support such a big building. Besides, he went on, he didn't think the city needed a bigger Whitney — there weren't enough resources or enough demand by the community. It needed other things more.

"What, for instance?" asked Tom.

Hospitals, he said, and Jewish education.

"Well, if you believe that, why are you on the board?" Tom blurted out.

Larry gave his cryptic smile, saying that he thought he'd been helpful in some ways. He meant, I was sure, as chairman of the finance committee.

Larry suggested, instead, a thorough review of the space we already occupied or owned. His voice was gentle, soothing. He said the building project would become a day-and-nightmare for me.

I could feel a cold sore starting on my lower lip. I asked if that was his final decision.

He said he'd make a pledge of ten thousand dollars, contingent on our raising the rest of the money.

On our way out, he showed us some photographs of buildings he was proud to have built or renovated. They were impressive.

In the outer office, the only decorations were colorful boxes of the cigarettes his company also made. Later, we wondered if they were more profitable than the buildings. We'd surely never ask him, not after hearing his reasons for turning us down.

Leonard Lauder was a splendid trustee; the time spent with him was always extremely useful and also enjoyable. He made a generous pledge toward buying the properties next door. He told me how much he liked the quick action at the Whitney that often followed his suggestions, such as starting a drawing acquisitions committee, improving our retail products, and advertising exhibitions. Along with Larry Tisch and Frances Lewis, however, Leonard believed that there was not currently enough financial strength on the board to buy all the properties we needed and also to build. He did agree, though, that the Museum needed more space and suggested certain preliminary steps, such as raising money for more endowment to help resolve the deficit.

Leonard, however, as early as 1978 expressed doubts about the wisdom of a large expansion. But he recognized our urgent need for more endowment.

Several months later, in May, in an executive committee meeting, we had a heated discussion about buying the properties next door. It ended in a close vote, with Charles Simon, David Solinger, and my cousin, Sandra Payson, opposed on the basis of too high a price for not

enough buildings. After much pleading from Tom, Joel, Steve Muller, and me, Charles gave in, saying, "Oh, all right, you can have my vote, go ahead." Sandra then agreed. Both Joel and Steve called after the meeting to congratulate me on my leadership. I was becoming more confident about chairing meetings, and at times even more forceful.

At the following trustees meeting, I noticed two extra tables attached to our oval granite one, added on to accommodate the large attendance. That so many trustees wanted to attend meetings also fed my new assurance.

After much discussion, the board finally and unanimously adopted the long range planning committee report. This meant a resounding "go ahead" for our plans to expand.

Bob Friedman, needing more time for his writing, became an honorary trustee. I believe he also felt alienated by the Museum's increased size and decreased intimacy, as well as by the style of its new director. He expressed his feelings for the current state of the Museum in his biography of my grandmother.

A collection, which really began in 1908 with the purchase of four paintings by The Eight, has grown to one containing over 6,000 works. . . . A staff of a dozen or so has grown to about 120. Annual attendance in the low thousands has grown to about half a million (including, now, that of a Downtown Branch). And openings such as biennials, once attended by a few hundred artists and their friends, are now art world events attracting as many as 3,500.

Gertrude's dream has become institutionalized, her shadow has lengthened — lengthened far beyond the walls of the museum which she founded. It now influences hundreds of newer museums, as well as patrons, collectors, and dealers. With mass media and mass marketing, everything about her dream has become enlarged, extrapolated, exaggerated, and, at times, caricatured. Partly because of Gertrude's pioneering, art in general, American art in particular, has become chic. . . .

Once, Juliana Force conferred intimately with Gertrude about comparatively small public relations matters or the details of a traveling exhibition. Now Thomas Newton Armstrong III, the fifth director of the museum, reports to 30 trustees. Five of Gertrude's relatives, including her daughter Flora Whitney Miller, honorary chairperson, and granddaughter Flora Miller Irving, president, still represent the family — and, indeed, eight board members are women — but the board is dominated by bankers and business men. They all listen as Armstrong reviews the cost of sending an exhibition — fully insured

and accompanied by a registrar — on a jet plane to England, France, Germany, and Japan. It will be expensive — perhaps $400,000. But attendance is growing. Interest in American art is growing. Corporate and foundation grants are growing. Financial support from federal, state, and city agencies is growing. And now support from foreign governments is also growing. Everything is growing.

Yes, with growth, with the qualitative change that accompanies quantitative change, Gertrude's museum has become democratized, popularized, even inflated, beyond her dream.

Bob was right, but what was the alternative? Grow or go, they say. Looking back, I can see that we rushed into the new world with more haste and enthusiasm than were perhaps wise. Still, in the midst of the expansive spirit of that time, we felt caught in the excitement and certain of our role.

After the trustees meeting, we served cocktails and played a game meant to educate our trustees about the Museum's need for more space. The game began with a tour of the permanent collection, at that time on two floors, representing less than 2 percent of the whole collection. Curators, stationed at various key locations, pointed out spatial or artistic needs. Then back to the board room for a quiz. Those who stayed seemed to enjoy it, but most businessmen, as usual, left right after the business part of the meeting. Their lack of interest in our programs disappointed me, as I always found myself hoping that all trustees would care a lot.

I measured the qualities of potential board candidates against Bob's — his profound love of art, his business acumen, his commitment, his intelligence. I was disappointed if a trustee gave less of him or herself than Bob had.

It was an unrealistic view.

Trustees are responsible for ensuring the Museum's financial stability while preserving its integrity. These days, everyone qualified to join the board doesn't necessarily love art and artists. Everyone isn't always there for the long term.

What if Bob hadn't resigned?

Would the Whitney's history have been different?

Or if he'd succeeded me as president? Would the outcome have been the same, without the museum being torn apart?

Eighteen

*N*egotiations for the property acquisition proceeded quickly.

By late summer, Joel succeeded in out-bluffing tough dealers and acquiring the properties.

At the budget and operations committee meeting, Tom's projected deficit of nearly $500,000 for the next fiscal year aroused strong displeasure — not only about the numbers, but about Tom's daring to present such a figure. The deficit figure seemed to be another justification for the disapproval of those trustees already against Tom.

The committee instructed him to reduce the deficit by one-half immediately and to produce a plan that would get rid of the other half. Tom and I could raise the money, I felt sure. Most of the deficit represented unfunded exhibitions, and corporations usually preferred to make commitments close to their current fiscal year. The idea of eliminating programs — the only apparent solution without cutting staff — was abhorrent. And canceling a scheduled exhibition would be disastrous, especially for a museum where living artists would consider such an act a betrayal of the Whitney's principles. The Museum's relationship with artists, dealers, and collectors was at stake. Tom was upset and angry, as was I.

Walking home with several board members after the meeting, Joel assured me we needn't make drastic program cuts. Knowing "an extravagant man is in charge" and that Palmer wasn't strong enough to control Tom's spending, the board, through the budget and operations committee, must. Otherwise, the Museum would go out of business.

This kind of ultimatum was the only way to put the brakes on Tom,

Howard said. I shouldn't be discouraged. But I felt the condescension inherent in the apparent doubletalk: why hadn't they told me that this was merely a ploy to intimidate Tom? That they didn't really want to cut programs? As president, I should be aware of such games.

They did it because they didn't trust me not to tell Tom.

In the end, we raised more than half the money, mostly from new donors. We called them, we introduced ourselves, we made dates to see them, we talked about the Whitney's vital importance to New York and to our country. This seemed easy, since we ourselves believed in our cause so strongly. And we discovered corporate leaders, foundation heads, and wealthy individuals who believed with us.

That first year as president was a year of learning for me, and one of new and sometimes heady experiences.

The Museum sponsored a trip to Paris for the Friends of the Whitney. We organized a variety of programs and art-oriented trips that both raised money for the Museum and also educated and entertained this important membership group. Tom couldn't leave New York just then, and I was delighted to go along and represent the Museum's leadership on the Friends' first trip abroad.

On June 28, after thirty-nine years at the Museum, Sylone Brown, our head guard, retired. He was an important symbol, one we were reluctant to part with. His retirement represented the end of an era. He'd been there with Gertrude, since the early years, and he exemplified the Whitney's history with all it implied — Museum ups and downs, and Museum ideals of loyalty and continuity. Tom arranged a festive party for him with the whole staff and even a few trustees. A three-piece band played cheerful music, guests ate and drank, and an upbeat spirit prevailed.

So much of my time was now spent working with the powerful people we were enlisting that, at that farewell for Brown, I was grateful for the chance to catch up with key, behind-the-scenes staff members whose role was so important to the functioning of the Museum.

Ruth Schnitzer was one of those. For decades, Ruth nurtured Friends and Whitney Circle members, counseling them on every aspect of their lives, apprising directors, curators, and presidents of their moods and desires. On museum trips, she always made certain that everyone felt comfortable. "Ruthie," Tom would erupt, "where on

earth can we put *this* one at dinner tonight?" And she'd always know. Her tough but fair judgments were leavened with humor and kindness. She took us all into her big heart.

Later, Jack and registrar Nancy McGary became ambassadors for the Museum as they installed our traveling exhibitions. Museum professionals all over the world responded to their skill. Nancy's responsibility was to keep track of all works in the collection as they traveled across the world or the city, or just from floor to floor, ensuring their safety and condition, dealing with a staggering array of complex problems and people.

Then there was engineer John Murray, self-assured, robust, confident of his important role, whose job was to keep all the building's aging, complicated guts in good condition, including wiring, plumbing, and temperature control. Jack Martin and John go almost as far back for me as the Whitney itself.

And Anita Duquette, for whom I had developed great respect and affection, was keeper not only of "Rights and Reproductions" (imagine the number of permissions sought each year!) but of the Whitney's history. She knows more of that history than anyone. I've known her since she was a young woman with a long braid, watched her through marriage, pregnancy, and motherhood to her lovely maturity today.

In a toast to Brown, Tom spoke of his emblematic meaning for the Whitney. Then Altamont Fairclough, the new chief guard, spoke movingly in his deep Jamaican voice and, with his radiant smile, presented a bronze plaque carved with an appreciative inscription from all the guards.

"Monty" Fairclough was another remarkable Whitney person. After emigrating from Jamaica to London, where he worked for British Rail, he arrived in New York and came to the Museum shortly after the Breuer building opened. He worked his way up to the position of head guard based on his intelligence, hard work, invincible cheerfulness, a genuine pleasure in dealing with the public, and an intuitive, nonjudgmental understanding of what the Museum is trying to do. His unerring common sense and his wonderful humor have often defused a tense situation or calmed a hostile patron. Few are aware, perhaps, that he and his staff of guards are the Whitney's primary interfaces with our public, and one former coworker, Rob Ingraham, says, "Monty's gentle, benevolent hand on the Museum's day-to-day operations is as

important to the Museum's reputation as any exhibition, any curator, or any trustee."

I presented Sylone Brown with a check from the board. Mum, who had come with me, in her usual warm way spoke fine and touching words and handed him her own check. Best of all, for me, Marie Appleton was there. Now retired from her job at the front desk, where I'd had *my* first job working beside her in the Museum on Fifty-fourth Street, she looked just the same: erect and exquisite in her black dress, Calder pin, and snowy hair. She had worked at the Whitney for fifty years!

This party rolled time back, reminding me of those who had died, or had gotten older — like Mum. I wanted to reassure her. My turn now, to nurture her — and also, to be on my own at the Whitney.

Visiting Brendan Gill in his office at the *New Yorker*, or "The Word Factory," as it was affectionately known, I noted that it was "marvelous, all piled up with books & magazines & ms. & photos & files with one cleared-off black leather sofa upon which we sat amid the literary clutter." We discussed the new Library Fellows Brendan would head. This group would sponsor a distinguished series of books, collaborations between writers and artists, directed by elegant May Castleberry. Librarian par excellence, with quirky taste and humor, May manages the Whitney's expertly catalogued and shelved library. In 1996 she organized a full floor exhibition of rare Western books, photographs, and prints. Her imagination roams freely in her selections of artists and writers who collaborate on the fine-art publications she creates for the Whitney. In the *Magic-Magic* book, an extraordinary magician, Ricky Jay, worked with May and six visual artists: Vija Celmins, Philip Taaffe, Jane Hammond, William Wegman, Glenn Ligon, and Justen Ladda. Who but May would ever have conceived such a project! It's a kind of flip-book, revealing its mysteries as one manipulates it. Almost simultaneously, she did *Mesa Verde*, by writer Evan Connell and artist Robert Therrien, a beautiful book printed on parchment and boxed in linen. May, Brendan, Tom, and I organized the Library Fellows, a group of book lovers who, besides helping to support the publishing program, provide special treats at writers' or scholars' libraries, or in unusual spots, with surprising guests to entertain and delight us. Once, stately, beautiful Jamaica Kincaid read from her latest horticultural piece in

Central Park's lovely Conservatory Garden. A light rain was falling, but May had provided umbrellas for all, and we perched dry and enchanted on green benches amidst lilies and roses.

Tom, Brendan, and I were also planning a national committee, to bring the Museum new friends and patrons who would spread news of the Whitney to the whole country, and whose dues would fund traveling exhibitions to small museums that could not otherwise afford to show them. This committee came into being in 1980, and Brendan was its first and most inspiring and beloved leader.

In July 1978 my cousin Nancy Tuckerman, an old friend of Jacqueline Onassis since school days who had worked with her ever since she'd been in the White House, arranged for the three of us to have lunch. I hoped to persuade Jackie to become involved once again with the Whitney, since she had written me an encouraging letter saying how wonderful the Museum was these days, particularly in its appeal to young people.

But Jackie got involved with the Met, instead.

Day after day, such journal entries as these remind me of those days: "Wrote letters. Will never catch up." "Overwhelmed by letters and phone calls." "Signed hundreds of letters at Museum." "Wrote letters again."

Some moments still reverberate with their original luminescence, such as the first time I met Jasper Johns, whose work I greatly admired. Tom had arranged lunch at Les Pleiades; I'd never met Jasper, and was timid at the thought of asking him for a favor at our first meeting. After preliminaries, finding Jasper friendly and unpretentious, I realized Tom was leaving the request up to me. So I asked. Would he make a poster for the Whitney's upcoming fiftieth anniversary of its founding, to disperse all around the city, on billboards, in subways, buses, everywhere we could manage to display it? A long silence. Had I offended him? But Jasper answered with great generosity, saying that he'd like to do it. I wanted to hug him. One bit of lunch talk: he said someone had referred to the "viciousness" of the art world. I asked, "Well, *is* it vicious?" He thought for a long time, looking inscrutable, then said, "Well, I don't know. I don't know any *other* world." A perfect answer.

On September 25, 1979, Jasper showed us his poster. One bright flag over another, letters stenciled in red, white, and yellow underneath, saying "1980 THE 50TH ANNIVERSARY OF THE WHITNEY MUSEUM OF AMERICAN ART." It was just perfect. We were so

overwhelmed that we didn't even notice how painstaking Jasper had been in depicting those fifty years. One flag had forty-eight stars, representing the number of states in the union in 1930; the other had fifty, the right number for 1980.

A few months later, Jasper gave me his first sketch for the poster. It's one of my most precious possessions. It's a wonderful, jaunty watercolor with all the strong elements of the final work, on a background of rich orange. I look at it almost daily. Somehow, it represents everything I valued most in those years. The reasons to care for the Museum, and its raison d'être. What it was all about, when you got past the relentless, dreadful money needs, meetings, talk, problems, manipulations, museum politics, pretense. Art and artists, the heart of it. That's what I remember when I look at Jasper's drawing. I also remember something Jasper once said about Tom, that he "always made things more fun." One of Tom's greatest attributes, it seems to me, and I was grateful that Jasper had recognized it, had articulated it.

I marveled at my good fortune. How, by some genetic fluke, because I happened to have been born to a particular family at a particular time, I now held a position of power and influence. I could meet and talk with Jasper Johns, for me the best and most emotionally moving artist of our day. I could waltz around the world, meeting anyone I wished to, wining and dining, despite my own deficiencies. Today, I represented the Whitney Museum of American Art just as my grandmother had. And the immediate future of the Museum now depended on me. As I reflected on all this, a tremendous pride and sense of mission overtook me.

Before leaving for a family sailing vacation, concerned about the Museum's finances, I wrote to Palmer Wald, urging him to prepare carefully for the September trustees meeting, which would focus on the budget. "It's very important to present the budget vividly, dramatically — flamboyantly? Song and dance — belly dancers to portray the different lines on the budget — below the line, the bottom line — all kinds of things come to mind."

Far from the Whitney, I looked back on the past year.

I had urged Tom to work more closely with trustees, to use them as advisors in their areas of expertise, and to make his staff more available to them, in the hope of bringing them closer to the Museum, so they'd

better understand our plans and support them. Tom had been concerned that trustees might take advantage of the staff — by asking for their help in identifying and buying works of art for their own collections, for instance, or using curators' powerful influence with dealers or artists. These trustees might unknowingly cause competition and divisions among curators by offering favors in exchange for their help. The commercial art world can be complex and devious — like any world — and Tom wanted to protect his curators.

I wrote Tom about some of the things on my mind:

> Affection; I enjoy being with you, having some good laughs, working together. I recognize that you have made a big effort to adjust to the changes implicit in working with me rather than Howard — for instance, in such delicate areas as staff participation in trustees' meetings or committee meetings, and of trustee help in borderline areas, or accessibility of staff other than yourself to trustees. I appreciate this a very great deal.
>
> Respect: for many reasons. Your complete commitment and dedication; your talents with people, which I've now observed at close hand; your intelligence; such details as your careful consideration before reaching a decision and taking action. Your strong leadership. And more.
>
> I am extremely impressed by the way the Whitney has looked in the past year.
>
> Obviously, *much* remains to be done. As you know, I think, as does Howard, that the right "senior" curator would be an important asset, in helping us to maintain a position of leadership and boldness in terms of contemporary American art. Because it *is* necessary to be bold, to have the courage to exhibit what we think is important, now. And I must do much more in terms of developing our board, and other funding sources. But I really believe we can accomplish a great deal, if we take care to communicate with each other about all matters of importance to the Museum. For me, the adjustment to a new leader was also difficult at times, and the struggle to see clearly what was in the best interests of the Museum was often unsuccessful. But now it seems easier, and one reason is obvious: we are really working together, and this is increasingly satisfying to me. I hope it is to you.

I see today that I was groping toward a performance review process, now a more formal part of the institution, and necessary for both board

and director. It's necessary to assess both positive and negative aspects of the job a director is doing, to give that director a chance to respond and to comment in turn on the board's performance. We didn't do that. I wish we had.

In my first report for the *Whitney Review*, our annual publication, I expressed optimism about the future, gratitude to all who had helped make my first year successful, and pride that, through a combination of various grants and policy decisions, the Museum's activities were now free to 40 percent of our audience, including senior citizens, students, artists, and all who visited on free Tuesday evenings, thus approaching the original ideal of free attendance. I wrote of new committees, new membership categories, and the need for new funds; of the Jasper Johns and Saul Steinberg exhibitions, now traveling around the world. This was my most heartfelt sentence: "It must always be stressed, however, that all our activities are based on the integrity and accomplishments of artists."

Nineteen

*I*n September 1978 Gertrude Vanderbilt Whitney's biography was published.

Bob had designed a beautiful pendant for me — a gold image of the Whitney, with a ruby as the window on Madison Avenue, his thanks for my collaboration. I treasured it and wore it often until, a few years later, it was stolen or lost. I miss it still.

The *Times* was on strike and so we couldn't expect the book to be reviewed there. Other publications, though, either did review it or wrote articles about Bob and me. Depending on what we read, we went from euphoria to depression. Here are a few excerpts, first, from a prepublication squib in *Publisher's Weekly:*

Friedman, with the able research collaboration of Whitney's granddaughter, Flora Miller Irving, has recreated a woman's life and an era in this long, rich, full biography. Whitney left journals that record the tensions through which she lived, detail the burdens and privileges of wealth, the conflict between public and private worlds, between the ideal and the real. The authors have brought this remarkable woman to life again as they follow her through the years of girlhood, marriage and after, reveal bit by bit (often in her own words) what she made of herself and her circumstances, her searchings through love and sculpture, and describe her finest achievement as patron of contemporary American art.

This first review arrived together with a note from my cousin Nancy Tuckerman at Doubleday, who had been immensely helpful and encouraging during the publication process.

"I really became very emotional myself when I read the review as I

saw in front of my eyes that all the caring and devotion you put into the book . . . has come to light and now your grandmother will be read about as she really was. . . ."

Frances Taliaferro's article in *Harper's* typified the numerous criticisms of the mass of detail in the book, although she also wrote that Gertrude's journals and correspondence provided remarkable documentation, and found her story "fascinating."

September 20, 1978.

Although private celebratory events generally weren't permitted, Tom decided, considering the book's subject and its authors, to have the book party at the Museum.

Fiona helped me find the perfect dress. It was simply designed, like a robe. Silk, striated in black and purple. Elegant. At 5:30, the Friedmans picked me up in a cab.

The fourth floor of the Museum was a visual paean to my grandmother. We had reproduced on the cover of our book Robert Henri's vivid portrait of her, stretched out on a sofa in peacock blue, green, and chartreuse silk pyjamas. Now, as we emerged from the blue-carpeted elevator, we saw the painting itself. About twenty of Gertrude's World War I sketches were mounted on either side of it. Two blown-up photographs, the rather severe 1930 portrait taken by Steichen when the Whitney opened and the one of Gertrude working on her last big commission, *To the Morrow*, for the 1939 World's Fair in Flushing, bracketed her sculptures. In front, flowers cascaded from her 1913 fountain with caryatids. On two nearby walls a continuous slide show of photographs played, some from the book, others by Tom of her studio in Long Island, and others still of works from the Whitney's collection acquired in her time. There was a piano player. There were small tables and chairs and drinks and hors d'oeuvres. The whole fourth floor looked like a wonderful café.

Abby, Bob Friedman's wife, and I took off our high-heeled party shoes and walked comfortably barefoot around the transformed space gawking at all of it, until suddenly, as we hastily put on our shoes, people began to flow in, more and more until the biggest floor in the Museum was filled. People hugged, ate, drank, talked, looked. Bob and I tried to speak with everyone, those from the art world, book world, friends, family. People waited in line to speak with Mum, sparkling in black sequins, as she sat at a table like a queen. My grandson Anthony,

who'd come from California with my daughter Michelle, ran all around the floor in his blue velvet "rock" jacket with diamond buttons and a fresh carnation, helping the caterers and delighting everyone. When questioned about his beautiful jacket, he said proudly, "My mom made it, have you heard of her?" Among the guests were the Christos, Diana Vreeland, John Fairchild, Cleve and Francine du Plessis Gray, Brendan Gill, and even Hilton Kramer, who stayed for two hours.

Why had we given five years of our lives to do this task, this gargantuan sorting-out of reams of paper? What, now, did it mean?

Well, the book definitely said something. It held 668 pages of information, documentation, photographs, and analysis, and a lot of good writing. Bob had the satisfaction of having written a fine biography, the only serious one about Gertrude and the Whitney, to date.

For me, those five years had been transforming. I had discovered a different kind of fulfillment in a new kind of accomplishment. I was *good* at research! And I enjoyed doing it.

Also in those years, I did well in college. All this was surprising and fulfilling. I came to realize that exploring Gertrude's life had unearthed not only *her* roots, *her* character, *her* faults, *her* virtues, but also my own. I ruminated on the process in a letter to Clare Forster:

> I was moved by Gertrude's intense struggle to be herself, to free herself from the constricting traditions she grew up with, to become an artist, and a friend to different kinds of people . . . we all have to do this, but I felt she had further to go than most with less support from others and less of a clear idea of where to go or how to get there. In some ways, the money, name, etc. made it easier — but in most I think it was a handicap. . . . I have learned so much about myself from all this. . . . So many of the characteristics of my mother, my aunt and uncle, my own cousins and siblings, myself, have become clearer. Our hangups, our unwillingness to confront problems, our anxiety for approval or to be loved, our attempts to be creative, our tendencies to alcoholism or other addictions, our extremes of emotions, moods, and much more, can be explained to *some* extent in the context of Gertrude and Harry. But it's dangerous to generalize too much. . . .
>
> Gertrude became so alive to both of us, as we discovered her, that I really think of her as a very good friend now — someone whose work I am trying to carry on, in some way or other, yet, al-

though I'm devoted to her, I'm also independent of her. Oddly, the book freed me of my last remaining fetters to the past — not its positive aspects, just the stultifying, fearsome, binding ones. I feel free. It's great, but sometimes scary, too — it has led me to new friends, new work, and a whole other way of life. I don't know what will come of it all. . . .

We'd been intent upon discovering every detail of her life and her emotions.

Both Bob and I had identified closely with Gertrude. When she received a commission, when she successfully completed a sculpture, we rejoiced. When she wrote desperate, unmailed letters to her husband, Harry, we longed so fervently for her to mail them, or to talk to him directly, that our stomachs knotted. When she was sick, we sometimes fell ill, too. I remember suffering a violent toothache for which my dentist could find no physical cause, at the time in the writing that Gertrude, toward the end of her life, became very ill with, among other things, a bad tooth infection.

Although my work with the book was over, the knowledge and understanding I'd gained during these years made my efforts to maintain Gertrude's most enduring accomplishment seem all the more important. At last, I felt able to make a real contribution to this end. Through the book, through college, through new friends and associates, and through day-to-day work at the Whitney, my confidence grew. Eager to test it, I plunged even more deeply into my "Museum" life. Leaving — and perhaps hurting — some old friends in my rush toward the new, I was as stubborn as any of my ancestors, determined that nothing would deflect me from my course.

Twenty

*W*e're all products of our own time and place. Tom was, too — but more so.

Tom's extraordinary foresight told him what the Whitney might become, although he couldn't always communicate it clearly. So, all at the same time, he searched and dreamed and directed, while others sometimes found his behavior oblique, his purposes mysterious.

Tom was a visionary, often way ahead of the rest of us. He deserved a board that matched his own faith in the Museum, in himself. Perhaps this was too much to expect from a large group made up in part of cautious businessmen who expected more hard facts and details than they received from Tom. And more accountability.

I've described Tom. Did I say he wore bow ties? Plain, polka-dotted, or striped; occasionally gaudy, splashy; for *very* special occasions, huge floppy caricatures of themselves, sometimes concealing flashing lights. His signature black-framed glasses intensified his gaze, accentuating the intense concentration he brought to bear — *if* he was interested — on whomever he was facing, whether a person, a work of art, an idea, or a project. With his lack of pretension and his humor he could lull the unwary into thinking he lacked intelligence, but that would be foolish, indeed.

The Museum seemed to touch Tom's whole life.

Paintings and sculptures borrowed from the Whitney filled Tom and Bunty's beautiful apartment, used again and again for Museum affairs. The Armstrongs gave spiffy seated dinners or amusing parties with lively music for the young Lobby Gallery Associates, and always a big Christmas party, with shepherd's pie, mostly for artists. That party be-

came a beloved and much talked-of tradition in the art world. Tom's tall tree was beautifully decorated, and glazed cookies made by an artist in special shapes (a work of art, a building, a book) were piled near the door as parting favors. Sometimes, the Armstrongs would also invite a few trustees, leaving out, and thus offending, other big supporters.

He often made turkey soup, and walked it in a big pot the few blocks from his home to the Museum, to share with his staff. Someone named it "Tom's Terrific Tasty Turkey Soup," and it was.

Tom loves gardens. He thought the terrace outside his office looked perfect for growing something, but what? One year, big tubs of flowers; the next, a competition with Jennifer Russell, to see who could grow the best tomatoes. Those half barrels produced so many fat, ripe tomatoes that Tom took to selling them on the street on Thursdays for the benefit of the Annual Fund. I still smile to think of Tom's big balding head turning pink in the August sun, at his tomato stand. And the art world came from far and near — from Soho, from New Jersey, from Brooklyn, from Harlem — to gather around that little stand right on Madison and Seventy-fifth Street.

Most trustees loved it. Some, though, found it demeaning. Their director, the Whitney Museum's director, out on the street selling tomatoes??

Tom loves to drink vodka, straight, on ice. Sometimes this led him into deep waters. Once he had a long and bibulous lunch with a trustee just before a major executive committee meeting. The two of them enjoyed the meeting a lot more than some other members, who took offense at Tom's giddiness, especially when, criticized for overspending, he responded from the depth of his heart, "We wouldn't have such a big deficit if trustees gave more money. That's what you're here for!"

Trustees, especially those he'd had in mind, didn't hesitate to complain to me. But I knew that Tom had been trying, at that lunch, to establish a friendship with this trustee, which would allow him to ask for a major gift to the building we were then planning, that Tom had decided this was the way to do it. When the gift indeed materialized, years later, I wished I could have pointed out the value of that lunch to the doubters — but it was too late.

Tom's private life was private. Never did he bring it to the office. I didn't bring mine, either. And we respected each other's privacy. Our relationship was close, in the most professional sense. Occasionally,

we'd have lunch alone together and talk a little about our families — about his four children and my four, about his beloved mother, about our childhood summers when we'd each worked on a farm, about Tom's striving at Cornell, long ago, to become an artist — and I would realize again how little most of us really knew about him. The understanding and love of art and artists fueling his energy often remained hidden, while one or another trustee would question his big plans, and criticize his ambition, and pick away at his style.

Tom never got sick — that always impressed me. He seemed absolutely impervious to ordinary ailments, to flu, colds, backaches, and any other miseries. He had too much to do to let illness interfere. Once, arriving to meet him, I found him feverish, flushed, and sweating. Jennifer and I finally persuaded him to go home only after he'd finished the most important business of the day. We later heard he'd had a temperature of 104.

In his social dealings, many trustees thought him a snob. For the Museum, he certainly tried to find and befriend everyone he could. Expecting exclusive generosity from those who'd committed themselves to the Whitney, he resented any whiff of disloyalty. He and Bunty had a wide range of friends, from Andy Warhol, to CEOs of banks and businesses, to an intellectual, artistic, and social elite. The Armstrongs made a herculean effort to keep themselves available. They were out every night; people enjoyed them as hosts or guests. Especially if they were on Tom's wavelength. Some of our trustees were not. I remember seeing Patsy, a Museum guard, dancing with Tom at a staff Christmas party; I also remember the tears in her eyes when Tom left for good. His "snobbery," if it existed at all, wasn't about class or ethnicity or wealth, it was about human quality.

Roughly, Tom's work, and also our work together, covered three primary areas: art, artists, and the permanent collection; physical expansion; attracting patrons to support the first two.

We also paid attention to the many other aspects of running the Museum, including exhibitions, education, publications, conservation, and the shop. But these were mainly in Tom's bailiwick; he and I worked most consistently and intensively together on those primary fields, although each, at one time or another, encompassed the others. He and I agreed perfectly on these main goals.

The first, of course, was the most important. Everything else was

based on art, artists, and the permanent collection, the heart and soul of the Museum. It was that first consideration that gave us the most joy and confidence, that made the others worthwhile. Although Tom and his staff made all decisions having to do with artistic matters, trustees could also participate in a number of ways, which we tried to improve and increase, thinking this would bring them pleasure, too. So we held discussions of specific shows at meetings; openings and parties where trustees could meet artists; seminars and classes where trustees could learn more about the Museum's wide variety of art, ranging from eighteenth- and nineteenth-century paintings to the new forms emerging in the '80s. We planned trips for trustees all over the country and the world, so they could visit museums and galleries. We did everything we could think of to pique trustees' interest and advance their knowledge. We also invited each trustee to join a programmatic committee, apart from any financially oriented committee on which he or she might be serving.

In the beginning of our partnership, Tom and I evaluated our non-standing committees and found them deficient. To redefine them, to make them work better for the Museum, we decided to change our hit-or-miss process of inviting anyone we found knowledgeable and caring about art to join, and then hoping for the best. In other words, we thought they'd *want* to contribute money or art. And sometimes, they did.

More and more often, they didn't. This was terrible. Worst of all, there was again no money in the budget for acquiring art. So we decided to form new committees to support each department: painting and sculpture, drawings, prints, library, film and video, education. For each committee, we'd ask members for a specific minimum contribution, giving that department, then, a minimum budget. Of course, we hoped members would give more.

This was a brand new idea, then, and controversial — one member was outraged. When he resigned, he told me that at another museum they never asked him for anything, they valued him just for his knowledge.

The time staff members spent preparing for committee meetings would become worthwhile, because more significant works of art could be bought for the permanent collection.

Tom felt that, even if we both did the preparatory work, it was up to me as a trustee to do the actual asking for money. Although I still found

asking directly for money difficult, it was getting easier all the time. In fact, I found that most people were understanding and even pleased to know exactly what the Museum expected.

We soon put this system to work when we asked people to join the board, making exceptions for those whom we'd asked for other reasons — like scholars, community leaders, and more. And we "grandfathered" current members who couldn't pay. Meetings varied. With connoisseurs at the drawings committee, discussions were intellectual, impassioned, and the votes reflected these qualities.

The print committee was similar, but had a national flavor, since its members came from all over the country, and would usually arrange to have a festive dinner with the curator and a few artists after its meetings.

At the painting and sculpture committee meetings, discussions tended to be more diffuse, mirroring the current explosion of forms and styles. Curators often brought older pieces along with the new, hoping to add established masterpieces to the collection, but members, often new collectors of new art, preferred to spend their money where their interests lay. Unsure of the work they were sometimes seeing for the first time, they were likely to be inclined toward artists they already knew or collected. Since the "dues" were high — $25,000 a year for this committee — this group was disparate, with members new to us and to the Museum. Some wanted to be educated, while others wanted to educate us.

Although this committee acquired the most important works for the collection, it was more problematic than the others. Once, after voting down a piece the curators felt strongly about, the Museum found other sources of funds and bought it anyway. All hell broke loose. I received angry phone calls from committee members, outraged to find their decision had been bypassed. One member resigned. Another, a generous man with big foundation money, threatened to withdraw his funds, unable to believe the Museum wouldn't abide by the committee's vote. This led to endless discussions and changes in policy.

Staff autonomy versus those who give the money is always the issue. As my daughter, Fiona, said of troublesome committee members, while recounting a meeting I had missed, "But they aren't curators!" Another problem: some committee members, seeing others but not themselves become trustees, resented this slight. Not that I blame them — $25,000 was a very large contribution to make to the Whitney,

and they knew it. But every member could not be on the board. We picked those we most wanted for reasons of personality or potential.

I was very upset with a member of our acquisitions committee for questioning Philip Guston's integrity due to a change in his painting style. Guston's best known work had been abstract, but he was now making work related to his earlier figurative mode, and this committee member thought his reversal indicated an unacceptable vacillation, a moral weakness. Ridiculous! At the same meeting, Patterson Sims presented *Merfrog and Her Pet Fish,* by Gilhooley, a marvelously baroque green figure with purple fish twined around her breasts, another crawling up her arm, a large bunch of flowers on her shoulders, and a blissful smile on her face. Lengthy arguments about art versus craft followed, but we did purchase *Merfrog.* She's about four feet long and four feet high, a powerful presence. Other ceramic sculptures were on view that afternoon, and the trustees' room looked like a glistening aqueous cavern. I loved it.

Besides Patterson, many other curators were part of these meetings. Lisa Phillips, for instance, who started as a student in the Museum's Independent Study Program, and was a curator until the spring of 1999, when she left to become director of the New Museum of Contemporary Art in Soho. Like a lean and lovely thoroughbred filly, she rushes energetically from New York to Los Angeles, where she and her husband, film director Leon Falk, have a house. She's everywhere at once, it seems, and — as with all Whitney curators — spends much time in artists' studios, absorbing the world through their work. She's introduced us to many artists who've become friends, including Terry Winters and his wife, art historian Hendel Teicher. Terry's vibrant abstractions never seem to lose a human, organic connection; their beauty draws us to search ever deeper. Terry epitomizes the artist who's as committed, even-tempered, delightful, generous, and good as anyone can be. This I say, knowing that a stereotype exists of the artist as temperamental, moody, and difficult — as true, and untrue, as any other stereotype!

Other curators left the Museum for one reason or another. Like Richard Armstrong, now director of the Carnegie Museum of Art in Pittsburgh. Tall and skinny, his Midwestern farming background and values have mingled with city art-world sophistication, yielding a kindly Richard with a bite. He knows all that's happening in his world, enjoys a lot of it, and is as charming as anyone could be. A strong

presence at our meetings, he created some memorable shows during his many years at the Whitney, and I miss him still. Sometimes, he brought his Jack Russell terrier to work. I got to borrow her once and take her home for a visit. I can still picture Clover carrying in her mouth a small steel wool piece, *Brillo* by Richard Artschwager, while Richard Armstrong was installing an exhibition. Through Richard, we met Vija Celmins, now a close friend, whose paintings we love so, whose life intersected with ours in New Mexico as well as in New York.

Since trustees have all the financial responsibility, power is ultimately in their hands. The staff, it seems, has all the fun of dealing with art and artists. Not too surprising that trustees want to deal with programs, especially if they are new to museums or knowledgeable about art. But no matter how much a trustee admires a particular artist, it remains crucial for staff to have the decision-making power in artistic matters. Part-time volunteers' interest may be educated and wise, but they are not professionals. They don't have the whole picture. And the museum suffers if it is perceived as yielding to pressures from outside.

The tenuous balance between staff and volunteers only exists through understanding, good will, and sensitivity. Not on written definitions or rules — although they can certainly help. Thus, the makeup of a board and its leadership are vital to its survival and health. There must be some who genuinely understand and love the Museum to maintain its integrity.

Deaccessioning is a thorny issue. Arriving a minute late at the new permanent collection review committee, I found I'd been made its chairman, presiding over a debate between Howard Lipman and Jules Prown of far-reaching importance to the Museum. What, if anything, should we get rid of? So much of the collection was never seen. So much seemed of inferior quality, stemming, Howard felt, from my grandmother's generous impulse to buy work the artist couldn't sell, thus leaving him a better chance to sell his best work. Wanting more money for purchases, certain that buying contemporary art was the Museum's basic mission, Howard wanted to review the collection with a view to selective deaccessioning. Only work by artists no longer living would be considered.

Jules, however, opposed this. We didn't have enough perspective or judgment yet, he said. We would be destroying our history, by far the most complete and most interesting history of early-twentieth-century American art in existence. Store it less expensively outside the city, make long-term loans, but don't deaccession. Besides, he pointed out, what Howard wanted to deaccession was worth little on the market. Jules's view prevailed, I'm glad to say.

In 1981, however, we decided to sell the Museum's valuable pre-twentieth-century works, which we hardly ever exhibited. Other institutions would make these works more available to the public. Feeling that the Museum should keep its masterpieces, whatever the period, Leonard Lauder opposed this view. Jules and Howard led frequent, provocative discussions on these issues. Howard believed most in quality, a concept more easily definable then than now, and believed with Leonard that we should sell only lesser works but keep the finest. Howard was a formal modernist. Jules saw art as a part of culture. He believed in context, in crossing boundaries, in diversity, and in the political nature of art, and thought we should keep all the pre-twentieth-century collection or sell it all.

After that first meeting, at supper with the artists in the new Biennial, I felt a surge of joy. Fourteen trustees, a record high, showed up for Tom's inspired menu of hot dogs and chicken à la king with artists like Chuck Close, Billy Al Bengston, Robert Arneson, and H. C. "Cliff" Westerman, the quirky sculptor whose wood pieces combine extraordinary craft with extraordinary inventiveness. In his introduction to the Whitney's one-person exhibition of Westerman's work, Tom wrote: "As a creative spirit, he is a distinct individual among those of us motivated by conformity. His art and his impressions of the world are filled with compassion for things disappearing, lost, or triumphant." Cliff charmed me. He refused solid food, saying he "only drinks and dances," which he'd already done for two hours at the Carlyle before coming to the Whitney. We had a fine and acrobatic dance. I saw us like his wonderful drawing of him and a lithe lady twirling.

And once again, I realized how lucky I was.

In 1980, the Whitney opened Cy Twombly's retrospective. I discovered both his work and the fact that we were cousins — distant, perhaps, but kissing cousins for sure. We haven't tracked down the exact relationship, but my great-great-aunt, Florence Adele Vanderbilt,

married in 1877 a relative of Cy's, Hamilton McKown Twombly. And from that day, I developed a deep friendship with Cy. I wrote about the opening in my journal:

> Whitney Circle tour of Twombly exhibition with Tom Armstrong. It looks superb. Like walking through roomfuls of visual poetry. Isabel Bishop came, spoke to the group very movingly about the exh, about T's work meaning much to her — surprising and nice. Raced home, changed to new gray dress, Charles [Simon] picked me up in limo . . . Don [the caterer] had called earlier in fear the place was too cold, asked me to turn the heat up!! The things I am asked to do! Sat between Cy T. and Henry Geldzahler, fear I was rude to the latter simply by not lavishing *all* my attention on him. Was captivated by Cy — he is charming, open, not uptight, happy with the exh, and the evening — esp because Bob Rauschenberg came. . . . He talked of poetry — says he reads 4–5 hours a day, doesn't paint enough, has gotten lazy. NYC gives you energy; Rome drains you of energy, he says. Says he'll come to Florence for a couple of days when I'm there, will show me some things. Wow. [I was planning my first trip to Italy, a 50th birthday present to myself.]

The exhibition was extraordinary, but alas, it was badly reviewed in the *Times* and very few people came to see it. I remember going with my present husband, Sydney Biddle, and spending at least an hour in just one room with beautiful paintings suffused with color, inspired by the ancient cultures of Europe and America, Dionysian rites, and Greek pastoral poetry. Who could imagine that paint laid so poetically on a flat surface could encompass emotion, time, history?

My friendship with Cy and his wife, Tatia, grew, and I was reminded how many friendships with certain artists changed the way I think about art, and therefore the way I perceive the Whitney. I did indeed stay with Cy and his wife Tatia, herself a fine artist, in Italy, in the summer of 1980.

It was my first trip to Italy, my first trip alone anywhere. Leo Castelli had arranged for me to visit Count Giuseppe Panza to see the minimalist and light art he had installed in his house and stables in Varese. Panza, after driving me through the green hills and treating me to my first Italian omelet, introduced me to the work of James Turrell, Sol Lewitt, Robert Irwin — and Maria Nordness, whose piece was in a

horse stall. I'll never forget sitting on a bale of hay there, in total darkness, waiting, waiting, for many minutes, until a faint sliver of light shone. As it brightened, I felt I was experiencing the dawn of the world.

Just before my trip Brendan Gill had agreed to become a trustee. At lunch at the Algonquin, he'd advised me to follow Emerson's words: "Give all to love! / When the half-gods go / The gods arrive."

"Have adventures in Florence," he said. "Make love!"

I fell in love with Italy. Staying mostly in Florence, I visited and revisited my favorites, sometimes with artist Dorothea Rockburne, through whose clear blue eyes I saw her beloved Brancacci Chapel with Masaccio's frescoes, and the glories of Siena.

Stopping at Cy and Tatia's palazzo in Bassano in Teverino, I slept in a four-poster with deep blue curtains all around, placed in the middle of a white cube of a room with a painted wooden ceiling and seventeenth-century Flemish tapestries on the walls. A suit of armor sat artlessly on an ancient brocaded chair. From my windows I looked down at the medieval part of Bassano, a tiny walled town mostly in ruins, with a glorious view beyond over the plains and mountains of Tuscany.

Rooms opened off a grassy sward in the middle of this glorious palazzo, stone stairways led to one studio up high and another down below, and an arched space on the very top looked over the world, with swallows flying through and a breeze scented with acacias and jasmine blowing sweetly in the soft Italian light. Ancient objects were everywhere — an Etruscan sarcophagus, a fifth-century B.C. Greek helmet, old watering troughs, a beautiful pale green stone object, thin, pierced in a design around the edges. And Cy's paintings. One with Shelley's words from his lament for Keats: "Weep for Adonis — he is dead!" I especially liked two of his god-drawings, one of Apollo, one of Venus.

Those days helped me sense the true life of an artist, the dedication as well as the playfulness. Cy and Tatia deepened my belief that art is essential to life.

Coming back from Italy marked, for me, both an ending and a new beginning. I kept my tender feelings for Mike, but my new life and emotions were pulling us apart, and in the summer of 1979 we separated. We both remained close to our children, sharing their joys and

concerns, conferring often about them and their lives. Mike in Roway-ton, Connecticut, continued to practice architecture, while I lived full-time in New York. Before long, Mike met his present wife, Patricia, and they were married in 1981.

Despite being on this earth a whole half century, a surge of energy sur-prised me with its intensity. I loved New York City and sometimes, at night, drove around its clamorous streets just for pleasure, absorbing the sounds and sights, the flashing lights, and the varied people. Other times, I walked for miles, or jogged in Central Park with a new friend, Sydney Biddle. I realize now that the feelings growing between Syd-ney and me were linked to the passion for life I felt then. They were embodied in this relationship that, of all these new experiences and emotions, was to last the longest.

Elegant and good-looking, Sydney has a high domed forehead that makes him look a bit like an "egg-head," strong well-defined features, and often, an intense, inquiring expression. His essential kindness is sometimes masked by his sharp sense of reality and a conscious wish to be forthright and honest. Sydney's life had been lonely and diffi-cult — he grew up without the presence of his parents, who existed in their own separate worlds. I find it extraordinary that, despite this vir-tual abandonment, he has been able to become such a whole human being. A splendid companion, imaginative, highly intelligent, and ea-ger for new ideas and experiences, he loves to read, to converse, to lis-ten to classical music and jazz, to visit museums and castles and temples. Together, we have traveled to exotic places — we decided, for instance, to get married in Hungary, on the banks of the Danube! Sydney is extremely understanding and supportive of my life and goals. We share household tasks, like today's younger generation — Sydney shops for many of our groceries and other quotidian needs, from toothpaste to vitamins. And he is *never* boring!

When we met, Sydney was at a turning point in his life and career; he had worked for years in the insurance business, but it was nearly time for him to retire. He hoped to return to the painting he'd done se-riously in the '50s at the Art Students' League of New York, when he'd won the Macdowell Prize, enabling him to spend a year in Italy. I greatly admired his large abstract paintings that I'd seen in his apart-ment on Central Park West. Now, he also followed his heart. We whirled through the city like children, we danced and laughed and

talked in every free moment we could find. Even a five-minute meeting on a street corner was precious. No problems, then, seemed insoluble.

We fell in love.

On September 15, 1981, we were married.

Beginning in Taos, in the '90s, and continuing in New York, Sydney works most days in his studio, creating vibrant abstract paintings in exceptional colors and forms. They appeal to me enormously, as they do to many artists who have visited his studios. Agnes Martin, for example, and George and Betty Woodman are enthusiastic about them. These works seem to spring directly from Sydney's mind and emotions unhampered by influence or hesitation. Enigmatic but appealing dark shapes float or fly over fields of yellow, blue, or green; red motes scatter like flocks of birds in a pale sky; delicate white lines tangle on black paper. Ribbons of blue or gray roll and billow over canvas like clouds or waves on some unknown planet. Unearthly, mysterious, these paintings and drawings are beautiful. I take great pleasure in them. I see them as young, exuberant, and joyous.

During the Whitney's birthday year of 1980, an opportunity suddenly arose — not only to acquire a masterwork, but to affirm our desire and capacity for so doing to the whole world.

The Whitney was only considered a minor force in the art world. We hadn't ever made the kind of purchases the media featured, our openings didn't hit society pages, and our public relations seemed woefully lacking to those experienced in such matters, such as Leonard Lauder and Gilbert Maurer, a trustee who was then the head of Hearst Magazines, and later, in the '90s, would serve a term as the Whitney's president. If we were to raise big money, we had to improve.

Tom thought of one way to do that, and to benefit the Museum's collection as well. Collectors Emily and Burton Tremaine had recently transferred their interest in art to a concern for overpopulation, and, through the Pace Gallery, were selling works they'd collected, including Jasper Johns's *Three Flags*. What a splendid acquisition it would be for the Whitney! Its subject, the American flag, made it particularly appropriate for the Whitney Museum of American Art. This painting's layers of paint and other materials, mirroring levels of meaning, satisfied anyone who cared to delve deeper. David Sylvester wrote lyrically about Johns's use of the flag image in *Art in America* (April, 1997):

"It was in one of the earliest versions, *White Flag*, 1955, that the metaphorical implications of simultaneously clarifying and obscuring were most richly realized: forming and melting, tightening and loosening, appearing and disappearing, flowering and decaying, brightness falling from the air. All participles but for one noun, and that an ethereal one. In other words, I see the work as being about process, not about matter. I don't see the surface as signifying, say, skin or wood, but as paint that composes an objective correlative for change. The change has two speeds. In the stars it's allegro vivace, agitated movement, flickering and exploding. In the stripes it's andante."

The price: $1 million. Then the highest price ever for a work by a living artist.

Leonard was eager to get *Three Flags*. He helped Tom to obtain pledges from four friends of the Museum, Sondra and Charles Gilman, national committee members Alfred Taubman and Laura Lee Woods (anonymous at the time, by her request).

Tom informed Leo Castelli of our wanting the work. Leo had originally sold *Three Flags* to the Tremaines in 1958 for a pittance, and he was convinced that the Whitney could not raise so much money. "No, no, I'm sure it's going to a Japanese buyer," he said, exemplifying the contemporary attitude.

At the executive committee meeting of September 17, 1980, Tom announced that we'd purchased the painting. Howard Lipman was concerned. Since $250,000 had not yet been pledged, the Museum's endowment funds were being put at risk.

Later, while on a trip to North Carolina with Tom and Brendan to cement relationships with national committee members, we heard that Grace Glueck, art critic for the *Times*, was about to announce the purchase. This was nearly two weeks before the acquisition would be presented to the full board of trustees. We rushed back to New York and contacted everyone we could, so, when the news hit the front page of the *Times* on September 27, it wouldn't come as a surprise to our trustees.

The consequences of this purchase were contradictory.

There was lots of publicity. *Three Flags*, shown in a special installation for several months, was much admired. Many people came to the Museum especially to see it. Those of us, including me, who loved the painting were grateful to those whose confidence and generosity had made it possible for the Whitney to own such a seminal work.

On the other hand, we lost a board member. Arthur Altschul, one of the original nonfamily trustees, had never really trusted Tom's ability. And, for Arthur, *Three Flags* was the last straw. He said it was too much money for any contemporary painting. He didn't like the Museum any more; our exhibitions, purchases, and policies were trendy and money-ridden. He wanted out.

Even more serious, perhaps, was the rift between Tom and Leonard, widened when Leonard obtained a gift from Ed Downe, a wealthy friend of Leonard's, Tom's, and the Museum's. Tom had decided to list on the *Three Flags* wall label all donors of $50,000 or more. While Leonard had asked Ed for $50,000, he only gave $25,000. Leonard sent the check to the Whitney, along with a note asking Tom and me to write proper "thank-yous," as Ed had abandoned another museum when these hadn't been forthcoming.

I wrote a long appreciative letter to Ed, with copies to Leonard and Tom. After reading it, Tom decided an additional letter from him was unnecessary. But fireworks over the omission from both Ed and Leonard followed. To add to Tom's perceived "insult" to Ed, having already announced the "wall label" policy, Tom felt he couldn't add Ed's name to it with the $25,000 donation.

Furious, Leonard lost interest in raising or giving the missing funds. I was saddened because I had really counted on him — and I felt caught in the middle of a little war, unable to find a solution.

Ed never made another contribution to the Whitney.

It is extremely difficult to raise money for a fait accompli, I found out. We never did raise the final $175,000. It came from the Whitney's already inadequate endowment.

The painting, *Three Flags*, however, remains a cornerstone of the collection. A magnificent painting. Emblematic of Tom's high standards as director.

Jasper's work affects my senses, through its rich surfaces, colors, layers, and patterns. My mind is affected as well, because I want to make connections — between play and work, for instance, or love and hate, or good and bad. Life and death, even. Between his pictorial symbols of agony and those of creativity and change. Looking at a Johns exhibition is mysteriously unifying. It's like reading Eliot's *Four Quartets* or Proust.

One of the very nicest evenings I can remember at the Museum took place on November 17, 1982, in the Lobby Gallery, where seventeen *Savarin* monotypes by Jasper Johns were installed. They fit perfectly in that space and looked wonderful. Jasper had made these in January; they were based on *Savarin*, a lithograph depicting a familiar image in his iconography: a Savarin coffee can filled with paintbrushes.

A small group of Jasper's friends gathered to celebrate, at tables right in the midst of these vibrant works. Sitting next to Jasper, I could imagine no better Museum moment. There was a unity of feeling in that room: everyone loved the Whitney, the art, and each other. Collectors Victor and Sally Ganz, Philip Johnson, and, from Baltimore, Bob and Jane Meyerhoff epitomized long-term commitment to Jasper's work and affection for the artist. Judith Goldman had written about Johns with insight. Leo Castelli, dean of New York dealers, had represented him ever since he first began showing his work. John Cage, Merce Cunningham, and Jasper had worked together on dances and performances, and were old and dear friends.

Tom and I persisted in our wish for expansion. We kept discussing our wish lists of art for the permanent collection galleries. Jasper Johns, of all the living artists woefully underrepresented in the collection, headed both Tom's list and mine. But we were facing our same problem: the Museum couldn't afford to buy his past works, and could only afford the new very rarely. What could we do?

Hoping Jasper would make the Whitney the ultimate home for those works he himself still owned, we decided to talk to him about it. Had we not shown our commitment by having his retrospective exhibition, by buying as much of his work as we could, and by our purchase of *Three Flags*, the most expensive painting by a living artist at that time? Surely he knew how much we believed in him and his work. And our trustee Victor Ganz, after all, was his earliest and biggest collector! His friend! On July 8, 1982, Tom, Victor, Jasper, and I met for lunch at the Knickerbocker Club, an appropriate ambiance for an important talk. We had a fine time, but it was difficult for us to broach the subject. After all, when asking for a bequest, one speaks of mortality. We were awkward, I'm sure, but we asked — and Jasper, as always, was gracious. He said he'd think about it.

It was many years later before the subject arose again, this time with an entirely different cast of characters. Victor had died. Tom was no

longer director. I was no longer president or chairman. In 1994, trustee chairman Leonard Lauder and I visited Jasper in his house on Sixty-third Street. Leonard did the talking, this time, offering a large gallery just for Jasper's work on the Whitney's soon-to-be-remodeled fifth floor. Asking to see the plans, Jasper looked carefully at a model of the proposed space.

Gracious as ever, his response was exactly the same. He'd consider it.

We're still hoping. After all, though, great artists probably want to be remembered in a wider context than the Whitney, with its focus on American art, can provide. Would want their work to be seen with that of other great artists of all time and all cultures, at the Metropolitan Museum or the National Gallery, perhaps. The Whitney can't offer that, no matter how much space we provide.

The opening of Andy Warhol's *Portraits of the '70s* in November 1979 was a gala benefit for the Fiftieth Anniversary Exhibition Fund, our way of raising money so we wouldn't have a 1980 budget deficit. We went all out to get trustees and friends to give dinners for everybody who'd bought tickets. Tom and I realized we'd forgotten to put our own names down for a dinner, so we decided to give our own. But where? Tom's inspired choice, the little Greek diner next to the Whitney.

We arranged for a red carpet and searchlights, just like those in front of the Whitney that night. The family who owned the restaurant promised all kinds of special Greek treats and were excited to have been picked for the gala. In honor of the great occasion, they decided to do a huge clean-up, so thorough that Tom remembers the place smelling "like the mens' room in an Esso service station!" Sitting at plastic booths in our best black tie outfits, we had a wonderful time, finding the event and the place very Warhol. Collector Henry McElhenny's sister, Bonnie Wintersteen, an old friend of Tom's from Philadelphia, got right into the spirit of the evening, roaring with laughter, in her diamonds and white mink. Leo Castelli was there, as was Marion Javits, and Jerry Zipkin, known as "The Social Moth," elegant and sharp-tongued escort for glamorous ladies whose husbands preferred to skip social events. And of course Andy dropped by with his gang and his little dachshund, very much approving of the dinner his friend Tom had arranged.

In February 1980, the Whitney held a birthday party at the Museum for Isamu Noguchi during his show, "The Sculpture of Spaces." During the Museum's fiftieth anniversary year, we wanted to honor the living artists most often shown at the Whitney, and Noguchi was one: he had been in the Museum's inaugural exhibition in 1931, his work had been included in eighteen annuals and biennials, and he'd had a major retrospective in 1968. Eleven of his pieces, dating from 1929 to 1965, were in the permanent collection. Because Noguchi's eloquent sense of space had been expressed with special clarity in the performing arts — he had collaborated with composers, choreographers, and dancers — the focus of this show was on these collaborations. Noguchi himself wrote the catalogue, saying, on the first page, "space itself gives validity to sculpture — beyond objects there is always the situation, the time, the performer and the spectator. . . ."

In 1981, in our continual effort to exhibit distinguished, American artists, we were struggling to have a big Georgia O'Keeffe retrospective. Lloyd Goodrich had done a show at the Whitney in 1970, but this one would be more comprehensive. O'Keeffe was in New York for a rare visit from her home in New Mexico with her young companion, artist Juan Hamilton, when he was having his first New York show of sculpture. We arranged a lunch. At ninety, elegant in a simple black dress with a snow white collar, she looked, as Sydney described her, like a "Hungarian nun." He'd stayed with her in Abiquiu, years before, while traveling with a friend who was her cousin. He'd given me impressions: Georgia beating egg yolks for a delicious zabaglione; the rocks and bones she'd lovingly arranged in her rooms; the spareness and austere beauty of her house; the desert, where she'd showed them her favorite places, had walked and talked with them.

At this time, though, Georgia was nearly blind, and since I was seated next to her in the restaurant, it fell to me to feed her, an intimate procedure allowing me, despite my awe, to have a real conversation with her. Looking deep into her eyes, I couldn't believe she wasn't looking back at me. Her intelligence and intensity still shone in that darkness. I was awkward putting her chicken and rice into her mouth, thinking she'd mind, but not at all — she seemed happy to be fed, and to recall the past. Her memory was stunning. She talked to me about the times she and artist Max Weber used to have Chinese lunches in Greenwich Village — he seemed to be one of the few artists she recalled with pleasure. She spoke of her then-husband, Alfred

Stieglitz, who had showed her work and photographed her so often — but now she remembered her impatience with Stieglitz. Life with him had been too busy, too full of people, and she'd needed tranquillity in order to paint. She'd been especially frustrated during their summers at Lake George. Hearing her still-impassioned tales made me think that her new relationship with Hamilton was somewhere between that of grandmother/grandson and two lovers. The teasing between them had a flirtatious ambivalence.

We never did the show. Georgia and Juan wanted too much autonomy. Since curators need to be responsible for the choices, the installation, and the catalogue, they would have been dissatisfied. Thanks to our new friendly relationship, however, O'Keeffe made paintings available to the Whitney, which we then found patrons to buy and promise to the museum. Each year, they would give a percentage to the Whitney until the gift was completed and the work entered the permanent collection. We arranged, for example, for my cousin Sandra Payson, then a Museum trustee, to visit O'Keeffe in Abiquiu, and she returned with an abstraction that Sandra has now given to the Whitney. Calvin Klein, in the same way, bought *Summer Days* and has completed his gift to the Museum of that masterpiece.

We were longing, too, for an Agnes Martin show in the early '80s, and Tom traveled to Galisteo, New Mexico, in a vain effort to persuade this artist to agree. It just wasn't the right time, though, and wasn't until 1993, when Barbara Haskell curated the Agnes Martin show that traveled around the world. By then, Sydney and I were living in Taos and were Agnes's neighbors. Today, thanks to Agnes herself and other generous donors, especially Leonard Lauder, the Whitney has a superb collection of her paintings.

Most of the parties we gave for the Museum had specific agendas. There is no question but that if they were enjoyable, they were nonetheless work-related. One in 1982, however, was about pure pleasure. After a small opening at the Museum of John Cage's scores and prints, Sydney and I gave a dinner in the garage under our carriage house apartment where we and members of our family kept their cars. Money was always an issue, so when I discovered a large bolt of red cotton in a budget store, red became the motif for our party. We draped it as scrims over the cars, painted the floor red, scattered seashells and pretty stones we'd gathered from a Long Island beach on the long, narrow red-covered table, and lit it with candles anchored in sand. Place

cards had names on their backs for a change of seats halfway through the meal. Chef Lauren Berdy and I had lengthy discussions about the menu. John and Merce were on serious macrobiotic diets, and they'd agreed not to bring their own dinner, as they usually did, when I'd promised them to provide the right food. We'd learned we couldn't have tomatoes, eggplants, peppers, or potatoes (the nightshade family of plants) or sugar, or dairy products. So we started with sushi, buckwheat noodles, and seaweed, continued with fish baked in broth, very long Chinese green beans, and brown rice with vegetables. For dessert, dried figs stuffed with nuts, papayas, kiwi fruit. John and Merce Cunningham said it was the first time in eight years they hadn't brought their own food, and it tasted good, even to less macrobiotically oriented guests. We had our piano tuned, hoping John might play. Instead, Bob Rauschenberg, after many drinks, decided to do a performance piece, and sat down at the piano for about ten minutes without touching the keys, a parody of an old piece of Cage's that we feared would be upsetting to John, but his lovely smile remained despite the bad joke. But the party was fun and lively and a big success — and no wonder, considering that John Cage had chosen the guests, including William Anastasi and Dove Bradshaw, Jasper Johns, Mark Lancaster, Porter McCray, Robert Rauschenberg and Terry van Brunt, Louise Nevelson and Diana Mackown, Teeny Duchamp and Dorothea Tanning, Cy and Tatia Twombly, Kathan Brown and Margarete Roeder, Tom and Bunty, curator Patterson Sims with writer Honor Moore (who was writing her book, *The White Blackbird*, about *her* artist grandmother), Anne d'Harnoncourt, director of the Philadelphia Museum of Art, originator of the show, and her curator husband Joe Rishel.

Should we have added a few trustees? Probably. But the party was full of fun and in many ways seemed perfect as it was, and we all felt relaxed and comfortable as we might not have if . . . well, if it were a party-with-an-agenda.

Monday, April 12, 1982. A *Times* headline announced "WHITNEY COULD LOSE CALDER 'CIRCUS.'"

In the Whitney's lobby, a photograph of Calder installing his *Circus* in 1976, the year of his retrospective, illustrated the ensuing long article. The French government had empowered cultural officials to take *Circus* for the Beaubourg in lieu of a cash tax settlement. By now,

though, *Circus* was a Whitney icon, with its full troupe of miniature circus performers and animals, and a nearby videotape playing a film of Calder, maneuvering the figures he'd created and talking them through their paces while his wife Louisa played circus music in the background.

In his book, *Alexander Calder,* James Johnson Sweeney remembered, in 1951, the way it had been.

At the beginning, the circus was merely a few ingenious figures which Calder had made for his own amusement. There was nothing elaborate about them: bits of articulated wire for arms and legs and a wooden body — a spool, or a cork. Still their creator could make them perform some most remarkable feats. Gradually the troupe increased. Word got around Montparnasse. A casual turn or two to amuse a friend soon became a full-length performance.

The circus was given in Calder's narrow room; the guests would crowd onto the low studio bed; the performance would take place on the floor in front of them. A bit of green carpet was unrolled; a ring was laid out; poles were erected to support the trapeze for the aerial act and wing indicators of the "big top"; a spotlight was thrown on the ring; an appropriate record placed on a small portable phonograph; "Mesdames et Messieurs, je vous presente —," and the performance began. There were acrobats, tumblers, trained dogs, slack-wire acts *à la Japonaise;* a lion-tamer; a sword-swallower; Rigoulet, the strong-man; the Sultan of Senegambia who hurled knives and axes; Don Rodriguez Kolynos who risked a death-defying slide down a tight wire; "living statues"; a trapeze act; a chariot race: every classic feature of the tan-bark program.

For the most part these toys were of a simplified marionette character. Yet they were astonishing in their condensed resemblance achieved almost entirely through movement.

Museum visitors of all ages loved *Circus.* The Whitney had the best collection of Calder's work anywhere, and this was the centerpiece, emblematic of the artist's career. As Jean Lipman, major collector with her husband, Howard, of Calder's work, wrote in the catalogue, "The circus esthetic — a combination of suspense, surprise, spontaneity, humor, gaiety, playfulness — has always been the basis of Calder's work."

We just couldn't lose it.

The Calder estate had given us a first option, until May 31, to buy this work for $1.25 million. A staggering sum, for us. And higher offers

reportedly had been received from European museums. So we knew we couldn't bargain, although as Harold Daitch, their lawyer, reassured us, "The family would like to see it stay with the Whitney."

An all-out, countrywide campaign to "Save the Calder Circus" was decided on. Buttons everywhere, printed in red, white, and blue; clowns from Ringling Brothers and Barnum & Bailey Circus, now owned by Irvin Feld and his son, Kenneth, collecting money all over the city; school children, even circus children, helping. *Newsday* announced "THE BIG CIRCUS TRIES TO HELP THE LITTLE ONE STAY IN U.S.," showing the Felds at the Whitney kicking off a drive for $1.25 million, and illustrated by a photograph of Targa the elephant hoisting me high above Madison Avenue, in front of the Museum, both of us laughing. Clowns, showgirls in sequined costumes, acrobats, and hordes of children crowded around, cheering, collecting small donations. All traffic on Madison Avenue stopped. I'd invited a Whitney patron who seemed interested, and when I spotted him in the crowd, I yelled from my perch, "Hello Seymour, great you're here!" He's smiling in the corner of that photograph, next to the Felds. I called him later to ask if he'd contribute, and he suggested a visit.

Meanwhile, trustees and others rushed to help, especially Leonard Lauder and Howard Lipman, each pledging $100,000. Howard declared that "Calder and the Whitney are one and the same. The Calder circus is the heart of Calder's youth and it must remain at the Whitney Museum."

The Robert Lehman Foundation, thanks to financier/writer Michael Thomas, gave $125,000.

You could hardly move in the city without becoming aware of our *Circus*. And newspaper articles appeared all over the United States, many with photographs of *Circus*, of the clowns, of Targa, and me.

On April 29, Tom and I showed up at the law offices of Shea and Gould. Seymour Klein was waiting. Before we were really into our request, Seymour let us know he'd already decided what to give us. "The foundation will contribute five hundred thousand dollars," he said. He'd already checked it out with the Johnson trust (the Robert Wood Johnson Charitable Trust, of which Seymour was a board member), and he'd like it announced to the press immediately. I was about to leap from my chair to hug Seymour, but Tom answered quickly: it was a wonderful offer, could we consider it overnight? When I found out why he'd been so cautious, I realized he was right. We needed

more time to raise the rest of the money, and it would be difficult if not impossible if such a big gift were known. The next day, we called and asked Seymour to give half the necessary funds, and to give us three weeks to raise the rest before announcing the gift. Seymour understood our reasons, and pledged the $625,000. Now I could hug our generous patron!

With over five hundred recognized donors, not counting the thousands who remained anonymous, we were able to more than match the Johnson trust's extraordinary gift. In only twenty days! Editorials and articles in newspapers and magazines across the country rejoiced along with us. Mayor Koch came to our press conference on May 5, along with Seymour and the circus people, who had by now become our dear friends. Standing in the lobby, Tom announced: "The Calder circus has been saved and will remain in the United States at the Whitney!"

The scheduled May 20 benefit of the Ringling Brothers and Barnum & Bailey Circus would now be a celebration, with contributors invited to a gala performance. And what a celebration it was. A cocktail party to meet the performers, a tour backstage. I remember "The Mighty Michu, Titan of Tinyness, Sultan of Smallness, The Smallest Man in the World," drinking a whole celebratory glass of red wine with awesome effects. Since he was so small it affected him powerfully, he said, and he almost couldn't go on. Best of all, the clowns invited Tom and me to join them. Tammy Parish and Wayne Sidley, who went through sixteen changes of identity during a performance, made us up, generously lending us not only their "faces" but their costumes. The *Times:*

"'They decided I was the street tramp type,' Mr. Armstrong said with an uncertain smile as he greeted guests wearing his grayish makeup, pink cheeks, a plastic red nose and a patched clown jacket, which only partly covered his preppy bow tie.

"Mrs. Biddle, in white face, manic red hair and tablecloth checked overalls, . . . and Mr. Armstrong appeared, center ring, in the clowns' Wash-the-Fierce-Dog act."

We also marched in the opening parade with the clowns, playing trumpet and tuba, clowning along with the rest, enjoying ourselves immensely.

The Whitney put out a newspaper celebrating this joyous moment. Among many tributes to Calder and his circus, I like John Updike's poem:

CALDER'S HANDS

In the little movie
at the Whitney
you can see them
at the center of the spell
of wire and metal:

a clumsy man's hands,
square and mitten-thick,
that do everything
without pause:
unroll a tiny rug

with a flick,
tug a doll's arm up,
separate threads.
These hands now dead
never doubted, never rested.

Artist and writer Robert Osborn, Alexander Calder's friend, occupies a whole page of that newspaper. Across the top, over Osborn's drawing of Calder-as-mountain, smiling and recumbent, a poetic tribute in his flowing cursive:

We can't compress Sandy into a few words./ Too much of him. . . . too large . . . and his qualities are too varied & contradictory. Engineer-Artist./ Capricious yet totally logical. A serious Santa Claus./ Mobile as a dream . . . Stabile as the very earth, & sometimes both./ A lover of fun, full of wit & play, *but* confronted by things evil he is as grim a battler as one could ask for. He is that rare combination of delight & powers with which he has blessed us all.

Thus was *Circus* saved.

Tom's dream for the permanent collection was evoked in an exhibition he curated in 1981 for the Haus der Kunst in Munich. The trustees and national committee members who went to the opening saw a group of extraordinary paintings. Tom had had his eye on them for some time, hoping their owners would give them to the Whitney. Viewers seemed impressed by the entire show and by Tom's tour de force in assembling all the various paintings. He had arranged them thematically rather than chronologically, with interesting juxtaposi-

tions: a Wyeth looked surprisingly abstract next to an Avery and a Hartley. The Germans crowded around those they most liked, especially the "individual expressions" section: Ivan Albright, Richard Lindner, Jim Nutt, Peter Saul. I remember noticing the many young Germans looking as funky as young Americans.

This show had reinforced our awareness of the tremendous interest in American art that exists in Europe, and back in New York, I reported this to the other trustees. We had seen hundreds of fine works by American artists of the '40s through the '70s, installed in museums that, in several instances, were created solely for the display of these works. Since these European museums and collections were generally supported by governments or government agencies, I was all the more grateful for, and impressed by, the extent of private patronage in our country — especially at our own Museum. In that year's *Bulletin* I wrote, "The United States today is on a par with the 'old countries' in abundance, quality, and geographical dispersion of cultural institutions of all kinds — and yet, we are comparative newcomers, regarded until recently as not only upstarts but philistines!"

At that time, once again, we felt impelled to grow, to build, so that Americans would not have to go to Europe to see their own twentieth-century art. We wanted to fulfill our mission to "increase public awareness of the significance of American civilization of the twentieth century." We wanted to have the best Museum for the best art of our century right here in New York City.

To give a hint of what we could do, with funding from the Alcoa Foundation, whose visionary CEO, Krome George, was a good friend of Tom's, we installed the first long-term exhibition of masterworks from the permanent collection. For five years! On the whole third floor! This was a response to the long range planning committee report, which recommended, in part, that "Examples from the permanent collection will, when possible, have first exhibition priority; a program to achieve this will be initiated."

One important result of the exhibition was its demonstration of the Whitney's need for more space. From six hundred works in 1930, the permanent collection had grown to more than six thousand works in 1981. In that third floor installation, we could only show seventy-three. To again quote the planning committee's report:

"Space in the present building is inadequate for the ideal needs of

the Museum. While the building is currently manageable and enjoyable, it is too small to function as the major center for the permanent exhibition of American art of the twentieth century, as a showcase for temporary exhibitions, and as an educational center."

This introduces our second goal, physical expansion. Over the next decade, it would occupy most of our time and cause most of our troubles.

Twenty-one

*W*as more space necessary? Was it even possible?

Those I respected were beginning to encourage me to think this was indeed the right time. The Whitney in 1978 was emerging at last from a long, barren slump into a period of bursting creativity and excitement. Sylvan Cole, erudite senior gallery owner, told me. Philip Johnson, mischievous dean of architects, leaned toward me at an opening and whispered with his sharp, silken tongue that he'd been noticing how the Whitney was doing many more vanguard shows than the Modern — for decades, "his" museum. And, on a rare moment alone with Johns Hopkins president Steve Muller, former chair of the long range planning committee and still on the Whitney's board, he said that institutions were always either on the rise or declining. This was the right time for the Whitney to be rising. He and others were interested only in this aspect of the Museum; we'd lose them if we opted for "gentility" instead. I was the right person to be leading now, Steve went on — and Tom was, too. I'd learned to "use my vulnerabilities."

What did he mean? That if I felt shy about leading a meeting, or asking for money, that quirk could make my plea more effective? Make people *want* to help?

In the September 1978 issue of the *AIA Journal*, Bernard P. Spring, dean of the school of architecture at City College, wrote a long article entitled "Evaluation: The Whitney Suffers from Success." Perfect for our purpose, to persuade trustees, and others, of the urgency to expand. Spring talked about many of the changes causing this need.

The first sign of the difference is the regular presence of a hot dog vendor's cart at the corner of 75th Street and Madison Avenue. . . . In New York, this can only mean that this once sedate location has become a lively center of popular culture. On Tuesday evenings when a major oil company underwrites free admission, a large crowd begins to gather an hour before opening time and with considerable camaraderie lounges along the granite balustrade surrounding the sunken outdoor sculpture court. . . .

My own recollections of the building in its first few years . . . remind me how much like a club or a private mansion it was at first. The people who conceived this original design must have been thinking of serving that small group of aficionados who before the 1960s were devoted to American art. . . . Even as the building was under construction, the recognition of the importance of American art and artists was growing rapidly along with the size of the audience for museums in general and American art in particular. . . .

Tom, he reported, believed that the building functioned perfectly for about one thousand visitors per day, not for the three thousand to five thousand people who now visited on a busy day. These crowds altered the nature of the building itself — small galleries, for instance, had changed from "intimate stopping places to part of the irresistible traffic flow patterns of the adjacent large galleries. Gone are the parquet floors. They have been covered with commercial carpet. Gone is the wood paneling on the walls. It has been covered with plaster to accommodate more works of art. Gone, too, is most of the domestic furniture. It has been replaced by the familiar museum bench which tells you not to linger if you must sit at all."

Spring continues with a detailed analysis of changes in partitions and gallery use, necessary in view of the changing perceptions of American art, the numbers of visitors, and the program itself. He concludes:

"The program has been so successful that it has outgrown its home. The collection is larger than the storage areas can hold. . . . Breuer and Smith's building continues to hold up well as a public monument to the importance of American art. Its only failure has been in keeping up with the success of the program it houses."

A good overview, it seems to me, of the years since 1966: changes in the building, changes in the art world. Convincing. An objective, qualified outsider was singing our song. We made copies for each trustee. Discussing our needs in trustees meetings, we made charts, curators led tours of our building — including the basement, including our

storage facilities, including the permanent collection installation, including offices once generous and windowed, now divided into tiny cells; including outmoded heating and air-conditioning systems; including guards' lounge areas; and even including public rest rooms. All, all, ranging from inadequate to uncomfortable to downright dangerous — for people, for the building, and for art. We pointed out the large knockout panel in the wall that Breuer and the building committee had installed to make expansion to the south easier.

While we couldn't immediately expand our building, we began to explore other ways to get the collection out into the world, and decided to enlarge our branch museum program. We found corporations, also expanding, that needed an "amenity" in exchange for more height, or to counter some kind of bad PR. By adding a public component to their building, they could make it bigger, and a museum space was just the thing. The corporation, the museum, and the public all benefited.

Ulrich ("Rick") Franzen, a leader of the young architects whose ideas and buildings were modifying and softening the strict tenets of modernism, had originally brought the Whitney and Philip Morris together in an art purchase program. He had then encouraged them to include a branch in their new building. Franzen also was the broker in our arrangement with Andrew Sigler, CEO of Champion International, where we had our first out-of-town branch in Franzen's fine building in Stamford, Connecticut. When Rick showed me his model for our branch museum in the new Philip Morris building he had designed at Park Avenue and Forty-Second Street, I was thrilled at this new opportunity to reach a new public, to put sculpture in a public place, and to make a new marriage between the corporation and the Museum. As in the ancient cities of Europe, we too have the potential to create art-filled buildings, streets, and parks, with fine sculptors like Frank Stella, Mark di Suvero, Tom Otterness, and many others who design their work for the public as well as for the museum-goer.

The idea of branch museums had been approved by the board on condition that they not put the Museum to any expense — preferably, that they make a profit — and we were all looking forward to this new outreach to a greater public.

Meantime, we were evicted from our first branch on Water Street, used for the education program. The Reichman brothers, who owned Olympia and York and had bought 55 Water Street, were quite

different from the Uris brothers, and seeing an exhibition there, or perhaps only hearing of it, they decided not to renew our lease. Their message was "Nude sculpture — no way." David Hupert, head of our education department, and I decided to have a last try at persuading them. They were, we learned, orthodox Jews so observant they wouldn't eat anything but unpeeled bananas if they didn't know the source of the food; they did all their business with a handshake; they probably wouldn't do any business with a woman. Nevertheless, one brother gave us an appointment, and turned out to be very polite, very sympathetic. Our hopes rose — but we were wrong. The nude sculpture was the culprit, no doubt, although he insisted they needed the space for added income. The Whitney was out.

Keeping other spaces for any length of time proved difficult. A jail we'd settled nicely into, with cells making perfect studios, was reclaimed; then another city building was taken back to be used for the homeless. The Museum's education department, however, flourished despite the setbacks.

The Independent Study Program is unique. There are three interacting subdivisions: the Studio Program, for artists; Critical Perspectives on Visual Culture, for writers, teachers and critics; and the Curatorial Fellows, for those wishing to work in museums. A quasi-independent entity, it's supported by the Whitney and is very much a part of it, but seems like a well-kept secret — few outsiders are aware of it. It's the only educational program in the country where art history majors and artists are students together; the only one where students from universities here and abroad interact with the roiling art world of New York; the only program where students can curate museum exhibitions; and the only program virtually free. It is oversubscribed; some years, as many as five hundred persons apply for two dozen places. Artists, musicians, dancers, critics, and professors advise, lecture, and critique. The tone and direction is often highly political. Some trustees might find it too left-wing, and would be surprised by some of the shows in the branch and occasionally in the uptown Whitney, but they rarely question the program. I recall one student exhibition uptown where a painting containing graphic homosexual imagery, years before Mapplethorpe shocked the world, caused one horrified trustee to threaten to resign unless it was removed (it wasn't and he didn't).

Ron Clark, head of ISP, arranges for people of extraordinarily high

quality to be available to students. Long-term teachers have included dancer and choreographer Yvonne Rainer; artists David Diao, Mary Kelly, and Martha Rosler; critics and writers Benjamin Buchloh and Hal Foster. Many graduates have become successful artists, curators, critics, and professors — for example, artists Julian Schnabel, John Newman, Bryan Hunt, Glenn Ligon, Jenny Holzer, Tom Otterness; art critic Robera Smith; and Jack Bankowsky, the editor of *Art Forum*. Several became curators at the Whitney: Lisa Phillips, Richard Marshall, Richard Armstrong, Karl Willers. And Joanne Cassullo has been a very meaningful trustee for many years.

Our central project, however, remained the expansion of our main building. In October, Leonard Lauder, Joel Ehrenkranz, Richard Ravitch, Tom, and I met to discuss plans. Ravitch had been a partner in H.R.H., the construction company that had built the Whitney. Now we hoped he would guide our expansion program. This was a good group to do the planning, I felt certain. The executive committee later that day started the whole project going. Discussion was led by Steve Muller, Joel, and especially Leonard, producing the decision I had both hoped for and dreaded — to move ahead with expansion.

Hoped for? Absolutely. This was right for the Museum and the world.

Dreaded? Well, the responsibility was daunting. I was prone to moments of doubt. In myself. In the board. In Tom. In our ability to carry through such an immense project with plenty of doubters in our midst. Still, my self-confidence had increased a great deal. I no longer quaked at the idea of running meetings, I loved the feeling of accomplishing, of meeting a challenge, of realizing that I was good at getting the most from people. At finding the position or the committee where they'd be the most helpful and most satisfied.

Meanwhile, this big executive, head of the Whitney Museum, wanted to come home to be cuddled. To read poetry, to laugh, to talk over the day, to put on blue jeans and make *poulet a l'estragon* and steamed fennel. Since I was staying in New York on weekdays in the late '70s, I spent many evenings alone. By 1980, Sydney and I were together, and we shared many quiet evenings of cooking, reading, or listening to music. "Despite these questionings," I wrote to my friend Clare Forster in 1978, "I've never felt better in my whole life, which amazes me, since I'm 50."

* * *

Despite exhilaration, despite the optimism of many trustees, despite Tom's confidence, nagging doubts persisted. Steve Muller had arrived at the first meeting of the long range planning committee already convinced that the Whitney should expand. Jules Prown told me he did not agree, nor did everyone else on the committee. I must decide, Jules said — I must maintain the Museum's continuity from Gertrude to Juliana, to Lloyd, to Jack, to Tom. He urged me to spend lots of time thinking about the future of the Museum. Good advice, but how to follow it? When day-to-day problems and people were absorbing all my time, when we lacked funds and I had constantly to raise them? Some advisors even maintained that expansion was not only necessary for our programs, but was the best way to raise money for desperately needed endowment.

Leonard, so positive both at executive committee meetings and when trustees approved buying the brownstones at their meeting, invited me for breakfast at the Plaza. I was feverish with incipient flu. I could barely get up — finally forcing myself — then found myself having to listen to endless criticism of Tom and the Whitney. All with a smile but absolutely devastating nonetheless. My head was spinning, my fever mounting. The collection was terrible, curators inept, Tom alienated people all over the United States, the board didn't have enough contributing trustees or the right ethnic balance, the Museum had no status or quality — but great potential! — and we should either fire Tom or hire a senior curator immediately. He planned to hit Tom with all this, wanted to tell me first. He asked to be on the nominating committee — I agreed — and said he'd contribute twenty-five thousand dollars to year-end giving. I thanked him, and tried to respond, but as I later said to Tom, one shouldn't have a meal with Leonard unless one is feeling perfect. Tom said, one shouldn't pass Leonard on the street unless one feels perfect!

I had no clout like Blanchette Rockefeller (president of MoMA), or Doug Dillon (president of the Metropolitan), Leonard said. While this was perhaps true, my heritage at the Museum was a big asset, and with the help of Tom and the curators I was getting to know the artists and patrons, becoming recognized, too, by them and by the media. Leonard's assessment would have intimidated me a few years ago. Now, I took it in stride, recognizing its truth in terms of the traditional power and

money I lacked, and determined to compensate by even harder work and greater commitment.

But the problems we would confront over the next years were already right there in 1978. Hurt and doubting Leonard's criticism of Tom and the Museum, I was blind to their effect — on our plans to expand; on the board's support and enthusiasm; on many of our most powerful and wealthy patrons. I didn't like what I was hearing from Leonard, so I pushed it aside, listening instead to the positive messages coming from others.

My heedlessness was dangerous for the Museum, as well as for Tom. We were forging ahead with plans even our tiny group of leaders weren't really sold on.

When Dick Ravitch came to my office on January 8 with his outline of a plan, he urged haste, saying he would help to organize and carry through the preliminary stages of hiring an architect to do a zoning study, get the permits we needed, meet with Mayor Koch, and accomplish various other tasks; all this shouldn't take more than thirty days. (Hard to believe we thought that anything could happen that fast!) Tom and I were ready to go. But there was always a mix of signals, saying go, and don't go. The state of the budget was directly tied to the trustees' acceptance of expansion plans. Occasionally, these meshed perfectly. One icy cold morning, after jogging around the Central Park reservoir, I prepared for that afternoon's executive committee and trustees meetings.

A messenger brought year-end figures around 11:30. I was absolutely astounded.

Trustees: unrestricted gifts by Jan. 8, 1978, had been $90,675.25 (eight trustees);

Jan. 8, 1979: $192,917.45 (thirteen trustees);

Members: Jan. 8, 1978: $130,371.72 (fifty-three members);

Jan. 8, 1979: $289,597.45 (ninety-three members);

45 of the 93 gifts were new, first time (or first in a long time).

Membership figures, during a period of having *no* development officer, had improved dramatically — from a total of 618 to 1,132. Corporate membership had gone from 80 to 100, mostly thanks to Leonard Lauder.

At the meeting, the trustees seemed pleased about our annual giving and membership figures; Joel said it was due to me, and all clapped. I was touched. "NOW comes the work," I wrote in my journal. "Will I ever be able to do it — to hold all these threads and keep them straight, and accomplish everything we want to?"

That day, despite all my anxieties, was one of triumph. I knew, however, and it pained me, that Tom hadn't received the credit due him for the good news.

We pushed ahead with planning, with buying the brownstones next door. With raising money. Thanks to Governor Nelson Rockefeller, the Trust for Cultural Resources act had just been passed by the state legislature. This act benefited the Museum of Modern Art by diverting taxes to them from an apartment building being constructed in conjunction with their major expansion. When, at a contentious executive committee meeting, Joel mentioned a million tax dollars a year as a possible benefit to the Whitney if we, too, used this legislation, Howard said puckishly, "Well, when we have this winter wonderland . . ." I grabbed a pencil to note these words indicating a happy change in atmosphere. Glancing across the table at Tom, I saw a mirror image, and we shared a secret smile.

Other questions to be addressed: Should we acquire the missing building on Seventy-fourth Street for $1.25 million? (We eventually bought it for $3.5 million in 1994.) Or the lease of Trinin's stationery store, extending to 1994, for $250,000? (We didn't.) Arthur Raybin, fund-raising expert, said he'd never had such promising interviews except at the Metropolitan Opera, a legendary success story, and we were encouraged. By April, we were "at last putting our feet in the water," as Steve Muller said. I was suddenly frightened. Doing what we decided implied commitment to build *something*. What would happen to me? Could I delegate most of it to Leonard? Would I be even more swamped than I was already? What about my private life?

Philip Johnson invited me to lunch at his special table in the Four Seasons Grill. He knew everyone and, it seemed, everything. All the answers. To my surprise, he thought — or pretended he thought — the Met should take over MoMA, but the Whitney had a clearer mission and should remain independent, having a unique role to fulfill — showing contemporary art by living artists. But we *must* expand. And he would like to help us find a head curator, such as Walter Hopps. We must also find a major funding source.

Problems plagued us. In February 1979, the National Labor Relations Board informed the Whitney that a petition for election to certify the United Auto Workers as the bargaining agent for office clerical workers had been filed by the UAW. This, we felt, was wrong for such a small institution as ours, and would also constitute a wedge driven in by an aggressive, powerful union, hoping, ultimately, to unionize our curatorial staff. Our clerical workers included many bright young college graduates and graduate students eager to be promoted to assistant curators; we hoped our own administrative staff could settle any problems with them, hoped a big impersonal union would not come between this small group and the intimate world of curators, a librarian, a public relations head, a financial officer, an administrator, Tom himself.

But museum salaries in general were low, including the Whitney's. And some employees were dissatisfied, wanting extra "perks," such as invitations to lenders' dinners and more recognition for the long hours they put in, promotions, and raises, which Tom didn't always feel were justified.

Leonard offered to fly Al Vadnais, a labor consultant for Estée Lauder (large, not unionized, and for-profit, in contrast to the Whitney, which was small, already had several unions, and was not-for-profit) from Chattanooga, Tennessee, to advise us on proper procedures.

The problems could be counteracted by compensating the unusually intelligent, well-educated employees for not having their qualities fully used, Al told us. Employees must feel appreciated. They must sense a new attitude. But despite Al's efforts to lead us in a campaign against the union, the election on March 15, 1979, recognized Local 259 of the UAW by a vote of twelve to nine. So we had the UAW in our midst. Palmer Wald, the Museum's administrator, who would have to deal most directly with union members, was very upset.

What happened? What changed?

Employees gave most of any increases in salary to the union. I could sense subtle differences: a lessening of trust, of openness, of easiness. I hated that.

Meantime, Al Vadnais had interviewed staff members and reported to the executive committee, of which I was the chair, without Tom present. He undermined Tom in a damaging way in front of our major supporters, blaming him for the whole union situation, and accusing him of being sexist, racist, and arrogant.

The Whitney, Tom thought, must emerge from a small family museum into a great institution serving a bigger public. He wanted to formalize the relationships he thought too casual, to establish hierarchies, to tighten the structure of the Museum. If he had faults, I could excuse many of them. Tom was not a racist, nor a sexist. Building a team who would work together, he sought the highest quality in staffing and in programs, according to his standards of excellence. Whether hiring a new curator, making a major acquisition, mounting an innovative exhibition, cleaning a dirty floor, correcting a misleading wall label, replacing fading flowers in a gallery, demanding better food or more attractive table settings for a dinner, Tom was aiming for perfection. And it showed. In the Museum, in its programs.

I knew all that, but no doubt I didn't articulate it well enough to counter Al's criticisms, probably backed, if not initiated, by Leonard. The executive committee was dismayed. It authorized me to employ a management consultant, Joe Merriam, whose recommendations for small changes seemed sensible to me. Tom, however, resented what he saw as unwarranted interference with his management of the Museum.

Tom's desire to keep board and staff separate was in the best tradition of the Whitney. In keeping with my grandmother's policy, the Museum had always been extremely liberal regarding staff autonomy. But she had never had to deal with fund-raising, she'd never had to face the resulting demands of generous donors who wanted a voice in how their money was spent.

Caught in the middle, instinctively wanting equality and fairness for all, I began to sense what was happening. Confrontations between Tom and Al Vadnais or Tom and Joe Merriam cloaked the worsening rift between Tom and Leonard. This to me was much more dangerous to the Museum than unions. By any objective standards, Leonard represented the Museum's only real power. He had earned wide respect, not simply for his wealth but for his generosity. And his commitment to the Museum, which he'd made clear, was essential for our future. So what if he sometimes talked a lot at meetings? He often had good ideas. Moreover, he was close to many political figures whose help we would need in seeking permits and zoning changes for our building, and to the CEOs we'd need for fund-raising. Leonard alone, I believed, could make our big dream happen. His growing resentment of Tom, and Tom's barely veiled impatience with Leonard, alarmed me.

I had no influence at all with Leonard. Polite and charming as always, he would not yield an inch in his opinion of our leader. It coincided with that of Al Vadnais, and of disgruntled staff members, and of whomever he was listening to outside the Museum.

They were squaring off like boxers, I see that now. Neither would give the other a break, but rather than having it out then and there, they complained to me, or, more destructively, to secret buddies. Could I have helped, if I'd seen it more clearly? Probably not.

Joe recommended that Tom hire an assistant director who would take on much programmatic responsibility, leaving Tom free to focus on our expansion project. But Tom had already found his assistant director, although he didn't give her the title for years: Jennifer Russell, an extremely intelligent and capable young woman who had joined the Museum in 1974 as curatorial assistant. A native New Yorker, Jennifer is a graduate of Wellesley College and the Institute of Fine Arts of New York University, from which she has an M.A. degree. Her extraordinary administrative skill was combined with equanimity and a great talent for laughing — at herself, as well as at much else in life. Totally unpretentious, she entirely appreciated Tom's humor. Many years later, when Jennifer applied for an important position at the Metropolitan Museum, the director called Tom to ask about her. Tom could think of nothing remotely negative to say. "But no one can be that perfect, surely?" said the director. "Well," said Tom, finally hitting upon a memory, "you shouldn't expect her to wear high heels to parties!" Increasingly, in the '80s, Jennifer took over responsibility for the many details of program and planning, including the expansion project. Her energy, ability, humor, and high standards made everything work, and she remained a bright star during all her years at the Museum. Jennifer and Tom worked together beautifully.

Leonard himself proposed a process whereby we'd come up with three schemes. The first included adding minimum necessary space, with and without the "doctor's building" on Seventy-fourth Street, which would square off our property and which we hadn't been able to acquire. The second would be with and without needing zoning changes. And the third would mean building either an apartment tower or a building for our own use (but with commercial space on the ground floor and office space above) in a structure of scale and character to suit that part of Madison Avenue.

A problem surfaced almost immediately. Tom's space projections

were high, much higher than Leonard had projected. "There's no use in going through all this," Tom said, "and still not having enough space for what we want to accomplish."

Again, I felt caught in the middle. Again, the budget and operations committee had rejected the budget for the next year, because the projected deficit was too big. In the deep hours of the night, I wondered if we could maintain a Museum doubled in size, even with an additional $15 million of endowment.

However, the small campaign group — Joel, Leonard, Tom, Palmer, and I — forged ahead. We explored. We were encouraged. Our fiftieth anniversary year, 1980, was fast approaching. The long-term implication of all we were planning — birthday celebrations; major exhibitions; two new branch museums; the new National Committee; new planning committees; greater public relations efforts; increased fundraising; an ever more intense search for new trustees and committee members — was expansion. Since acquisition committees now raised big money, the collection was growing, in quality and quantity. Therefore, the need for more exhibition space was growing. The board itself was growing.

Steve Muller put the case well in a letter he wrote to me explaining why he couldn't come to a key executive committee meeting but inviting me to use his letter:

> It remains my wholehearted conviction that an inescapable obligation now confronts the trustees of the Whitney Museum to proceed with a capital campaign. The right moment is inexorably now. There is a 50th anniversary coming up. The board itself is stronger than it has ever been. The reputation of the Whitney has been growing by leaps and bounds, and its public exposure has been superb. (I congratulate you on the fine article and picture in today's *New York Times*.) Everyone connected with the Museum has over the past few years acquired a deeper understanding of its institutional mission and importance. Facility expansion is mandatory. The step forward to a campaign is inescapable.
>
> To back away from the responsibility which circumstances will literally thrust on the Board at this moment would be an unconscionable betrayal of the future of the Museum, perhaps forever. At least five years of preparation of various kinds have generated a momentum that few institutions ever acquire. To abort all that at the last moment would be a catastrophe which I cannot imagine,

and which I absolutely believe no objective observer nor the judgment of history could ever condone. Trustees bear the burden of leadership. Leadership must move forward, not backward. The opportunity before the Museum is quite literally a once in a lifetime situation. It has a need and a right to life.

By 1985, Bob Wilson had replaced Larry Tisch as head of the investment committee. Not until February 1985 did the board formally authorize a capital campaign of $52.5 million, on the basis of trustee pledges made in the previous three months and of good news on the financial front.

Now, in 1979, Tom reported that attendance for ten months was up 43 percent from the previous year, attendance income was up 85 percent, net sales were up 63 percent. Membership was way up, too. Joel announced that the deficit would be less than half of what had been budgeted. Tom and I had raised $325,000 from new sources for the fiftieth anniversary exhibition fund, and seventy-five gifts of outstanding works of art had been given or promised to the Museum in honor of its birthday, to be shown together that summer.

By the next year, we were optimistic enough to think about an architect. This, of course, was the fun part, although there was controversy about whether to look for an "artist-architect" or a "nuts and bolts" firm to do the preliminary study. The first serious discussion took place at Philip Johnson and David Whitney's apartment with Tom and me. Armchairs and a glass table designed by Le Corbusier sat on a gray rug, prints by Jasper Johns stood out against dark gray walls. I still remember five freesia plants in red, violet, and purple, and a cool white calla lily, all grown by David. As it grew dark, David dimmed the lights and, from our perch on the twenty-third floor, the city moved in. We must tell Dick Ravitch that we want an "artist-architect" to work with Davis Brody, and must start the process of choosing him soon, was the upshot of our talk. A small group would be best: Tom and I, advised by Philip and David, and others as we saw fit — Bob Wilson, Sondra Gilman, Leonard Lauder, Victor Ganz.

From the beginning, Philip influenced our project. He was purported to make or break the reputations of innovative young or even older architects. That was probably true. He was both beloved and hated by them, both admired and excoriated for his wit and accomplishments. To me, he was a helpful advisor.

Discussing the building program with the executive committee the next day, I was surprised to find that members were only interested in its cost, not even asking which architects we'd consider.

The first to contribute money toward buying the neighboring brownstones, Bob Wilson was now the first to offer a generous pledge for expansion: $1.5 million, if we matched it five times. In March 1981, Bob joined Tom, Philip Johnson, and me at the Four Seasons Grill in the Seagram Building. "Philip was charming," I wrote in my diary, "he went out of his way to bring Bob into his charmed circle (me too maybe!) with conversation, our cocktails 'Americanos' on table, wit, erudition. We made a list of about eight architects to interview, starting with Richard Meier because he's doing two museums right now, in Atlanta and Stuttgart."

Feeling it to be appropriate to the Whitney's persona and mission, we limited our search to the generation after Breuer's. This decision eliminated, for example, I. M. Pei and Edward Larrabee Barnes, who had experience, with distinction, in building or adding to museums, and were close to Marcel Breuer. Little did we foresee the distress we would cause by not even considering most modernist architects, who were threatened by the new wave of "youngsters," already in their late forties or fifties. For architects, though, that's young and immature. Philip, for instance, already in his seventies, was at the peak of his career.

Soon after, we began the search.

First, a meeting with the kernel of our building committee: Elizabeth Petrie, Brendan Gill, Alfred Taubman, Victor Ganz, Tom, and me. (Philip came to this first meeting as an advisor.) Elizabeth agreed to be its chairman, although she felt her brief time in New York would prevent her from being an effective fund-raiser, and she knew how important money would be. But others would take care of that, we told her. The Petries had chosen Robert Venturi, dean of the "postmodernist" school, to design their house on Georgica Pond, in Wainscot, Long Island, and Elizabeth had interviewed and researched the field before making the final choice. She'd had broad experience with institutions in Philadelphia. In addition, she was one of the few women to whom men really listened. They appreciated her intelligence, her grasp of a situation, her ideas, and, despite her strength and determination, her gentle, nonthreatening ways. We were grateful to Eliza-

Flora Whitney Miller and Flora Miller Biddle circa 1950, in front of Eugene Speicher's portrait of Gertrude Vanderbilt Whitney.

July 1, 1961. First nonfamily trustees with Flora Whitney Miller: *(from left)* David M. Solinger, B. H. Friedman, John I. H. Baur, associate director, Flora Whitney Miller, Roy R. Neuberger, Lloyd Goodrich, director, Arthur G. Altschul, and Michael H. Irving. *Brooks Elder.*

Marcel Breuer, *(at left)*, the architect of the third Whitney Museum building, with *(from left to right)* the author, Lloyd Goodrich, and Flora Whitney Miller, 1964. *Brooks Elder.*

Above: Cornerstone-laying ceremony, October 1964, with Mayor Robert F. Wagner (speaking), and Flora Miller and August Heckscher, Director of 20th Century Fund, seated at rear. *Whitney Museum of American Art.*

Right: Whitney trustee and author, B. H. Friedman, and Flora Miller Biddle, 1978. *Alex Gotfryd.*

Ribbon-cutting ceremony
on September 27, 1966,
with (*from left*) trustees
Jacqueline Kennedy and
William Marsteller, Nathan
Cummings, Flora
Whitney Miller, trustee
Robert W. Sarnoff,
Marylou Whitney (Mrs.
Cornelius Vanderbilt
Whitney), and Lloyd
Goodrich. *Women's Wear
Daily copyright © 1966 by
Fairchild Publications, Inc.,
a Capital Cities /ABC
Company.*

Philip Johnson and the
author at the opening
dinner for Frank Stella.

The author as new
president of the
Whitney Museum, in
her office at 110 East
66th Street, circa
1979. *Helaine Messer.*

First meeting of the Whitney Museum's National Committee, in the Breuer
trustees' room, 1966. *From left:* John I. H. Baur, associate director; Flora Whitney
Miller, president of the board; Jacqueline Kennedy, chair of the National
Committee; Lloyd Goodrich, director; and the author, vice president of the
board. *New York Times copyright © 1966.*

Mayor Edward Koch *(right)* January 3, 1980, proclaiming Whitney Museum of
American Art Week at City Hall. *Starting third from left,* Thomas N. Armstrong
III, director; Isamu Noguchi, sculptor; Richard Marshall, curator, and Flora
Biddle. *Helaine Messer.*

Flora Whitney Miller and Edward Hopper in front of Hopper's painting, *Early Sunday Morning,* 1961. *Brooks Elder.*

From left: Flora Biddle, Elizabeth Petrie, trustee and chair of the building committee for the Graves building, and Frank Stella, at his exhibition at the Whitney in 1982.

Ellsworth Kelly installing his exhibition at the Whitney Museum in 1982, with the author.

Top: Trustee Victor Ganz, in front of one of his Picasso paintings, circa 1980.

Middle: (from left) Andrew Sigler, CEO Champion Paper Company International, his wife Peggy, Alexander Calder, and Flora Biddle at the opening of the Calder exhibition at the Whitney Museum, 1976.

Below: (left to right) Tom Armstrong, Mayor Koch, and the author with Alexander Calder's *Circus,* 1982. *Helaine Messer.*

Above: Flora Biddle announcing campaign to "Save the Calder Circus," April 15, 1982. *Helaine Messer.*

Flora Miller Biddle and Targa the elephant, on Madison Avenue, doing their best to save the circus, in front of the Whitney Museum, with clowns from the Ringling Bros. Barnum & Bailey Circus, 1982. *Helaine Messer.*

Flora Biddle celebrating the success of "Save the Calder Circus" campaign with Ringling Bros. friends, May 7, 1982. *Helaine Messer.*

Tom Armstrong *(left)* and Jasper Johns in front of Johns' *Three Flags.*

The author and
Alfonso Ossorio at
the opening of his
exhibition at the
Oscarson Hood
Gallery, 1984.

Flora Biddle *(center)*
with Mei Mei
Bersenbrugge and
Richard Tuttle at
party celebrating the
Whitney Museum's
publication of their
book, *Hiddenness*,
1989. *Nancy
Crampton.*

Flora Biddle, Fiona
Donovan, and Jasper
Johns at the opening
of an exhibition of
Johns' drawings at
the Whitney, 1991.
Jeanne Trudeau.

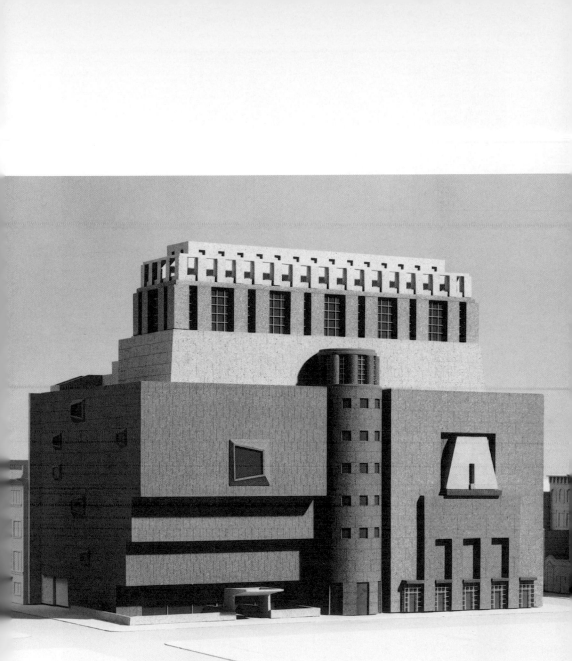

Model of Michael Graves' planned addition to the
Whitney Museum, 1989. *Jerry L. Thompson*

Leonard Lauder, president of the Whitney, Flora Biddle, and
Fiona Donovan, trustee and author's daughter, celebrating the
Breuer building's thirtieth anniversary, 1996. *Jeanne Trudeau.*

Sydney Francis Biddle and author, at a Whitney Museum party, circa 1994.

beth for undertaking this job. We had no idea how traumatic it would become, for her, for us all.

Victor's voice, his passion, were essential to our project. Since he didn't hold a position of great power in the business world, he had the same doubts as Elizabeth did about fund-raising, but we persuaded him he was not only vital to our choice of architect but to our whole definition and articulation of our mission.

I had hoped that someday Brendan Gill would write of this search. For a merry search it was, especially with his superior understanding of the history, poetry, excitement, and glory of architecture. How he loved buildings! How richly he responded to those we now saw, which represented the buoyant, humanistic spirit of the '80s! Captivated by Brendan's response, his understanding, his contextualizing, and his dazzling language, we gained a deeper understanding of what we saw and heard. How I treasured the wonder of listening, again and again, to some of the most brilliant minds of the day enunciating their concerns and ideas about art, architecture, and life itself.

Traveling, learning, looking at innovative buildings, made this part of 1981 a magical time.

Sondra Gilman, planning to contribute the auditorium, joined us sometimes; Leonard Lauder, occasionally; Alfred Taubman became a key member; others sat in from time to time. But we were a small group. An elite group. Did we shut out others on the board who would have liked to be more closely involved? Probably, especially if they were to make major gifts to the building. One of our many mistakes, no doubt. On the other hand, working with a small, hand-picked group ensured flexibility and also the likelihood of agreement.

In May we "did" New York architects: Charles Gwathmey in the morning and Hardy Holzman Pfeiffer Associates in the afternoon. On a June morning, Helmut Jahn visited us from Chicago with a dazzling presentation at the Museum, and we decided to visit his office in Chicago. That afternoon we met with Sam Brody and Lou Davis, most recently involved in planning some of the new Met spaces. The next day, off to Philadelphia to see Robert Venturi and his partner and wife, Denise Scott-Brown. They rolled out the red carpet, showing us their detailed plans for renovating and adding to the Philadelphia Museum of Art, and feeding us a delicious lunch. Their emphasis on community relations and city planning made good sense, especially when

they made a point of their knowledge and experience with this aspect of urban construction. We had no concept yet of its importance, but we were impressed.

Now I started to get flak from all those architects who were sure they knew exactly what the Museum needed. Ed Barnes, for instance, pushed hard for barnlike spaces. "You have your great building," he argued, "all you need is big flexible space for the huge paintings and sculpture artists are creating today. Knowing I'm not in the running, I could be helpful, since I know Lajko so well, and the building too." I respected Ed's advice — but other ideas were already attracting us.

When we visited Michael Graves's office in Princeton, New Jersey, we knew we were still more interested. Michael and his associate, Karen Wheeler, showed us models and drawings different from any we'd seen, combining classical ideas and a modern idiom that would produce clean-cut structures with age-old, proven elements: doors as ceremonial entries, windows you could open, city buildings of human scale, finished with marbles and precious metals, warm colors, varied textures, and even humor. Garlands, sculptures, carved ribbons, and greenery enriched his walls, roofs, doorways, and landscapes. When the budget allowed, Michael used sumptuous materials, but assured us he could make the most humble substance into a thing of beauty.

We were still looking when Marcel Breuer died. I was sad for his wife, Connie, and their children; I grieved for the friend with whom I had so recently played chess. Despite illness and lessening vigor, his intelligence had still flamed. His blue eyes still sparkling with humor, he had responded eagerly to questions about form, beauty, the earthy pleasures of life. His death gave us an even greater sense of responsibility for our choice of an architect to add to his building, his most famous in the United States and the only one in New York. We felt this obligation deeply, making all the more ironic the later objections of architects who seemed to think we wished to destroy Lajko's work.

All these months, we had interviewed, explored, and seen a half-dozen eminent architects. It was time to decide. On Tuesday, October 13, 1981, I headed for New Jersey with Elizabeth, Tom, Brendan, and Alfred. Michael Graves was ready with designs and ideas. He spoke to us eloquently: all architecture before modernism was figurative — had sought to elaborate the themes of man and landscape. The cumulative effect of the modern movement had been to dismember the cultural language of architecture — to undermine the poetic form in favor of

nonfigural, abstract geometries. Michael emphasized his wish that architecture would once again become figurative; that it would represent the mythic and ritual aspects of society. Michael's poetic words, the beauty of his drawings, the ideas he expressed, all made us certain of our choice. We sat in his office, discussing details — timing, costs, and such — when I realized we hadn't signaled our decision. "Wait! Stop talking!" I burst out. "We must remember this moment. Michael Graves, will you be our architect?" He beamed, while Alfred shattered my euphoria: "Oh Flora, we haven't established his fees — that comes first!"

I knew it didn't, though, so we enjoyed a few minutes of celebration.

The next day, at the trustees' meeting, we announced our choice to the board. Michael would come to the next meeting, I said, so everyone could meet him and hear his ideas. Afterward, the Lauders gave a dinner party for trustees and spouses. Enthusiasm abounded. I couldn't resist, while thanking our hosts, proclaiming the bold project and its newly anointed architect, toasting the new building, although Leonard scolded me later, saying it *must* be a secret, for the time being. That we needed to get our ducks in order: zoning permissions, Community Board, the Landmarks Commission, all that. If we talked about it too much, he reminded me, we'd be asking for trouble. The more people knew, the more they'd talk — "you know that." Of course, he was right. And I had warned the trustees, at the meeting, and again tonight. But it seemed a shame not to capitalize on the ebullience of the moment, impossible to recapture later.

By May 1982, Michael Graves had put together a lengthy document titled "Working Papers Toward a Building Program," developed from interviews with staff members by his associate Karen Wheeler. The report first recognized the large, flexible spaces in the Breuer building, ideal for temporary exhibitions. Therefore, "The basic concept for the exhibition space in the new building is first, to provide a continuous, chronological survey of twentieth century American art by displaying 'highlights' of the permanent collection. Then, radiating from this core would be individual galleries devoted to special 'concentrations' of the Whitney Museum."

These galleries would occupy forty thousand net square feet, not too big for retaining the sense of human scale and experience we so valued. Special rooms for the Hopper collection and for works on

paper, orientation space, a roof garden for sculpture, a film/video gallery, some storage, and many support areas were researched and described. The library collection, corresponding to the Museum's permanent collection, would form an exceptional resource for studies in American art and culture. Curators' offices would be located nearby. The lobby, shop, and mailroom would be rethought and redesigned.

An auditorium seating 300 to 350 persons would be used primarily for lectures, symposia, and panel discussions but could also accommodate musical events, dance concerts, and modest dramatic productions. (The audience now sat on the floors of galleries for all such events.) A special events room near the kitchen, for parties, would be good for public relations, and could help us raise significant amounts of money for the Museum. A larger boardroom for our larger board would be necessary; a small dining room for entertaining special guests would also be useful: "a domestic scale room could also be seen as a remembrance of the Whitney's history as a family institution."

Much in the draft would be revised. But it was a fine start, and it was exciting to hold in our hands such a detailed document. At the 1982 annual meeting, Elizabeth Petrie felt able to say, "The planning process is proceeding with great care and devotion."

In November, trustees met to discuss the building program that had been presented to them earlier. Elizabeth led the discussion, reviewing the six-year process leading to this day, beginning in 1976 with a memo from Mike Irving surveying the basic needs of the Museum, and delineating the program's two primary accomplishments: to provide space for the permanent collection and facilities for its study. She announced the consensus of the building committee that the Archives of American Art should be included in the proposed building. The program, she emphasized, should not be considered a "wish list" but a carefully honed and examined document.

Based on experiences of dealing with any number of building programs, this was probably one of the most thoughtful and well done that he had ever seen, Leonard said.

This opinion from our most influential trustee was a big factor in the board's unanimous approval of the architect's fee of $175,000 plus expenses for the initial schematic design of the new building. Tom pointed out that the contract included delivery of a representative group of the architect's drawings to show the basic stages of the design

process, to become the property of the Museum, a most unusual agreement.

We felt sure we could raise the money we needed, albeit with a tremendous amount of work, but it would all be worth it in the end. We had a great architect, a great program, and we'd have a great building. Tom's capacity for work seemed infinite. Focused on the Museum and its expansion, we were working more than ever as a real team.

Despite all the time I spent with trustees and staff, Sydney and I were adjusting happily to married life. We were getting to know each other's friends and family. His daughter Alexandra ("Bimmy" to her loved ones) and her husband John Basinski, a delightful couple, welcomed me warmly into their family when we visited them in Philadelphia. Bimmy is a horticulturist and teacher, who gives erudite and lively classes at nearby Longwood Gardens and elsewhere. John was a proficient woodworker when we first met, and now, in addition to being a developer of malls in Pennsylvania and beyond, he rows daily on the Schuylkill — he logged a thousand miles in 1998! They recently organized a marvelous party for Sydney's eightieth birthday at John's rowing club, of which he is president. As we sipped champagne, delicate shells sped by us, oars flashing in the sunset, a lovely scene right out of an Eakins painting.

All the "children" were very involved with their own families and their work — I felt blessed when they could take time out for a dinner or an outing. Every summer, until 1990, we spent time in the Adirondacks together, refreshing times of renewal and fun, of getting to know each other all over again. Grandchildren arrived, and these weeks became even more precious, as I watched the next generation swimming, canoeing, and fishing in the same places as had I, my parents, grandparents, and great-grandparents. We'd breakfast on Duncan's flapjacks, made from a recipe from Louis Duane. We'd talk about old times, and make our plans for the day — for fishing, sailing, hikes. One day, my granddaughter Emily glimpsed a bear and shrieked with terror and joy — and I remembered the evening my son-in-law Bill Evans had answered a knock on the door, thinking some poor fisherman was lost in the dark and looking for help. But no, there was a huge bear, up on his hind legs, pushing on the screen door, only inches from Bill's ashen face! At eight, Emily's brother Michael caught his first bass in Plumley Pond, and I showed him a picture of myself, also at eight,

with my first bass. My oldest grandchild, Anthony Evans, learned to water-ski when he was only nine. I'd sit on the deck watching him, drifting into reveries — was that my brother and sister, having their famous mile-long swimming race, or was it Miche and Dunc out there competing in Forked Lake? Was that my father trying out his new bamboo rod, rowing slowly in the varnished guideboat, or was it his namesake, my son Cully, practicing his casts before heading off to Bog Stream to lure elusive trout from their deep pools and feed us all our dinner? As I watched Fiona and her British beau preparing for a picnic outing, I remembered as if it were yesterday doing the same with my first love, the nephew of "Doc" Bergamini, the doctor who'd spent summers across the lake, at Squirrel Point, and who'd removed my appendix when I was eight. How shy I'd felt with his nephew David, lying in a canoe while the northern lights streamed across the sky above us, gorgeous, almost as dizzying as the first stirrings of passion.

Twenty-two

*T*he third theme Tom and I outlined as a goal, attracting supporters, was inseparable from the other two. Mostly, our searches were joyous. In my memory, we were always dancing!

My friend Anne Zinsser had introduced me to the Ganzes in Connecticut, and in 1980, during another dinner with the Zinssers, Victor Ganz took me aside. I'd totally changed, over the last year or two, he said. I obviously had the Museum job in hand, I was clear and confident. He couldn't get over the difference. After an evening discussing art and artists — including Victor's reasoned, eloquent defense of Richard Tuttle's genius — I lay awake wondering how to capitalize on this new-found strength. One way, I realized, was to persuade Victor to join the board of trustees, but that would take quite a while. Art was all-important to him, he was always interested in new ideas, but didn't make a connection between furthering the art he loved and serving on a board he saw as a fund-raising and social body. Tom and I, on the other hand, strongly felt that his conviction about the importance of art could inspire trustees to believe in our plans.

Tom persuaded him to join the drawings acquisitions committee led by Paul Cummings, with a membership of articulate connoisseurs. Discussions were long, informed, animated. Members backed up their strong opinions with intelligence and wit. No one left meetings early. Many members were from out of town, but they almost always showed up: Steven Paine, a wonderful collector from Boston who had MS and was in a wheelchair; Nancy O'Boyle, a close friend with a connoisseur's eye for art, flew in from Texas; Ed Bergman, a trustee with an astounding collection of Surrealist art, came from Chicago; Walter Fillin,

whose collection was more conservative than that of the others, but of equally high quality, drove in from Long Island; Jules Prown, the chairman, who ran the best meetings ever, took the train from New Haven. Hanging drawings of the highest quality alongside others of slightly lesser worth for members to chew over and ultimately to vote on, Paul would challenge the group to select the best. Only quality mattered — and indeed, in 1987 the National Gallery in Washington validated the committee's discrimination by showing, as their very first American drawings exhibition, selections from the Whitney's drawings collection.

Perhaps my favorite social evening of all those years was the small, perfect dinner at their home to which Sally and Victor Ganz invited me on November 18, 1980. Sally was an equal partner with Victor in their understanding and appreciation of art, and Sally had an additional warmth. Jasper Johns, Calvin Tomkins, Susan Cheever, Philip Johnson, and David Whitney were the guests that evening, and conversation was relaxed, as it is among good friends. I was delighted to be seated next to Jasper. After dinner, Victor told the story of acquiring Picasso's "Algerian Women" series (1954–55), five of which hung on the red walls of the Ganzes' sitting room. He'd been in Paris on business when he had first seen them, and had immediately called Sally. "They're Picasso's finest works yet," he said — only for sale as a whole series of fifteen paintings — "of course, I couldn't buy them, it would mean pulling the children out of their schools, no college for them, God knows what else." Of course he wouldn't, said Sally.

But of course, he did! He eventually sold most of them, but he'd been unable to resist the extraordinary innovation he believed they represented in the history of painting — the leap to a fourth dimension, the possibility of seeing all around the object. Victor, I realized, was on an entirely different level than most collectors, in his intellectual and emotional response to painting.

As the evening ended, we descended sixteen floors to the basement, originally connected to a marina so tenants could leave their yachts and enter the building directly from the East River. (In the '40s, during World War II, that space was turned into an air-raid shelter.) The Ganzes had appropriated this huge space for the overflow of their collection — large works by Frank Stella, Eva Hesse, Robert Rauschenberg, and, of course, Jasper Johns.

One day, Victor invited me to his office to discuss the Whitney.

Walking through the door of the costume jewelry business his grandfather had founded, which Victor was now running, I was dazzled by cases of glittering faux diamonds, rubies, pearls set in extravagant bracelets, necklaces, rings, brooches. Above and around them, prints by Jasper Johns literally papered the walls, outshining the baubles, drawing the eye and the mind beyond the world they inhabited so calmly. An astonishing mélange, a wonderful extension of Victor's vision.

Finally, in 1981, my opportunity arrived after dinner with the artists in the Biennial. Punk was the current fad, and I remember Alexis Smith, a wonderful artist who later had a retrospective at the Whitney, wearing white bobby socks with one green shoe and one purple shoe. In a corner of the trustees' room with Victor Ganz, each of us with glass in hand, I decided it was the moment to propose. Knowing how strongly he supported it, I felt our expansion hung on Victor's answer: on his speaking for us, articulating the importance of the Whitney and its project, as an *insider*. Victor looked pensive for quite a while. I waited.

"All right, I will."

I leaped into the air, I hugged him.

Victor looked a bit glum. "I've lost my virginity," he said, with his inimitable puckish smile.

Tom and I put Victor on every possible trustee committee — in the areas of both art and business, because he was equally able in each. Hours before a budget and operations committee meeting he'd come to the Museum and go over all the figures and their background with the financial officer, and be more fully prepared at the meeting than anyone. Before an acquisitions committee meeting, he'd read, he'd go to galleries to see other work by the upcoming artists, he'd talk to their collectors — and he'd have a proper perspective to make a judgment.

Oh, how I miss Victor, still.

Money, money, money — an unending need, constantly impelling us to think of new people and new ways to get it. Increasing our expectations of the board, we soon counted on most members — especially new ones — to support the Museum's Annual Giving campaign with at least fifty thousand dollars a year, and to give money for their committees only after fulfilling that obligation. I learned not to be shy about asking. Trustees helped me in this.

In the still recent old days, my grandmother and mother had literally "given 'til it hurt." In their wake, the first nonfamily trustees, without being asked, had also been as generous as they felt they could be. Now, more money was available than ever before from new, richer trustees who expected some form of recognition — publicly expressed gratitude; social or business contacts; a say in programming; a more "successful" Museum in terms of attendance or public relations; one or more of these, to bring them credit — as a "successful" child does for ambitious parents.

I finally gained the courage to ask a reluctant trustee to increase his gift, and he did. After that, with Charlie Simon's coaching and even a practice session with him, I visited Larry Tisch and asked him for a substantial contribution. Despite his dismay at the current deficit, he promised to help, surprising me by saying he thought I was "terrific" and doing a good job. He sent $5,000, twice the amount of his last gift four years earlier. Not much for him, but the big jump boded well. In a welcome turnaround, David Solinger sent Tom a check for $5,000, with a note also saying he was doing a great job.

For programs, we tried to find donors other than trustees. Collectors of contemporary art were multiplying rapidly, and we had a bigger pool to fish in every year.

Early on, in 1978, we met with Jane and Bob Meyerhoff, of Baltimore, top-notch horse breeders and racers with an outstanding collection of work by Jasper Johns, Frank Stella, Robert Rauschenberg, Ellsworth Kelly, and others. Direct, delightful, they were more at home with art and artists than anyone I'd met except the Ganzes. Learning of their disagreement with their local museum, I immediately proposed that they build *us* a wing instead. Bob laughed, and said I was learning fast — but that they planned to build their own museum.

Assembled over many years, the Meyerhoffs' collection unquestionably has a specific character, and its owners, loyal to this concept, rather than to an institution, were eager to keep the paintings and sculptures together and on view. We were alarmed by the increasing number of intelligent patrons who were moving away from giving major works to public museums. Bad for the public, we thought, since most private museums are not easily accessible to large numbers, and our focus was on making the Whitney more so. Worse still, in the '80s, as prices for contemporary art skyrocketed, some collectors couldn't

resist the lure of big money and sold their collections at auction, scattering them, nullifying the ideas that had made them distinctive, and betraying the trust of the artists and dealers who'd often sold them rare and special works. Most museums didn't have enough money to compete with private buyers. The Whitney certainly didn't.

The Meyerhoffs became personal friends of mine, and generous friends to the Whitney as well.

I remember a "fishing" trip to Florida in 1979, when Tom and I drove by an enormous house Richard Meier was building for Alfred Taubman, a real estate developer from Detroit, and we determined to find a way to meet its owner. The next year, on a visit to my mother in Hobe Sound, Tom met me in Palm Beach and we visited Alfred, who invited us along with Mum to lunch. His house intrigued her. She was especially impressed by the TV at the foot of his bed that appeared and disappeared at the touch of a button, also by the rows of clothes in his closet. He never packed anything, all he needed was in each place he lived. Two hundred shirts lined up on white hangers! Fifty pairs of shoes! It was a shiny white ocean-liner-of-the-thirties house, with catwalks, glass bricks, and classical sculpture and modern paintings by Rothko, Moore, de Kooning. Curved glass walls like huge portholes in a house of gleaming white porcelain, with crisp geometric lines and curves constantly changing as we walked, a brilliant green croquet crease, a boat like a shark tied to the dock, and the telephone a constant background. Food, drinks, towels, wrappers, appeared effortlessly; instant gratification. Can we deal with it? Tom and I wondered.

In my photograph album, Alfred stands with a croquet mallet in a teeny bathing suit and a big scarlet T-shirt, on his emerald lawn, right by Willem de Kooning's bronze *Clamdigger.*

Alfred himself was a rotund, ebullient man with small observant eyes and a quick mind. He seemed so friendly and warm, but everything surrounding him was so exquisite, so expensive — so inhuman? Even his guest, Anna Marks, looked perfect, a blonde woman with an impeccable figure. Our desire for some of his riches, so needed by the Museum, engulfed any warning signals, and we persevered in our quest for Alfred.

The following spring, I lunched with Alfred Taubman, Tom, and Joel at the Knick. "Hard sell," I noted in my journal, "urged on by Joel, re past, present and future of the WM — Joel helped a lot to get us

talking. At end of lunch Alfred said 'Well, the Whitney is my favorite Museum,' and will consider joining acquisitions committee — $25,000 no problem. Joel then told us just one of his real estate companies has made about 100 million over the last 2 years. I like him — but think he's tough, might give us grief."

The next time Alfred invited Tom and me for dinner in that Palm Beach house, we planned to ask him to become a trustee and to help us build our new building. We'd become friends. I remember, after the hour-long drive from my mother's rented house in Hobe Sound, changing into my linen pants in the car outside his driveway, so I'd arrive unmussed! Luckily I did. Because it was a very elegant dinner for fourteen, including Alfred's friend from Paris, Anna Marks, in a gorgeous veil of gold and flowers within which she floated; and — most significantly — Alfred's friend, partner, and chief advisor from Detroit, Max Fisher, and his wife. We knew right away we were on trial. Seated on Alfred's right, I admired the extravagant flower arrangements (he'd fixed them himself), the food (he'd planned it with the new chef), and the house (we had no idea of all the trouble he'd gone through)!

With Max on my other side, I was cautious. But he knew how to draw me out, and I found myself telling him all about Sydney, soon to be my husband, whom he already knew about — but how? — and the Museum, describing the reasons for our space needs, our big hopes of becoming the place where people from all over the world would come to see American art. He seemed interested, and told me a bit about Detroit, its problems and its potential. I imagined he had much to do with the likelihood of achieving that potential.

After dinner, a three-piece orchestra appeared, and we danced on the terrace, by the light of a full moon, around the sapphire pool. Alfred had great rhythm and was light on his feet; dancing with him was delightful. Staggered by the opulence of the whole evening, wondering what was to come, we finally departed in a moonlit haze, after inviting Alfred and Anna for lunch with Mum in Hobe Sound the next day.

They came, along with Douglas and Mary Dillon and Mum's old friend, Harlan Miller. Mum shone. The strange mix of people really worked. Surely, Douglas foresaw big bucks for the Met, whose chairman he was. Just like us, only better at it, I feared.

The next day, we went back to Alfred's and, in between phone calls from people we'd have liked for the Whitney, such as Charles Allen

and Henry Ford, we tried to have a serious talk. Alfred asked for a month to decide. (Was he hoping for a bid from a more prestigious institution?)

And the result?

Alfred joined the board. Joined the building committee. Was involved in our choice of architect, which he applauded, even hiring Michael Graves to design many of his own most cherished projects. Came to every building committee meeting, staying for hours, keeping an impatient secretary outside the boardroom trying to remind him how late he was for his other appointments. Trained as an architect himself, glorying in his expertise, loving this role, confident, glowing with pleasure, Alfred engaged our architects in lengthy confabs about details only he and they understood.

We assumed that his intense interest in the building ensured a major gift toward its becoming a reality. But he had a new ambition: to buy Sotheby–Parke Bernet, currently looking for a "white knight" to prevent an unwelcome takeover. Would this aristocratic, elite, very British institution accept America's rough diamond? The question was eagerly addressed by the press of two continents. We watched and waited, until one day Alfred asked Tom to write one of the two letters of recommendation Sotheby's had requested. Of course Tom agreed. The letter must have been effective, because soon after Alfred became the owner of Sotheby's, to his delight, as he never failed to tell us. And he spent more and more time on it, traveling from one end of the world to another, charming, persuading this one or that one to sell through him their precious gems, objets d'art, paintings, or castles. Shooting parties in Spain, country weekends in Sussex, or parties in the new apartment he'd moved to with his new wife, Judy, a beautiful young woman and the perfect hostess for all the entertaining now necessary. Alfred was at the peak of his career. Perhaps of his life?

In New York, I later approached him for a major gift to our campaign, sure he would respond generously, but he danced as lightly around my request as he had around that Florida pool. He didn't know. What was Leonard giving? It was a bad time. His real home was in Detroit. He was chairman of the museum's fund drive there, a huge responsibility.

A big challenge gift from Alfred would have done wonders for our project. I was terribly disappointed, but I should have known. It was always traumatic to pry from Alfred his promised annual trustee gift

and committee dues, involving numerous phone calls, usually from me, to his secretaries, assistants, and finally to Alfred himself. Strange how the very wealthy often seem obstinately reluctant to part with what is for them the smallest amount of money.

We'd been naive about Alfred's regard for the Whitney and his respect for us. Although he'd contributed generously to the purchase of *Three Flags* early in our relationship, and eventually made a verbal pledge of $1.5 million, Alfred left the board without giving to either of our campaigns.

There's an old French proverb: "He who can lick, can bite."

Among many who helped, Tom and I accepted a challenge from one we admired and liked a lot: Jean Riboud, chairman of Schlumberger. Although we'd only come to ask for his company's sponsorship of an exhibition, we hoped in time he'd become a trustee. No corporate stereotype, Jean Riboud was a sophisticated, educated, and charming Frenchman. Over vintage red wine and perfect omelettes, surrounded by American paintings and sculptures in his office, he told us of his search during his first years in New York for its intellectual and cultural hub. "When I discovered the Museum of Modern Art," he said, "I wanted to be there all the time, to see exhibitions, to meet people, hear the talk — to have a sense of what was happening. Twenty years ago, it was the vital core of your culture. The heart of all new and exciting ideas." Now, he felt, that was no longer true. Could we take up the banner? Become the center for contemporary creativity, in New York, in the United States, even in the world? Then, and only then, would he support the Whitney.

Exhilarated, confident we were already on the way, we assured Jean he would be surprised by how soon we would ask to see him again. He laughed. When Jean agreed to have Schlumberger sponsor the Louise Nevelson exhibition, held at the Whitney in 1980, we felt triumphant.

On a trip to visit potential patrons in Kansas City, Chicago, and St. Louis, Tom and I were vastly impressed by Ed and Lindy Bergman and their commitment to the art they believed in. Ed, already a national committee member and a trustee, was another collector who had been ignored by the local museum until the Whitney recognized him. A founder of Chicago's Institute of Contemporary Art, Ed was a successful businessman who had sold his company to American Can Co.,

headed by Bill Woodside, and then become chancellor of the University of Chicago. We reveled in the Bergmans' fine Surrealist collection, in their carefully chosen Gorky, de Kooning, and Picasso drawings, in the exquisite boxes by Joseph Cornell poking out from walls, bookshelves, and drawers — even the floors were strewn with them! When we suggested a gift from their collection to the Whitney, they seemed open to this idea. Impelled by us, they were beginning to think about its ultimate home. But the subject implied, as always, finality — of the collection, of life.

Unlike many wealthy figures, Ed was open and warm. He never failed to ask about my family, my life. He was a wise and loving man, always ready to give his most honest advice about the Museum. I remember walking along Madison Avenue after lunch with him, following a drawing committee meeting at which we'd turned down a Gorky drawing as unworthy of the collection. Ed said, "Oh, that was the right decision. I have a much better one, would you like it?" How rare, such a spontaneous gesture of enthusiasm and generosity! When the Bergmans gave their collection to the Chicago Art Institute, we didn't even resent their decision. It was the right one for people of such deep convictions and values, people as dedicated to their community as they were to their art.

Becoming aware of the boundaries of the art world, I wondered if museums couldn't cooperate rather than always compete for the same people and the same art. With this goal, in December 1978, I invited the presidents and directors of the four major museums in Manhattan for lunch in my apartment. Everyone actually showed up. Blanchette Rockefeller and Dick Oldenburg of MoMA; Douglas Dillon, Bill Macomber, and Phillippe de Montebello from the Met; Peter Lawson-Johnson and Tom Messer from the Guggenheim; Tom and me. After a slightly stiff start, over poached red snapper and a little wine, everyone loosened up.

We were a pretty powerful bunch, remarked Tom Messer, and could wield tremendous clout if ever we decided to make a joint approach to an organization we had no hope of succeeding with as individual institutions. Corporate sponsorship was usually based on personal relationships, we agreed, and I suggested foundations. "Did you have a specific one in mind?" asked Messer. "The ones that have been shockingly uninterested in the visual arts," said Blanchette, "are Ford and

Rockefeller." I was impressed by her candor. Tom Messer would, he said, consider a joint approach, perhaps to match challenge grants from the NEA, and would get back to us later.

I asked Douglas if the Met would be more active in the contemporary American field in their new 150,000-foot, five-level American wing. Only up to World War II, he said firmly — then added that they'd be doing more contemporary shows through their Department of Painting and Sculpture, so I wasn't sure. (After lunch, Dick Oldenburg told me "Douglas was lying through his teeth, don't listen to a word.") Still, everyone seemed to think the meeting was a good idea, and Blanchette offered MoMA as host next time.

The next day the Met announced they had hired Bill Lieberman, a top curator at MoMA, to become head of their new contemporary art program.

We never heard from Tom Messer about foundation approaches.

And there was never another such meeting.

We were all, no doubt, too hungry for every dollar, too jealous of our connections, relationships, and "turfs" to have a genuine collaboration that might jeopardize any of that. The experience added a layer to my increasing disillusionment with the politics of museums. Although not as naive as I'd once been, I could still be deeply disappointed when things didn't turn out as I thought they should, when those I'd trusted to perform feats of goodness and mercy turned out to be merely human.

One of our goals was to become more widely known across our country. Our first effort to have a national committee had fizzled after its first meeting in 1966, when Jacqueline Kennedy had been its first chair. Now, in 1979, Tom and I determined to revive it and to make it an integral part of the Museum. We wanted to invite collectors who were involved with the museums in their own communities, who would bond together and form a lively group committed to the Whitney. First, we had to get approval from the board.

Bob Friedman and Frances Lewis were concerned that the "by invitation only" process was elitist, versus the traditional Whitney policy that anyone who wanted could join in activities. When Frances mentioned, as an example, the Virginia Museum's exclusive Collectors' Club and its policy of "keeping people out," we realized she was talking about anti-Semitism, at one time directed against the very generous

Lewises themselves. Ed Bergman from Chicago and Barbara Millhouse from North Carolina, soon to become members of the national committee as well as trustees, told us they were against exclusivity for the wrong reasons, but felt a *little* elitism was necessary to attract people. And in no way were either of them elitist. The Whitney was special because it was open to a wide spectrum of people, and Leonard proposed the final decision: to make membership more open and flexible, we would have members themselves suggest other members.

Pleased with this "go-ahead," we met right away with protocol official Grace Belt, a friend of Tom's who represented the State Department in New York City, and asked her to help us. We wanted to have our first meeting as soon as possible, to set up a network of young, energetic, and involved people all across the country who loved the Whitney and American art. Charter members were invited by Tom or me, either in person or by telephone: K. K. and Douglas Auchincloss from Kingsville, Texas; Graham Gund of Boston; Carolyn and Roger Horchow from Dallas; Arlene and Robert Kogod of Washington, D.C.; Seymour Knox from Buffalo; Jane and Richard Lang of Seattle; Susan and Lewis Manilow of Chicago; Buddy Mayer of Chicago; Jane and Bob Meyerhoff of Baltimore; Susie and S. I. Morris of Houston; Emily and Joe Pulitzer of Saint Louis; and Ellen and Jim Walton of Pittsburgh.

Others joined a little later, and the first annual three-day meeting took place in May 1980, as part of our fiftieth anniversary celebration. Brendan Gill was instrumental in infusing the group with his buoyant spirit.

The format was typical of many to come: Marylou and Sonny Whitney started things off with a bang, giving an elegant lunch at Le Cirque. After lunch came the business meeting, when members established a tradition of deciding on which special programs would be sponsored with their dues. Curators made presentations, and there was keen competition, since those programs not voted for probably wouldn't happen. The first one approved by the national committee, "Art of the Thirties" from the permanent collection, was to travel around the country to smaller institutions that might not otherwise be able to afford such exhibitions. This program has since grown, reaching hundreds of small museums and university galleries and hundreds of thousands who enjoy these exhibitions. On Friday evening, a seated dinner-dance with artists, writers, and other art world guests. A

Saturday seminar, followed by visits to special collections or places, and a variety of dinners in homes or studios. On Sunday, a special trip.

Tom had noticed Doris Palca, our dynamic head of publications, working in an engineer's dark blue jumpsuit to keep her clothes from dirt and dust. "That's cute," he said to Doris, and immediately decided on a uniform for national committee Sundays. How many photos I have of picnics, excursions, boat rides, with us all in our Whitney jumpsuits, suitably accessorized!

That first Sunday, May 18, to give members a sense of the Museum's history, we took the group to my grandmother's studio for a picnic. Mum herself came and enjoyed talking with many members, including her old friend from Buffalo and Aiken, Seymour "Shorty" Knox, the great patron of the Albright-Knox Museum, and Joe Pulitzer, from Saint Louis, with whose uncle, Ralph, she had played in a regular poker game. All were fascinated by her memories of her mother's dozens of birds wandering in the garden, or when artist Robert Chanler had sent Gertrude a kangaroo from Australia and she'd emptied out the pool for it. She described Howard Cushing doing the murals in the stairwell: "He painted that lovely lady, right up there, imagining her dark hair, almond-shaped eyes, and beautiful figure. He'd never seen her, but when he married, his wife was exactly the image of that lady!"

As usual, Mum enchanted everyone.

A beautiful day, a happy day. We were looking forward to our second meeting, to be held every year out of town. That same year, in October 1980, we met at Jane and Bob Meyerhoff's farm near Baltimore. They were extraordinary hosts, arranging visits to museums and private collections, encouraging us to wander all over their farm, showing us their racehorses as well as their extraordinary art collection, and making us feel completely welcome. They put the seal of perfection on the whole idea. Ever since, host members have tried to live up to the standard they set.

Ed Hudson of Fort Worth ran the official business meeting in Baltimore, and enthusiasm was so high that members discussed increasing their yearly dues, then fifteen hundred dollars. After going back and forth about the right amount, Dick Lang said, Oh, for heavens' sakes, let's stop talking and just make it five thousand! And everyone agreed. Tom and I were flabbergasted, and would never, ourselves, have suggested such a drastic rise. But the group decided they wanted to have

a real impact, by sponsoring traveling exhibitions and sometimes even programs at the Whitney itself. We were delighted they'd identified with the Museum and its needs so quickly.

Among many examples of the national committee's munificent spirit, I recall a dinner in our apartment at the time of the national committee's second meeting in New York. I'd invited Marylou and Sonny Whitney (Marylou has always been vice chairman, and a high-spirited, generous one she is), Tom and Bunty Armstrong, Laura Lee and Bob Woods from Los Angeles, Dathel and Tommy Coleman from New Orleans, Anne and Brendan Gill, Jerry Zipkin, who knew everything about everyone, Charlotte Curtis, on the editorial board of the *Times*, and new members Bebe and Crosby Kemper of Kansas City. Marylou exclaimed in wonder when she first glimpsed Crosby's handsome six-foot seven-and-a-half-inch frame in our living room, "Why Crosby Kemper!! I haven't seen you since I was selling war bonds in Kansas City in the forties! You haven't changed a bit!" and flung her arms about his barely reachable neck. He turned pink with pleasure while his new wife Bebe looked astounded. Determined not to let the opportunity pass, Marylou plunged right on.

"Now you must meet my niece Flora, she's the head of the Museum you know, and she needs lots of money, you must give her something extraordinary."

Crosby said, a bit bewildered, "Of course, yes, what would you like? What does the Museum need?"

"Oh, how wonderful!" I said, madly stalling, with no idea of the extent of his fortune. Should I ask for a new typewriter for an office or a new building?

Crosby said, "Well, what shall it be?"

I took a deep breath. "We've been longing for a beautiful painting by Georgia O'Keeffe, one she'll only sell to a museum."

"Sounds lovely," Crosby said. "How much would it cost?"

Another deep breath. "$250,000," I said.

"Fine, it's yours. I'll bring you a check tomorrow."

And he did! He handed it to me on the bus we were taking to Soho. That's the kind of fund-raiser Marylou is.

We planned a big party for the fiftieth anniversary of the Museum's founding, which Gertrude had announced on January 6, 1930. It was to be on Gertrude's birthday, January 9, 1980, in honor of all the artists in

the Museum's collection. Mayor Edward I. Koch proclaimed that week as "Whitney Museum of American Art Fiftieth Anniversary week in New York City." On the cover of the brochure was Jasper Johns's beautiful poster of the two flags, and inside, along with greetings from Governor Hugh L. Carey, the Mayor's announcement, and a short introduction by my mother, was a list of the 944 artists represented in the permanent collection who were invited. And so many of them came! It was a joyous occasion. The evening party was nostalgic and fun, with big posters on the walls of my grandmother and her work, the Museum on Eighth Street, and Juliana Force. Paintings Gertrude had given the Museum when it opened in 1931 hung in the galleries. Fiona and I wore fringed brocade jackets my grandmother — her great-grandmother — had bought while on her honeymoon in Japan. They were a bit frayed, but evocative.

One of the artists present, Harry Sternberg, wrote this in a letter to Tom:

> I had the good fortune to attend the first annual exhibition of the Whitney Museum when it opened on Eighth Street. It was a spectacular opening.
>
> Juliana Force presided regally, the building was indeed beautiful, warm and friendly. Our paintings looked magnificent. And there was an unlimited flow of booze! By midnight the artists and the place had become a glorious shambles — sandwiches ground into the carpets, cigarette butts everywhere, even in the outstretched hands of some sculptures, and happily drunken artists passing out. Mrs. Force had two big strong men in livery standing by — and at a nod from her, these men began carrying drunks out of the Eighth Street entrance and stacking them on the sidewalk like cord wood.
>
> It was a magnificent, never-to-be-forgotten opening. I only regale you with this account on the off chance that you were not present.
>
> Bless Juliana Force, the Whitney Museum, and you.

The fiftieth birthday party was a joyful moment in the Whitney's life.

In December 1979, Jack Baur, Mother, and I had a Christmas lunch at Les Pleiades. We felt at home in its cozy ambiance with big mural

paintings of France on the walls, and a familiar menu: cold poached salmon or bass on the buffet table, perfect salade Niçoise, omelettes, and on Mondays fluffy cheese soufflé. Sotheby's was still a block away on Madison, and Mum's old friend, John Marion, renowned auctioneer, was at the next table with a client.

My mother and I loved and respected Jack, and were sorry to hear it when he began giving his negative views of Tom. "Trendy." "Starstruck." "Lacking artistic judgment." Despite Jack's criticisms, all made from a safe distance, we had a lovely time, Jack and Mum reminiscing about the good old days as people no longer deeply involved can do. As I do, today.

At Sotheby's, after lunch, John Marion sold a Persian manuscript Mum had inherited from her parents, who had inherited it from *their* parents, for the benefit of the Museum. Sitting on the edge of our chairs, willing more bids with all our energies, we were disappointed when it went for $44,000 instead of the $50,000 to $80,000 estimated price.

Still, it represented yet another generous gift to the Whitney from my mother.

A bit later, Mum made a major decision.

One fine spring day Everett Fahey, the erudite young director of the Frick Collection, invited me for lunch in his upstairs lair. Ceremoniously, he poured ancient sherry as we gazed out the French windows at his garden, where magnolias, daffodils, and blue pansies bloomed luxuriantly. Immediately enchanted by Everett's openness and enthusiasm — and his good looks! — I relaxed happily on a tapestry-covered chair at a Renaissance table. After a bit of museum gossip, Everett said casually, "Your mother has, I think, a very beautiful Turner. Does she, or do you, have any idea of its worth?"

Of course, we didn't. I guessed, vaguely, $250,000. He laughed and said that wasn't even close. When I told him Mum lugged it back and forth between Westbury and New York in the back of her station wagon he was scandalized. "You should really have it appraised," he said. "I imagine it's worth several million."

Discussions ensued, in the family, and with a few others. Passed down to her from her mother, who had inherited it from her husband, who had been left it by his uncle, Oliver Payne, Mum felt attached to it, but she finally decided to sell the painting — urged, I now know, by her lawyer, who realized how little cash she would have in her estate.

She would give a substantial sum to the Museum, however, making, as Tom said, "the first, and most significant, gift . . . which launched this campaign for the future."

I still remember when John Pope-Hennessey, aristocratic head of the Met's European Paintings department, came to see *Juliet and Her Nurse*. The apartment at 10 Gracie Square was elegantly shabby; I couldn't even find the teacups. Our conversation was stilted because his British accent was so thick I could hardly understand a word he said. The Turner, as later described by Rita Rief in the *Times*, is "painted in his soft, dreamy style that anticipated Impressionism." It depicts a festive scene in Venice, with crowds watching fireworks near San Marco, and Juliet and her nurse watching from a balcony lit by the flaming sky. The painting hung on green boiseries, over a Bechstein grand piano also painted green and decorated inside with illustrations for La Fontaine's fables. It glowed in the gentle light from the East River. John was pacing slowly back and forth, looking intently, his concentration becoming absolute. We were silent for many minutes. I sensed how badly he wanted this painting for the Met.

I have a photograph of my mother sitting at Sotheby's, on May 29, 1980, at 11:00 A.M. Elegant as always, in black trousers and a yellow and black silk print jacket, she sits between my brother Whit and me. John Marion leans over her, smiling, while Mum seems to be saying "Ooooh," as she often did, with what Alida Morgan, a young cousin, calls "her fluted mouth." And in fact she *was* excited, rather than sad. As John Marion described it in the "Flora" book:

"One of the highlights of my career occurred on May 29, 1980 when I was privileged to share with Mrs. Miller one moment that combined two of her greatest passions — the Whitney Museum and her Turner. . . . She knew it would be widely sought after, as did I. Neither of us, however, could anticipate that it would make auction history. . . . When I leaned forward to wish her good luck she whispered in response to me, 'You'll do just fine.' Inspired by that gracious reassurance, I took my position. A hush fell over the room as I began the auction. Rather quickly the bidding passed the $2.5 million mark. The silence in the auction room was punctuated only by the sound from the two bidders — one over the telephone calling from London, the other present in the salesroom. In 6 minutes 4 seconds, I brought the

hammer down for a record $6.4 million . . . the highest price at that time ever paid at auction for any work of art. . . . I will not forget this moment of history. Nor will I forget the special style and grace of the woman who made it possible."

We were only disappointed that an individual, rather than a museum, had acquired *Juliet*. Someday, I hope, this wonderful work of art will settle where the public can see it.

The money from the sale that my mother gave the Museum paid for much of Michael Grave's design fees for the addition to the Whitney that was never built.

For trustees, their spouses, and Michael Graves, in 1981 we had the "Ganzes' and the 2 Floras" party. Bright red invitations bid guests to drinks at the Ganzes', then across the hall to my mother's apartment for dinner. On my black dress I pinned Gertrude's parrot pin, exquisitely crafted with bright jewels and enamel, and felt just great. Trustees gasped at the Ganzes' Picassos and Johnses, Rauschenbergs and Stellas. Then, next door, at seven round tables with pink tablecloths, green napkins, freesias and poppies, after duck and snowpeas, trustees made exuberant speeches with the pears and chocolate. A happy tone prevailed, and Mum was the queen of the evening. At eighty-four, still beautiful, elegant in her black sequins, she greeted everyone with sparkling warmth, making them feel welcome, part of her family.

How I miss Mum, still! How blessed I was to not only love my mother and be loved by her, but to work with her. While I had been grieved by her absences when I was a child, as she'd been by her own mother's, we'd become close later, just as she and Gertrude had. She encouraged me in all I tried to do at the Whitney. She supported me with unfailing interest. She seemed delighted with everything Tom and I told her about. She always cared.

I remember so well the last day she came to the city, when she visited Michael Graves and me just a few months before she died in the summer of 1986. She wanted to see his final design for the Museum's expansion. Although her failing eyesight made it difficult to see the drawings, she looked as hard as she could, and was enthusiastic about them and about our descriptions. She couldn't have guessed how

much that meant at a time when we were discouraged by the opposition the design had aroused.

Feeling it was vital for the institution, she wanted the family to keep its connection with the Whitney. How happy Fiona's involvement with the Museum would make her today!

Twenty-three

Only deep emotions and momentous events resist time's flattening effect, but these stay raw and vivid. Even today I can feel as distressed as I did in 1981 by the trouble between Larry Tisch and Tom. For a long time, I thought it could have been avoided, that somehow, there was a way I could have mediated, if I'd been more aware, stronger.

I no longer believe that.

Larry's son had made an offer for an apartment in the Armstrongs' co-op and was awaiting approval, sure he'd get it, because he knew Tom was on the building's board and Larry had asked Tom to help. The board, however, despite Tom's support, had just turned the son down. Board members had taken a strong dislike to him. Despite his son's wanting to back out, Larry was determined and angry, using his power and influence to reverse the decision. I knew this situation could polarize the board and ruin all we had been working toward.

When Joel called me to say what a great job I was doing — how he heard this all over New York — I was appreciative, but wondered if it was really to see if I knew about the whole affair.

A few days later I received an angry phone call from Larry Tisch asking for an appointment to visit me the next morning at home.

Tom and I still hoped that together we could defuse the crisis. Certain Tom was being painted as an anti-Semite by Larry, I rushed about keeping busy. As Tom and I were having lunch together at Les Pleiades to discuss the matter, Leo Castelli joined us for coffee to ask me to meet Frank Stella and persuade him to sell the Whitney a painting Frank wanted someone else to have, since I'd had no part

in whatever had happened to cool the Museum's relationship with Frank. (The Whitney got the painting, and Frank and his wife Harriet soon became our friends.) When Leo left our table, I remember saying to Tom, "That is someone who wouldn't speak to me if I weren't president of the Whitney." "If I were fired from the Whitney, I'd lose ninety percent of my 'friends,'" said Tom cheerfully, and we agreed it was a good idea to distinguish friend from "friend," little realizing how important it would soon become.

The next morning in a downpour, Larry arrived dripping, followed by Joel, an unexpected addition to our meeting. Calm at first, as soon as I disagreed with his version of what had happened, Larry became enraged, calling Tom a second-rate person, an anti-Semite.

Tom had supported Larry's son to the best of his ability, I insisted; he *hadn't* voted against him. On the contrary, he had spoken on his behalf, there was nothing he could do, and seeing it was hopeless, he had finally left the room before the vote.

None of this was true, Larry replied, and Tom was a liar, besides all his other bad qualities. Larry would resign from the board immediately, today, unless I fired Tom.

I used every argument I could to persuade him to consider the Museum. I reminded him of how I'd accepted his advice and taken the Whitney's money away from my family's advisors the very day I became president, demonstrating my loyalty to the institution, not the family. Didn't he see he'd split the board, the most damaging thing he could do, by resigning?

But his face was stone. He just didn't seem to care about the Museum. He'd tell everyone about Tom.

The Whitney, I insisted, had never been in the least bit prejudiced against any group. Right now a large percentage of the board was Jewish, many trustees identified and brought on by Tom. But Larry's grim expression never changed. Finally, in desperation, I told him that I had two children marrying Jews, that very spring.

"In that case, they're not real Jews!" he answered.

Larry wasn't angry at me, he insisted, only at Tom. The result, however, was the same for the Museum, and, therefore, for me.

Joel sat silent all this time as, more and more distressed by his tacit support of Larry, I finally asked him what he was doing there — wasn't he the Museum's vice president? "I thought I could help" was his only answer.

They left together, black umbrellas raised between my front door and the black limousine that awaited them.

I felt betrayed and angry, too. And I identified with Tom, with his distress.

Much later, in 1996, I learned that a member of the building's board told David Solinger that he had blackballed Larry's son. Tom had left the meeting, he said, so as not to be part of the decision. David believed this man, and changed his mind about Tom's being responsible. If only he'd known at the time, the course of events might have been quite different.

Just before the trustees meeting, Tom, Howard, and I were wondering what to do when Joel walked in. Larry wanted to know if we'd be announcing his resignation that afternoon, he told us. "But we don't have it in writing," Howard answered. So I called Larry right away, and asked him for his resignation in writing, a sneaky — but lawful — device to delay the announcement I didn't want to make at the meeting. Of course, that annoyed Larry all the more, as Joel told me the next day. His resignation wouldn't be announced officially until the next meeting, in two months.

Larry withdrew his companies' advertising from *Time*, because an editor there happened to be on the building's board. He took his vengefulness further by calling a number of patients of a board member who was a doctor and persuading them to leave his care. Against Tom, his campaign was far-reaching and endless. Slander, lies, debasement. Most of it, I wasn't even aware of. Knowing my support of Tom, few people would tell me. A year or more later, I consulted a reputable lawyer, who said we undoubtedly had a libel case against Larry — but Tom didn't want to pursue it, feeling it would damage the Whitney. The harm done was pervasive and subtle: a web of gossip portraying Tom as arrogant, anti-Semitic, evil — and also a fool, a clown. A campaign destructive of all we had built, of all we hoped to build, and, ultimately, of Tom himself, as director of the Whitney.

The Whitney had been the first of the museums in Manhattan founded and maintained by WASPs to open its board to minorities. The others — the Metropolitan and the Modern — had been closed, as had many other cultural institutions, to the diversity we had welcomed. Had I thought Tom was anti-Semitic, I'd have fired him myself.

Torn between sympathy for Larry's feelings and scorn for his

methods, between believing in Tom's actions and annoyance at its results, nightmares wracked my sleep.

Larry wasn't angry at me, he kept insisting, but I felt his anger through the part of me that was the Museum.

Finally, although Larry's fury was understandable given his mistaken impressions, his actions against Tom and the Whitney were outrageous. Justice, however, is often no match for the power of money. In the end, there seemed nothing to do but brazen it out. To continue. As time went on, things calmed down and I hoped they'd be forgotten. Howard Lipman advised me not to worry so much about Larry and Joel; "Don't make life complicated," he advised.

Twenty-four

*T*he budget. More and more, everything seemed related to the budget.

Even the duration of my presidency.

One of my most important tasks, I had decided in 1978, early in my term, was to determine a good successor. After the David Solinger incident, I insisted on limited terms for officers. Vice president Joel agreed with me that they'd give both the president and the board an "out," and would enable other trustees to realize that they too could or must accept major responsibility. The situation would become more dynamic.

I was surprised at how well I had been able to adapt to the change in my life — from wife, suburban mother of four, to hardworking president of a demanding institution. I liked much of it, especially the sense of accomplishment when things were going well. Nevertheless, I was beginning to need more of a private life. My new relationship with Sydney needed room to develop, to deepen. Sometimes, after a particularly long stretch of social events, my head was spinning, I hardly knew who I was. And of course, I had this gnawing doubt whether, without great wealth, I could ultimately lead the board to accomplish all we were trying to do. Leonard, I was convinced, could do a better job.

At an executive committee meeting in 1979, defining terms for officers was controversial. It was very sensitive of me to propose this, Leonard said, since I was the only one who could — as I had already pointed out. Trustees Dan Childs and David Solinger were opposed, saying that when someone is doing a good job, the institution should

be able to keep them in their jobs. Leonard was the spokesman for those in favor: anyone, he maintained, uses up their resources, contacts, and probably their energy, after a while; opportunity for change is important. The vote was close: Joel, Leonard, Sandra Payson, Charles Simon, and I in favor; David, Dan, and Tom opposed.

If Tom had proposed such a far-reaching policy without consulting me, in direct opposition to our agreement, I would have been furious. And Tom was very upset. To change presidents in the midst of a major campaign for a new building could throw all our plans into chaos, he said. It had been a mistake not to discuss it with him beforehand. I had learned my lesson — the hard way, as usual.

Howard was also opposed to limited terms. Bad for the institution, he felt. Others, including myself, had confidence in the vitality of the institution to provide the necessary leadership. I promised to reopen the discussion at the next executive committee meeting, so Howard could present his views, but the decision remained the same. At the trustees meeting of March 1, Ed Bergman and Bob Friedman expressed strong disapproval, but with Leonard again leading those in favor, a maximum of two three-year terms for presidents was voted in.

Late in 1982, the time was fast approaching to act on my resolve. My term would be over in six months. I knew who should be our new leader, but could he, would he, work with Tom? Victor and I cornered Leonard at one of our parties: "You can be an enormous success in business, you can make the best lipstick in the world, you can make many millions, and you have *done* that. But nothing, nothing, will give you the satisfaction, the feeling of accomplishment, that the Museum will. Nothing will be as important to you in your whole life as knowing you have made the Whitney into the greatest museum of American art in the world, at a time when American art is the greatest art in the world. Who else has the privilege of doing this? It's a unique chance."

"Please say yes, Leonard, please. Only you can do this," I pleaded. Leonard looked at us both. And agreed.

We did a little dance as the doors opened on a surprised elevator operator and Leonard disappeared, smiling.

Tom promised to do his all to make the new partnership work. But his questions still remained: Why had the Lauders collected superb European art rather than American? Why had Leonard preferred to help with special drives for Calder's *Circus* or Johns's *Three Flags*, rather than to give large sums for general operations?

He warned that Leonard wanted to interfere with artistic policy, push certain artists, insist on exhibitions that might draw big crowds.

But Tom knew, as did Victor and I, that we had undertaken a project too immense for the two of us. That many necessary elements were not yet in place, those that only Leonard could provide. Among us only he had achieved the power that success and money bring. Only he had the necessary connections — political, corporate, communal. Only Leonard had such a fine reputation in the city. And most important, perhaps, was the quality of leadership, where he excelled.

We were ecstatic.

A meeting with Leonard, however, soon changed my joy to deepest gloom. He had thought long and hard, he said, about his spontaneous decision. He realized how disappointed I would be, but he had changed his mind. It was impossible for him to do the big job he realized was necessary — after all, he was the key figure in Estée Lauder, two people he'd counted on were leaving, he couldn't find enough time. Moreover, he'd always thought the addition too big, he couldn't support its size or its cost, and Tom would never agree to reducing either.

And — the crux of the matter — he felt he couldn't work with Tom.

But he certainly wouldn't want his first act as president to be firing the director. Unless — could I . . . ?

"No, I couldn't do that," I said. "This whole project is Tom's. Without Tom, it would never have started and won't happen."

No words of mine could change his mind.

He must have talked to advisors, those whose support he would need as president. They must have warned him he'd lose that support, unless he got rid of Tom. Larry Tisch? Others?

This is what I thought at the time, and what I still think today. It was a portentous moment for the Museum, and a sad moment for me. The coalition we'd worked so hard to create, for which we had such high hopes, seemed about to fall apart.

At the next trustees meeting, Leonard reported for the nominating committee, which, he said, had considered the question of the length of term of office of the president. The term had always been unlimited, until, initiated by me, the by-laws were amended in 1979 to provide that "no person shall be eligible for election to the office of president for more than six consecutive one-year terms." Now, the nominating committee was considering a change, to make it

inapplicable to the incumbent. Would Mrs. Biddle, George Weissman asked, be willing to serve further? I felt it was my responsibility, I said, to identify stronger leadership for the future, which had not yet been done, and would be the primary reason for my continuing.

Leonard, Victor, Tom, and I alone knew the real reason: that it was impossible to find anyone with Leonard's qualifications. Victor had refused to consider it, sure he couldn't do the necessary fund-raising. Alfred was too busy with the campaign he was chairing for his museum in Detroit. Bob Wilson was chairman of the New York City Opera. Steve Muller and Ed Bergman were resigning from the board in June, when their terms were up.

Who was qualified, able, and willing?

We needed a political and financial powerhouse.

We needed time.

I was ready to step down, but since there was no one to take my place, I agreed to stay on.

At the April trustees meeting, I asked Joel to take the chair, and I left the room. The sentence limiting terms for presidents was deleted by unanimous vote.

When I criticize compromises the Museum makes today, I should remember those we made in the '80s. Our bedfellows included some whose principles I questioned to myself, but kept quiet about in public, persuading myself and others that the end justified the means. But does it ever? Were we justified, for instance, in our relationship with a corporation dedicated to smoking? Philip Morris was public-spirited, the leader among companies supporting the arts. With Philip Morris as exhibition sponsor and host to our branch museum, and its CEO, George Weissman, an influential Whitney trustee, did we help it to sell cigarettes by allowing it to identify with us so fully? At the time, I thought it unfair to condemn one source of funds more than another, since negative qualities existed in most corporations and in most people, too.

Now, I wonder. Along with millions of others, both my mother and my father had smoking-related problems that contributed to their deaths. Although the worst effects of smoking weren't known when my parents had started to smoke, these facts have been public knowledge at least since the early '60s.

In April 1983, our branch museum was ready in Rick Franzen's new Philip Morris building at Forty-second Street and Park: a 5,200-

square-foot sculpture court in the lobby, and an adjacent exhibition gallery of about 1,100 square feet, both operated by Museum staff. Mayor Koch came to the festive opening party; coverage was extensive and positive. Paul Goldberger wrote in the *Times*:

> ... the Whitney Museum branch ... seems likely to become one of Midtown's most appealing spots, ... at once a refuge and a center of energy, a place where the city seems to swirl around you, yet is held enticingly at bay. The architect, Ulrich Franzen, is one of New York's most respected practitioners, and he has created a space that is lively in itself yet respectful of the demands of different kinds of art.

The space was filled with invited guests, including many reporters — I especially remember one, very persistent, who kept asking me how I felt about smoking. She pursued me, and, to my horror, the photograph of George and me in the *Times* the next day was accompanied by the following article:

> Flora Miller Biddle ... who wore a black velvet suit and carved jade earrings, said she thought her grandmother would be "absolutely thrilled" with the branch museum. ...
>
> Philip Morris, long a supporter of the arts, is a corporation that produces cigarettes, beer and soft drinks. Asked whether she was troubled about cigarettes and beer being the source of some of the money for the museum, Mrs. Biddle said: That doesn't bother me at all. In art and in life, there are positive and negative aspects to almost everything. One has to accept the duality of life.
>
> Besides, she added with a smile, this doesn't mean I'm going to encourage people to smoke.

George Weissman was understandably upset, as he made clear on the phone and at the trustees meeting the following week. But, despite my loyalty to the Museum and, by extension, to Philip Morris, my true feelings had emerged.

Should I have articulated them? Should I have tried to establish moral standards in our money-raising?

It would have been moralistic rather than moral to even try to do that. Who could cast the first stone?

The Museum — all museums, all institutions — were caught up in the same dilemma. How could we survive without money? How could

we serve the public unless we accepted money from whomever was inclined to give it? How could we criticize the source of the generosity and be extremely grateful at the same time?

Our branches were free to the public, entirely funded by their host corporations, and extremely well attended by new audiences. We were proud of our initiative, and felt it was a splendid expansion of our mission: to show American art to the broadest possible audience.

We were planning a branch in the Equitable Life Assurance Corporation's new building on the West Side, to reach yet another, different audience, and to advise this corporation on many purchases of art for their lobby and offices. One three-thousand-foot gallery would show our permanent collection, another would have temporary exhibitions, and both were right off the lobby and right on the street. Joel Ehrenkranz negotiated stringent requirements: Equitable would pay all expenses, give 5 percent of the budget for any art purchased or commissioned through the Museum, and fund a major Museum exhibition every three years. We were grateful to Joel for ensuring that the Museum wouldn't be at risk in this venture, especially since we were again facing terrible budgetary problems.

At the trustees meeting in February 1983, Joel reported that the deficit approved for fiscal year 1982–83 was $266,000. Now, he said, it would be significantly higher, approximately $1.3 million, and he was still unsure that the situation was under control. There was no question of fraud or misappropriation of funds, but he was not receiving correct and timely information. One exhibition was not funded. Admissions income was down. Tom was told to make programmatic cuts.

Very disturbing news, especially with a campaign ahead. The confidence of the board was essential to their generosity. Troubled, I realized this was another reason for a new president: many board members surely thought I was incapable of understanding and enforcing budgetary discipline, of controlling Tom's spending. I tried, but essentially, they were right.

The good news six months later: Bob Wilson, as head of the investment committee, said that as of June 30, 1983, the value of the investment fund was $18,262,000, up from $11,543,000 a year before. His choices of investment advisors were working, and the stock market was a big bull.

Joel reported that the operating deficit (excluding depreciation)

would be approximately $600,000, much lower than projected in February. Not from making cuts, as he had recommended, though, but from higher income from admissions, memberships, sales. Making those hard cuts had seemed impossible, when Tom was trying to present the Museum in the best possible light, to show how deserving it was of expansion.

At the executive committee meeting later that year, Joel resigned from the budget and operations committee, saying, "It isn't fun any more." Distressed, unable to conceive why such a committee should be "fun," I imagined he was referring to the whole job of trusteeship in an inadequately funded and overspending museum. Tom thought trustees should raise more money to cover deficits, but, in fact, trustees were already being extremely generous, and would become more so, in this difficult year. Joel resigned from the drawing committee, also, and I wondered: was he *that* worried about the Museum's finances? *That* upset with Tom? With me?

Today, I can see why he was annoyed. As head of the budget and operations committee, he had demanded hard programmatic cuts to bring the budget closer to its approved deficit of $266,000. Instead of supporting his view, as I should have, I'd sided publicly with Tom against Joel, arguing in favor of keeping all the programs Tom had planned for that year. It was a costly mistake for the Museum and for Tom.

Sydney and I went to Italy, that summer, to a little stone pigsty-turned-into-cottage our friends Shirley and François Carraciolo had given us for a month. Fields of grapes, olives, and sunflowers lay before us in the valley below, with Bramante's octagonal church, the Consolazione, and the hilltown of Todi in the distance. We read Dante in Italian and English, we explored the lovely countryside, we bought eggs from a farm woman walking her large pig on a leash, who dove headfirst into a haystack to retrieve them. We followed the Piero della Francesca trail of churches and paintings all through Arezzo, Sansepolcro, and Urbino, and discovered our favorite pregnant Madonna in a cemetery at Monterchi. When Fiona visited for a few days, we drove through medieval villages and landscapes to exult in Giotto and Cimabue at Assisi.

And then, one day, Tom called.

"Do you think," he said, from across the ocean, "we should give it

all up? Alfred talked to me for a long time, he doesn't think it's possible. It was discouraging. What do you think?"

In the midst of my euphoric Italian summer, I refused to be discouraged. "But why now?" I said. "The redesign seems to be going well. And we haven't even asked trustees for written pledges yet. Has anything else happened? Why give up all we've planned, all we've worked for?"

"I just needed to hear you say that."

And we agreed to continue, for the moment.

I should have listened better to the underlying uncertainty in Tom's voice. I should have paid attention to Alfred, and especially to Leonard, who, while supporting the expansion plans at meetings, in private was telling me it was too big, too ambitious. I wouldn't necessarily have changed my mind, nor Tom's, but I would have been better prepared for what eventually happened.

We agonized over the budget at meeting after meeting, formal and informal. Both Elizabeth Petrie and Elizabeth McCormack, a trustee who was chief advisor to the Rockefellers on their charitable giving, and who had been head of Manhattanville College when I was a student there in the '70s, encouraged me to push hard for less spending. They met with Tom, Jennifer, and me to warn us of the perils we faced, if Tom didn't decrease the deficit. A new era was upon us. We *must* economize. The whole expansion project was in jeopardy — the whole Museum.

Still wrestling with deficits and morale, I announced at the January 1984 executive committee meeting that trustees had given more to the Annual Fund drive than ever before. This seemed to indicate continuing support, despite our problems. Like the boy putting his finger in the dike, I wanted to be optimistic and proactive, but we just couldn't seem to keep up with financial needs. For instance, we had long since run out of storage space in the Museum itself, and it was costing almost twice as much as expected to prepare our leased space on the West Side to store the collection.

In response to Elizabeth McCormack's concerns, our financial officer wrote her a long letter with figures showing that the branch museums were paying their way, but that large deficits were bound to continue unless income was raised substantially, or whole programs and exhibitions cut. Finally, the executive committee approved the

budget Martin Gruss, new chairman of the budget and operations committee, had presented, with a deficit of $700,000. Leonard suggested that the Museum schedule show at least one "blockbuster" exhibition each year, to which Tom answered that it was virtually impossible to predict which exhibitions would be enthusiastically received by the public. I doubt that Leonard believed him.

At a special board meeting to approve the budget, Joel emphasized that staff had raised income projections without significantly reducing expenses. With such a high deficit, trustees must be willing to immediately increase their financial support of the Museum if they approved this budget. Bob Wilson, head of the investment committee, added they would be in effect authorizing the further depletion of the investment fund and the continuation of major deficits. When I said that I, too, was distressed by the deficits but felt the vitality of the Museum was at stake, Bob responded that it was the duty of the management of an institution to maintain its vitality within the funds available. Leonard said — very helpfully — that a zero deficit was neither feasible nor beneficial to a cultural institution and suggested that a reasonable deficit level be established, within which the Museum must operate. But Bob asked that $700,000 in expenses be eliminated from the present budget, saying this would still result in a small deficit, as he didn't believe income projections would be realized.

Trustees then voted to send the budget back to the operations and budget committee, which, with the staff, would identify the areas to be affected by a $700,000 reduction in expenses and then present these cuts to the board.

At another special meeting, the deficit was now projected at a more manageable $250,000. Reductions in all areas of Museum operations had been necessary, and one exhibition would be cancelled unless funding was received by July 1. Tom said the $450,000 cut from the original budget required the Museum to close on most national holidays and to decrease public hours, and described other major changes in the Museum's operation. Bob Wilson suggested approving the budget but asked that tighter controls be implemented. And approved it was, marking a significant moment in the Museum's history.

A consequential decrease in services to the public, the threat of canceling non-funded exhibitions, and a general down-scaling at a time when we were planning a major expansion! At a time when the American Association of Museum's reaccreditation committee was

immensely enthusiastic about our management and programs! What discrepancies! I was fearful, not only about the financial survival of the Whitney, but about the increased volume of concerns expressed by some trustees about our leadership and about our lack of fiscal responsibility.

Our efforts to inform and inspire trustees about the building were cresting: all spring, Michael Graves had presented preliminary schematic plans and elevations to small groups of trustees and to other major supporters. For these, Tom and I led a three-day trip to Los Angeles in February to visit the San Juan Capistrano Regional Library, Michael's most recent building. Enthusiasm for Michael's library was high. And yet, and yet . . . there was this nagging problem, always unresolved, about our finances.

Marcel Breuer's widow, Connie, and a number of architects had banded together to protest our expansion, based on our choice of architect, although they hadn't seen the plans. I felt they couldn't speak for Breuer, had no idea what he would have thought, and shouldn't interfere with our project.

The Whitney was becoming a cause célèbre — all over the country, architectural schools were giving "an addition to the Whitney" as a design problem. Invited to a critique at Columbia, I remember the astonishing variety of elevations proposed by the students. And the media was starting to write about it before final designs had even been determined.

Then Tom's firing of Gail Levin, associate curator, Hopper collection, had far-reaching repercussions.

Gail was the Museum's only curator with a Ph.D. in art history, as she made quite clear, telling her colleagues that they could refer to her as Dr. Levin. "Is the doc here yet?" Tom would ask ironically. Because she was tall, thin, and wore a white fur hat, staff members referred to her instead as "the giant Q-tip"— but never in her hearing, as her sense of humor was minimal, her rages mighty and unpredictable.

Gail was becoming a Hopper expert. In November 1982, she had asked Tom if she could write an essay for a book about Edward Hopper to be distributed in the United States by Crown Publishers. Tom forbade her to do so, knowing she'd be using the Whitney's material, and knowing, too, that she was already behind schedule with the Hopper catalogue raisonné she was committed to doing for the Whitney.

Like other curators with access to confidential or unpublished materials, Gail was in a position of trust and was given considerable discretion in the handling of these materials. In this case, Museum administrator Palmer Wald notified her in writing that she could not participate in any outside activities of this sort until she had finished the catalogue raisonné. But Gail went ahead. Besides this essay, Tom reported to the executive committee, "again without my knowledge or authorization, Gail worked for other institutions, including the Museum of Modern Art, and at least one European museum, and had used Museum staff and time to prepare material competitive with Museum programs." When he found out, Tom was furious and fired her.

Leonard agreed that her dismissal was necessary. He warned, though, that the Museum, as a public institution, must be especially concerned about potential damage from the suit Gail was threatening to bring, alleging discrimination. Trustees, he said, must support and protect the director of the Museum, and negotiations should be directed toward avoiding a lawsuit without compromising the director's position. Tom felt that the important issue was not protecting him, but rather protecting the integrity of the Museum.

There lay one of the big differences between them. For Leonard, as for many in public life, appearances are all-important. "Perception"— how many times have I heard that word applied to the making of a policy or a decision! Of course, this issue was extremely dangerous: for Leonard to be a trustee of a museum whose director was publicly accused of anti-Semitism would be impossible. Tom, on the other hand, had less interest in how things seemed and more in how they actually were.

As usual, I came down somewhere in between. In this case, we instructed our lawyer to begin negotiating with Gail's lawyer. I sent a memo to trustees informing them of the general situation, asking them not to communicate with Gail about the matter.

Gail's fury knew no bounds. Staff members thought she might have taken with her Museum documents relating to Hopper and other artists. She probably initiated an investigation by the Anti-Defamation League of B'nai B'rith based on her accusation that Tom was anti-Semitic and sexist. When I met her at an opening soon after, she flew at me, saying she'd drag the Whitney's name into the mud, and mine and my family's. Shades of Larry Tisch! I didn't take her seriously, thinking her quite mad, but I probably should have.

Around this time, Tom also fired our development officer, Jane Heffner, who also accused Tom of sexism and anti-Semitism, and made her feelings known to others who disliked Tom. Tom, in fact, wanted to give added priority to fund-raising, and felt Jane wasn't the right person for the job. By giving her successor, James Kraft, the title of Assistant Director, Development and Membership, Tom gave the position more importance.

While we continued to work toward the expansion project, entirely committed to it, I worried about the ever-present problems the Museum was facing. The budget. Tom and Leonard. Keeping the board of trustees informed and enthusiastic. Community reactions to our plans.

Twenty-five

*T*om, in a snapshot taken at Liberty State Park, in New Jersey, at the National Committee meeting in May 1984, is marching along with the brass band he'd picked up on the sidewalk near the Public Library and recruited for our picnic, jaunty in his Whitney jumpsuit, accessorized this time with a drapey collar made from a flag. His fuzzy red, white, and blue wig is blowing in the breeze. He looks every inch the leader — to some of us. Not to others, who resent his bizarre sense of the ridiculous. He was definitely on his best behavior, however, at the annual trustees meeting in June on a broiling hot day. It was to be a very important meeting, scheduled at two o'clock instead of the usual four thirty, to allow time for the trustees to consider the fund drive for addition and endowment. We'd planned it carefully.

First, Tom narrated a slide show on the history and development of the Museum, covering the origins and growth of the permanent collection and the exhibition program. He ended by showing several outstanding works acquired within the last ten years, saying that "it has now become the Museum's obligation to present these and the other great works that form the core of the permanent collection to the public."

Elizabeth Petrie then made her report, as chairman of the building committee. She prefaced it with quotes from the recent, and extremely enthusiastic, American Association of Museums accreditation report: "The Whitney remains one of our great museums and is a major national treasure. . . . This is a great museum in various ways. The collections are outstanding, and continue to grow in stature. The program is one of high quality. The staff is generally excellent. . . . And

the prospects for the future are not only favorable but potentially exciting."

She went on to say that the expansion program was the result of many years of study and work by countless professionals. Alfred Taubman, who had been professionally involved with many major building projects, had said he'd never worked with a committee where more thought, effort, and good judgment had been expended in the planning process. Michael Graves, still refining the details of the proposed addition, already had trimmed building costs by about 15 percent. The resultant estimate by Pavarini Construction Company, including renovation of the Breuer building, was $27 million. With endowment and "soft costs," the whole campaign would be for $52 million.

Leonard Lauder and Elizabeth had exchanged detailed letters just before this meeting, and reading them over now is a bitter reminder of the doubts Leonard had about the size and cost of the expansion project. Having already discussed this with me on several occasions, he started his long letter with these words: "Basically, I am 100% in favor of the expansion of the Museum, and of the choice of Michael Graves as architect. Michael's selection was a brave decision that will give us a building that we're all proud of. The Program: Unfortunately, I feel it is too ambitious. It raises the question of whether we can match our ambitions to our means." He continued with specific questions. Was the building too vertical? The superstructure too costly and controversial? Was the cost estimate accurate, or should we get another? Might getting occupancy of the buildings we owned be difficult, time-consuming, and expensive? Could we get the zoning permissions we needed from the city? Would the Museum have to be closed for longer than we thought? Would the cost of operating the enlarged Museum be too great, even with increased endowment? He made other points, but these were the principal ones.

With accurate information from Jennifer Russell, now assistant director, Elizabeth's letter answered each point cogently. At the meeting, she corrected misassumptions: Leonard had thought the program almost tripled the space of the Breuer building, when, in fact, it would be two and a quarter times its size, about one hundred thousand square feet. The building committee, after long deliberations, had concluded it was more desirable to build part of the addition over the Breuer building, resulting in a lower structure, than to build a higher tower that would be more obtrusive.

Sandy Lindenbaum, who advised on all real estate and zoning questions, had recommended a firm to handle repossession of the buildings next door, including Books & Company. After investigating, they gave us a reasonable date for emptying the buildings: January 1987, at a cost of $2.3 million, included in our schedule of capital expenses.

Operating costs for the first year the addition would be open had been carefully estimated. There would be additional income from the $15 million to be raised for endowment, and from rentals for the commercial spaces on the first floor, lower level, and second floor that were part of the design — an idea of Richard Ravitch's. Morgan Stanley's real estate division, Brooks Harvey & Co., had given us very conservative figures for these rentals, but even so, there would be no projected deficit.

Sandy Lindenbaum, who would coordinate the whole process of obtaining city permissions, felt that we had a good chance of ultimate approval from the Landmarks Preservation Commission, the City Planning Commission, and the local community board.

Long discussion of the building program ensued. Leonard still felt we should reduce the size of the building; the library, for example, was too big, and a library was not one of the chartered responsibilities of the Museum. But library facilities had always been an important part of the Museum, I answered, and my grandmother herself had first established the library in 1914, at that time in the Whitney Studio. Jules Prown added that one of the Museum's primary purposes was educational, and that a library was integral to this purpose. He also thought, concerning the height of the building, that Michael's design was a brilliant solution to the limitations of the site and the requirements of the Museum and its public.

And so it went, back and forth, until at last Elizabeth McCormack proposed the following resolutions, which were unanimously adopted:

"Resolved: that the board of trustees of the Whitney Museum of American Art enthusiastically supports in principle the plan for physical expansion of the Museum; and be it further

"Resolved: that the board authorizes and directs the development committee to solicit $20 million for the capital campaign from the board of trustees, to be pledged by the trustees before November 30, 1984."

Tom and I glanced at each other down the length of the granite table. We had surmounted the first hurdle. Although we knew the

"development committee" in this case meant the two of us, that we would have to solicit each trustee ourselves, we felt confident of raising at least as much as we needed for the next step.

But the meeting wasn't quite over. We had asked Victor Ganz to articulate why he thought the Whitney was ready to take this enormous step, why it should. Once again, he really came through.

When I was invited to join the newly created Drawing Committee almost ten years ago I was initially very doubtful, but I was finally persuaded by the enthusiasm of Flora and Tom, and by the prospect that this committee would be involved in the creation and development of a completely new department in the Whitney program.

My perception of the Whitney and that of my friends and acquaintances in the art world was not very bright — it seemed like a quiet, comfortable little village set in a valley between twin peaks, the Metropolitan and the Modern.

In the decades from 1940 to 1970 it had come close to missing the greatest moment in the history of American art. If it hadn't been for the courage and generosity of the Lipmans in the field of sculpture, for several daring purchases by the "Friends," [and some important gifts] the record from 1940 on would have been dismal indeed.

All of this has now changed. I fear that many of us are so close to the situation that we see the problems and not the progress — but the progress has in fact been astonishing:

In 8 years: We have tripled in size (except physically). We have filled some of the most important gaps in our collection. We have pioneered and developed a branch program which is respected nationwide. We have created and expanded the National Committee so that it now plays an essential role in our affairs. We have put together an American drawing collection which is one of the finest in the country. We have exhibited and acquired excellent examples of the important trends in American art of recent years. We have in fact become an ambitious and successful national institution.

Many of us realized that the situation in New York during the past 5 years was very favorable to our growth: both the Modern and the Met were deeply involved in their expansion programs and there were good reasons to be concerned about what the future would be. That future has become the present and the present looks fine!

The newly opened Modern has declared itself: it is, and wants to remain, the great museum of the art of the first half of the twentieth century.

The Metropolitan has never really cared about contemporary art and apparently still doesn't — it minces hesitantly to the water's edge, but it seldom goes in.

The Guggenheim basks on the beach.

It's really amazing! The opportunities for the Whitney are greater than ever. The perceptions of those in the art world have changed completely — they love the Whitney — they love its open-minded and open-handed approach — they love its daring and its generosity of spirit — they love its friendliness and its guts.

This is our great opportunity. Our village is out of the valley and now it's a city near the top of the mountain.

It certainly takes courage to move a city! — but we may never get the chance again.

Wow! Rereading that brings back all the euphoria of that moment, all our confidence and high hopes. It also brings the conviction that, had Victor only lived longer, we might have succeeded.

I saw Leonard quite a lot that summer. Lunch at his office. Breakfast at Park Lane. He was communicating, ever more forcefully, his mistrust of Tom's ability to manage the Museum, his wish to have a new director or at least a senior curator, and better financial controls. I, on the other hand, was asking him for a pledge for the campaign, a leadership gift. I wouldn't give in to his criticisms, he wouldn't give me a number; we were both stubborn. At the same time, Leonard was completely supportive in public, at meetings, or openings, or to the press.

In 1984, in Dallas with the National Committee, we celebrated Tom's tenth anniversary as director, along with a big birthday for Brendan. Jennifer had provided T-shirts for all, "Happy Birthday Brendan" on one side, "Happy 10th Tom" on the other. At a signal, we all whipped out masks and became Brendan look-alikes as we bellowed out our birthday wishes. Reporting on this at the November trustees meeting, Bob Wilson remarked that the celebration was especially fitting since Tom was, indeed, a "10."

One of the Museum's new initiatives was the Curators' Discussion Group, which Victor and Tom had recently dreamed up to enable patrons to explore in depth various facets of contemporary art. After a candlelit dinner in the Lower Gallery, we repaired upstairs to the trustees room for lively discussion. I remember one especially animated meeting with John Cage, Ivan Karp, and Nam June Paik. John, as I recall, maintained that nothing was intrinsically boring, and immediately was loudly challenged by several of the members. "What about

that noisy air conditioner?" said one, pointing up at the ceiling. John listened for a long moment, then answered that one could meditate to its soft sounds, as one could to any number of other city noises often heard as unpleasant interruptions. He articulated his Zen and Taoist-inspired beliefs in the nonlinear logic of chance and process with such patience and gentleness, such a beautiful expression, that I believe skeptics were impressed, maybe even convinced. I certainly was.

Five new trustees joined the board in 1984:

Joan Hardy Clark became chair of the education committee and of the Library Fellows. She was responsible for the first million-dollar pledge to the campaign, and later funded the memorial book about my mother, the "Flora" book. Joan remains one of my closest friends.

Gilbert C. Maurer became president of the Museum in the '90s, and funded Michael Graves's initial fee through the Hearst Foundation, a heartening gesture of support.

Stephen E. O'Neil, chairman of the development committee, is a lawyer with a great sense of humor and a fine mind.

C. Lawson Reed, national committee member from Cincinnati, was a member of the building and development committees. Lawson, a business leader who had led important cultural projects in his city, was a passionate, articulate believer in our building, and in Michael. He and his wife Dorothy gave a major gift towards the campaign.

Leslie Wexner, founder and chairman of the Limited clothing store group, member of the national committee from Columbus, served on the painting and sculpture committee. A close friend and protégé of Alfred Taubman's, he promised major support, but never came to meetings and never made a pledge.

We needed pledges from trustees. The development committee had recommended that the solicitation of trustees be postponed until a new president was chosen, but those we had sounded out for the job had said no, and we weren't sure where to turn next. In November, the development committee gave Tom and me approval to proceed.

The first trustee to make a commitment was Bob Wilson, with a long-standing pledge for $1 million, and the understanding that, if we obtained five $1.5 million pledges, he would match them. Before long I wrote: "Your confidence and generosity have often kept us optimistic about the long run, when the short run seemed downhill. . . . You are an extraordinary trustee — the combination of intelligence, wisdom,

and support you give is unique — I'd like to clone you, except I'd really rather you stayed unique! I think we have five $1.5 million pledges, and should know for sure by mid or late January."

Tom and I usually made dates for breakfast at the Carlyle, two blocks up Madison, with individual trustees. The headwaiter seemed to be on to our plan, and we decided the dining room staff was making bets on how we did, according to our expressions at the end of breakfast. Theirs would reflect ours: our waiter beamed when we smiled with satisfaction. Bob's challenge had really put us on our mettle. Breakfast after breakfast, we'd describe, enthuse, cajole, and flatter, as we'd watch trustees help themselves to scrambled eggs and bacon from silver chafing dishes on the buffet. Ice water, starched linen napkins, soft lighting. Our cozy corner banquette exuded all the comfort and reliability with which we could imbue a hotel dining room.

And no one said no!

Amounts varied, but mostly, we were immensely encouraged by trustees' enthusiasm and pledges.

After a lunch meeting with Michael Graves, Mary and Laurance Rockefeller, who had already contributed so much to the acquisition of the brownstones next door, firmed up their verbal pledge of $500,000. This gift, when completed, would bring their total to a munificent $1,200,000 — nearly enough to match to Bob Wilson's challenge. "We thought," Laurance wrote, "the presentation by the architect was splendid. His solution to the problem of providing additional and necessary space is both brilliant and uniquely responsive to the site and existing buildings."

After talking with Sondra Gilman about her foundation's possible gift in memory of her husband Charles, the Gilman Foundation board met in the Trustees Room with Michael Graves, Karen Wheeler, Tom, and Jennifer. They asked tough questions, and listened without saying much. But after their next meeting, Sondra told us that they had approved the biggest gift the Whitney had ever received; $3 million for the auditorium, "a jewel," as Sondra called it. We were overwhelmed. In honor of Sondra, Sydney and I gave our last dinner in Mum's apartment at 10 Gracie Square, where we were staying while Michael Graves was redoing ours.

One of the new trustees we invited to that party was Joanne Cassullo. A recent graduate of our Independent Study Program and a gifted woman, Joanne had access to a large foundation through which

she is extremely generous to the Whitney. Committed and loyal, besides endowing the Independent Study Program and contributing to many other programs, she continues to give a great deal of herself to the Museum.

Trustee Berthe Kolin had introduced us to Joanne — an important one of her many gifts to the Whitney. Her husband, Oscar, was Helena Rubenstein's nephew and president of her foundation. Chic in French couture suits, impeccably coiffed and made-up, Berthe hardly ever missed a meeting and always added her inimitable touch. After a particularly tense budget discussion she might say "But do you have a di Suvero sculpture? Mark is a very close friend, you know, I can ask him." And then one day she gave us her favorite treasure, David Smith's *Running Daughter*. A masterpiece. She always missed it, always visited it when she came to the Whitney. She and Oscar, she told us during lunch in their East Hampton house, had fled their Paris home during World War II, riding across the Pyrenees on bicycles with one suitcase each — a harrowing journey. After somehow arriving in South America, they managed to get on a boat to New York, and sailed proudly into the harbor, Berthe in the brand new Chanel suit she'd preserved in that single bag for just this moment. She was irrepressible, obstinate, and delightful.

In February 1985, I was able to report to the board that Tom and I, after speaking to most trustees, were confident that the future of the Museum was assured. After thanking Bob for being the first to express his confidence in the project, and for his challenge gift, now matched, I announced Sondra's pledge, the largest single gift in the Museum's history, and asked if she would say a few words. The opportunity, she said, to support the expansion program was a great privilege for two reasons: "first, organizations are not static, either they progress or regress, and by providing funding for expansion, trustees enable the Museum to continue to grow; second, support of the expansion program allows trustees to play a key role in one of the greatest architectural projects of the decade, which I believe the addition designed by Michael Graves will be."

The board then unanimously adopted a motion authorizing Tom and me to launch a capital campaign for $52.5 million, and to proceed with plans for building an addition. Alfred emphasized the trustees' serious responsibility to see that the capital campaign goal was

achieved — by passing the resolution, he said, they had committed themselves personally to the realization of the expansion project.

May 1985 was a big month for the Museum, the month we were to announce the building to the world. Michael Graves, Jennifer, Sandy Lindenbaum, members of the building committee, and the staff met informally with members of the local community board, the Landmarks staff, and other agencies representing the community. All this was timed to precede the filing of formal applications, called certificates of appropriateness, with Landmarks in late May for the permissions required: one to demolish the structures currently occupying the Museum-owned properties, and one to build the Museum addition. Sandy recommended that we ourselves announce it to the press.

We got a hint of future trouble at a Community Board 8 hearing. Some enthusiasm, but mostly aggressive questions, negative comments. We dismissed these as coming from cranks, and forged ahead.

The next week, a crowd of journalists arrived at the Whitney to view a model, drawings, and elevations. A. M. Rosenthal, editor of the *Times*, had invited me to call him when we were ready, and I did, hoping for a front-page story. I was sure we'd receive hurrahs and thanks from our city, our community, and the art world.

I thanked people: first, the men and women who are the basis of our being, the artists whose works were all around us. Then the building committee, especially Elizabeth Petrie, its chairperson. The board of trustees. Tom explained the reasons for needing to expand, emphasizing the Museum's services to the public.

Michael spoke eloquently about his design, especially about the need to bind together our proposed addition with the building completed by Breuer in 1966, saying, "We have attempted to use to our advantage the apparent contradiction of modernity versus a more figurative architecture . . . a particularly American spirit, one which combines architecture derived from traditional sources with the modern architecture of the recent past."

We got our first-page story.

Paul Goldberger, who wrote about architecture for the *Times*, praised Michael's design in an article the next day, calling it "both daring and sensitive" and describing it as "a richly colored, ornamented assemblage of pure geometries and variations on classical elements such as colonnades and pergolas, and it feels right for the eclectic mix that Madison Avenue is." But he saw the Breuer building as "a nagging

presence, a problem that defies complete solution." To him, Michael's bold composition was "the tougher, and more courageous architectural route, and he has produced a design that is both powerful and subtle. It is just that making the old Whitney part of a larger composition, no matter how well-wrought that composition is, undercuts what integrity that harsh and difficult Breuer building has."

And then, and then, came the groaning and shrieking and gnashing of teeth.

Moving back into our home at 110 East Sixty-sixth Street was taking almost all our time. The whole place was a wonderful affirmation of our belief in Michael's talent. He had made our small space seem bigger by creating an axial design, allowing light to flow from one end to the other. As Carol Vogel said in the Sunday *Times* magazine, "The architect grappled with the issue of light right from the entrance. He created a formal skylight rotunda as a unifying element, linking all the main rooms." With warm colors, special lighting, and the excellent kitchen/dining room right in the middle, we felt at home immediately and reveled in our lovely new surroundings. And Michael had done it with plasterboard and 2 x 4s instead of marble, gold, and real plaster. My pictures show Eric Regh, the architect in Michael's firm who had carried the project through, standing on the kitchen island, placing a shade carefully on a vintage lamp, while we unpack books in the coved library space, and my son Duncan installs the beautifully crafted stereo and television cabinets he made in the living room. Oh, that living room, with its vaulted, gridded ceiling; the twin sofas Libby bought and dressed in moss-green velvet; Sydney's round Biedermeier table and delicate chairs, near my father's two embracing Biedermeier armchairs; and, presiding over our reading and conversations, two tall, naked marble ladies, one toying sensuously with a bunch of juicy grapes, the other playing her pipes, commissioned by my grandmother for niches on the stairs of the Whitney Museum on Eighth Street, by her friend and lover John Gregory.

We had such happy times in that apartment. Sunday mornings, Sydney and I would read aloud to each other, bright sun streaming into our bedroom from the latticed terrace where pots of geraniums and Atlas cedars flourished. Mann's *Buddenbrooks*, Byron's *Don Juan*, bits of the memoirs of his uncle, artist George Biddle. Besides giving parties for the Museum, we celebrated family birthdays and holidays — we'd

gather at the round table Michael Graves had designed for us, pale fruitwood with ebony inlays, sitting on delicate chairs, once wrecks, that Libby had identified with her discerning eye as Biedermeier, and restored to their former beauty. Flipping through my photograph albums, there's Flora, Cully and Libby's oldest daughter, running into that dining room, her little hands full of her very first snow, gathered from the terrace. Blue eyes wide, she's giggling with surprise and delight, pressing it on her baby sister Charlotte's pink cheeks. And there are Sydney and I, dancing at our wedding party in the garage under the apartment, as my cousin, composer Francis Thorne, plays and sings "The Lady Is a Tramp." Or Michael and Emily, Duncan and Linda's two, are shooting baskets in that garage with my niece and nephew Aurora and Alfred Tower, who lived with my brother Whit and his wife Lucy in the carriage house next to ours.

Just writing about 110 makes me miss it. And makes me realize once again the privilege of participating in the making of a unique work of art with a brilliant architect.

Twenty-six

*I*t was 1984 and we still hadn't identified a new president. Leonard, Elizabeth McCormack, and others urged me to consider hiring a paid president. The Met had one. This president, Elizabeth said, would have primary responsibility for financial matters, would help with fund-raising, public relations, labor affairs, other such matters. Tom, among others, felt the Whitney was too small to split the leadership in this way. Elizabeth asked him to write a description of his role as director, and I quote part of his essay:

The primary responsibilities of the director of the Whitney Museum of American Art are to assist the trustees to establish immediate and long-range goals for the institution; to lead the staff in professional management of the institution in accordance with established policies; to articulate the defined goals; and, with the trustees and staff, to initiate programs to accomplish these objectives; and to translate the particular character and international importance of the Whitney Museum to the public, members, and patrons. . . .

Historically, it has been the director of the Museum who takes responsibility for determining the character of all programs and activities, and he is publicly accountable for those decisions. The director ultimately must create the public perception of the Museum. . . . He serves as the spokesman for programs, while the president plays the major role in articulating policy. If the Museum is to continue to attract new patronage, the director must remain the chief fund-raiser as well as the person associated in the minds of the public with programs and living artists.

The threat of a paid president impelled Tom and me to hurry. We examined our board and came up with a new name, one that might

appeal to the financially anxious: William S. Woodside, chairman of the American Can Company. A trustee since 1979, he currently served as cochairman of the corporate committee, and as a member of the development committee. His personal interest in the work of contemporary artists was reflected in American Can's collection of "emerging" artists and in its support, through its foundation, of several important and daring exhibitions at the Whitney: "New Image Painting" in 1978, the 1981 Biennial, and "Jonathan Borofsky" in 1984. Bill, a director of several other economic and educational institutions, had recently spoken strongly in favor of our expansion program and against the idea of a divided professional leadership.

After discussing this idea with a few others, I asked Bill if he'd be interested. Elizabeth McCormack, for instance, served on the board of American Can, and was all for it. Ed Bergman, who had sold his company to American Can and now sat on its board, was enthusiastic, too, saying he'd urge Bill to take the job. So, on Tuesday, May 7, Steve O'Neil and I had breakfast at the Carlyle with Bill. Surprised, perhaps because he hadn't played a major role at the Museum, he said this appointment would be a great honor, mentioning his love for the Whitney and his affection for me. Since he already planned to retire from business in eighteen months, this time seemed ideal for him to strike out into a new adventure. And for those remaining eighteen months he would still have all the advantages of being a major CEO — staff, fund-raising ability, entertainment budget, available funds from the American Can Company Foundation. He would think over our proposal, talk to his wife Migs, and get back to us soon.

A call from overseas came within a few days. Bill accepted, on condition that I stay involved, as chairman. Even Migs came on the line to say how touched and pleased they both were.

I was deeply gratified, thinking we'd now have a fine team for our project, one to inspire confidence in our supporters.

Before he was officially elected, I took Bill to have lunch with my mother. Growing weaker now, with eye problems, she remained as gallant and attractive as ever. Thinking he'd want to know more of the history of the Whitney, I told him all I could on the drive out to Long Island. Then I talked of the role of president. How vitally important it was to meet weekly with Tom. To keep in touch with trustees and other big donors. To prepare for meetings, especially the annual meeting.

He understood, he assured me. He would spend at least one and a

half days a week working for the Museum, and more after retirement. He would bring in a team from American Can to advise on improving financial controls. He was eager to move ahead with the building.

Charmed by Mum, pleased by our visit to the Studio, he said he'd enjoyed meeting my sister Pam, living there now, who had both preserved and transformed the house and garden.

Pam, however, was mystified by Bill. "What's he all about? Why *him?* He doesn't seem very interesting or lively. Does he know anything about art? About the Museum?"

My mother, unimpressed with Bill, wished I'd stay on as president.

"What can I do to help you, Bill?" I asked as we spun along Grand Central Parkway. "How can I use my experience best, now, for the Museum?"

"Oh . . . if you could just keep on writing your great letters, and giving parties, that would be the best," said Bill.

Oh, no! He was asking me to continue to do the very things I had counted on *him* to do: the president's job. I had planned to work with Tom, the curators, collectors, and artists on expanding the permanent collection, on special gifts of masterpieces, work for which I felt I now had the knowledge and experience. To continue my involvement with the national committee, perhaps with the collecting committees, yes. Not, however, with every committee or every aspect of fund-raising. I envisioned a new relationship with the Museum: instead of the day-to-day responsibility of keeping in touch with all our varied constituencies, I'd perform special art-related tasks. Could that have been an unrealistic dream?

At the annual board meeting, Howard Lipman, living now mostly in Arizona, stepped down as chairman. Although he would remain a trustee, he became increasingly inactive, and increasingly critical of the Whitney.

On one of those sweltering summer days when tarry steam fills the air, the board voted their thanks to Howard for serving as president from 1974 to 1977, and as chairman from 1977 to 1985.

Elizabeth McCormack, on behalf of the nominating committee, then proposed the new slate of officers: Flora Miller Biddle, Chairman; Leonard A. Lauder, Vice Chairman; William S. Woodside, President; Joel S. Ehrenkranz, Victor W. Ganz, Stephen E. O'Neil, Vice Presidents; Charles Simon, Treasurer; and Jennifer Russell, Secretary. The room darkened. A violent thunderstorm broke the heat wave, as Bill

spoke of his long association with the Whitney, dating back to 1950, when he had attended exhibitions on Eighth Street, and of his support of the Museum's mission. His primary short-term goal, he said, was to "maintain a tight budget for this fiscal year so that the Museum does not incur a deficit." His long-term goals were "to run a successful capital campaign which will represent an enormous fund-raising effort; to see that the Museum's administrative structure is adequate to handle the recent and future growth; and to ensure that the trustees and staff are working toward the same objectives." He mentioned the "creative tension" that often exists between trustees and staff in not-for-profit organizations and stressed the need for agreement as to the goals of the institution although opinions may differ as to the best means of achieving these goals.

These words should have warned me. Who was responsible for "the administrative staff" but Tom? The idea that we weren't "working toward the same objectives" was the kernel of trouble ahead.

Bill had assured me of his support of the building program and of the campaign. At breakfast one day in June, however, he had dropped a disquieting note into our pleasant conference: "I haven't decided yet," he said casually, "what to do about Tom. Whether to keep him or not." Horrified, I urged Bill to "keep him," and asked, "Why not?" "Trustees are complaining about him, you know," he said, smiling. He'd work with him for a while, and see how it went.

Pretty soon, I found Bill's promised weekly meetings with Tom were only a pipe dream. Mine. Bill was busy, unavailable, traveling. Not at the Museum.

To make room for Bill, I had cleared my desk in the office I'd used in one of the brownstones, but since he never appeared, I gradually moved back in. Fund-raising, keeping up with the many people we'd built relationships with, lunching with trustees, writing letters, staying in touch with curators and other staff, going to all the meetings Bill couldn't make, kept me almost as busy as before. Hanging around the Museum, I had told Bill, was the most important thing — to get the feel of it, to get to know the people, the exhibitions, the programs. But he didn't. Was he shy? Bored? Too busy? Uninterested? I never knew. I would call him, politely, and remind him to speak, for example, to trustees whose three-year terms were up, to ascertain their interest in being reelected. He never did. I wrote memos with suggestions about this or that urgent matter but never got an answer.

At the same time, Tom became disheartened. He needed to bounce ideas back and forth. He needed the support only a president could give. He talked to Victor about programs, about art. But there were so many other issues these days! Our weekly meeting petered out, too. It was summer. And then, I didn't have the power any more. Tom, well aware of hierarchy, needed a powerful partner to achieve our goals. We saw each other, yes, but it was definitely different. We weren't planning strategy, we weren't making decisions. Instead, we found ourselves making increasingly desperate plans to get Bill more involved, to make him want to be there, to make him happy, to make him love the Museum.

Could I, should I, have known how this choice would turn out?

Eager to put the "paid president" idea to bed, feeling I should not extend my term any longer, knowing we must infuse trustees with confidence in our financial stability, did my desperation push me to a quick and ill-advised solution? With little research, without even talking with anyone Bill had worked closely with, we took him at face value, and were pleased with ourselves for our great idea.

Bill simply didn't see it the way we did.

I realize now that he couldn't have done what we expected. It just wasn't in him to be friendly and warm, to write expressive letters, to reach out and entertain our patrons and friends. His corporate style was distant, impersonal.

Although he told the board at his first meeting that he would entertain often for the Museum, especially in the months remaining before his retirement, while he had a big salary and a budget for entertaining, he hardly ever did.

I saw very few personal letters, although I received copies of his Museum correspondence, as he did of mine.

Now, besides worries about Tom and Bill, abuse began to shower upon our building plans. Neighbors and other critics complained: There would be too much garbage, traffic, and noise on Seventy-fourth Street. Our building would cast shadows on the street, on other buildings. We would block light from the apartment buildings east of us on Park Avenue. The design was offensive. "A wedding cake" on top of Breuer — how dare we? We were desecrating Breuer's building.

In the media, at lunch, at dinner parties, in bars and bedrooms, everyone in the city seemed fascinated by the Whitney's plans, debating, arguing, and, for sure, knowing better than we did what we should do.

In the *Village Voice*, Michael Sorkin wrote:

> The Breuer Whitney is a masterpiece. . . .
> The violence offered by Michael Graves's proposed addition is almost un-
> believable. Adding to a masterpiece is always difficult, calling for discipline,
> sensitivity, restraint. Above all, though, it calls for respect. The Graves addi-
> tion isn't simply disrespectful, it's hostile, an assault on virtually everything
> that makes the Breuer original particular. It's a petulant, Oedipal piece of
> work, an attack on a modernist father by an upstart, intolerant child, blind or
> callow perhaps, but murderous . . .
> The Graves scheme leaves no aspect of the Whitney unvandalized. . . . I'm
> no knee-jerk preservationist, but if the only way to get this awful addition
> subtracted is to save those brownstones, let's save the hell out of them. Hands
> off the Whitney, Graves!

And Hamilton Smith, associate architect of the building, writing for
the "Op-Ed" page of the *Times*, said that, rather than see the Whitney
"invaded and disfigured," Breuer would have "strongly preferred" it
completely torn down.

The New York chapter of the American Institute of Architects spon-
sored a public discussion of the project. It was standing room only, in
the Donnell Library. Michael Graves, taking the podium to explain
renderings and floor plans, began: "I did smell some faint odor of tar
coming in tonight. I'm sure it was just coming from resurfacing of the
street."

A number of distinguished architects praised the building — Philip
Johnson and Ulrich Franzen, Yale professor of architectural history
Vincent Scully, others. The good news: Only one heckler, a student,
expressed real anger. The bad news: He drew loud applause. *New York*
magazine reported "the SRO audience was treated to a full-dress de-
bate that touched on nearly every major issue affecting high design in
the evolution of this city's architecture." Afterward, the architects who
had supported the building celebrated at "21," a joyous moment in our
bumpy voyage, replete with cheerful toasts and predictions.

Connie Breuer addressed a formal, impassioned plea to jettison the
design to the president of the Whitney's board. Surely written by com-
mittee, it nonetheless distressed me more than any other criticism.

A second article by Paul Goldberger in the *Times* indicated that he
had changed his mind somewhat. Saying the design had caused "the
biggest architectural brouhaha" and that the summer would "forever

be remembered as the summer of debate over whether the Whitney will be enhanced or destroyed," he spoke of the Breuer building's "kind of nasty integrity," which would inevitably be compromised by any addition whatsoever. Michael, he still maintained, had respected Breuer. He praised the Graves scheme as "remarkable," especially "the cubic mass proposed for the southern half of the Madison Avenue blockfront." But the "massive top section," he felt, could be eliminated "quite happily."

Extraordinary, we thought, that those who criticized the aesthetics of our expansion didn't take into account our needs and our program.

Some excellent articles finally appeared, led by a big spread in August's *House & Garden* illustrated by a beautiful color picture of the model. Editor Martin Filler, a distinguished architectural historian, gave the building high praise, calling it "one of the pleasantest architectural surprises of the year":

"This is Graves's best design yet . . . it captures much of the liveliness and variety that have marked his most successful small-scale projects. The architect has not tried to obliterate Breuer's given; deftly and respectfully, he simultaneously sets it off and incorporates it into the larger whole . . . it seems certain that Michael Graves's new Whitney Museum will add much to the cultural richness of a city that has always seemed oddly short of architectural masterpieces. Its boldness is tempered by a real attempt at beauty, a goal no longer prized as highly as it once was in art and architecture. For the latter medium at least, this imaginative design promises to raise the Whitney from its unquestioned national stature to a new international eminence."

Then the former dean of Yale's School of Art and Architecture, Gibson A. Danes, wrote to the *Times*, saying, "The Graves plan is much more on the mark of the moment than Marcel Breuer was in the mid-'60s. The complexity, intelligence and inventiveness of the Graves design is refreshing. It is brilliantly audacious, and it may serve as a powerful symbol of what architecture can and may be up to, as the fin-de-siècle rapidly approaches."

The encouragement we felt was slightly deflated by Hilton Kramer's article in the *New Criterion*, scathing about the Whitney in general and Michael's design in particular.

Tom and I had to keep our spirits up, so we planned yet another trip, this time for the national committee to view American art and new

museum architecture in Europe. We sped through Holland, Germany, Switzerland, and London, astounded by the size, excellence, and number of new museums we saw and, again, by the enthusiasm for American art we found everywhere — much greater, we thought, than in our own country. En route from Stuttgart to Zurich by bus, we had a memorable celebration of Seattle members Jane and David Davis's wedding, which had taken place just before the start of our trip. Tom planned a surprise for them. We all had our parts to play, preparing a song, poem, or speech, and bringing shower caps from our hotel in Frankfurt to wear for this singular wedding shower. Since they lived partly in Hawaii, Bunty and the curators somehow procured leis and grass skirts from the opera company in Frankfurt, and, as we were spinning along the highway, they appeared in the aisle doing lively hula dances while singing sweet Hawaiian songs to the astonished bride and groom. Passing champagne around, we each took our turn to toast the couple — Sydney's and my contribution, as I recall, was a long rhyming limerick about the romance — and then came the real tour de force. In the front of the bus, Byron Meyer rose to his feet and, with a perfect German accent, became, right before our eyes, Dr. Ruth Westheimer, outspoken sexologist, radio, and television star. What a performance! He interviewed the newlyweds, especially on their sex lives, and then he zeroed in on the rest of us. Hilarity reigned, helium balloons floated above us and escaped from open windows, and we soon noticed traffic on the other side of the highway swerving dangerously all over the road, as drivers craned their necks to see what all the excitement was about. Just before dinner, we reeled into the Dolder Grand Hotel in high spirits, shower caps, champagne glasses, and all, astounding staid Swiss guests.

Back in New York, we were faced with a jarring petition, circulated by the new "Ad Hoc Committee to Save the Whitney," asking us to abandon a plan that "would totally destroy the architectural integrity of the original building." More than six hundred signers included well-known architects Ed Barnes, Romaldo Giurgolo, John Johanson, and I. M. Pei, sculptor Isamu Noguchi, and writer Arthur Miller. This group and several others — the Seventy-fifth Street Block Association, the co-op board of 35 East Seventy-fifth Street, the Friends of the Upper East Side Historic Districts — had hired an aggressive law firm, famous for winning the decade-long fight over building the Westway

along the Hudson by turning it into a "save-the-striped-bass" issue. We knew members would now appear at all upcoming hearings and public meetings to oppose Michael's design. Michael himself was distressed by the vituperative words — especially when, asked to comment on I. M. Pei's glass pyramid entrance to the Louvre the year before, he had refused, saying "Architects don't do that sort of thing." Alas for gentlemanly courtesy in a once-polite profession! It was going the way of hoop skirts and chivalry, resembling the corporate takeover sharks more and more.

Most ominous of all was an article in the *Times* in late November. Douglas McGill had managed to unearth, and publicize, the thing that could damage us the most: the disagreement among our board. That trustees would talk to the press was a terrible betrayal, we thought, threatening our institution as no outside group ever could. McGill wrote first of criticisms from without, what he called "other long-standing complaints about the Whitney"; we were called the "McDonald's of the art world" because of our branch museums; the biennial emphasized "trendy" art, as did other programs. Then he went for the jugular: some trustees said we had serious deficits, and questioned our ambitious plans. "At least two trustees, both of them former presidents and chairmen of the board, said the museum had operated at a deficit in recent years — averaging around half a million a year over the past five years." This figure was inaccurate, although we surely had deficits, as did most not-for-profit institutions, and often those deficits were too big.

He then quoted David Solinger and Howard Lipman directly. Howard had said: "Instead of running a tight museum, and putting on the most interesting shows you can put on, you're trying to raise money for an expansion. This will go on for years, and you can't do that without hurting somewhat the creative energy that you have for the museum's activities." The Lipmans hadn't been really involved with Museum matters lately, but they had been identified with the Museum for years, and had been major patrons. That Howard was speaking negatively to the press hurt Tom. Howard had been his mentor, a father figure, and had brought him to the Whitney. Why had he turned against Tom? In other circumstances — if he'd stayed well and involved — I feel sure he'd have been an ardent supporter; after all, he'd started the whole idea of expansion, with the long range planning committee. Ill now, tired, bitter, he must have been listening to

associates who had something against the Whitney, against Tom, in particular. Although I tried, I never found out the reasons for his discontent.

But the bitterest blow was a quote from Leonard Lauder, whom we had counted on to be spokesman and future leader of the Whitney. "When you pare it all away . . . the greatest area of discussion is that everyone agrees an expansion is necessary, but does it have to be that large?"

The unanimous vote to proceed? The $18 million in pledges we had received by the last trustees meeting? The ten years of planning? What had happened? For one thing, I had ignored Leonard's long-time criticisms of the size of our expansion. On the other hand, he'd always said he'd be supportive in public. What had changed his mind?

Although Doug McGill quoted Tom, Victor, and me, briefly but positively, the damage was done. We were surely seen by the art world, and anyone else who read the article, as a house divided.

Jules Prown, our scholar/trustee, grew concerned at this time about the dividing line between staff and trustees. In a long letter to Tom, he expressed his view that, as a museum matures, it becomes less dependent on raising money for both operations and acquisitions, and "professional management is relegated to the professional staff." Wanting to prevent trustees from becoming involved in museum operations "except to the extent that the professional staff finds it useful, or in those areas such as fiscal or legal or real estate expertise where the knowledge of the trustees exceeds that of the professional staff," he expected the staff "in the person of the director to be fully accountable to the board for the operation of the museum, and I expect the trustees as a board and through board committees to monitor that operation attentively." Jules believed that the board had now grown so big that it was only used for fund-raising, leaving the executive committee as the de facto board.

Jules had spent energy and time on this letter, and was raising issues that would surface only later, after it was too late for Tom to address them. Tom sent copies to Bill, Victor, and me. On Bill's copy he wrote in big letters across the top: "Let's talk about this sometime." Months later, he showed me this copy, as only one example of the important communications Bill never responded to. I wonder if things would have turned out differently if we'd discussed it seriously, perhaps with the executive committee?

Twenty-seven

*I*n those days, thinking the days of my Museum life numbered, I was considering new ways and new projects. An editor had approached me to do an article, giving me the impetus to do a series of interviews on the meaning of the Whitney. The notes I took then, wanting to re-affirm the Whitney's basic values and traditions, its mission, still seem relevant today.

Ellsworth Kelly: The Whitney had always been a great friend — had bought the first big painting he had sold, in 1957, had bought his sculpture early, too, and he had felt very good about it. Shows were much better now than they'd been in the '60s, and the permanent collection installation on the third floor was "the best group of pictures in New York at this moment."

Elizabeth Murray: "It was the first museum, when I was quite young, to show any interest in my work whatsoever, even before any dealer had shown any interest in the work. The Whitney is the only major museum in New York City that has consistently gone out of its way to pay attention to what's happening among younger artists in the United States — and not just younger artists, but artists who are lesser known . . . not involved with blue-chip, or things that have already found support . . . and it has a staff that can't be matched anywhere else. . . . All kinds of people go there who would never think of walking into a gallery. . . ."

Patterson Sims, curator of the permanent collection: I asked him about the patterns originally established by Gertrude Vanderbilt Whitney.

"I think she really plays a very critical role in this Museum, because so many of the policies she put in place are the guiding principles of the Museum today. . . . MoMA did not begin with a big collection — the Whitney

did. The Whitney unlike the Modern began with a commitment to collecting, and, as frequently as possible, to show it.

"The collection is the core of what we do. Your grandmother was responsible for about a quarter of the works in the Masterworks book [a catalogue Patterson had recently put together of masterworks in the collection]. Given the fact that she died over forty years ago, that's a pretty remarkable legacy. She bought pivotal works which have become the keystones of the collection, the cornerstones of everything the Museum does — they give us our sense of quality, of what a masterpiece is — and she was integral to that.

"She also began the Biennial and that sense of commitment to contemporary artists. She established the thrust — and her name is constantly evoked as we consider different kinds of commitment the Museum makes. For instance, whether to continue the Biennial. . . . And also her interest in sculpture. It's unquestionably her legacy which makes the sculpture connection meaningful to the Museum. . . ."

What is the meaning of this current controversy, I asked him?

"The meaning is," said Patterson bitterly, "that there's no civic pride in New York, and people don't see the goodness of what the Museum's trying to do."

Carter Ratcliffe, critic: "There must be a public forum in order for there to be art of our own time, and the Whitney is the only place that even approaches a salon."

Leo Castelli, art dealer. Despite what he saw as the handicap of showing only American art, this, he said was overcome by the extraordinary circumstance of American art becoming so dominant. "Personally, the Whitney became the Whitney, the precious institution I so much love and admire, when Tom took over. And he has accomplished miracles there. . . ."

Brendan Gill. He summarized our situation with his usual clarity, saying that now it's clear what we are, what our mandate is: National. But we can't really fulfill it, because of our lack of space. He stated that museums have ceased to be what they were — none of them know what to be, today. Art is part of the life of the people, as never before. He exhorted the board to be very strong and optimistic, because it had found its way.

Our problems are due to our success, he said, and we have the responsibility of success. The Whitney is the natural and good place for artists to be — it's a relationship that really works. It's like the *New Yorker*, one is grateful to be there. We feel we belong, even if we don't see each other much. There's a family feeling, a feeling of intimacy.

About the building, he said that scale is so important. The new building will be intimate. One hundred thirty thousand feet won't make that different. The staff won't be much bigger.

Very few architects have built *over* another building, he noted. They usually swallow it up, as at the Met.

"The Chinese ideogram for change is the same as the one for opportunity," he said.

Brendan encapsulated, in a few phrases, my own feelings about the Whitney.

I'm so glad I wrote my mother a long letter after Christmas, thanking her for presents, and for her carefully handwritten notes to us, to our children and grandchildren, because it turned out to be my last chance. How difficult it was for *her* to write, with all her eye problems, but how much she wished to remember and connect with each one of us at Christmas! My worries about the Whitney, I think, had made me reflect about the past, and what had brought me to where I was today:

> The painting of All Satin [my horse, as a teenager] and me is reposing against a wall in the living room, at the moment, waiting for a more permanent home here, bringing back all kinds of memories of Aiken, especially. What a wonderful and unique place and way to grow up that was, Mum. I've probably never told you of all the things I appreciate and am aware of about my upbringing. I'll try to do that when I come to visit in January — but for now, I can say that the encouragement, the sense of support you and Daddy gave us in an ambiance of warmth and a happy home were all-important in whatever I became later. My sense of independence, the knowledge in my bones and head that I was loved deeply, all this combined with the gentle climate of Aiken and the smells of horses, roses, jasmine, pines, and the colors of red clay, brilliant camellias, lush green foliage and true blue sky. . . .
>
> Then the people. The beloved schoolteachers. Sis, that splendid extraordinary member of the family [our French governess]. From J. D. [the man my father painted] to Maria [our laundress], their soft voices a murmurous background to all that happened, their care responsible for our comfort. You and Daddy with your fascinating friends, to us kids, mysterious and "grown up," awesome or adored — Huston Rawls, Dr. Wilds, the Meads, the Von Stades, the Knoxes, etc. — and the events: the shoots (remember, Mum, reading aloud in the dove blinds? I can even remember the books we read — probably those times are the roots of my love of books today —). And the meals! Oh those amazing feasts, with

food for the gods. The turkeys, the chestnuts, on Christmas — the desserts, the croquembouche, the tarts, the *real* ice creams. The glorious teas with five kinds of cakes and cookies and the silver teakettle boiling water and exotic people stopping by — Ilya Tolstoi telling tales — and the sound of the martini shaker, as evening approached — well, it was all a dream, wasn't it.

A dream, yes, like so much else, like everything, perhaps.

Twenty-eight

*I*n 1986, my mother died.

That winter, when we visited her in Florida, she'd made such a valiant effort to welcome us. Despite her failing eyesight, she loved to watch television. Her curiosity was still keen as she tried so hard to grasp how polar bears survived, what really happened to the space shuttle or to Philippine president Marcos, or to unravel the affairs of J. R. and Suellen on "Dallas." Fascinated by the love lives of her unmarried grandchildren, she clung to life while accepting the imminence of death, of which she talked calmly and concretely. She believed in an afterlife, in spirits, in life on other planets, and that she'd see us all again. We couldn't get over how beautiful she looked. Her face was unlined, neither drawn nor sad, she dressed elegantly, and she still smoked cigarettes in her long holder.

She greeted us with the same smile, the same love, the same interest in all our doings. In other words, with the same spirit. When a doctor told her she had an aneurism that, at any time, might burst, she asked every possible question about the effects, whether it would hurt, and how long she would last before she died. I'd thought her reluctant, in her life, to face many unpleasant realities, but now she showed a radiant courage. Facing the ultimate reality, she was as down-to-earth as she was about her grandchildren's or her nurses' romantic entanglements.

I was profoundly moved by my mother's strength, and by her beauty, both physical and spiritual. But I *hated* seeing her so old and weak. Her children and grandchildren drew close, saving stories to entertain her. I told her about things at the Museum, I read aloud to her,

talked of family and old friends. She always pretended interest, but I could see she was really somewhere else, much of the time. And her efforts to walk or go out for a car ride were becoming more and more uncomfortable.

Mum enjoyed a piece by Robert Becker in the April *Art and Antiques,* entitled "All in the Family," illustrated by a photograph of her, Fiona, and myself at the Whitney, in 1986. Fiona is wearing a blouse her great-grandmother Gertrude had brought from China in 1896, on her honeymoon, and the article is subtitled "Four Generations of Whitney Women Grow Up with a Museum." Now we were four: four women, four generations; probably unique in major American institutions.

Becker quotes me: "Americans don't have the kind of respect for their own culture, for themselves in a way, that they have for European culture. Most don't see what is right under their noses, which is probably the highest level of creative achievement in our times. My role, like my mother's, has been to support the Museum through fund-raising, helping to bring together two elements of our culture — society and art. My daughter, like my grandmother, is concerned more with the art itself."

And here is Fiona: "I rebelled against a career in the arts for quite some time. All I ever heard about at dinner when I was growing up was talk of boards and trustees and meetings. Eventually I realized there is more to museums. I chose the other side, so to speak. Of course, it does make me happy that I can do some of the things my great-grandmother loved. . . . My grandmother Flora still believes that someone from the family should be involved. She always speaks to me about the Whitney with the hope that I will work there. I think she still thinks of the Museum as a family institution."

I see these generations weaving in and out of each other. I look at a daughter and see my grandmother; one granddaughter becomes my mother, another seems like myself in some long ago past. The wheel of life turns, and I'm blessed to have experienced so much love. Nothing else matters as much.

Becker writes of the Vanderbilts and Whitneys as they once were: powerful, patriarchal families. Odd, almost the only thing left of all the power and wealth is the museum Gertrude created. What does that say? Powerful men today, no doubt, recognize what it says. If they want to be remembered, aim at the long-term. Buy a museum.

* * *

By the time Mum came to see Michael Graves's new design for the
Museum, in June, she looked tiny and ate very little — just a few bites
of even her favorite puddings or ice cream. It was pitiful to see our
mother, our once vibrant, enthusiastic, wonderful mother, diminished
and dependent. Sad, worried, my siblings and I took turns visiting her,
hoping she'd improve, planning for her eighty-ninth birthday, on July
29, at the Studio, now Pam's home. Exceptionally devoted, Pam
arranged every possible comfort for Mum, making sure she had food
she liked, visiting many times a day, organizing nurses and doctors.

We knew she was very ill.

I was absent from the July trustees meeting because Mum had been
taken to the hospital in an ambulance the day before, with one of a se-
ries of severe nosebleeds. Doctors didn't seem to know the reason.
They put her in intensive care, where she was cold and lonely, and
didn't understand why she was there at all. We were angry at the in-
sensitivity of both nurses and doctors, but once Mum was in the hos-
pital, it seemed impossible to regain control of her care. We took turns
visiting her, five minutes every hour, but could do little but hold her
hand and assure her we loved her, and that she'd be out soon. With
tubes in her nose and mouth, she could hardly speak. We felt helpless.
Miserable.

Pam had Mum's own nurses ready to be there, once she was out of
intensive care, and, in a couple of days, she was established in a regu-
lar room. She seemed better, so, after stopping at the hospital for a visit
on July 17, Sydney and I drove on to our rented house in Wainscott for
the night. I'd been reassured by seeing Mum watching her beloved
Mets on television, although she drifted in and out of sleep.

We had told the doctor Mum did not want extreme measures of re-
suscitation, and he had assured us he'd given that order. And yet, when
she became desperately ill later that night, doctors and nurses did all
they could do to restart her heart. Her life.

Pam called in the early hours of morning and told me Mum was
dead.

Dawn, its intense pinks and oranges blurred by mist rising from the
ocean and from my own eyes, seemed irrelevant, its beauty almost of-
fensive. I drove toward my sister's house through the tender green of
potato fields whose burgeoning life seemed to reproach death.

Strange, what images remain of significant moments — that dawn remains as vivid today as it was then, the lonely road, the racing car, my racing thoughts. I wanted only to think of Mum, but other thoughts intruded: who to call? a funeral? an obituary? who to write it? I must ask Mum, flashed through my mind, her loss still unreal. Her absence took so long to accept that I still want to call her on the telephone at times of major family or Museum joys or crises. The death of one's mother breaks the most fundamental tie of all. Its meaning is the same at any age: I'm really on my own. If a mother and child have been close, how much more conscious the realization, how much deeper the grief. Answering hundreds of condolence letters that summer, trying to express the loss I felt in just a few words was impossible — but it helped, I think, to increase my awareness and to bring my sorrow to the surface.

We were all submerged in details immediately. My brothers and sister and I telephoned, arranged, and talked, until after the funeral, to which we only asked close family. Pam thought it best, thought Mum would have preferred it. We chose things for her to wear: her Cairo wedding ring — the elephant hair encased in thin gold; a gold duck pin my father had given her; a blouse Sydney and I had brought her from Venice. A simple stone marks her grave in the Quaker cemetery in Westbury.

We drifted back in time, deciding what to do with her clothes, her art, her photograph albums. Recently, she'd filled fat scrapbooks with articles about the Mets, her family, and other things that interested her, still poignant reminders today of Mum's curiosity, her vibrancy, her great capacity for love.

Never, in her humility, would she have believed the numbers of letters we each received, nor how much people had cared for her.

One day, we assembled all the granddaughters at Mum's house, so they could choose things from her wardrobe. She had kept all her clothes forever, it seemed, in huge closets and dressers on the third floor. Pam and I, thinking we'd be too sad, hadn't planned to be there, but we couldn't stay away, and when we saw our daughters and nieces in Mum's suits and dresses, we were captivated. Each one, of vastly differing size, age, coloring, and personality, had found the perfect fit and style for herself.

My brother Leverett's oldest daughter, beautiful Maria Flora with her long blonde hair, was stunning in the pants suit covered with black

paillettes that her grandmother had worn for special parties at the Whitney. I could picture my older daughter Michelle singing the blues in her sweet husky voice, in the gray and white Balenciaga gown Mum had taken to London for the ball her cousin Jock Whitney and his wife Betsy had given when he was ambassador to the Court of St. James. California nightclub audiences, I imagined, would wonder at that dress. Pam's and my younger daughters, Pamela and Fiona, found perfect Chanel suits, and we suddenly recognized our "babies" as elegant and mature women. Frances, Whit's and his former wife Francie's younger daughter, a trained nurse and midwife, perched a Paulette hat on her blonde curls and became a gamine, while Susie, Pam's expert rider and show judge, found that an ancient shooting jacket and trousers from London, soft now from many cleanings, were an exact fit. Whit's older daughter Alexandra was enchanted by a pair of buckskin pants and a fringed, beaded jacket, acquired by Mum on a long-ago trip out West.

They wept a bit, and laughed with each other, too, as they preened in all the finery, adding huge ostrich fans, fine leather pocketbooks, silk and chiffon scarves, kidskin gloves in white and in dazzling colors, negligees, bedjackets trimmed in swansdown, and dozens of hats — veiled, feathered, sequinned, beribboned, with tassels and furbelows. One granddaughter even fit into Mum's custom-made shoes, almost as wide as they were long, high-heeled or wedge-heeled, brilliantly colored or sober black.

All the different facets of Mum were assembled before us, creating a vivid image of the extraordinary woman who was our mother and grandmother. That deeply touching moment recurs whenever I see a daughter or a niece wearing anything reminding me of Mum.

I thought often of my last real conversation with Mum, before she went to the hospital. She was having breakfast in bed, as she always did: orange juice, toast with a little honey or jam, and coffee. I sat on the bed, we chatted, and she talked of my father, Cully, whom she looked forward to seeing in another world. "Who will live in my house?" she asked, looking around at the room, once her mother's, with the same painted furniture Gertrude had commissioned, including the huge bed richly painted with animals and plants by artist Max Kuehne; tiny bronzes by Cecil Howard, paintings by my father, cat andirons, and all the other objects, unchanged since my grandmother's time. "Will you?"

Alas, I thoughtlessly said I didn't think I could afford to. I've regretted that ever since. She loved her house so much. It symbolized all she cared for most. Family, above all. Warmth, love, continuity, beauty. Happiness, that elusive sprite whose pursuit was guaranteed us by our forebears.

Tom had adored my mother. Distressed that he couldn't attend the funeral, since we'd only asked the family, he'd made a plan right away and set it in motion. We would do a book in honor of Mum, a kind of scrapbook with pictures and words by her family and friends. A marvelous way to memorialize her. A way to mourn, but an active way.

Joan Clark, by now a close friend who had liked and admired Mum, supported the project from the very beginning. We wouldn't have been able to do it so lavishly without Joan's help, and I'm grateful to her forever. "To realize dreams is one aspect of Joan Clark's generous, creative nature," I wrote in the Introduction, and this is true. Phyllis Wattis, a member of the national committee and good friend, contributed, as well. And Joan Weakley was key to the project.

Joan Weakley: assistant, friend, and confidante, she and I shared an office in a Museum brownstone for many years. She's young, slim, and pretty with becoming, prematurely gray hair. Her husband, Rob Ingraham, who once worked at the Museum, is a writer, and adores Joan even more than the rest of us. Joan was beloved by *all* the Whitney's staff, from Nelson, who cleaned our office, to Tom himself. She's incredibly thoughtful, remembering everyone's joys and sorrows, illnesses, and birthdays. She knew everything that was going on, but was entirely discreet. She wrote the best minutes of meetings ever, and the best letters — but she always made me feel it was I who did that. People gravitate to Joan, wanting to confide in her, seek her advice, be nurtured.

For about a year, Joan and I worked with Tom on this project. We called it the "Flora" book, and no one could possibly have made a more elegant, professional, loving tribute to Mum. I can still visualize the long tables and folding metal supports holding the hundreds of photographs for which I'd searched Mum's house and my own, for which Tom went through Museum files. We both asked people to write their memories of Mum — and every one answered. Bob Friedman wrote "A Brief Biography and Personal Reminiscence" to start it off, and it was perfect, eloquent, placing Mum within her time and her

family. Tom creatively envisioned the different aspects of my mother's life, from her childhood to her old age. He found a superb designer, Karen Salsgiver, who combined Tom's ideas with her own expertise to produce a beautiful book. We felt that yellow, Mum's favorite color, must be on the cover — and we visited 10 Gracie Square for ideas, finding just the right floral edge on a yellow curtain. On this, Karen superimposed Mum's distinctive signature, just "Flora," in green.

The book captures Mum's quicksilver self, and I am grateful to Tom for this enduring portrait of her. We sent copies to all members of the Whitney. The response to it was astounding, both from those who knew Mum and from those who had never even met her.

Tom felt it crucial to the Museum's future that people have a sense of its roots, in order to better understand the Museum's character and mission.

I will quote from two more pages of the "Flora" book, the last two. The first, by my daughter Fiona, sits across from a photograph taken at the Whitney, of Mum, Fiona, and myself:

"When I look at this photograph, I imagine my grandmother, having noticed the photographer, warmly cooing in her inimitable fashion, 'Ooooh.' Among other attributes, this sound, like my grandmother, was full of elegance, wonder and curiosity, as well as humor and empathy. She said it while watching TV (which she loved), observing the Mets (whose games she never missed), hearing intriguing news of her family and acquaintances, and even eating ice cream. She was a cheerful confidante to her grandchildren — interested in hearing about all aspects of our lives and thoughtfully giving advice, while sharing with us colorful stories about herself. She had an eye for charming people and beautiful objects, especially painting and sculpture. She was of course particularly interested in the Whitney Museum. When I visited her she seemed fascinated to hear about the variety of exhibitions and events taking place there. Through amusing anecdotes about her mother's place in the art world, as well as her own, she instilled in me a sense of pride at having the opportunity to be involved in the Museum founded by my great-grandmother. . . ."

The last picture in the book shows one end of my mother's living room in Old Westbury, with the yellow sofa (now facing me in our living room in New York), where, late in her life, Mum always sat. From her seat on that sofa, she greeted guests, served tea, and ate most of

her meals. Sculptures by her mother and favorite watercolors by my father Cully surrounded her; on the sofa we can glimpse a Mets baseball cap and Mum's needlepoint pillows.

Across from that photograph, Tom wrote:

> To those who knew her in the last decade of her life, Flora Whitney Miller might have seemed removed from the daily events of the Whitney Museum of American Art. But in my sense of the history of the Museum, she always will be the most vital and essential part of the evolution of the institution. . . .
>
> As I sat with her, next to the sun porch filled with sculpture from her mother's era, it was impossible not to recognize that even though Gertrude Vanderbilt Whitney will always be revered as the founder of the Whitney Museum, it was Flora who accomplished a more difficult task — to bring it from the domain of private wealth and personal concern for artists into the ranks of major public institutions, enjoyed and acclaimed by international audiences. . . .

The party we had for the "Flora" book was a touchstone of those late '80s, when we floated in a kind of limbo, somewhere between euphoria and desolation. The gathering in her honor brought an outpouring of affection, respect, and sorrow from hundreds in the Museum community, and from her family and friends, all invited by the three directors still alive with whom she'd worked: Lloyd Goodrich, Jack Baur, and Tom Armstrong.

Within a year, Lloyd and Jack would both be dead. Links with the Museum's very beginnings were to be abruptly severed. The Museum's living history was wiped out, quickly, irrevocably.

For now, though, a wonderfully diverse crowd talked of Mum and toasted her. Brooke Astor, Peter Duchin, C. Z. Guest, and others from the social whirl joined the art world, represented by art historians, directors, and curators, writers, and many artists. Old-time Whitney faithfuls, such as Louise Nevelson, Paul Cadmus, Isabel Bishop, John Heliker, and Elsie Driggs, came, along with younger artists, such as Jasper Johns, Alex Katz, Chuck Close, Nancy Graves, and Michael Heizer. Swizzling the bubbles from my champagne, as Mum had always done — we both preferred it flat — I wondered if she'd have liked the occasion, the book . . . and decided, yes, she would have, especially since the book was made by the Whitney, and the party was there, too.

*　　*　　*

I missed Mum more, as time passed. Once in a while, I felt I had some-how betrayed the trust handed down to me by my grandmother and mother, and had nowhere to turn, now, for counsel. I went over the past years, hunting for the moment I'd taken a wrong turn, but it was like groping through a murky fog. The building project? The new trustees? Tom? Bill? Control of the Museum was passing to others, but that was necessary, if we were to survive financially. Or was it? I was no longer sure it was either necessary or right, or the best thing for the Museum. No one seemed willing or able to give it the time and nur-ture it needed so desperately.

To accept the final separation of death is the hardest thing in life. "Never" is the word that recurs, again and again. When it's your par-ents who have died, besides the emptiness, your whole perspective on life changes. You are senior. It's all up to you. You must hand down to the next generation whatever you can of your parents, their history, their values. Maybe that's why we cling so to objects and their associa-tions. Why I like to serve dessert on my great-grandparents' mono-grammed plates, even though their gold monograms and fluted edges can't go in the dishwasher. Why I treasure my father's desk, although it's really too small to write on. Why I love the yellow sofa my mother sat on. Why I'm so careful of the pretty glass with painted roses and translucent lozenges I keep my toothbrush in, used by my grand-mother and then my mother, which I took from the long white marble counter in their Old Westbury bathroom. Why I wear Mum's pearls and the strange, bifurcated star ruby ring she always wore, her mother's engagement ring.

Dead objects, to recall a living mother and father.

One spring day in 1987, I went to lunch at Susan Gutfreund's magnif-icent home on Fifth Avenue. Alfred Taubman had called me, after John Gutfreund had left Solomon Brothers, suggesting it would be a good time to show warm feelings to these acquaintances we'd never brought close to the Museum. They'd be pleased, and the Whitney would be the beneficiary. So I called Susan. She showed me up the curving staircase, past a gorgeous Monet, into a vast living room over-looking Central Park. Turning left, she seemed to await a special re-sponse, and suddenly I noticed my favorite chair, formerly in my

parents' yellow library, covered in the same fabric we'd used for the "Flora" book. Surely she thought I'd be delighted to see it again, but it was hard to be polite, imagining Mum's reaction, wishing I could have kept that particular chair.

But we'd had to sell it, along with so much else, to pay taxes.

Twenty-nine

The media, especially the *Times*, seemed to have it in for the Whitney. Michael Brenson, for instance, observed a shift from anticommercial '70s art to that of the '80s, reflecting the larger society. Many of the most popular artists were too young, he said, and galleries showed too few of them, too often. Their works were too big, too easy, and too often mass-produced and mass-marketed.

Following Hilton Kramer's lead, Brenson maintained that museums, especially the Whitney, were guilty of following this trend. "With their passion for spectacle, with the way they allow corporations to serve business interests, particularly through advertising, museums are part of the problem. It is in the context of this general failure that the criticism of the 1985 Whitney Biennial for trying to reflect the moment rather than confront it needs to be understood."

The Whitney Biennial had been intended to "reflect the moment" ever since my grandmother's time. Adam Weinberg, who was then curator of the permanent collection, and is now director of the Addison Gallery of American Art, quoted in one of his catalogues Lloyd Goodrich's response to a group of artists criticizing the Museum in 1960 for showing abstraction at the expense of realism. "The Whitney's job is to recognize the best in all tendencies . . . In the past the Whitney Museum's showing of successive trends among younger artists — expressionism, the American scene, social realism — met with the same kind of criticism as its present showing of abstraction and surrealism. To surrender to such opposition and confine its activities to the popularly acceptable would be to betray its primary duty to the public, to the artist, and to the future."

Weinberg amplifies this when he writes of the Whitney's philosophy, as defined by Jack Baur: "The ethical, art historical imperative to exhibit and collect a complete range of artistic production at any given moment. For to exhibit only one or a few stylistic directions is to potentially fall prey to fashion and misjudgment. . . ."

The artists to whom the Museum gave exhibitions — most recently, Eric Fischl and David Salle — comprised part of a program carefully balanced between different eras and different styles. That they were young and widely shown in museums and galleries didn't prove them worthless. If a context that would place them more clearly was lacking, was that not exactly the rationale for our expansion project?

However, we knew that our public — even our trustees — read and probably believed much of what they read in the *Times*. We must address Michael Brenson's criticisms, at trustees meetings, in smaller meetings, whenever we had the chance. Soon, on the first page of the Sunday *Times'* Arts and Leisure section, he reproduced Roy Lichtenstein's spectacular sixty-eight-foot-high *Mural with Blue Brushstroke* in the Equitable lobby. Under the headline "Museum and Corporation — A Delicate Balance" Michael Brenson explored all the pluses and minuses of the Whitney's partnership with business. Calling the opening of the Equitable branch "an event of major artistic importance," he maintained, nevertheless, it placed the Museum "in an uneasy relationship with an essential and enduring aspect of influential twentieth century art. That is its wariness of institutional power." Postwar artists, Brenson maintained, had resisted the artistic and cultural values they saw around them — Jackson Pollock, for instance, had rejected easel painting, and Johns and Rauschenberg had attacked the whole idea of "good taste. . . . The radical content of the work could be appreciated because it was in some basic way consistent with the museum environment. That environment has been changing. The issue is not ideological purity. Nor is it corporations. It is the ability of a museum to maintain its clarity of purpose and broad understanding of art and leave no doubt that the values it stands for are paramount. To prove itself worthy of public trust, a museum's ongoing struggle for independence and purpose has to be unmistakable."

Brenson thought it would be difficult for us to ignore our situation, while quoting both Equitable and Tom as to the inviolability of the Museum's autonomy. Tom emphasized that any lapse of our contract

allowed either party to terminate the agreement on short notice. But Brenson found it "jarring" to see some paintings in a corporate setting, in galleries with big windows opening onto the busy streets of New York, especially for "a painting as dense and wistful as Johns's 'Racing Thoughts,' or as spiritually absolute as Rothko's 'Untitled,' with its silent fields of color." While he recognized the possibilities — bringing shows that bypassed New York to our galleries, exposing a new public to art — he feared the Museum might "cheapen and diminish the art whose job it is to consider, support, and defend."

We had recognized the dangers. But we'd decided the benefits outweighed them. Especially in view of the inaccessibility of our permanent collection; we could show only seventy works on our third floor, while ten thousand were in storage. Now, just as the Whitney published a new book by Patterson Sims showing one hundred of its masterpieces, along with a new award-winning video by Russell Connor to go with that book, we had a whole new gallery just for the collection.

We thought we could handle the problems Michael Brenson thought might overwhelm the Museum and the art. We liked the streets, so visible from the galleries; we felt they gave context to many contemporary paintings and sculptures.

Actually, though, we'd experienced some of the perils of partnership with corporations.

Ben Holloway, executive vice president of the Equitable, was our contact. He was now on our board, serving on the building committee and the campaign committee. An ideal trustee, we thought: generous, enthusiastic about art and artists. I'd given a dinner for him and his wife, Rita; had arranged a special meeting with Michael Graves to show him our plans; had taken him to visit Bill Goldston, presiding genius of the print workshop ULAE (Universal Limited Art Editions) in Long Island, to see prints in process and have a delicious lunch with artists and artisans. In other words, we did all we could to make him one of the Whitney "family." We liked him. Also, we expected more from Equitable — a seven-figure campaign contribution.

Ben had initiated expansion of Equitable's real estate holdings and the acquisition and commissioning of considerable contemporary art. We didn't realize that powerful figures in the traditionally conservative company opposed the revolutionary upstart in their midst and worried about all the money he was spending. To emphasize the importance to the company of the image he was creating, to show all he'd accom-

plished, Ben had arranged an elegant dinner in Equitable's new corporate dining room, for after the opening of the two galleries. John Carter, CEO of the whole corporation, was to speak.

Just as all this was about to happen, leaks were discovered in one of the galleries. Impossible to open, with water coming in, possibly on the Whitney's paintings. The curators were adamant.

Then we found out how corporations react to adversity.

Ben was frantic. First, he tried everything in his arsenal to change the curators' minds, finally losing his temper and making dire and personal threats to the staff, who stood firm, but were hurt and upset.

Next, Ben called Tom, who backed his staff.

Then he called me. Horrified by Ben's lack of understanding about danger to the art, I supported the curators and tried to explain that art came first. Fruitlessly. Larry Tisch's earlier visit reverberated in my mind as I faced similar fury, similar threats.

Bill Woodside overrode everyone, as he had the power to do, and insisted that we open on schedule. After a mad scramble to fix the most dangerous leaks, the paintings were hung — but removed immediately after the opening festivities.

I'd had a clear indication of Bill's priorities.

Did I learn anything? Did I connect the merciless will of powerful executives with the Whitney's future?

Not enough.

Calvin Tomkins in the *New Yorker* wrote:

The main event of this somewhat lackluster art season has been the furor over the proposed expansion of the Whitney Museum. Breuer's dark, granite blockhouse — a highly aggressive form that stands out like a mailed fist from the urbane gentility of Madison Avenue — was praised by architecture critics but greatly disliked and disparaged by the public in its early years. Although it has become a familiar part of the uptown East Side landscape, the current surge of affection for it is something new. . . .

The emergence during the last decade of what has been called postmodernist architecture, with its borrowings from historical styles, its bold use of color and ornamentation, and its playful (or frivolous, depending on your point of view) mixing of forms, represents an almost total break with the austere, "less is more" aesthetic of Mies van der Rohe, Walter Gropius, and the other giants of architectural modernism. (It also represents an economic threat to architectural firms that have based their practice on steel-and-glass office towers, which many clients no longer seem to want.) . . .

Saying that "for much of its history, the Whitney has been looked upon with great affection," Tomkins felt this attitude had changed:

> But it is clear that the climate of affection in which the Whitney once basked has chilled considerably, and one of Armstrong's big problems is that the Museum has not yet gained enough professional respect to give it real power as an institution. The Whitney's board of trustees wields relatively little clout in New York's social or political life. . . .

After describing the additional space and explaining our justification for a seemingly large expansion, he described the process we were faced with:

> Armstrong has indicated that if the building expansion and the development plans that go with it are shelved he will resign. The Whitney's trustees would then be obliged to sit down and rethink a number of issues. This could turn out to be an interesting process. There has been very little hard thinking lately about the nature and the purpose of art museums. Should they really try to be all things to all people, as so many museums feel they must these days — community centers as well as research institutions, places of entertainment as well as temples of high culture? Must they forever grow larger and more "comprehensive" in their appeal? Is public education in the visual arts really part of the museum's job? The Whitney has already expanded its activities by establishing three branch museums — and this week it will open a fourth branch, in the Equitable Life Assurance Society's new building. . . . Could this be an alternative to enlarging the Breuer space — Whitney branches exfoliating across the country, spreading the good word about American art? . . .

Tom's statement struck me forcibly: he'd actually leave, if the expansion failed? This was news to me, and I was upset he hadn't told me. I think now it was a reaction to all the bad publicity, to all the hassles, and — most of all — to the impossibility of getting Bill to focus.

No matter how absent he was from day-to-day activities, Bill, it seemed, was nevertheless having a positive effect on the Museum's budgetary situation: the projected deficit was way down, and trustees were beginning to fund exhibitions above and beyond their regular annual giving. This spirit, these gifts, reflected the confidence his financial experience and control inspired. I was grateful for that. But I was concerned that he and Tom weren't talking, that the nominating committee wasn't meeting, that Bill wasn't asking trustees if they wanted

to be reelected, wasn't asking officers if they'd continue to serve, wasn't following through with trustees who were no longer attending meetings or otherwise participating. That trustees meetings were getting shorter — an hour or less — with little time for discussing art.

Was I expecting too much of a busy businessman? Was Bill's apparently successful fiscal management more important for the Whitney than any hands-on involvement? If so, it seemed to negate much of what I'd done, as president. I felt frustrated, confused, and, worse, useless.

Now that some time has passed, I see an inevitable tidal ebb and flow. More businesslike approaches both preceded and followed my style of personal contact and supportive partnership. They represent growth and consolidation. We made no mistake in choosing a business leader as president, we only chose the wrong one.

Tom and the Whitney were honored at the annual award dinner of the National Arts Club, in November 1986. Among others, Arthur Danto, professor of philosophy at Columbia and art critic for the *Nation*, spoke:

"The Whitney is like the rest of us in the art world today, confusion writ large. Its mistakes are those of the well-intentioned person facing intolerable pressures but obliged to make decisions. They are not the mistakes of an indifferent institution, nor of an authoritarian one, but of a human one. The Whitney is the only museum there is in which affection is an ingredient in our attitude toward it, and a degree of understanding and compassion. To imagine an art world without it is to imagine a desert of greed, vanity, and meretriciousness."

In October 1987, Victor Ganz died.

Speaking at his memorial service was unbearable. I felt I couldn't possibly do justice to that extraordinary man, couldn't possibly say all that was in my heart. I quote the beginning of my eulogy because it bears on the Whitney, and also because Tom suggested the generational idea.

"Victor's relationship with the Whitney Museum of American Art was very personal, very specific — as mysterious, perhaps, as the profound relationships of a devoted couple, of loving siblings, or of two close friends.

"I want to speak to Victor and Sally's family, to convey to them something of what Victor means to the Whitney. I know how important grandparents are — the direction of my life has been influenced

by my grandmother, she who founded the Whitney Museum and gave it its shape, that shape which Victor came to believe in, to modify, to revitalize. Having a passionately committed, articulate, and creative grandmother has been a challenge, a joy, and a constant source of energy and faith for me — I feel that this will also be the case for you, Victor's grandchildren."

Victor's passion for art and artists, his lifelong search for understanding, had made me feel more and more intensely the centrality of art to life. And Victor himself was central to the Whitney, to all we were trying to do. Even when he was very ill, he asked me about the building project, wanting to know who was impeding it, who was helping. "You must persevere," he insisted.

In the *Whitney Bulletin*, Brendan Gill distilled Victor's essence:

Victor Ganz was a short, stocky man, with a well-shaped head and a resonant voice; behind large, black-framed spectacles, his eyes were exceptionally alert and, on the many occasions that we shared as Trustees of the Whitney, nearly always merry. It is a commonplace to speak of collectors as having a good "eye" — a gift that Victor had in abundance — but eyes in the plural are also worthy of praise, as being in physical terms extensions of the brain and therefore the means by which we are able to look into people's minds and pass accurate judgment on them. What shone out of Victor's eyes was high intelligence and an eagerness to be in affectionate contact with his fellow human beings. He and Sally Ganz were accustomed to speak their minds, openly and with humor but also, if need be, with compassion. The number of distinguished collectors is very large; the number of distinguished lovable collectors is, shall we say, comparatively small, and Victor and Sally have been notable among them.

The Museum continued, in public, as if nothing was wrong. In May, we presented Michael Graves's new designs to different membership categories at lunches and special meetings in the Film and Video gallery. We presented them to the Landmarks Conservancy, to the Municipal Arts Society, and three times to Community Board 8. We went to an eight-hour public hearing at the Landmarks Commission on our "certificates of appropriateness to demolish the rowhouses and construct an addition." Tod Williams, architect of our newest branch museum near Wall Street, had prepared a well-researched book on the brownstones, showing that their original fabric, at best a "handful of store-bought lintels, jambs and cornices," had deteriorated beyond

restoration by the time the Whitney moved next door. Madison Avenue, he pointed out, with photographs as proof, had "evolved in only 100 years from open farm land to the premier international shopping street of a world class city." Speculative builders, including Silas Styles, "architect" of those buildings, had quickly moved in to build mile after mile of "repetitious brownstone rowhouses right out of the pattern books . . . architectural design appears to have been incidental to his real estate development interests . . . rectangular boxes with uniform fenestration and builders' standard details." Whatever the value of the original fabric of these buildings, most of it had disappeared long before the Whitney came along.

"I shed no tears on behalf of these woebegone orphans," said Brendan Gill at that hearing.

A distinguished professional group spoke in favor of demolition: Ulrich Franzen, William Pederson, Cesar Pelli, Helen Searing, and Peter Eisenman. I spoke last, hoping to stir the souls of these cool judges by reminding them of our glorious heritage of American art, of far greater benefit to our citizens than these ugly brownstones. Probably, I sounded like a broken record.

Months of indecision by the Commission followed, then a mixed bag of publicity. Connie Breuer signed another letter to the *Times*, ending, "Having seen the revised model, I continue to believe that Marcel Breuer would have preferred to see his building razed rather than have it subjected to this kind of arrogant encroachment."

But the *Times'* lead editorial came out strongly in favor of both our plan and that of the Guggenheim.

At a special meeting of the board on November 9, 1988, trustees unanimously approved Michael's third design. Some liked it better. Some didn't. Some only said they did. Among the first group, Leonard called the new design excellent and said it represented "a significant improvement over the first two, in part because it is the work of an architect who has matured and gained self-confidence over the past few years." Elizabeth Petrie, Brendan, Tom, and I still loved design #1, but none of us said so in public, then. We knew this scaled-down scheme was our only chance to get any expansion at all, and even this seemed unlikely, given all the approvals we must seek all over again and changes in the staff and membership of Landmarks.

"Multiculturalism" was in the air. Already in the '70s urban sociologist Herbert Gans, castigating the preservation movement's "patriarchal"

policies, charged that the Landmarks Preservation Commission was favoring the stately mansions of the rich while neglecting common buildings. The shift was beginning. The Whitney, in addition to its inner stresses, was being ground between the tectonic plates of modernism, postmodernism, and multiculturalism.

After becoming a docent and organizing a series of art-oriented trips abroad for high-level members, generous businesswoman Adriana Mnuchin had joined the board in 1986. She had new ideas and put them into effect: for example, she invited trustees, their spouses, and curators to the house she and her husband Bob had filled with twentieth-century masterpieces of American art. Dinner at the Whitney followed, in one of the galleries, with a curator leading serious discussion at each table. As a toast I recited a long poem of praise, with a verse for each trustee present, starting:

> I sing a song of trustees true
> of followed up leads
> of recognized needs
> of planted seeds
> of generous deeds
> of an institution's glue —
> YOU!

I felt trustees needed bucking up, and I wanted to express appreciation to each one. They seemed to like the intimacy of the dinner.

One subject we discussed that evening was the relationship of art and money, perennially talked of, but never more than in the late '80s, when van Gogh's *Irises* sold at auction for $53.9 million, when about 150 galleries existed in Soho alone, when works of "emerging" artists were priced at $20,000 or more in their first shows, and some artists talked seriously of their career choices. Minimalism, conceptual art, and site-specific earthworks, despite dire prophecies, had not discouraged collectors, who snapped them up. These presumably empty, unwieldy, uncollectible works were now extraordinarily popular, selling sometimes for hundreds of thousands.

Was the marriage of art and money new? Undesirable? Wicked? Immoral?

American artists hadn't expected to make a go of their profession, fi-

nancially, until the explosion of Pop Art in the '50s. I felt happy that some artists could now make their living without having to wait on tables, or work in a bank or a carpenter shop, or even teach. The marriage of art and money was nothing new, as Carter Ratcliff wrote in *Art in America:*

"We still assume that a price tag is one thing and a critical evaluation is another thing entirely. They are not. . . . Western art gains its entrepreneurial flavor from the Western self. . . . The esthetic is an aspect of the economic, as the economic is an aspect of the esthetic. So to carry on — as some still do, in however desultory a way — the project of isolating the market value of an art work in the hope of excluding that supposedly crass, vulgar consideration from the realm of the esthetic is as misconceived a procedure as the formalist protocol that tried to banish content from the realm of form. . . ."

Seeing the entangled relationships and complex forces of the art world, however, some powerful people were criticizing collectors, dealers, museums, artists, and auction houses, saying they were manipulating the market. As we brought many formidable members of these groups together, some came to believe they knew a great deal. Listening to people who had their own agendas, which did not include the betterment of the Whitney Museum, they made assumptions that we gave preferential treatment to artists represented by certain galleries. That our curators only visited certain galleries. That there was collusion between dealers and the Museum. Nasty rumors, harmful to the Whitney.

The Whitney's delicate balance — between trustees and staff, between the need for money and the need for integrity, between its mission and its fund-raising — was at risk. Large sums of money and costly works of art were changing hands. The power that accrues from owning a superb painting is extraordinary. And if you can meet the artist, too — what a fine fellow you are! You, too, can be immortal! It surely follows that *you* know what's best for your Museum, and you should be making the decisions.

We spoke, too, of the exhibitions then in the Museum, including "Elizabeth Murray: Paintings and Drawings," sponsored by Emily Fisher Landau, one of our most committed trustees. We discussed Murray's eccentrically shaped or fragmented canvases, with household objects of offbeat, beautiful colors changing before our eyes into

abstractions, work that moved me by its beauty and strength, as well as by the associations I made with life at home — the dailiness of babies, food, drink, clothes.

Tom suggested, in November, with my enthusiastic approval, that small groups of Trustees and staff be established to discuss specific topics. They would meet once or twice for extended discussions and report to the board. Topics and their descriptions included:

Collections: Private collectors are not donating masterworks to the Whitney Museum of American Art, and our acquisition funds do not allow the purchase of major works. Under these restraints, what should guide the staff in acquisition programs and how can these difficulties be overcome?

Audience, hours, food: Museums have a particular audience whose habits are constantly changing because of the dynamics of the work force of the United States, better levels of education of the population, and increased interest in American art. Do our hours of operation accommodate the available time of our audiences? How can our food service and opportunities for relaxation within the Museum best accommodate the needs of our audience?

Future options: If difficulties in expanding the Whitney Museum of American Art are not overcome, what is the future of the Museum in terms of temporary exhibitions, permanent collection, acquisitions, and other aspects of operations? Should attention be focused on a time limit for pursuing the expansion project before considering other options for operations?

Compensation: New York City is among the most expensive cities in the United States in which to live. The levels of compensation at the Whitney Museum of American Art make it extremely difficult to hire individuals with family responsibilities and individuals not currently living in the city. How should the issue of compensation at the Museum be addressed in relation to the cost of living and needs of employees in New York City?

We assigned specific and appropriate trustees and staff to each discussion group. I thought this a wonderful idea. It would refocus board members on real issues, bring them together, and give them a much-needed assurance of active participation in the Museum. Of moving ahead, despite our expansion woes. Even Bill, I hoped, would be

caught up in this. But despite my calls to his office, the November trustees meeting, at which we had planned to announce the discussions, including the chairs of each group, passed with no response from Bill. Weeks more, then months, went by. In January 1989, Joan Weakley nudged Bill with a memo to his secretary, asking her to remind him to call the projected chairmen. But nothing happened.

Apathy was growing.

Thirty
1989

*I*n Beijing, a thousand dissident students were killed in Tiananmen Square.

The Ayatollah Khomeini announced a death sentence on Salman Rushdie for "blasphemy" in *The Satanic Verses*.

The Berlin Wall was demolished.

Václav Havel, after being jailed in February, became president of Czechoslovakia in December.

The Whitney reported an operating surplus for the third consecutive year. "This success is a source of pride to the trustees and staff and a reflection of loyal, sustained patronage. But should we judge a museum by its financial solvency? No. It is a museum's programs, which contribute to the understanding and enjoyment of art, that should capture our attention," Tom wrote in the *Whitney Bulletin*. He was right, and he was defining his clear responsibility. But the board, besides fulfilling their mandate to insure fiscal stability, needed to be familiar with those programs in order to support them intellectually, as well as financially. Otherwise, their enthusiasm and therefore their contributions would decline.

I saw that familiarity, that enthusiasm, waning.

January 1, 1989, a headline in the Arts & Leisure section of the *Times* awakened us rudely to the new year.

THE WHITNEY TODAY: FASHIONABLE TO A FAULT

Calling new art seductive, dangerous, and sinister, Michael Brenson spoke of it as a force that gave a privileged elite "the authority to decide what is good and bad, what is in and out, who belongs and who doesn't, what is mainstream and what is provincial." The Whitney had

made the new itself a value, he claimed, saying, "No New York museum seems more trendy and hip, and none is more at sea." The Whitney's curators lacked art history credentials and were too young. The Museum placed too much emphasis on the Biennial; blurred the distinction between gallery shows and museum shows; showed "hot" or mainstream artists; conceived of and installed exhibitions badly; and produced catalogues lacking, according to him, "independent and scholarly perspective."

Brenson ended his article by saying, "It would be nice if the most important museum of American art in the world would stand for something that matters."

I was desolate. I knew the respect many of our trustees had for Michael Brenson. We ourselves had invited him for dinner several times, liking him, feeling his was an intelligent voice, and wanting him to understand the Whitney, its background and history, as well as its present. I still believe this article influenced all the events of that ill-starred year. It appealed to those who didn't have the security to trust either in their own opinions, in the Whitney — both as it was and as it was changing — or in its traditional *and* new goals and ideals.

To Brenson's criticisms that we were only interested in the new, we could point to a number of distinguished historical exhibitions we'd had, and continued to have. With our emphasis on the Biennial and other contemporary shows, we were following our tradition — respecting our particular history. We could point out the scholarly excellence of Barbara Haskell's catalogues and exhibitions of such artists as Milton Avery and Marsden Hartley, among others. As to "hot" artists, were they not, often, the best artists of a given time? Was it not the Whitney's obligation and traditional role to show these artists, in a more extended way than a gallery could, and to a different, wider audience? There was no doubt in my mind that the gallery audience was a small, "in" group of the art world, whereas museums welcomed a bigger, more diverse populace.

Upset and hurt, we pondered a response: Who should write it, one of us, or an outsider? We finally decided that arguing with the media was no use. I now believe we were wrong. Even if the *Times* had never printed it, we could have mailed copies to the trustees, many of whom were distressed and didn't have the information necessary to counter the attack — either to themselves or others. At least we would have gone on record.

Looking back at that year, I see we had eleven exhibitions, which seemed to provide the kind of balanced programming Michael Brenson denied we tried for. Three are historical:.

"Frederick Kiesler," 1892–1965, visionary artist and theoretician from Vienna, best known for his innovative architecture and stage designs, who brought twentieth-century European movements such as Constructivism, Futurism, and de Stijl to the attention of the American public.

"Treasures of American Folk Art from the Abby Aldrich Rockefeller Folk Art Center." The finest examples from the preeminent collection of American folk art in the world.

"Thomas Hart Benton," tracing his career from his early explorations of Impressionism, Cubism, and Synchronism through the evolution of his epic representational style.

Two one-artist exhibitions:

"David Park," a California artist, now dead, who moved from early quasi-abstract gestural painting toward figural and representational work.

"Yoko Ono," a central figure within the vanguard aesthetic of Fluxus, a loosely affiliated group of musicians, painters, dancers, and visual artists. She initiated an interdisciplinary mode of performance and object art that used chance and audience participation to blur the distinction between art and life.

Two survey shows:

"The Biennial," the Whitney's invitational survey of recent developments in American painting, sculpture, photography, film, video, and mixed-media installations.

"Image World" explored the ways in which the mass media have influenced American art of the past thirty years.

Four exhibitions from the permanent collection:

"3-Dimensional Narratives," an exhibition of sculpture that creates the conditions of mystery and inaccessibility.

"Twentieth Century Art: Highlights of the Permanent Collection."

"Edward Hopper."

"Art in Place: Fifteen Years of Acquisitions," with nearly three hundred of the finest works to enter the collection under Tom's directorship.

This list excludes the many Branch Museum exhibitions, eleven traveling exhibitions from the permanent collection, the forty-week

"New American Film and Video" series, and a wide range of other programs.

At the February trustees meeting, Tom stated his view: The article was primarily an opportunity for Michael Brenson to express resentment about current conditions in the art world. Paul Goldberger's piece in the *Times* about Michael Graves's third design, he reminded trustees, had been positive. Discussing the issue of criticism in general, Tom said it was difficult to be a trustee of the Whitney because of the controversial nature of its programs, and urged trustees to attend educational events at the Museum, the best possible way to understand those programs, and enable them to better respond to questions about the Whitney. He went on to quote from several negative articles by Hilton Kramer, remarking Brenson wasn't the first critic to attack the Museum nor would he be the last.

Ray Learsy said he felt the staff should seriously consider Brenson's criticism about scholarship in the presentation and installation of exhibitions and in catalogues. Coming from a trustee, this was a worrisome view, a signal that trouble was brewing. As a member of the National Council on the Arts and a serious collector, Ray's opinions were respected. Tom responded by suggesting a discussion group for trustees, led by outside scholars, on the nature of scholarship in contemporary art and the role of scholarship in a museum.

When Tom announced that trustee giving for fiscal year 1989 had reached $1.5 million, a new record, I was somewhat reassured about the bad effects of the article.

The Museum must now file new applications for demolition of the brownstones, based on hardship; and also must occupy some portion of each building, so they would be tax-exempt. This required some construction and repairs. More money, more time. Despite the stalled project, Bill remained optimistic — at least, in public — about a successful expansion.

In early March, Sally Ganz, Sydney, and I went to Anguilla for a week of sketching and writing. In the mornings, Sally and I wrote on our verandas by the sea while Sydney sketched. One day, Jasper Johns invited us to St. Maartens, just a short ferry-ride away, and we set off gaily to his house in a surprising downpour. Jasper had prepared lunch: a bowl of icy gazpacho; shrimps sent by his mother from South Carolina, arranged on a big platter with lettuce, sliced potatoes with

yogurt, chopped red hot peppers, and parsley; and for dessert, sherbet he'd made with local fruit, tart and wonderful. After lunch, Jasper walked me through his garden — tiny purple orchids growing in trees, masses of blue flowers on tall bushes, loblolly pines whose name I happily rolled around my tongue, sea grapes, and thunbergia — vines with vivid blue or pink flowers.

Jasper's South Carolina shrimps had whirled me back to a small pink house on the Inland Waterway north of Charleston, where my parents went to shoot ducks. In the little village of McClellanville, shrimp boats chugged through the inlet and unloaded their tasty cargo. We'd bring home a bucketful for dinner, and exclaim with delight at the fresh briny morsels. I'd felt so close to my parents, then. Far from the bigger world of friends and activities, they'd seemed so happy — and they'd had plenty of time for me.

A beautiful, heart-rending service in remembrance of Louise Nevelson took place in the Weill Recital Hall, at Carnegie Hall, on March 28, 1989. Invited by Bill Katz, Diana MacKown, and Jasper Johns, guests were ushered to their places and heard "An Hour of Song." Jessye Norman sang, James Levine played the piano, and Linda Chesis played flute for a program of music by Richard Strauss and Maurice Ravel. Looking at the photograph in the program of Louise's precise, angular profile above a brocaded robe still gives me gooseflesh. A remarkable artist, a vibrant person; I remembered the times we'd been together, especially the evening Louise had led Sydney and me through her palace. One room held her black-painted constructions, looming against black walls like the shuttered structures of a wartime city; another glowed richly gold like a fabled El Dorado; another was all moonlight, bridal, mysterious white shapes melting into one another. Black cats raced by us in rooms hung with the richly embroidered robes Louise loved to wear; in them, she looked as queenly as Nefertiti or Cleopatra. Then, suddenly, we emerged into a high-ceilinged space and, as we sat drinking and talking, it suddenly filled with men bearing delicious dishes of beans, greens, rice, squashes, turnips, breads. Then, astonished, we realized who they were: Bill Katz, John Cage, Merce Cunningham. Memorable, wonderful, as magical as Louise herself, with her furry eyebrows, long lashes, kohl-rimmed, piercing eyes, and the deep melodic voice with which she spoke riddles and tales.

Listening to Jessye Norman's deep swelling voice, I mourned those I'd loved and those I'd only admired from afar. The darkness and finality of death, the separation no one can repair, were communally in that room, in that hour. And also their converse, the creativity that held us all together.

May, and it was national committee time. This year, another theme: the jungle. Appropriate, in view of events to come. Tom made sure each member's packet contained a length of colorful jungle-patterned cotton, with instructions to incorporate it into their outfits for the Saturday dance at the Museum.

On Sunday, the last day of the meeting, we lunched at Mrs. John Hay Whitney's house in Manhasset, Long Island. Betsy Whitney, the widow of Mum's first cousin Jock and a former Whitney trustee, welcomed us warmly and showed us everything: gardens, greenhouses, pool, tennis court, the Impressionist paintings. Filled with English furniture and silver and downy chintz sofas, the house had the unmistakable casual, insouciant ambiance Sister Parish had created with her new partner, my talented daughter-in-law, Libby Cameron. It was all comfort and style. Perfect maintenance! Gleaming brasses! Flowers, at their peak, in profusion, delicately scenting the whole house!

But to others, mostly trustees, Tom was becoming more willful; he was playing the clown and playing favorites. Inseparable from the Whitney, he was unbearable to those who scoffed at him.

Tom and I continued our memos to Bill, including an update on trustee contributions, with a note from the development office: "Tom is concerned about two main issues: Are we taking care of those who are being very generous and are we addressing the problem of those who are not?"

These were serious problems, demanding attention. Most trustees need nurturing in order to feel involved and appreciated, and a board needs weeding out — for obvious reasons, but also to ensure that active members don't resent the inactivity of others. In a continuing effort to make up for Bill's inaction, Sydney and I gave a party for Emily Fisher Landau, to thank her for her latest generosity: the sponsorship of "Art in Place, Fifteen Years of Acquisitions." This show summed up Tom's first fifteen years as director of the Whitney. A spectacular

installation, a magnificent affirmation of his emphasis on acquiring the highest quality works of art, the show was praised by trustees and, this time, even by the media.

The catalogue reminds me anew of Tom's convictions about the Museum, his interpretation of its history, and his vision for it. Especially of his deep commitment to it.

When I became director of the Whitney Museum of American Art in 1974, my first priority was to determine the true nature of the institution: how it reflected the ambitions of the founder and the leadership which had guided it through its history, a period when American art had achieved international preeminence. It was the permanent collection of twentieth-century art that had attracted my attention when I was offered the job, and so I decided to attempt to unravel the mysteries of how it had been formed.

The permanent collection of a museum is an extension of the intellectual and aesthetic concerns of the institution's leaders. The Whitney Museum was totally supported by its founder, Gertrude Vanderbilt Whitney, from 1930 until 1942. Since her death, her daughter, Flora Whitney Miller, and then her granddaughter, Flora Miller Biddle, have played the major leadership roles as trustees. Outside trustees were not invited to join the board until 1961. The professional leadership, until 1974, was always selected from long-term staff members who perpetuated Mrs. Whitney's concerns, as reinforced by her daughter and granddaughter. For forty-four years, from 1930 until 1974, these circumstances assured that the Whitney Museum was guided by the spirit of its founder, who believed that the Museum's primary function was to assist American artists.

After summarizing the Museum's history, Tom concluded:

"The works in this book attest to our attention and loyalty to the history and established strengths of the Museum, to our acknowledgment of past omissions, and our effort to recognize quality in our own time."

Some of the anecdotal pieces that follow are scattered throughout this memoir, since Tom and I worked together on many of the acquisitions. Each was an old friend, bringing its own, often sweet memories — of an artist, of a dedicated collector, of a conversation or a trip — or even a tussle — and also of the many hours Tom and I spent working out ways and means to accomplish our goals. There, for example, is Claus Oldenburg's *Soft Toilet, 1966,* a gift from Sally and Victor Ganz, who remembered even Alfred Barr, great connoisseur though he was,

asking Sally, "Is Victor really going to keep it there?" He was standing in their dining room, elegantly designed by Robsjohn-Gibbings, where a large, gleaming vinyl toilet in white and blue was the focal point. As Tom wrote in his essay about the piece,

"It is a regrettable situation that there are so few people with the necessary knowledge, experience, generosity, and integrity to advise public institutions in the way Victor Ganz did. As a private collector he was motivated by a desire to assemble objects and understand them. As a patron, he had one agenda in our long association, the Whitney Museum and its relationship to the art of our times."

Tom invited trustees and spouses to walk through the exhibition with him, and as we toured through the rooms he recounted some of the livelier stories about individual works. Revved up by the high quality of the art, either given or bought within their time at the Whitney, often with their money, trustees were on a high, as we took the big blue elevator down to the Lower Gallery for a candlelit dinner. I felt a surge of enthusiasm from the entire group. At each table, a curator led us through a conversation about the Museum, the collection, the addition. The dream.

And then, and then . . .

Tom got up to make a toast, saying, incredibly, "We don't know where we're going."

Then he expanded on that assertion. Disappointments during the building project, leadership we lacked, art we hadn't bought, faith we didn't have, all, all, came out, at the most inappropriate possible moment.

It was honest, yes. Perhaps too honest. Tom had exposed his deepest fears, for all to see — just as trustees were particularly aware of his most significant accomplishments. Why, *at that moment*, was he so self-destructive? I have so often wondered.

The curators were aghast.

The trustees were absolutely crushed.

In mid-August, Sydney and I traveled to France, to an ancient stone house whose foundations held Roman building blocks, from whose garden we looked across the lavender fields and vineyards of Provence to Mount Ventoux's craggy peak. We walked along village streets in the sparkling early mornings, to pick bursting purple figs and buy buttery croissants. In the soft, misty evenings, we walked again, to smell

the harvested grapes, to see what artist Joe Downing had painted in the lofty studio where his feathery brush strokes covered old terracotta roof tiles, a weathered door from a crumbling barn, or a large, hand-woven linen sheet. Sundays, we heard the church bells toll from our high white bed. Cooking pistou in the warm buzz of bees flying in and out the kitchen window, walking ancient paths, exploring fields and forests, abbeys and castles, we felt so far away from Museum problems, from the worry over possibly not being able to sell our home in New York and pay my brother Leverett his share. From the dailiness of life.

A month later, Joan Clark stepped off the train in Avignon and we drove her to our house. Seeing Joan was wonderful — she's like rays of light in her beauty and lively, warm spirit. We showed her our favorite things; on her last day, we visited the Cistercian abbey of Senanque, all three of us moved by its austere beauty. Suddenly, as we stood alone in the grey stone church, we thought we heard choirs of angels. We hadn't noticed a lone singer standing in the middle of the sanctuary, producing the music of both organ and choir, swelling, filling the whole space. "Organum," he called it, but it seemed like magic to us.

Reluctantly, Joan brought us back to earth. She had had a call from Leonard Lauder. Many trustees were dissatisfied, he'd said. They thought Tom should resign. Did she agree?.

Joan had asked Leonard, "What does Flora think?"

"She'll go along with it, for the good of the Museum."

Of course, I had said no such thing. It was an assumption of others and I would certainly have denied it. But everyone at the Museum knew we were abroad until the end of September.

What was going on?

On the plane from Lyons, having lunch and eating the fruit Joe Downing had picked from his jujube tree for us, I started to cry. Why did I mind leaving so much? Was it Menerbes? Our village life? Or was it the prospect of going home to everyday business once more, to Museum problems, to selling our house — or to not selling it?

Menerbes had seemed like home, warm and secure, beautiful. "People care about each other in the village," artist Jane Eakin had said. "I know everyone in the village. Come back and live here."

Soon after our return to New York, Bill Woodside asked me to meet him for breakfast at the Carlyle. I noticed Tom sitting across the room from us, waiting for a guest who never arrived, as Bill spoke to me

calmly, as if about a routine matter. Listening, appalled, I kept glancing at Tom, isolated like a figure in a Hopper painting, an eerie backdrop to Bill's words.

He planned to ask Tom to resign as director, as of June 30. To give him one year's salary; to start the search for a new director immediately. To halt the building project right away. Although, Bill insisted, he himself had never brought up this idea, an overwhelming consensus of the board showed they were dissatisfied with Tom's leadership. The subject had came up spontaneously, as he'd spoken with each member in the past weeks.

Trying also to remain calm, I answered that the Museum stood for continuity and stability. Order, not disorder. We'd had only five directors in the Museum's history, and had never fired one; each had led to the next in an easy transition. Finally, I said that Bill himself, not Tom, was the problem, because he hadn't formed the good working relationship with his director so necessary for board and staff relations, had never taken the time required to be a good president.

Bill barely reacted. He seemed singly determined, untroubled by the turmoil he would set in motion. Maybe, I thought, he's acting out the anger he'd felt when his chosen successor, Jerry Sigh, had decimated American Can earlier that same year, destroying the company Bill had led over the years he'd been chairman.

"I'm afraid I'm somewhat emotional about this, Bill," I said, as we left, and he answered with a hug and words that caught me by surprise: "But all these things are emotional issues, I know that."

Nevertheless, *he* didn't seem to care.

All this time, I could see Tom waiting. A bizarre situation for me — looking right at Tom, listening to Bill's plan.

Heading straight for the Museum, when Tom returned I asked him and Jennifer Russell, now the Whitney's associate director with a leading role in running the Museum, to meet me in the trustees room, and tried to warn them. Tom, though, didn't seem to realize the seriousness of what I was saying — that Bill was blaming him for the dissatisfactions of trustees, that, for Tom, it was a dangerous situation. We agreed that trustees were frustrated — they didn't understand the lack of action, the loss of momentum. All that seemed obvious to us. Perhaps that was why Jennifer and Tom didn't react, didn't really believe the serious threat I was describing. I couldn't figure it out. I saw disaster ahead. I could hardly sleep, that night, and for many to come.

On a brilliant Indian summer morning, Bill came to 110 for a breakfast of croissants and coffee.

I argued for Tom.

He said the board was determined and so was he.

Why?

Tom has been director long enough. He's getting older. His energy seems diminished. We need a new vision. The new building seems stalled.

As I pondered to myself if I should call other trustees, thus risking a dangerous fight on the board, Bill said he hoped I'd agree.

I told him I never would.

The next week, Bill visited me again. He reiterated his determination to ask Tom to resign.

"I don't agree, but you're president," I told him. "You have the power to do whatever you like."

In my heart, I was confident the board would support Tom. Apparently, though, my words then were all he needed to act.

The Museum had never had a better week in terms of giving "perks" to its "family." Tom's imagination and energy were soaring.

On Monday, October 30, after a print committee meeting, he arranged a dinner at the Museum for trustees, their spouses, and Hopper collectors, in honor of the final day of the popular Hopper exhibit.

On Wednesday, a reception for the many new members and a dinner for the drawing committee and a few artists at collector David Supino's apartment.

On Thursday, Tom invited trustees, acquisition committee members, and their significant others to the kind of evening he usually organized for the national committee, which some trustees envied. So this time, our most important patrons visited artist Terry Winters, whose retrospective exhibition was soon to be held at the Whitney, and his wife, art historian Hendel Teicher, in their Tribeca loft. The arrangements were perfect. Everyone seemed most appreciative. Afterward, at Barocco for dinner, with a number of artists scattered among the tables, we toasted Tom.

In the midst of all those happy events, once again Bill told me, sotto voce, that he planned to wait until they were over, then ask Tom to resign.

What if Tom did not accept his suggestion? I asked.

"I am sure he will, for his own sake, and for the sake of the institution. I will have a scenario ready by the time we talk."

Why didn't I call Leonard? Why didn't I insist on the proper procedure? On informing trustees *first*, or at least the executive committee? Why did I become paralyzed?

Of course, I supposed Leonard was involved. And I had gone into a kind of denial, pretending it couldn't really happen. I could have taken steps to prevent it. Or at least to have had it happen in a different way.

Friday, Bill called. He had asked Tom to resign. And Tom, he said, had taken it calmly, like the gentleman he was. He was thinking it over for the weekend and they would speak Monday.

I finally managed to reach Tom in his office early the next morning. He had decided to fight. Bill had told him he had an overwhelming consensus of the board, but after talking to a few trustees, Tom was already convinced that was untrue.

Now trustees, distressed, started to call. What did *I* think? For one thing, the process was wrong, I said. The director has done a great job, and should continue to do so. The board must meet, we must deal with this together.

At 4:00 on Monday, Bill came to 110. He was upset that Tom had been calling around. "Considering Tom's personality, his strong leadership, how could he not?" I asked.

I would call a board meeting, I told him, but Bill wanted to keep the whole affair quiet.

Impossible, I told him; we must discuss it as a family.

While we were talking, Elizabeth Petrie called and made several points: that Woodside had made a mistake; he'd handled it terribly, insensitively. That Tom's turning to trustees was self-destructive, selfish. That the total picture was very bad for the Museum.

A vote? she would probably vote against Tom.

What to do? Have a trustees meeting, deal first with the building project. If they decided to stop it, that would give Tom a shield to leave.

I listened, but I didn't hear.

Elizabeth had always thought that the trustees' frustration at the stalled expansion project had ballooned into anger at Tom. Her idea of linking them into a plan of action was brilliant. If we had followed her advice, we might have been spared a lot of grief and pain.

But Tom, besides fighting his own battle, was also protesting Bill's

unfair, unilateral action on behalf of the many museum directors who had recently been unjustly fired, but who, needing jobs to support their families, could neither afford to fight nor afford to risk the reputation of being "difficult."

We set the trustees meeting for Wednesday.

"If Victor were here, it would never have happened," Sally Ganz said sadly, as we were driving home one night.

On Tuesday I had another breakfast with Bill, at the Carlyle. I felt more confident, with Tom wanting to fight, and told Bill it was a question of him or Tom.

"Don't you think we could work something out?" he asked.

No, I answered, but back in my office I thought better of it, and called him, saying maybe we could go back to the situation as it was, and then review the building program and the trustees' complaints in an orderly way.

Tom agreed to talk with Bill. He promised to do his best to mend matters. Tom thought I should be present at their meeting, but I believed they could work things out better by themselves.

I was wrong.

Bill had opened their conversation, Tom told me, with insults, saying Tom was an arrogant son-of-a-bitch and a goddamned snob and that he had an overwhelming consensus of the board for Tom's removal.

He said that the board had problems with Tom's judgment about art, which he did not want to discuss.

Only then did Bill broach the subject of a reconciliation.

When Tom gave his conditions, Bill ended the meeting.

On Wednesday, Leonard came over to 110. We talked for an hour. He was very persuasive, very reasonable, even very sympathetic.

Wary, trying to be polite, I said I'd been lied to by Bill.

We arranged to meet later that day, with Bill.

Leonard was worried. We were in a dangerous situation, considering public relations, as well. And I, being unpredictable, exacerbated his fear.

The comments from trustees were varied: some felt Tom had been a terrific director, but fifteen years was enough, that anyone would begin to get stale. Some said Tom should have another chance. Others believed the process was all wrong. Tom shouldn't leave now, they said; trustees need self-evaluation. Still others felt the main problem

was the building; it was Tom's fault we had failed, the Museum was ridiculed for that, they thought.

At 2:30, Bill and Leonard came to my office. They assured me that they agreed with me, we were seeking to reunite the board, therefore *no votes of any kind* would be taken. (No official vote could be taken, anyway, since the notice of the meeting was insufficient.) There was to be no discussion of Tom based on personality. No inflammatory conversation. No one should take notes. Tom would not be present. They asked me to read them my notes on what I'd say to open the meeting; naively, I did. Bill outlined what he would say: a short history of why he did what he did, then a suggestion of a cooling-off period, with the matter referred to a committee.

At 4:00 the trustees met and I made a plea for unity, for the spirit of a family, for no votes, for a cooling-off period.

Bill followed: the meeting was to discuss calmly the question of Tom. Bill loved the Whitney. He loved Flora.

And then, despite his promise, he inflamed the trustees by telling of a threatened action by B'nai B'rith's Anti-Defamation League in the first year of his presidency, only averted with the great help of Leonard. He was not Jewish, but Migs (Bill's wife) was. He understood such things, said Bill.

The implication was clear. Tom was being accused of anti-Semitism.

Bill said that he'd asked Tom to resign in order to be kind, in recognition of his great accomplishments of the past, and to save him from being fired.

But, in the ensuing conversation, it became apparent that at least ten, if not more, trustees had *not* been approached, as Bill said several times they had been.

Brendan spoke eloquently of Tom's fine leadership, and emphasized the necessity for board involvement in any such proceeding. He was sure, he said, that Joel had spoken to many trustees individually to convince them that Tom should leave, and now Brendan went on, saying to him in front of all the trustees that Joel had a moral responsibility to the Museum to give facts and reasons for his feeling. To say *why*.

But Joel answered that he had no such responsibility and would not.

Someone proposed a vote to decide whether to vote to give Bill a consensus with which to pursue his demand for Tom to resign.

Despite Bill's and Leonard's promise of no votes, they did allow this vote: two to one, in favor of a straw vote.

At that crucial point, a hero emerged. George Kaufman, at most meetings a quiet trustee, rose, insisted on being heard, and won the day with a motion to refer the matter to the executive committee, with a few additional trustees.

Bill left, triumphant, borne on a cloud of glory by a smiling group of trustees, revealed in this parade as his cohorts in the shameful plot.

The board was hopelessly split.

Despite sorrow and distress, I went on to the Library Fellows' celebration of the new book by Richard Tuttle and poet Mei Mei Bersenbrugge that the Whitney had published. Richard and Mei Mei had met and fallen in love through this project. Seeing the joy in their eyes helped a lot to renew my own sense of life and love, to put things into some perspective.

At the meeting of the beefed-up executive committee, Bill read his notes of trustee criticisms, and I challenged Bill with my criticisms of his presidency; but the committee voted, 7 to 3, to recommend to the board that Bill should again ask Tom to resign. I was unprepared for the ugly insinuations and feelings surfacing among a group I'd perceived as congenial and intelligent human beings, all of them dedicated to the Whitney — mostly people Tom and I ourselves had brought on board.

A curator called: the staff could help. To some of them, it appeared that Tom didn't have the support of the board. So few trustees had spoken out in favor of Tom — maybe Tom should accept the idea of resigning rather than rupture the institution by being fired? What we'd built would continue. Don't topple it. An easy transition was best, this curator thought.

This was the voice I heard but didn't listen to, this, the other option. Caught up in the struggle, determined we should do the "right thing," the "fair thing," for Tom and, I thought, for the Whitney.

Was I wrong?

After all, the staff were those I felt closest to; if some had doubts, why didn't I pay more attention? Was this one curator speaking for most of the curators, for all of them, perhaps? (No, others told me they'd support Tom to the end.).

Did trustees have any idea what was involved in actually running a museum? What did "vision" mean? The dictionary defines it as: "Unusual competence in discernment or perception; intelligent foresight."

Tom, I thought, had plenty of vision.

"Fifteen years is too long," "Tom is tired," were some of the criticisms we heard. And the list went on.

I was certain that Larry Tisch was a pervasive force. He was capable of influencing his friends and his business associates. And, surely, he still bore a grudge against Tom. But how could we counter that might? That ill-will?

We couldn't.

Although Larry's role in the "cabal" was probably the most important, he was invisible, an éminence grise.

Nothing appeared in the media until Sunday, December 10, and then it was just an item in a gossip column. But on the following Tuesday, Grace Glueck wrote an article in the *Times* headed WHITNEY DIRECTOR SAID TO BE UNDER FIRE, claiming as her sources "board members who would not speak for attribution." Since we had all agreed not to talk to reporters, this was further evidence of dissension and lies. Bill had denied rumors that he had asked for Tom's resignation, but he'd added, hurting any tender feelings I might have had left, "The Museum is still coming out of its family stage." Tom, Glueck claimed, had "mustered support among a minority of the board's trustees, including Flora Biddle, the board's chairman."

From then on, the media had a feast. "The Whitney Museum is participating in the art world rather than standing outside it, but that's part of what it means to be a museum of American art in New York City now," Arthur Danto wrote in the *Nation*.

The *New York Observer*'s Clare McHugh, on the front page of the Christmas day issue, asked, "What is it about the Whitney that generates such intense feeling?" Concluding that it was a variety of issues, she summarized the Museum's history, then quoted "sources at the museum": "Mrs. Biddle is Mr. Armstrong's staunchest supporter among the trustees. 'She thinks that as long as he's there she'll be controlling the place,' one staff member said."

I fumed. It was *I* who had originally supported strongly our decision to have nonfamily trustees, *I* who had urged a first nonfamily president (David Solinger), *I* who, as president myself, had set a term limit for the presidency, *I* who had passed the baton to Bill, *I* who had wanted the Museum to be a truly public institution.

I lay awake long hours, examining my motives, wondering whether I was helping to destroy or preserve the Museum, feeling sometimes guilty, sometimes angry.

The next trustees meeting was remarkably easy, since the work had been done ahead of time. Bill, Leonard, or I had spoken with all trustees. Bill and I proposed a committee to "review the current status and consider future directions of the Museum, including the performance of the director, and to report its recommendations to the full board of trustees early in 1990." The motion was unanimously approved, and Jules was appointed chairman. From then on, Bill, Leonard, and I were removed from the process, which continued for several months as the committee Jules appointed interviewed all trustees in depth. The Museum continued to function, with Jennifer Russell taking increased responsibility.

Nineteen eighty-nine ended. We were launched into the last decade of this millennium.

Following is text from a letter to Bill from an interested observer, Robert Rosenblum.

Dear Mr. Woodside,

I was disturbed to read the news about the current dissension over Tom's directorship. I hope it isn't presumptuous of me to offer my own opinions; but as a decades-old member of the art world (I'm a professor of fine arts at New York University, a member of the Museum of Modern Art's Dept. of Painting and Sculpture Acquisitions Committee, a trustee of the Hirshhorn), I have a serious view, I think, of the Whitney's achievements.

Above all, I believe — and this against the constant onslaught of cheap journalistic attacks on the Whitney — that no other major museum in Manhattan (i.e. the Met, MOMA, & the Guggenheim) can come near its exhibition record. Assuming that the Whitney's mandate has been to keep us all fully informed about the widest range of American art, from c. 1900 to the present, then it has done exactly that in an amazing abundance of shows that, for number and coverage, put other museums to shame. Where else could we have seen such astonishing diversity — from Sargent to Salle, from Hopper to Turrell, from Kiesler to Katz, from Storrs to Red Grooms, from Demuth to Warhol, from Avery to Johns, from folk-art to high-style design? The list is mind-boggling, and happily includes exhibitions originated by other institutions (a practice other NY museums are often too haughty about, leaving many traveling shows unseen here). And there have been first-rate period shows as

well by the Whitney's own curators (I'm thinking, for instance, of BLAM, and of the '50s sculpture round-up). And I would cite the admirably quiet achievement of presenting the Mapplethorpe show without ever raising the red flag of censorship, public decency, etc., that has disgraced the Corcoran and its director. This, too, is a tribute to the firmness of the Whitney's conviction that the fullness of our changing moral codes and values should not be hidden from the museum-going public.

I would applaud as well the selection of Michael Graves for the Whitney extension, a choice that, whether one liked it or not (I happen to be a fan of the initial design), indicated an infinitely more adventurous stance than that taken by most museum directors who would select tepid, uncontroversial designs for a new building campaign.

I also find that, despite predictable backlash in the press, the Biennial is a thriving institution important to NY art life, where we can immerse ourselves in a buoyant anthology of what's up and down, in and out, and where we can all learn and argue. No other museum here offers this kind of regular, feisty round-up. And I would also cite the many lectures and educational activities sponsored by the Whitney. . . .

All of these assets, and countless others, strike me as immensely positive. I could certainly not muster up this kind of enthusiasm for any of the Whitney's competitors in the NY museum world. And I cannot help concluding that the director of an institution that has done so much in the last decade must be steering it firmly in the right direction.

And Arthur Danto addressed the following letter to Bill:

Dear William S. Woodside:

I would move rather carefully out of what the *Times* records you as describing as "the family stage" of the Whitney, on its evolution into just another museum. Yours is a unique and remarkably personal institution, it has a personality unlike its sister museums in New York, it has a human side that none of the others have, and which in my view is priceless. I have been a frequent critic of your shows and even of your practices in my column in the *Nation*, but the Whitney remains for me the true New York institution, the one that plays the role and takes the heat and runs the risks of the true leader in the arts in a living artworld.

In my view, Tom Armstrong deserves enormous credit for the Whitney's vitality over these past years, and I would regard him as priceless among directors. I am sure there are frictions within the institution of which I am unaware — there always are — but as an interested and concerned outsider, I urge you to think long and hard before doing anything drastic.

I do wish you well, personally and institutionally, and hope that you can survive this crisis without losing someone as conspicuously valuable as Tom is.

Because of my respect for them both, Arthur's and Robert's letters were most important to me. Bill, however, never answered or acknowledged them. Presumably, they, and all the many others, meant little to him.

In an eloquent letter to the board, my daughter Fiona first gave her qualifications for writing: not only her lifetime of exposure to the Whitney, but her current experience on the print committee and the budget and operations committee, her volunteer work at the membership desk, her observations as an art historian and a Ph.D. candidate at Columbia University, her professional contacts with members of the art community, and her ability to make comparisons with the museums she'd worked in.

My four years as a member of the Print Committee have left me with the impression that the director and curatorial staff have well-founded, precise goals that they wish to meet as far as acquisitions are concerned. . . . Such exhibitions and publications as "Art in Place" are a testament to the sound acquisition program conceived by the Whitney's current director. His vision about the collection continues to lay a solid foundation for the Museum's future. . . .

The Whitney is the liveliest of New York's museums. . . . Where else can one go to see at the same time a scholarly exhibition of the work of an American modernist, a controversial program of videotapes by American filmmakers, a comprehensive survey of twentieth-century American art composed from the museum's collection, and an exhibition that traces a significant theme in American art from the beginning of the twentieth century to the present? Consider also such education programs as the Independent Study Program, the annual Whitney Symposium for art historians, and the multitude of gallery talks and tours for schoolchildren and adults. The variety of such exhibitions and programs reveals the

director's conception of what the museum should be. And it is in almost all instances both engaging and intelligent.

It is time to look at the Whitney's uplifting spirit, to see the joy and wonder in the faces of all those who look at the Calder Circus. The Whitney has achieved a vitality in the last fifteen years unparalleled by any other museum I know. That is not to say that everyone likes it, only that it provides a challenging forum for the most significant issues in American art today. Credit for this must go to the Whitney's director.

The increasingly active role Fiona was taking at the Museum gave me great pride and pleasure. She was "hanging around" the Museum, the only way I know to become intimately connected with it — a process very few trustees had either the time or the interest to pursue.

Thirty-one

*I*n January 1990 I met with the committee. I remember feeling I couldn't possibly convince that group of anything, that their minds were made up. After the meeting, I made notes only of my concern about how the Museum could survive with a split board, whether the "losers" would leave the Museum, how to heal wounds made by cruel words and deeds. Jules and the other members told me, emphatically, that everyone they'd spoken with insisted I remain central to the Museum's future, no matter what happened. But why, when they disagreed so profoundly with my views? I asked. "You are the only one who can heal it. You are the soul of the Museum," they said oxymoronically, each in his or her own way, knowing that for me the Museum would always come first.

Frances and Sydney Lewis sent me a copy of her letter to Bill:

"How does one get rid of a person when there are no valid charges? Smear tactics!

"The unfounded rumors that Tom Armstrong is an anti-Semite and 'elitist' are good indications that there are probably *no* solid grounds for his dismissal.

"Tom is *not* an anti-Semite. He is a true egalitarian. If you have any real charges against him, let's hear these, instead of the character assassination being leaked to the press. As long-time supporters of the Whitney Museum, we're extremely embarrassed."

In despair over inaccuracies in the press, and also over quotes from insiders who had promised silence, Tom and I decided to talk with Kay Larsen of *New York* magazine. On the cover of the February 12 issue,

Tom, cheerful in a polka-dot blue bow tie and a pin-striped suit, in front of Jasper Johns's *Three Flags*, faces the art world. Heavy black print proclaims "WAR AT THE WHITNEY: Whose Museum Is It, Anyway?" Inside, five revealing photographs:

On the Whitney's fifth-floor terrace, an oversized statue of a nude male towers over Bill Woodside, who's smiling grimly.

Larry Tisch smirks in his leather office chair, hands folded over his stomach.

Seemingly entangled with Eva Hesse's poignant *Untitled — Rope Piece*, I'm gazing sadly from its webbed and dripping ropes, looking as old and tired as Tom was accused of being.

All three Michael Graves building designs.

Finally, the Henri portrait of my grandmother, all sensuous silks and languid pose. But look again: see Gertrude's unflinching gaze, belying her vulnerability. See the focus in those large lovely eyes. Was I betraying her dream, or protecting it?

Kay's article was long and detailed:

Museums are legally governed by boards of trustees, and museum directors can be fired at whim. Directors describe a "tremendously uneasy, often hostile relationship" with trustees, one that is "inherently adversarial. . . ."

Whatever their motives, the Whitney trustees who back Woodside apparently didn't consider the potential damage. One board member who heard about the attempted coup after it happened was horrified. "A very small group of people exercised a force majeure that came as a surprise to most of us," he said. "I was shocked most of all at their attitude toward the museum. They acted as though it was a fait accompli; they expected you to think there was a consensus when there wasn't one. It's a very dangerous thing to do. When a not-for-profit organization breaks stride, it's much harder to recover itself. . . ."

The Whitney's troubles are both personal and institutional. "Every trustee on the Whitney board has a different opinion of what the museum should be," said a fellow director. "There is one person in the middle — Tom — who has to keep them all smiling. Trustees keep score of social slights and decisions they don't agree with. People have been keeping score on Tom."

The personal side is hard for outsiders to glimpse, but it will be the deciding factor in the struggle for control of the museum.

After describing several board members, Larsen concluded that "Woodside, Lauder, and Ehrenkranz are the most visible members of the anti-Armstrong faction." She confronted the anti-Semitic

question, recounting Larry Tisch's visit to me. Tisch, in her interview with him, denied saying he'd destroy Tom. "But does he deny saying anything about Armstrong? 'I won't deny or confirm. I'm not a person who goes out to destroy people. I figure that things take care of themselves.'" But Larsen's investigations showed that Tisch had at least threatened other co-op board members. As for Tom: "'I don't say anti-Semitic things,' Armstrong insists. 'I don't know how to. I say things like "The patronage of twentieth-century art is primarily Jewish," but you can document that. It's not anti-Semitic; it's just fact.'"

Thirty-two

*N*ow it was wind-up time — not toys, today, but real-life endings.

Tom met with the committee on February 8 and came straight from that meeting to a joint party for the Whitney's sixtieth birthday and the publication of *Rebel on 8th Street*, Avis Berman's biography of Juliana Force. However disheartened he may have been, he cheerfully greeted the many guests, including several artists who had actually known Juliana and Gertrude. In my album, for example, is Paul Cadmus, one of the first artists whose paintings I remember. My mother owned one, and he often exhibited at the old Whitney; now in his eighties, handsome and gallant as ever, he's shaking hands with fellow old-timer David Solinger. And there's my sister Pam, who came in from Long Island to bring me love and support.

Tom sent to each trustee a long summary of his fifteen-year tenure at the Whitney. It's a reasoned, accurate assessment of the Museum's accomplishments under his direction, and also of its history in those years, a valuable document for the Whitney's history. In his first sentence, Tom made the salient point that his "competence and performance should be the primary considerations," implying his certainty (and mine) that his personality and the feelings of trustees would, instead, be paramount.

Tom and all other trustees except Leslie Wexner (usually absent) and three who were chronically ill (Willie Cohen, Howard Lipman, and Lawson Reed) attended the trustees meeting on March 5. Most arrived half an hour early to read the confidential report of the review and future directions committee, which was not to leave the trustees room. "A guiding principle, . . ." it says in the introduction, "has been

'the primacy of institutional goals over all personal or interpersonal considerations'" (from *Museum Ethics*, American Association of Museums, 1978).

When Bill took over from me, the report stated, there was "change in the style as well as the substance of the governance of the Museum." Bill was "much less involved in day-to-day operations, and expected more independence and accountability in staff operations." (But I had never been involved in day-to-day operations — only in day-to-day work — and staff had always been independent and accountable.) This marked, the committee felt, "one more step away from the historic pattern of governance of the Museum — a close collaboration between the Whitney family and the director." There's an implication that the "close personal relationship" that had existed between Juliana Force, Lloyd Goodrich, and Jack Baur, and the "controlling family," is no longer appropriate as a modus operandi for the director and president.

Extensive delay of the building project is seen as a primary reason for trustee dissatisfaction. Our mission is unclear, and should be clarified at a board retreat. (I'd been trying to talk Bill into having one for years.) These and other specific criticisms could have been addressed by the current administration. The real reasons for Tom's dismissal were, I believe, all in one paragraph:

For the well-being of the institution, the director must maintain a close working relationship with the trustees. The director and the staff should be willing to listen attentively to ideas proposed by the trustees, even though they are under no obligation to accept or act upon those ideas. Tom Armstrong has at times lacked tact and diplomacy in disagreeing with or rejecting the ideas of trustees and other supporters of the Museum. Some trustees complained that their questions and advice are brushed aside. Despite his self-assured manner, he frequently takes suggestions as personal criticisms rather than constructive advice. As a result, his stance vis-à-vis others on particular matters tends to be one of rejection or denial rather than a mutual attempt to resolve or explain a problem. The director (and board officers) must be open to hearing dissenting opinions, and must have the emotional strength to take criticism and not be defensive; otherwise neither the individual nor the institution can improve. The director and some staff have also been criticized for unresponsiveness, a failure to answer phone calls or letters promptly, to act upon pending matters, to extend thanks when appropriate, and similar neglects that are not major in themselves but which tend to annoy individuals with whom it is important for the Museum to maintain good relations. The

cumulative effect of individual rebuffs and small affronts has contributed to the director's erosion of support.

There it is. Laid out in black and white. Some of it true; because Tom surely does not pretend enthusiasm when it's not there. Is not polite when dealing with works of art he considers inferior, or ideas for programs he thinks are stupid. He'd make an effort with people he didn't really respect, when he realized it was important or when Jennifer and I urged him to. But Tom's main thrust, properly, was in the direction of programmatic excellence, and toward spending time with those he found intelligent and helpful.

The report continues with a variety of detailed criticisms, such as "especially in the professional community . . . the scholarly and intellectual work of the curatorial staff as manifest in exhibitions and catalogues is not as good as it should be." This probably reflects Jules's views, since very few other trustees were intimately familiar with our programs.

Jules summarizes, at the end of the report:

Within the context of the continued delay or termination of the building project, a pronounced drop in the extent to which endowment income covers the operating budget, and the prospect of increasing competition for diminishing resources in the years ahead, the board must decide whether the Whitney Museum has the most appropriate director to lead it in the 1990s or whether it should look to new leadership. We have discussed above many of the strengths and accomplishments of Tom Armstrong, but our report also recounts the dissatisfaction expressed both within and outside of the Museum in regard to him and to areas of activity for which he must take responsibility. These include occasional neglect and defensiveness that has alienated potential supporters of the Museum; overemphasis on the social side of the Museum at the expense of scholarship; failure to maintain the reputation of the Whitney for the highest standards of intellectual excellence in the exhibition and publication of twentieth century American art; failure to achieve greater cultural and geographical diversity; resistance to hiring strong people in areas in which he has an interest, notably the failure to hire a chief curator despite the urging of the board, in effect serving as chief curator himself; and other criticisms, direct and indirect. The cumulative result has been a gradual erosion of support for the Director.

After pointing out grave board deficiencies, Jules says "there is enough blame for everybody" but "the fact is that the director has lost

the confidence of a substantial part of the board of trustees, and a director who does not enjoy the full support of the board cannot lead."

A somber mood prevailed. After individual members of the committee had presented various sections of the report, Tom spoke. His red-white-and-blue bow tie was as jaunty as ever, his voice hoarse but strong, as he summarized the essay he'd sent the trustees. He then added,

the present situation could have a cathartic effect on the Museum if the real issues, those of confirming the Museum's purposes and defining what scholarship means in a museum devoted primarily to living artists, are confronted and resolved jointly, and with mutual understanding, by the trustees and staff. . . . Together, you and I have led this Museum through the most dynamic period in its history. I have responded successfully to your challenge fifteen years ago to confirm its greatness. I ask you now to assess all of the assets that have brought us this far. I would hope you would not dismiss those that have succeeded because someone felt the rewards were not equitably shared. A museum is a moral, humane endeavor — not a business, not a playing field of power. Success should be judged on competency and accomplishment; not in relation to the fulfillment of individual ambitions.

Harold Price, chairman of the national committee, in a letter to Bill, expressed his and their support for Tom and their dismay at the proceedings: "The National Committee is exceedingly important. Members think that the scholarly level of the curators is high, that they receive good guidance, that the Whitney is much more involved with artists than is the case with other museums." Everyone knew members of this committee were almost all deeply involved with art, and with museums in their own cities. Those with whom I had spoken were incensed by being left out of the discussion, their views and near-unanimous support of Tom ignored. They spoke from a context, they could compare other museum directors with Tom. But they and other outside supporters were not heard.

Tom withdrew from the meeting. Trustees then voted to adopt the report of the review and future directions committee, with the exception of Bob Wilson, who said he didn't believe the committee's recommendations would improve things, and didn't believe the performance of the board had been at fault.

Saying my vote was against hastily accepting the report without more time to consider and discuss it, I also voted no.

Bill then spoke, stating, in part, that "his passion for the Whitney Museum and his affection for Mrs. Biddle led him to accept the office of president of the Museum in 1985, and that while there are many positive aspects of the Museum, it must be better overall, and not function as an extension of the commercial galleries." He then asked for a secret ballot, and a majority of the trustees currently in office voted to "remove Mr. Armstrong from the office of director of the Whitney Museum of American Art." Jennifer Russell was then appointed acting director.

Certain of the outcome, certain I must say something, certain, too, that I'd be too upset to speak extemporaneously, I had prepared a short speech.

What do I hope for the Whitney?

First: that it should continue its historical mission and its historical character — to exhibit and collect the art of our country and our own time, in the most broadly defined way possible.

Second: that those who are responsible for its goals and for its very existence — its board of trustees — should believe in the institution wholeheartedly, should have its welfare and integrity as their most important priority in terms of their commitments to public institutions, and should be filled with pride and joy in the Whitney, identifying with its goals and happily reaching deep into their pockets to enable it to achieve its potential.

I hope we will remember this splitting, and the anguish which I think we all share, for which we all bear responsibility. In my view, it was completely unnecessary. We must not forget this pain, but it is time for a healing process to begin. If I can help in this, I want to, and we must start right away if we care about our Museum. We must aim at the Biblical "newness of life," and that clearly means changes on our board as well as on our staff.

I have been touched by the many letters in support of Tom, as I am sure you have, and by the outpouring of praise for our Museum from a wide variety of passionately partisan people. . . . It's going to be a big challenge to live up to that in our complex world, perhaps the biggest challenge the Whitney has ever faced. Are we up to it? Please, say yes.

In conclusion, I read the last part of Matthew Arnold's *Dover Beach*:.

. . . . let us be true
To one another! for the world, which seems.
To lie before us like a land of dreams,

So various, so beautiful, so new,
Hath really neither joy, nor love, nor light,
Nor certitude, nor peace, nor help for pain;
And we are here as on a darkling plain.
Swept with confused alarms of struggle and flight,
Where ignorant armies clash by night.

I wanted to express my emotion in the words of a poet, since I couldn't say all I felt for fear of further damaging the Museum and alienating the trustees. Tears flooded my eyes, but I got through it, and through the discussion of the wording of the press release, and through the 6:00 adjournment.

No one seemed to remember that Tom didn't know the result of the vote. I quickly left the men who were working on the press release and found him in his office, with some of the curators. No one was surprised. But now it was different, definite. I heard years later that Tom, Jennifer, Lisa Phillips, and other curators repaired to Les Pleiades, where Lisa remembers drinking so many vodka martinis that she could barely walk out of the restaurant. Owner and friend Pierre Amestoy, in despair, wanting to comfort Tom, brought them soufflés, one after another — first cheese, then lobster, then chocolate —

I went home alone.

No one, Jennifer remembers, no one who fired Tom had a clue about what to do next. There was no plan. No one had talked with her about the future.

Tom acted with integrity. He never spoke to the press. Never said a word against the Whitney.

The next morning, Jennifer asked me to talk to the staff and tell them what had happened. They didn't know Bill, didn't trust him, and were upset, unsettled. This was most dangerous for the Museum. So I agreed. It was so hard, the hardest thing yet. I loved them, felt myself a part of the staff, perhaps now more than of the board. I'd worked with them, socialized with them, had known some of them almost all my life. They were demoralized and disheartened. I did my best to be cheerful, but alas, I really did cry as I begged for their continued loyalty and commitment to the Museum, and to Jennifer — which they gave, unstintingly, during all her directorship.

Jennifer — plucky, capable, intelligent, and ethical — kept the Mu-

seum functioning, held it all together for the next year. Never losing her sense of humor, her balanced view of matters, or her immense capacity for work, she triumphed over the problems and adversities inherent in the difficult situation. She and the staff made it possible for the Museum to survive.

A day or so later, I found this invitation from Tom on my desk:

Baldy

invites you

to a

Changing Climate

party

Wednesday, March 14

It was fabulous. With dancing, and toasts, and no tears at all. Tom, at his best.

Aftermath

We cannot revive old factions
We cannot restore old policies
Or follow an antique drum.

T. S. Eliot, from *Little Gidding*

The building project Tom and I and many others had spent over ten years working toward was abandoned, without even being considered or rejected. The whole plan just drifted away.

The media lapped up the blood. "For the sake of the Whitney," the Whitney's public relations officer persuaded me to be photographed outside the museum with Jennifer and Bill. Jen's smile is forced and mine is nonexistent. The *Times* headline:
PRESIDENT OF THE WHITNEY FORESEES NEW EMPHASIS ON SCHOLARSHIP.
In the article, Bill refers to "quickie show-and-tell operations" and Grace Glueck reports, "Neither Mr. Woodside nor Mr. Armstrong has ever said why the director's resignation was requested." She quotes me: "It was a nightmare. . . . But the Museum means a lot more than any of us does as an individual, and it's important to start the healing process."

John Russell, senior art critic of the *Times*, wrote an encomium to Tom: "Man-hunting, like bear-baiting, has no place in a civilized society. Yet in the last month or two the manhunt has become a fact of life in the cultural life of New York." He listed other losses caused by "power in the hands of board members, managers or moneymen," and went on to counter the criticisms of Tom's exhibition program with high marks for its quality over the fifteen years of his directorship. Russell recalled adventuresome films we'd shown, our unique education program, Trisha Brown's dances up walls. Ecstatic moments: "I

can remember for instance, how at the end of his address at the memorial ceremony for Alexander Calder in 1976 James Johnson Sweeney looked at the Calder mobiles all around him and said, 'Though the dancer has gone, the dance remains. . . .' Besides, no museum director was ever as much fun as Tom Armstrong. Who else would have dressed up and paraded with the clowns in the Ringling Brothers Circus in Madison Square Garden to raise money for the purchase of Calder's *Circus?* . . . There are ways to behave well, and there are ways to behave badly. And we know which are the ones that have lately prevailed."

In *New York* magazine, Kay Larsen wrote a follow-up to her previous long article:

In retrospect, the way he was unseated was abysmal. The coup was begun by a small group of trustees, angry for their own personal reasons, who enlisted the discontent of the majority. The argument seems to have been transferred to "larger issues" as a face-saving device . . . the callous, arrogant, and supercilious attitude displayed to Armstrong by his president, William S. Woodside, chairman of Sky Chefs, who trod with the tact of a bull through the glass corridors of a humanist institution. Woodside's quoted statement in the *Times* about "quickie show-and-tell operations . . ." betrays a barely concealed contempt for living artists. It's an appallingly ignorant and insensitive statement for the president of the Whitney to make. If the trustees care about the Museum, they will ask Woodside to resign.

In the *Nation*, Arthur Danto wrote a review of the Whitney's current exhibition, "The New Sculpture 1975–1985." Here is the last paragraph:

This is a flawless exhibition, the Whitney at its best, doing what it understands, meticulously and theatrically. With it, the Museum's trustees condemn themselves for the terrible way in which they fired the director of the Museum, Tom Armstrong, who was outstanding. It is everything the trustees said the Whitney was *not* under Armstrong's stewardship: serious, historical, scholarly and resolutely as untrendy as the impulses of the work shown were. It is historical in an especially difficult way, giving historical shape to a period that would be difficult to grasp without it and the superlative catalogue that accompanies it. Had the trustees known about the show, they could not have said what they did about Armstrong. It follows further that the reasons they discharged this director must have been personal and frivolous, as everyone

suspects, and the action itself one by men and women used to getting their own way, the institution be damned. They stand red-handed and shamed by an excellence to which they have no right.

Letters poured in. A few were encouraging, notably one that Adriana Mnuchin handed me on the day of the trustees' meeting, urging board unity and healing, enclosing a special, unrestricted contribution to the Whitney of $200,000, asking that it be anonymous.

Some people resigned. Some foundations threatened to pull their support — and some did. Attendance dropped. Catherine Curran wrote a note with her letter of resignation from the print committee that expressed the feelings of many: "I'm sure you know what a difficult decision this was — I have *so* enjoyed my association with the Whitney. When I first came back to New York, it was like my club — it was welcoming and friendly and fun. I *loved* the gatherings, made friends, learned a lot by going to lectures and exhibitions. It had great style — yours and Tom's."

In a formal letter of resignation to Bill, she wrote:

"I cannot but feel that any financial support that I might at present give to the Museum could only be considered tantamount to granting approval to the recent actions and decisions taken by the board. . . . I am horrified by what has happened, and even more, by the way in which it happened. . . . I must take my stand, however insignificant, on the side of the civilized values that some of us treasure."

I will only quote one more letter, dated March 1990, a surprising and touching one, since I had assumed David Solinger's disagreement with me.

Dear Flora,

I am delighted that you are serving on the Search Committee for a new director. Indeed, as the Museum enters yet another era, I am impelled to express how important I believe it is for you always to remain active in its affairs. There is a paucity of people who know the Museum's traditions and understand the nature of its commitment to contemporary American art. Memories are short and firsthand knowledge of the past is more and more unavailable; and as the years pass there will be fewer and fewer of us to remind trustees and others what the Museum stands for.

I have genuine concern that, no matter how excellent it may continue to be, the Whitney may lose its character and unique place in the museum world.

The buzz word of the moment is "scholarship." While scholarship is fine, there is no substitute for an eye, the ability to recognize quality and artistry (as distinguished from technical skills), and the importance of the biennial (which, fortunately, has survived many an assault) and the long tradition of friendship to visual artists.

It will be harder and harder with each passing year to sustain the Museum's unique traditions, and I hope you will be there for many years to remind one and all what the Whitney stands for.

> Affectionately,
>
> David

I'd opposed the majority of trustees on a vital issue, and had lost. Should I resign from the board? David's letter suggested one answer. Everyone was urging me to remain, to join the search committee for a new director, to stay involved with committees and with policy. The staff, especially Jennifer, argued for the importance of continuity and commitment to the institution.

Unfinished business, too, needed to be attended to: surely Bill would see he must resign. I hoped Leonard Lauder would take his place, even though he'd been one of those who had led the attack on Tom. Only Leonard, I felt, could unite the board and raise the funds necessary for the Museum's survival. At that moment, being president of the Whitney wasn't the glorious honor I'd hoped it would always be.

So I asked him.

As a responsible human being, as a community leader, as a decent person with the skill, power, and personality to pull things back together, and also, surely, because he now wanted to balance his part in the coup by taking a positive role, Leonard agreed to become president.

He asked me to remain active, and I said I would, knowing he and the others were right, that this was still my heritage and my responsibility, and knowing, too, how much I still cared for the Museum. It had also become a way of life; so many friendships and loyalties were involved. Tom himself encouraged me to stay — yet further evidence of

his genuine love for the Museum. And then, a new fear entered into my decision: if I left, would that seem to confirm the rumors about anti-Semitism? Would the Museum, as well as Tom and I, be further dishonored?

Somehow Bill's resignation was arranged behind the scenes. I don't know the details. On June 13, at the annual meeting, Leonard was elected president; I remained as chairman; and, in a gesture of reconciliation, Tom was elected and agreed to become director emeritus.

In her introduction to the 1989–90 Bulletin, Jennifer wrote:

"The outstanding quality and variety of the programs presented by the Whitney Museum of American Art in fiscal year 1990 represent the accomplishments of Tom Armstrong, whose sixteen-year tenure as director ended in March. The Museum flourished under his leadership, with new programs, expanded constituencies, and the building of the permanent collection. To achieve his goals he delegated a great deal of responsibility to a relatively young staff. He challenged us, nurtured us, and gave us the opportunity to grow as professionals. The smooth continuation of the Museum's exhibitions, publications, acquisitions, and public education programs following his departure testifies to the vitality and strength he left with the institution."

Epilogue

*F*or a long time, I expected perfection — in events, in places, in objects. Above all, in people. When they fell short, I found fault with them. I'd reject things, I'd reject people. Wanting to move on, to change lives. Hardest on myself, I'd also criticize those I most loved: my parents, my husband, my children. I didn't see this for years. Even now, my critical nature is a problem. As a small child, I was expected to be good, all the time. The perfect posture I still retain, that erect and quite confrontational attitude, is a metaphor for that opposite side of my "ideal childhood": Hold on tight to bad feelings. Control them. Sit on them.

How did these attitudes carry through to the Whitney Museum?

Though the world's, and my own, imperfections loomed ever larger, the Museum always kept its magical aura. There, I believed, ideals could actually reach fruition. And I could help this to happen.

For some time, the dream was real. As it waned, my old tendencies revived. Finding villains aplenty, I insisted on the purity of the hero. I soon saw a battle between good and evil. And I wanted to win.

Instead, Tom was fired.

Why was this so important?

I'd assumed that many "family" aspects of the Museum would never change: the board's sense of fairness toward the director. Smooth transitions from one director to another, from one president to the next. But now, the tightly knit, idealistic structure of the institution that was my heritage was dismantled. Board and staff were ruptured. I felt responsible, hurt, and guilty.

In this book, I've chosen what facts to use to bolster my own truth.

It's the story of a journey from childhood to age, from illusion to reality. It tells of change in an institution and change in me. Realizing, now, that I, like all humans, have the capacity for hostile and vengeful feelings, I've reached a better understanding and acceptance of myself and of others. Larry Tisch's actions were destructive, but his feelings were genuine. What happened to Tom was wrong, but predictable, given the personalities involved plus the imbalance of power and money. As Jules said, there's plenty of blame for everyone — but there's a chance for growth, too.

The subtext of the story is about art and artists. Without them the story wouldn't exist. Since Neolithic times, art has been a necessity for human beings, and artists have been the heart and soul of culture and society. No one, not even the artists who make it, can control art. These men and women are in touch with an ultimate mystery, with the essence of life's meaning, and they bring it to us as a gift. The Museum's politics must reflect an understanding of the importance of that vision in order to fully represent the art it exhibits.

This story is about how the Whitney changed as it grew. It's about the three women who've been corner posts of the Whitney since its inception, and a fourth whose time is just beginning.

First, Gertrude. Passionate, striving, ambitious, she sought to escape from tedium, from the big social life she was born to, in order to work and create. In her spacious studios, with beautiful models, she developed her talent and became a fine sculptor. At the same time, impelled by generosity, love, and guilt, she became a patron. From this combination of motives, her powerful ideas, and then her public institution, evolved. The Whitney Museum, its striving to achieve a sympathetic environment for American art and artists, its perseverance, its faith, its beauty, and even its playfulness, was pure Gertrude.

Flora Miller succeeded her mother. Her motives were pristine. She wanted to continue the Museum exactly as the mother she'd admired and loved had imagined it. Through the institution, she would keep her mother alive. How faithful she was! How she worked, and pondered, and gave of herself — her time, her charm, and her heart. If not for my mother, there would be no Whitney Museum today. Deviations from the original dream were difficult for Flora Miller; she worried, even agonized, over the smallest of them. She was less self-confident than her mother; though courageous and willing, she was not an artist, not deeply involved in the art world. Moreover, her money was drib-

bling away. If she could pass the Museum on to me, she thought, it might stay true to its original principles.

Then I came along, with yet another set of incentives. Questing. A bigger life. An unrecognized need to achieve. Too much of this was unknown to me. All three of us, Gertrude, Mum, and I, were taught to hide from ourselves. We survived the depressions all humans are prone to, in various ways, each according to our natures: through work, art, children, play, lovers, amusements, rather than through self-knowledge.

At the Museum, I struggled to both maintain tradition and push the institution into today's world — to provide the necessary balance between past and present. Money became such a pressing need, though, that *today* won out. Oh, the irony of having wanted change so badly, of having worked to bring it about, and then to see that change spin out of orbit. Change itself, though, is an elemental force. Like earth, air, fire, and water, like us humans too, it mirrors the disorder of earthquakes, hurricanes, volcanos, and floods.

Could I have saved Tom's career? The question keeps haunting me. I could, perhaps, have warned him more decisively to be easier on those he didn't respect, to give more attention to certain trustees. But it wasn't in my nature to be authoritarian. That's one of the reasons we were a good team. I'd have to be a real egotist to believe I could have controlled that situation. Power always went with money — why didn't I know that? Because I didn't know myself, or the world, well enough. I still thought I could make things happen because they seemed right. Supporting Tom and fighting for his tenure, I contravened my own desire that the board should operate by consensus. Convincing myself that a few of us could persuade, that we could change the minds of many, I was stubborn and nearsighted.

Thus, I was forced to recognize reality, and the pain it can bring. Has it made me cynical, callous? I don't believe so. Bringing the real and painful into the light of consciousness may have helped me deal with it better. Although more suspicious and less trusting, I'm still ready to rejoice in the good and the beautiful.

Fiona Donovan — the fourth Whitney woman — is much clearer, more direct. She's self-aware. Mature, with intuitive wisdom and compassion. Trained in art history, she's capable of being either president or director, has been both a trustee and an employee, and is respected and liked by both board and staff. She's strong and has a realistic view of things. She is married to Mark Donovan, a solid, delightful man —

a gifted teacher, writer, and editor. They have two wonderful children, Flora and Tess. Fiona could leave the Museum without guilt. She doesn't need it for escape or for anything else. Still, she loves it and feels responsible to its family tradition.

And now? Nearly ten years have passed since Tom was fired. Director David Ross has come and gone, leaving his imprint on the Whitney: a commitment to the living artist, especially the young, the adventuresome. In those years, Leonard Lauder, first as president, then as chairman, led a fund-raising campaign to create galleries for the permanent collection, designed by architect Richard Gluckman, on the fifth floor and mezzanine of the Breuer building. Gluckman, at the same time, relocated the Museum's offices and library to the "doctor's building" and the adjacent brownstone on Seventy-fourth Street, and gave the Breuer building itself a thorough rehabilitation.

Maxwell Anderson, the new director, is endeavoring to balance the budget, to encourage warmer relationships with artists and patrons, to move into the new electronic world, and to carry out his fine and ambitious plans for exhibitions, education, and the permanent collection.

Despite the large amounts of money raised, the bottom line has remained red. In fact, during the early '90s, deficits were higher than ever before.

As new directors have brought in their own curators, development, financial, and personnel officers, registrars, assistant or associate directors, and assistants for all these, the staff has changed markedly. New staff members soon become friends, but I'm saddened by the lack of continuity resulting from this reshuffling of essential positions, of those who give the Museum its character. Sometimes, as I walk from one floor to another, only guards and preparators are familiar, dependable presences. There's been a break in history, in stability; the atmosphere is different. Until recently, the Whitney was filled with people who could remember almost all the way back to its beginnings, or could recall hearing stories firsthand from those who were actually there. The passage of time alone alters every institution, leaving the earlier generations to contemplate not progress, but its inevitable disadvantages. The familiar disappears, grows strange. And change, however necessary, isn't always pleasant.

At the Museum, fine exhibitions continue to be curated and installed, although I worry when financial pressures cause the board to

ask that curators try for the easy, the popular — the "blockbuster" — at the expense of the new and innovative or the revival of a worthy, long-ignored, or forgotten artist. The permanent collection galleries are splendid, affording the public a fresh look at the classics of American art. Education programs flourish, reaching out to teachers and students in the public school system, challenging future artists and curators in the ISP, and providing classes, lectures, symposia, and other information, both in person and on the Internet, to our members. More, much more is happening. There are always parties, too, although they are likelier now to be fund-raisers. All in all, the Whitney looks great.

Since 1990, while I've participated much less in decision-making, I've continued to serve with pleasure on acquisition committees. I've worked with curators to add works of art to the permanent collection, and with the development department to raise money, and I've cochaired the Library Fellows. Recently, though, I had been living in Taos for half the year. Although I love the Museum as always and remain fixed in my concern for its welfare, I recognize that my time of active participation is over.

Who, since 1990, has cared for the Whitney?

Leonard Lauder, during David Ross's tenure as director (1990–1998), became increasingly involved with the Whitney. He gave Ross his support and worked with him closely. It was Lauder's idea, for example, to hold the "American Century" exhibition in 1999–2000, and he was instrumental in raising more money for it than for any previous Whitney exhibition. The show, curated by Barbara Haskell and Lisa Phillips, was not only elegant and illuminating but immensely popular.

During the 1990s, Lauder in many ways assumed the role that my family once held in the Museum. By bringing in powerful CEOs and other prominent businessmen and women, he shaped the board of trustees and, in addition, maintained its stability by staying in close touch with the trustees. After five years as president, he became chairman and chose the next two presidents: first, Gilbert Maurer, and now, Joel Ehrenkranz. Lauder donated a considerable amount to the Museum and he's raised still more. Further, he's purchased major works of art for the Whitney — among them, groups of paintings by Ad Reinhardt and Agnes Martin, a series of Brice Marden drawings, and a superb Jasper Johns drawing. He has personally funded very much needed curators for drawings and prints. In short, Leonard has given most

generously to the Museum, not only of his wealth and art but of himself. The donation of his time and energy goes on and on.

Most importantly, perhaps, he has been an outstanding leader, infusing the board with his own confidence and enthusiasm. He runs meetings, or participates in them, with assurance, skill, and humor. Still the head of a multibillion dollar business, he manages nonetheless to attend most Whitney meetings — trustees, executive, budget, and drawing committees, all national committee weekends and trips — and continues to work closely with the director and curators.

The Whitney is indeed indebted to Leonard Lauder. It's likely that he'll take his place in history as the person who most enabled the Whitney to continue to grow larger and stronger in the '90s.

No one will ever replace Gertrude Vanderbilt Whitney, the visionary creator of the Whitney Museum of American Art. A sculptor herself, she well understood the need for the artist's freedom to experiment, for the director's freedom to choose, and for the absolute separation mandatory between staff and patron to ensure these freedoms. Since it never occurred to her — and at that time why should it have? — that the Museum one day might need money other than hers, her considerations were chiefly artistic. The wide attendance she'd hoped for had nothing to do with financial gain. The Museum's needs were bound to change as it evolved into the great public institution it is today.

The Whitney, as other institutions before and since, has had to make the compromises its survival and growth demanded. These sacrifices were not small. Necessary, but not small. I hope that we never forget exactly what we had to lose to protect our gains. I hope we keep these losses precise in our memories and carry those ideals into the future. Let us remember, especially, the woman who believed that her ideals and her small, beloved Museum were inseparable.

While looking back is essential for understanding, I must now look forward. These words about the Whitney, written in 1954 by Lloyd Goodrich, remain as apt today:

The new Museum's basic principles had already been shaped by years of experience and they have not changed essentially since. Though never precisely formulated, they might be summed up as a set of general beliefs: that

the contemporary art of a nation has a special importance for its people regardless of comparisons with that of other nations or periods; that a museum's function is not merely to conserve the past but to play an active part in the creative life of the present; that a museum should always be open to the new, the young, the experimental; that it should never forget that the artist is the prime mover in all artistic matters; that it should support his freedom of expression, respect his opinions and avoid any attempt to found a school.

May the Whitney always adhere to these values. May they remain the changeless root of all growth and change, the heart of the Museum.

As I leave the Whitney's board in June 1999, after more than forty-one years, I will watch eagerly as Fiona takes her place as a trustee. Looking back over many years, I realize anew how central the Museum has been for me. As our relationship evolved, it's been, in turn, mother, sister, child, and lover. It's given me a richer life than I could possibly have imagined for myself, and it's given me more pain, too — plus a true education. I've been blessed with a wonderful family, and the Whitney is a part of that complex orbit within which I spin out my days.

Acknowledgments

*W*ithout Lenora De Sio, this book might not exist. Teacher, guru, editor, and friend, Lenora makes, in the works of her beloved T. S. Eliot, "a raid on the inarticulate." With her guidance, ideas and feelings become words, one's own voice emerges. All the way, from the beginning through many revisions, she has been with me. She has helped me to provide a context for the events I was writing about, and to develop and deepen my ideas. Always ready for discussion, in a thick stack of eloquent letters she inspired, urged, edited, and gave me the confidence to continue. I am deeply grateful to Lenora for her wisdom, insight, and goodness.

Joan Clark's enthusiasm and generosity led directly to this book, through her introduction and warm words about my manuscript to Jeannette and Richard Seaver. I am infinitely grateful to her, for that and for her friendship.

Heartfelt thanks go to B. H. Friedman, an accomplished writer with an acute mind, who improved its shape and substance, page by page. He also allowed me to quote from the biography he wrote about my grandmother, Gertrude Vanderbilt Whitney (Doubleday, 1978), and I have used many of its pages, almost verbatim, in writing about my Vanderbilt and Whitney ancestors.

Joan Weakley and her husband Rob Ingraham were greatly encouraging. A proficient editor, Rob gave me helpful pages of articulate notes.

Anabel Davis-Goff, a superb writer who is also an adept editor, was kind enough to make excellent suggestions for strengthening this book.

Arthur Danto, pellucid philosopher and critic, scrutinized my pages,

and elucidated the book's shape and meaning, increasing my resolve to publish it.

Susan Cofer, gifted artist, faithful friend, was by my side during all these years of writing, challenging me in thoughtful letters and discussions to analyze, dig, question, and — above all — to finish.

I am extremely grateful to my son-in-law Mark Donovan, an expert editor, for his insight, and for all his incisive, affectionate, and eloquent advice.

Tom Armstrong's acceptance was vital, especially since I know that reliving the late '80s through this book was painful for him. His enthusiasm means a great deal to me. He is, after all, the hero of this story.

Friends who read versions of the manuscript and whose responses and encouragement were precious include Mei Mei Bersenbrugge, Lesley Dill, Gabriella de Ferrari, Brendan Gill, Barklie Henry, Jacqueline Hoefer, David McIntosh, Doris Palca, Christine Taylor Patten, Lisa Phillips, Jennifer Russell, Patterson Sims, Julie Sylvester, Linda Tarnay, Richard Tuttle, Adam Weinberg, George and Betty Woodman, and Paul Wolff. Several friends read certain chapters, and I appreciate their bolstering: Pamela McCarthy, David Michaelis, Elizabeth Seydel Morgan, Happy Price, June Roth, and Bill Valentine.

I appreciate the help of many people at the Whitney Museum, especially that of Anita Duquette, who located many photographs and arranged for permissions to use them.

My sons and daughters and their spouses: Michelle and Bill Evans, Duncan Duer and Linda Stern Irving, Macculloch Miller Irving and Libby Cameron, and Fiona and Mark Donovan, have been abundantly supportive. I'm profoundly thankful to them, not only for their outpouring of love now, but over all the years of their being. And for giving me such fabulous grandchildren and even a great-grandchild!

Fiona has read more than one revision, and her pertinent comments have been indispensable to its final form. She has picked up stylistic and factual errors, mistakes in wording and interpretation, and lapses of inclusion and exclusion. Her willingness to discuss many aspects of the Whitney has helped me to formulate and adjust many of my ideas and conclusions, since she knows the Museum and its cast of characters so very well, and her commitment to my project has been of measureless value.

My editor, Jeannette Seaver, is wondrous. Her faith and her

experienced enthusiasm enabled me to believe that the manuscript would become a book, and I feel tremendously blessed by her brilliant editing. She has improved the book very much. It has been a joy to work with both Jeannette and Richard Seaver, publishers extraordinaire, and I'm deeply grateful to them for their confidence in the book and in me.

My final editing was done at the Virginia Center for the Creative Arts. Its serenity, warm embrace, and beauty made it possible to concentrate and work productively.

Last, but definitely not least, I thank my husband, Sydney Francis Biddle, for bearing with my Museum life and love, and for participating eagerly in dinners, lunches, symposia, lectures, national committee meetings, and Whitney tours here and abroad — a seemingly endless flow of events and people. Sydney has been entirely supportive during the making of this book, and his comments have always been cogent and thought-provoking. He makes me know that he's proud of me for writing it — and this has been a powerful incentive. Heartfelt thanks, Sydney, for that, and for our eighteen years of adventuresome, lively, and loving married life.

While I'll appreciate forever the help and support I've received from all these wonderful friends and family members, I want to emphasize that all errors, lapses, inconsistencies, and other faults are mine alone.

Index

Note the following abbreviations:
author—Flora Miller Biddle
FWM—Flora Whitney Miller
GVW—Gertrude Vanderbilt Whitney
WMAA—Whitney Museum of American Art